ART NOUVEAU

30/11/04

30/11/04

ART NOUVEAU

ROBERT SCHMUTZLER

T & H

THAMES AND HUDSON

First published in Great Britain in 1978
by Thames and Hudson Ltd, London

Copyright © 1977 by Verlag Gerd Hatje, Stuttgart
An abridged edition of the 1962 book of the same title

Printed and bound in Japan

CONTENTS

THE PHENOMENON

Art Nouveau is the term generally used for defining the style of art which, around 1900, had as its main theme a long, sensitive, sinuous line that reminds us of seaweed or of creeping plants. Such a line might also be suggested by the way the spots are scattered in a leopard skin or by the flick of a whiplash, flowing or flaring up, *moderato* or *furioso*, always moving in a sort of narcissistic self-delight. We likewise find it illustrated in the figures of swans on a wallpaper, or making the locks of nymphlike girls flow and undulate, or thrusting electrical blooms into space from lampstands whose metal stems are as delicate as those of lilies.

Historically speaking, Art Nouveau developed between the style now known as historicism and what later developed as our own style of modern art. Like both of these, broadly speaking, Art Nouveau is a phenomenon of the Western world. "Between" does not mean that it was a style of transition: Art Nouveau, the German term for which is *Jugendstil*, its Viennese form being *Sezessionsstil*, and its Catalan version known as *Modernista*, also became known in Paris, in the nineties, under the name of "Modern Style," an Anglicism that is explained by its English origins. As a style, it carried its emphasis and its value, its center and its purpose within itself. Seen in retrospect, styles generally appear rigorously defined. In reality, however, their frontiers were often uncertain, representing a slow transition rather than a sudden break. In spite of the countermovement of the pendulum which seems to govern all successions of styles, each style, in the living metamorphosis of art, grows out of the one that preceded it and begins immediately to develop the seeds of the one that is destined to replace it. The origins of Art Nouveau are thus to be found in historicism, just as Art Nouveau later became the point of departure of modern art, transcending itself with new aims and solutions. The creative will which inspired Art Nouveau found its area of expression mainly between London and Barcelona, between New York and Vienna, between Brussels and Munich, in a great number of works which achieved real perfection, even if the truly creative artists, here as elsewhere, were so rare that their style survived only for a short while.

Art Nouveau reached its maximum diffusion and concentration in the last decade of the nineteenth century and in the first years of our own. Although its birth as a style can, in certain cases, be specified within a year, the art that it produced as a whole cannot be circumscribed with any exactitude. In the case of the architect Horta, the style's richest phase, High Art Nouveau, appeared in 1892 in Brussels, emerging completely armed like Athene from the head of Zeus. *Jugendstil* likewise came into being in Munich in 1894, almost without any recognizable preliminary stage. In London, however, whence the European continent drew its inspiration to a very great extent, the late form of Art Nouveau, with the organic life that animated its curves, began as early as 1880, after having been preceded by a much earlier form in the middle of the century. However, even before 1900 a countermovement could also be detected: in 1898 or 1899, the more geometrical or cubic late Art Nouveau thus began to appear in Vienna. It is true that Mackintosh had already begun to develop something similar in Glasgow in the early nineties. But Gaudí, the greatest genius among Art Nouveau architects, created on the other hand, between 1905 and 1910, the most important examples of his undulating and sculptural architecture, the carved movements of which were inspired by living forms; and, as late as 1914, such a gifted master as Van de Velde created work in High Art Nouveau style, seven years after Picasso had created Cubist painting and three years after the building of the Fagus Factory in which Gropius had given definitive expression to the forms of modern architecture. The chronological frontiers of Art Nouveau thus remain indistinct, each year being of great significance in such a confused period when one style dovetailed into another. Even in the nineties, truly creative works did not all necessarily belong to Art Nouveau: Cézanne's paintings, for instance, stand apart, though they are of course closely related to other phenomena that likewise influenced the styles of Art Nouveau.

On the whole, Art Nouveau may not have culminated in any "great art," being represented as a definite school neither in easel-painting, so preponderantly popular in the nineteenth century, nor in the autotelic statue, conceived as a work of art in itself rather than as a decorative element in some architectural whole. Art Nouveau was indeed striving, in a single figure as well as in the integrated whole of an area, after a connected whole and, if possible, a structural homogeneity, the illustration of palpable objects always being of secondary importance.

We recognize the decorative and applied arts as the basic concern of Art Nouveau, understood both in the broadest sense, extending from the industrial product, such as wallpaper and furniture, to the whole of an interior and, in a wider sense, even to "applied" or practical architecture or also to graphic work, principally posters and book illustrations, whether symbolic and illustrative or ornamental and almost abstract. The pulse of Art Nouveau can thus be felt to beat at its liveliest in ornament.

This ornamental element determines the entire style, extending to its "free" painting and "free" sculpture too.

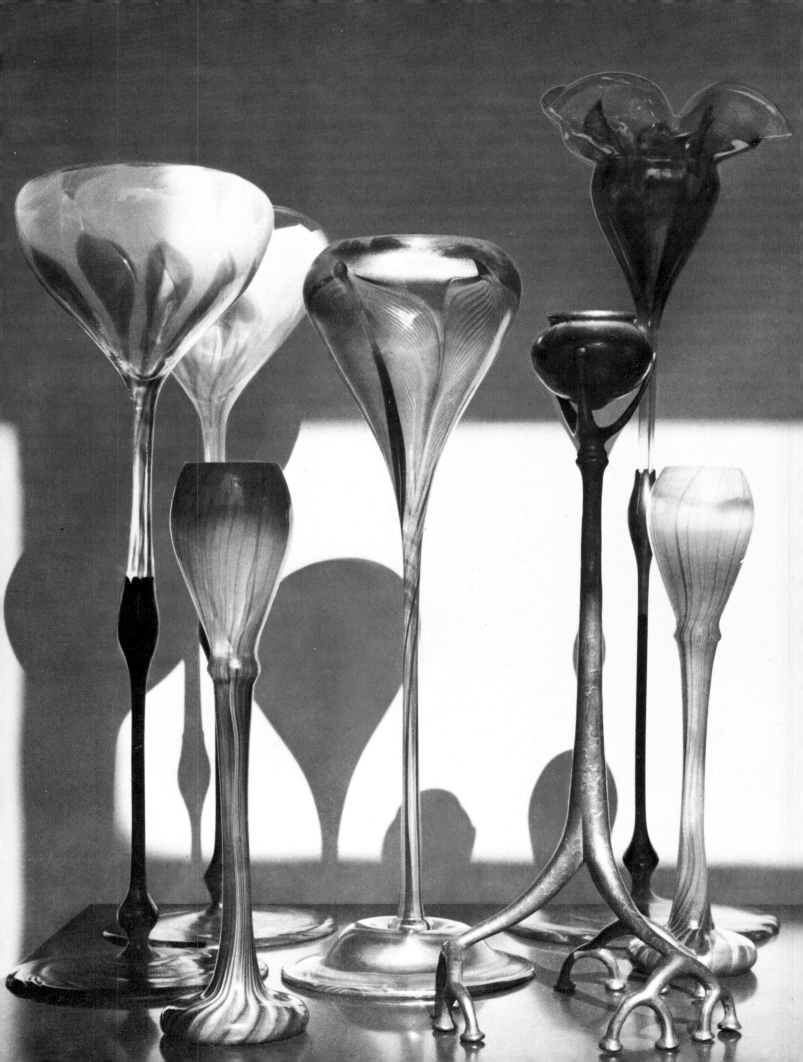

In principle, Art Nouveau expresses itself genetically, first of all, as an ornamental surface-movement where the ornamental element remains dominant, even if applied to the representation of figures or of objects situated in space. Even artists like Gaudí, Tiffany, or Maillol, who have created extreme examples of three-dimensional form, interpret Art Nouveau first and foremost as a phenomenon of surface. On the other hand, ornament now began to dominate figures and objects set in space as an inner force too, imposing on them an ornamental structure. Since, by its very nature, this ornament is always flowing, its structure must reveal itself full of movement too. Horta's fragile and elegant linear framework of architecture is ornamental, producing, so to speak, vibrating structures; Tiffany's and Gallé's vases, with or without further ornament on their curved surfaces, are ornamental bodies in what appears to be a continuously flowing movement; the masses, swelling like sand dunes or humped like a camel's back, that provide the forms of Gaudí's houses and cupolas, with their reptilious and iridescent surfaces of scale-like ceramics, are architectonic ornamental bodies developed in space, animated from within by an almost vital morphology (plates 1, 2, and 3).

Seen as a whole, such useful Art Nouveau objects as pieces of furniture likewise adopt the appearance of ornaments. A chair, for instance, is interpreted as if it were made of a substance that puts out stems and buds (much as Blake had already designed it), or as if it had become the abstract three-dimensional emblem of its own function. The ornaments of Art Nouveau are not decorative or noncommittal; they are signs, closely connected with form, meaning, and symbols. This is why lettering proved to be a fruitful field of activity for Art Nouveau; also, why it is comparatively easy to force such a world of ornamental emblematic forms to ''speak'' and deliver its message that is hidden behind the pattern and even behind the consciously intended ''content.''

Human form, as far as it appears in Art Nouveau, is no exception: it is likewise relegated to realms of ornament. Just as the animated ornaments of Art Nouveau are open to the fourth dimension, to the flow of time that is of a distinctly ''musical'' nature, so is man marked by an ornamental character, not only when he is represented in art but also in life and, above all, in the dance, where living man, set in motion by music, becomes a figure of art. ''Then came the first 'Girls,' the Barrison Sisters, six or seven of them; with their black-stockinged legs, they threw up their long baby-dresses in rhythmical lines.'' With this phenomenon of the ''Girls,'' the effect of the parallel row also appeared, with the repetition of identical ornament and the ''infinite regression'' of pattern which remains valid from Blake and Rossetti to Hodler

and Minne. ''Or Loïe Fuller who, whirling on her own axis like a corkscrew or a spinning top, with countless yards of veil-like materials shining in colored light like an iridescent Tiffany vase, became, in her increasingly audacious serpentines, a gigantic ornament; the metamorphosis it underwent, as it flared up or sank again, being swallowed up by darkness or by the fall of the curtain, seems to us now, as we look back, to have been the very symbol of *Jugendstil*.''[1] What we have just quoted about Loïe Fuller confirms first and foremost the way in which the human figure was then subjected to an alienation that created something nonhuman, nonanthropomorphic, a self-impelling ornament which reminds one less of a human being than of a jellyfish or of a Tiffany glass. One should therefore not be surprised that Loïe Fuller should have so frequently inspired themes for design and for sculpture. Lautrec (colorplate I), Bradley (plate 4), Chéret, and Thomas Theodor Heine have all made use of her figure in ever-renewed variations and abstract ornaments: Bronze statuettes that represent her emphasize the whirling and gliding element in her dance (plate 5), stylizing the human figure, in the literal sense of the word, as an asymmetrical ''plastic ornament,'' an idea first conceived in those years.[2]

Art Nouveau expressed moreover an unmistakable preference for hybrid forms and figures of bastard origin, not only in the numerous mermaids that decorate its buildings or in its many pieces of furniture that are conceived as if they were plants, but also in the disappearance of a clear boundary line between its different fields of art, when it created ''plastic ornaments,'' for instance, or fused the frame and the picture in an ornamental and undivided whole that is full of significance, as had been anticipated by Rossetti and Whistler and was then achieved fully by Toorop, Munch, and Gauguin; that is why Art Nouveau also produced books and bindings in which the typography, the illustrations, and the ornament fuse in a small but fully integrated work of art. In *ensembles* such as the ''illuminated'' books of Blake, in the typography of pages of poems in the German art periodical *Pan*, or in the fine bindings by Charles Ricketts, there arises, out of originally heterogeneous elements, a calligraphic synthesis of homogeneous forms and signs that are all subjected to the same rhythm. Similarly, Art Nouveau also achieved a synthesis of the lettering and the picture or the lettering and the ornament in a poster.

The metamorphosis Art Nouveau was capable of achieving and its indifference to the various genres of art not only facilitated the ''synthesis of art'' (a term used by Van de Velde in *Pan*), but also brought about the appearance of the ''universal artist'' who worked, a typical phenomenon, in a number of different media or fields, for various purposes and in various areas. The most many-sided of these ''universal artists'' was Van de Velde who, outdoing William Morris, produced designs for everything imaginable. From painting he went, through applied art and design, to book decoration and typography, then to the abstract poster also, and to designs

1 LOUIS COMFORT TIFFANY *Glass vases and candlestick* (*circa* 1900)
 EMILE GALLÉ *Small glass goblets* (*circa* 1900)

9

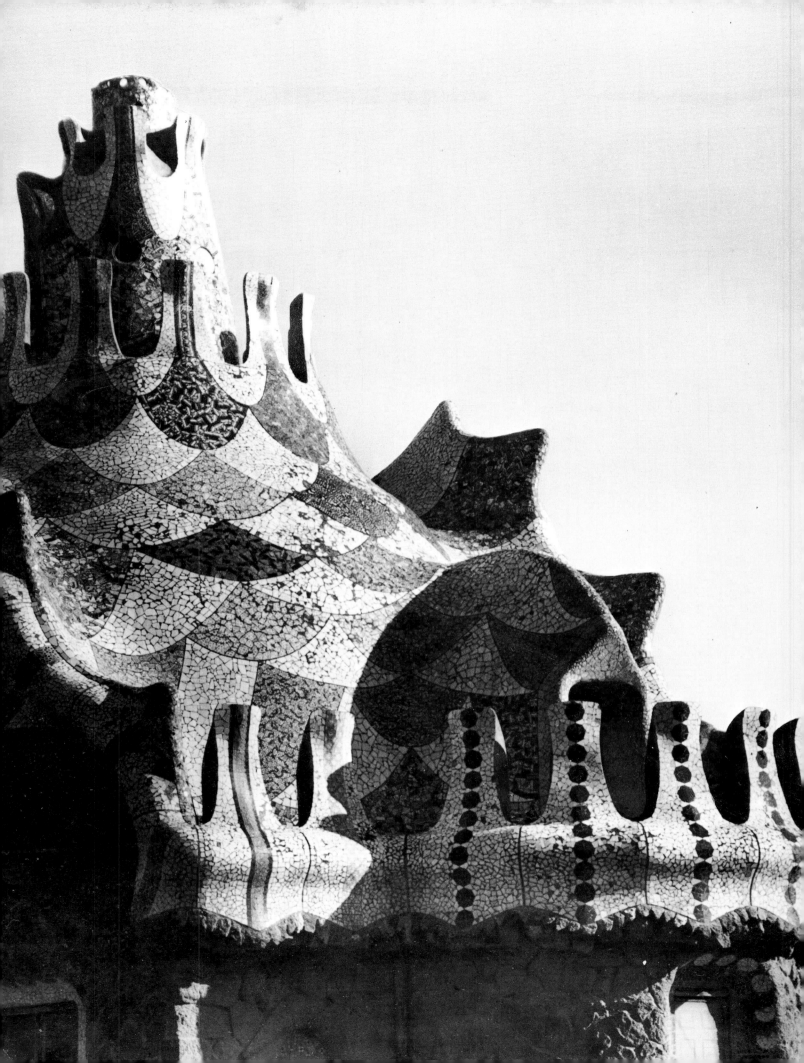

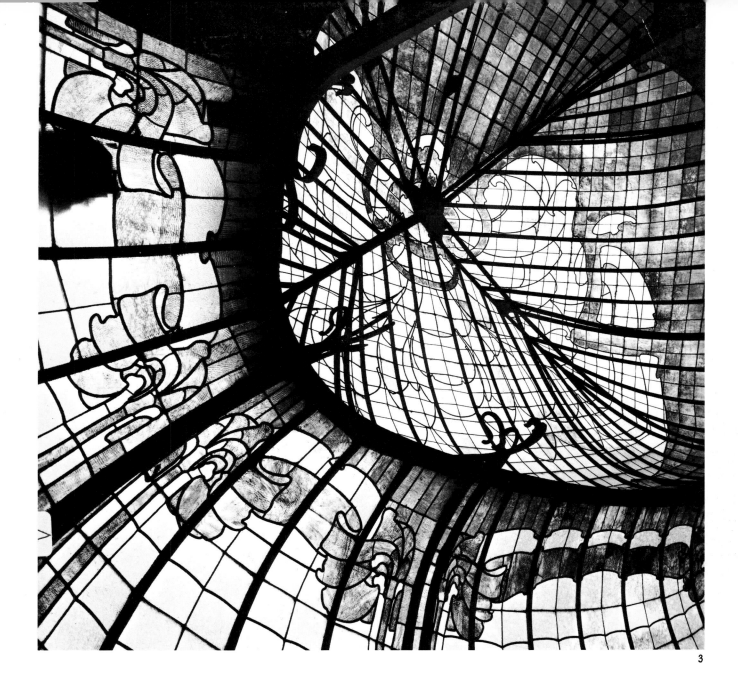

3

for packaging of industrial products; from the patterns for wallpapers, upholstery and decorating materials or carpets, to those for embroideries and fabrics for women's clothing; from designs for windows, skylights, individual pieces of furniture and ensembles, to architecture itself and even to the industrial designing of ocean liners, domestic utensils, crockery, silver flatware, candlesticks, lamps, jewelry, ceramics, and porcelain. In fact, there is no field, except sculpture in the round, in which Van de Velde did not express his own unmistakable sense of form. This "reciprocal osmosis through inner affinity"[3]

2 ANTONI GAUDÍ *Cupola of the porter's lodge, Park Güell, Barcelona* (before 1906)
3 VICTOR HORTA *Glass dome above the staircase of the Aubecq residence, Brussels* (1900)

is also brought about between the graphic or plastic arts and literature. No other period appears to have had a greater number of artists endowed with dual talents, such as painter-poets, than can be found in the history and prehistory of Art Nouveau. Blake and Rossetti, William Morris, and Aubrey Beardsley have left us poems of as great a value as their creations in the field of art. Rossetti painted pictures for poems and wrote poems on pictures, Swinburne composed poems on paintings by Whistler which, written on gold paper, were then attached to the frames; and the titles of Whistler's paintings, read in succession from a catalogue, one after the other, sound like a kind of abstract poetry, devoid of subject matter. So it was not fortuitous that Art Nouveau expressed itself mainly and most completely in book design, where poetry and decoration achieved their closest relationship.

Many of the most important Art Nouveau artists have indeed also written on the theory and the practice of art. From Dresser and Owen Jones, Morris and Walter Crane, to Obrist and Endell, Gallé and Guimard, Sullivan and Loos, they have all added literary works to their artistic creation, thereby adding clarity to their work and giving information to others or acting as teachers. Here too Van de Velde remains a leader in·the sheer quantity and overall effectiveness of his work. The same back-and-forth movement is also achieved between the graphic and plastic arts and music, and between literature and music. Beardsley started out as a pianist; Antoni Gaudí and his patron, Count Güell, were enthusiastic Wagnerians; Beardsley has left us a drawing entitled *Wagnerites*, and there exists a legend about the *Palau Güell* in Barcelona which says that Gaudi constructed it around the music room. The French Symbolistic *Revue Wagnérienne* was not intended for music criticism, its title being merely metaphorical. Setting to music Mallarmé's *L'Après-midi d'un faune* and Maeterlinck's *Pelléas et Mélisande* and blending aural and visual elements, Debussy created a mixed type of ballet and opera; Oscar Wilde's *Salome* became the libretto for an opera composed by Richard Strauss; the young Schönberg, a late Romantic who was by no means a stranger to Art Nouveau, composed his *Gurre-Lieder* on poems by Jens Peter Jacobsen, while typical *Jugendstil* poems of a minor sort constitute the text of his *Pierrot*

Lunaire. From the very beginning, Stravinsky tended toward "applied music," that is to say ballet and a synthesis of aural and visual elements. His titles, *Oiseau de feu, Sacre du Printemps* (a periodical was similarly entitled *Ver Sacrum*), are as intimately allied to Art Nouveau as Scriabin's *Poème de feu* and *Poème d'extase*. Besides, Scriabin also composed "Promethean fantasies" in which the abstract totality of the work consists of tones, colors, and moving lights. There even exist paintings by the Lithuanian composer Ciurlionis representing "painted music" which are almost abstract and very close to Art Nouveau. In Holland, Toorop produced a drawing entitled *Organ Tones*; in his *Cry* (colorplate II), Munch painted sound waves, and his paintings in general were once described in *Pan* as "emotional hallucinations of music and poetry."

The extraordinary importance of music, and of an approximation of painting to music, in Gauguin's theory of art is widely known. Oscar Wilde claimed, as Baudelaire had done earlier, that music was the ideal type of art, the lodestar for all the other arts, the one art in which form and its object are always one and where the object cannot be separated from its technical expression, in fact an art that achieves most completely the artistic ideal which is constantly pursued by all the other arts. Hugo von Hofmannsthal, one of the most sensitive minds of his age, noted briefly: "The time: 1892. Its spirit: the musical element." Whistler, moreover, as early as the seventies, already gave titles to his pictures in which not only the nature of the colors of his Thames landscapes and his portraits was formulated in abstract and musical terms like *Capriccio, Variations, Scherzo*, but where terms taken from the field of music were combined with names of colors: *Nocturne in Blue and Green, Symphony in White, Harmony in Violet and Yellow*. Whistler thus anticipated color harmonies which were to become typical of Art Nouveau: yellow, white, the combination of yellow and violet, and of blue and green, all carefully avoided by most artists both before and after this period.

Such marriages of visual and aural elements, as well as the dual gift of the painter-poets and the quality of symbolism expressed in ornament, all prove the great inclination that Art Nouveau felt toward synthesis. Over and above all this, important theoretical works on art written by many of the Art Nouveau artists, and their very predilection for talking or writing about such problems, all point toward the reflecting and conscious attitude adopted by the creators and supporters of this style who were, without exception, artists of higher than average intelligence. However, a psychological analysis of Art Nouveau might also prove that it was a narcissistic style. The leitmotiv of the sinuous curve already gives us the impression that such a line is in love with itself. It is reflected moreover in parallel phenomena as well as in a "complementary attitude," that of the mutual compatibility of positive

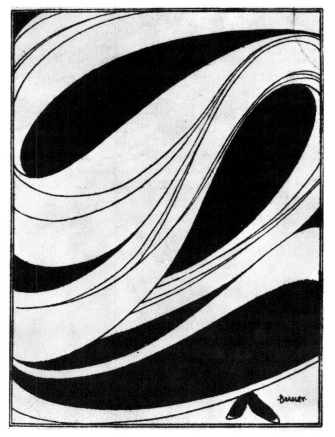

4 WILLIAM H. BRADLEY *The Serpentine Dancer* (1894–95)
5 PIERRE ROCHE *Loïe Fuller* (before 1900)

and negative forms situated on either side of a common formal frontier. Unconsciously Art Nouveau was influenced by no other mythical or symbolical figure as strongly as by Narcissus. One of the masterpieces of *Jugendstil* sculpture, Minne's fountain in the Folkwang Museum (plate 85), shows an adolescent looking at his reflected image in the water. The figure is represented five times, so that the poet Karel van de Woestijne has called the fountain "Narcissus in fivefold reflection."

Art Nouveau distinguishes itself not only through its pursuit of beauty, of beauty at almost any cost, and through its narcissistic self-admiration, but also through its exhibitionism. Before the twentieth century, no other style had, in as great a number of "exhibitions," admired itself and courted admiration. No other art had yet produced so many and such beautiful periodicals to mirror and reveal itself, though the overt purpose or pretext for these exhibitions and publications may have been the need to reform all of art. It is no coincidence that Art Nouveau had a predilection for the peacock, the symbol of vanity, as well as for the swan.

The first of these art periodicals appeared in England, where Mackmurdo, in 1884, published *The Century Guild Hobby Horse;* Ricketts, after 1889, edited *The Dial;* Beardsley, after 1894, *The Yellow Book* and, after 1896, *The Savoy; The Evergreen* began to be published in 1895 in Edinburgh; as the movement spread to America, *The Chap-Book* was published in Chicago as early as 1894. Then, around 1900, there also appeared in England some short-lived "one-man periodicals" like *The Venture,* published by the painter-poet Laurence Housman, and Edward Gordon Craig's *The Page* and *The Dome. The Studio,* which began to appear in 1893, was the most important of all these publications and contributed toward a worldwide diffusion of Art Nouveau in the forms in which it had already developed in England. Unlike all the other above-mentioned reviews, where literary contributions, graphic originals, and "book-ornaments" held first place, *The Studio* devoted itself mainly to the applied arts.

Very soon the Continent found itself stimulated by these English publications. In Germany, *Pan* appeared in 1895 and *Die Jugend* in 1896; emulating *The Studio,* several other important German periodicals concerned themselves with the applied arts in order to satisfy the exhibitionistic tendencies and the zeal for reform by which *Jugendstil* was inspired. The style itself was even named, in Germany, after one of these reviews, *Die Jugend.* In Vienna there likewise appeared *Ver Sacrum* and, in Barcelona, *Jovendud,* which means "youth," as does *Die Jugend;* in Belgium, *Van Nu en Straks* was published and, in far-off Russia, Sergei Diaghilev founded *Mir Isskustva.* As for Paris, some short-lived literary reviews of the Symbolists first appeared there; among these, the *Revue Blanche,* started in 1891, was later to become closely connected with an Art Nouveau movement in painting. But Symbolism and Art Nouveau were not identical. Though all Symbolistic poetry is not

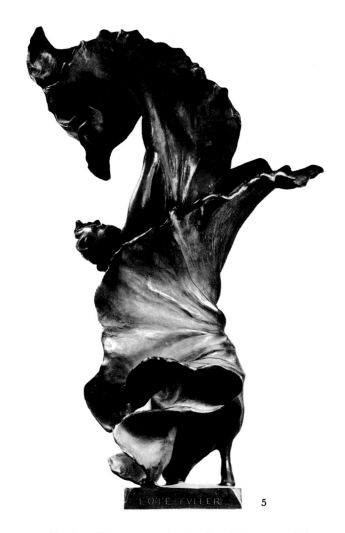

5

necessarily Art Nouveau poetry, all of the art of Art Nouveau that can be perceived by the eye is always Symbolistic. "Art is at the same time both surface and symbol," Oscar Wilde had indeed affirmed.

The esoteric trend pursued by the Symbolists, among whom Mallarmé had declared, as a guiding principle, that "to be clear is to rob the reader of three-quarters of his pleasure which consists in slow guessing," and the very restricted number of copies of the Symbolistic reviews, which circulated only in limited circles, hermetically closed to profane elements, all these characteristics indeed betray another inclination of Art Nouveau toward an introversion which is closely related to narcissism though it may seem opposed to exhibitionism.

Everywhere in the art and literature of Art Nouveau one finds the notion of isolation. It makes itself felt in the poet Hofmannsthal's motto, "I'm nothing to anybody, but nobody is anything to me," and in the titles of Fernand Khnopff's bookplates, *Mihi* and *On n'a que soi* (plate 89), both decorated with blossoms. Again, introversion, narcissism, and a withdrawal from the world express themselves in the title of a periodical *Die Insel (The Island),* a name given to it "with the proud intention of isolation," by its founder, Walter Heymel. Later, Heymel was to call his publishing house by the

same name, and in both instances the title should be taken to mean something like an ivory tower, a refuge for the aesthetes and a place of exile for *l'art pour l'art.* Indeed, a kind of island of art in the midst of the humdrum sea of daily life.

In addition to this symbolical meaning, an island also has a curious significance for Art Nouveau as a geographical fact. Before any other country, England had indeed played the decisive role in the creation of the new style; and Japan, another island, had, with its art and its applied arts, similarly exerted the greatest influence on English Art Nouveau. In art history the style which can best be compared to Art Nouveau is that of the island of Crete in the Minoan period, especially the palaces at Knossos which were first unearthed immediately after 1900, moreover by an Englishman, Sir Arthur Evans, two facts that now seem suspiciously significant. Obviously, Cretan art could no longer in any way influence Art Nouveau, but appeared on the contrary in the absurd guise of a consequence of it, almost like the discovery of some other style of Art Nouveau. As Wölfflin said, one sees only what one wishes to see. But Cretan and Japanese art and to a certain degree the English style of Art Nouveau all reveal distinctive symptoms of an "insular" character: instability, a tendency toward asymmetrical arrangements, patterns, or ornaments, suggestions of the aquatic element in their patterns, with the squid or the octopus painted on Cretan vases, submarine creatures such as also appear in Japanese art where, as in the wood-block prints of Hokusai, water, waterfalls, and waves play an important part, all contrasting clearly with the more classical styles of Western art.

The case of Celtic art, another element in the prehistory of Art Nouveau, appears to be similar. If one studies it, however, exact results are difficult even if one sees it stated, in the *Architectural Review* of 1898, that the Pre-Raphaelite painter Edward Burne-Jones helped the Celtic element in art to gain a victory. But this was not only because he chose as themes Merlin and Vivien or other figures from Celtic legends which, like Tristram and Isolde, King Arthur, or goblins and fairies, all acquired a new life in the aura of Art Nouveau. Above all, the *Architectural Review* refers here to the style of Burne-Jones and to the type of beauty of his figures. The Irish poet William Butler Yeats, the leader of the "Celtic movement" in literature, inaugurated his Celtic renaissance in 1889 with the publication of *The Wanderings of Oisin and Other Poems,* and then published in 1893 a volume of lyric poetry, *The Celtic Twilight.* Not only was he much concerned with William Blake, whose work was a determining factor in the genesis of Art Nouveau, but Yeats also belonged to the group who declared, though it can never be proved, that Blake had been of Irish and consequently of Celtic origin. Oscar Wilde, in the full splendor of his Celtic and Ossianic name, Oscar Finghal O'Flaherty Wills Wilde, was indeed Irish. Even Barcelona and the rest of Catalonia, Gaudi's region, was said to be the most "Celtic" Spanish province! Gauguin, whose style of painting tended toward Art Nouveau, was not closest to *Jugendstil* in the pictures that he painted earlier in Paris or later in Tahiti, but in those that he created during his stay in Pont-Aven, in Brittany, the most purely Celtic of all French provinces. The branch-like metal supports in Guimard's auditorium in the Humbert de Romans Building in Paris (plate 115) suggested to contemporaries a resemblance to a druidic grove.

But we must first examine in greater detail the essentially artistic character of Art Nouveau, clarifying its form and its structure. If Malraux, in reply to the question "What is art?" gives what he believes to be the only correct answer, "That which creates a style out of forms," we may say here, as if in contradiction, that a style can be recognized by what supports it, by form and its inner structure.

FORM AND STRUCTURE OF ART NOUVEAU

By its very nature Art Nouveau remains an ornamental and decorative style, which at least offers a concept that may allow us to understand all its variations and possibilities. Above all, Art Nouveau expresses itself in the surface, though it is by no means always a superficial style. But, almost without exception, its principles find their full application only in the creation of bodily appearances and of spaces which, so to speak, must first pass through a filter which limits them to two dimensions.

Scarcely any work could be more typical of Art Nouveau than Marcus Behmer's drawing in the style of Aubrey Beardsley, published 1903 (plate 6). Its absolute flatness reveals the main feature of the swinging line that flows in unsteady curves from the burning candle. This linear movement is so far extended in its uninterrupted flow that it can change its direction several times, filling considerable areas of the surface. In contrast, other areas, equally important, remain intentionally empty. The undulating movement of curves is curiously flat, its narrow course shifting slowly back and forth within two lines as it repeatedly changes its direction in soft curves.

The limits of the strongly simplified and clear-cut forms are planned so as to allow the adjacent background to be activated too. The intended or positive forms of objects and the negative forms of the empty spaces become interchangeable, as do the black and white elements too, in a complementary relationship that is founded to a great extent on the disappearance of any perceptible element of representation. Emil Rudolf Weiss developed all this to its logical conclusion in a design for the endpapers of a book (plate 7) where one can scarcely distinguish the pattern from the background, or the positive from negative forms. Largely abstracted forms are filled with zoomorphic and plant-like shapes; they can thus undergo a complete metamorphosis in one and the same stroke. Everything is shown at close range, but the whole retains the power of a poster that is seen from a distance. Limitation to the dimensions of the surface, at the cost of any illusion created by sculpture in the round, or by space, thus becomes an absolute rule. In the same rigorous way the artist pursues his aims by means of pure line or clearly circumscribed and uniform elements of surface, all of them homogeneous in themselves, which have been called "surface-bodies." As a means of representation in terms of space, color is of secondary importance. Being nonstructural and nonstatic, such forms elude the law of gravity so that there is often little difference between top and bottom. Asymmetry remains dominant and is even emphasized. But even symmetrical forms cannot conceal that they are in fact born of a basically asymmetrical impulse; composed of single asymmetrical elements, they seem to have emerged from a reflected reduplication or from the radical torsion of asymmetrical details of forms.

An example of the alternation between positive and negative forms and of the subtle shift from rigid symmetry to forms of organic life is given by the star-like flower at the bottom of a Tiffany bowl (plate 8). The ebb and flow of the lines finds itself repeated in the increase and decrease of their width, which varies from that of a ribbon to that of a thread. Around the central flower-like pattern an area of carded texture is formed which, in spite of all symmetry, changes its density ceaselessly, like the pattern in a zebra skin. Individual radiating lines and paths of design illustrate here the typical behavior of the so-called "Belgian" line. Its characteristic is that by not really being a line but more a sort of path or a linear "surface-body," it becomes thicker in the narrow curves where the change of direction is most stressed, and thinner again in those curves that swing more widely.

In the marginal area of the Tiffany bowl the structure of its ornament is revealed in the points of the flower-star which are directed both outward and inward. This structure of ornament shows a tendency to reverse and repeat the curves in spirals so that ultimately the two-dimensional pattern suggests an incursion into the realm of three-dimensional space. Moreover, the two-dimensional ornament occurs on a curved surface, in the curvature of the bowl, yet the flat and graphic elements, even as purely represented as here, include an element of space. Ambiguous as the form and structure of the whole design may be, so is also its "meaning": an organic flower design has grown out of the inorganic glass, out of the threads drawn in the course of blowing it, and within the total curvature of the bowl the flower-like design of its interior becomes something like the pulsating organism in the gelatinous and transparent wrapping that sheathes the body of a Medusa jellyfish.

Art Nouveau in Terms of Line and Volume

However great the similarities in Art Nouveau, two basic attitudes nevertheless confront each other here: linear Art Nouveau and the "three-dimensional" Art Nouveau, concepts that hold true independently of real dimensions of surface, body, and space. These diametrically opposed possibilities may, however, penetrate each

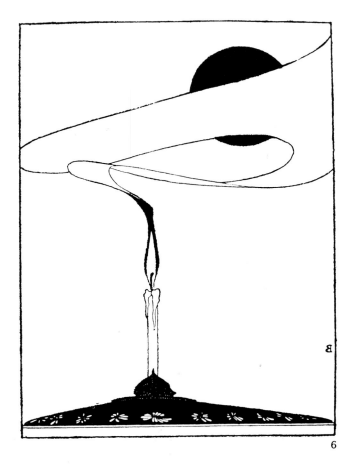

6

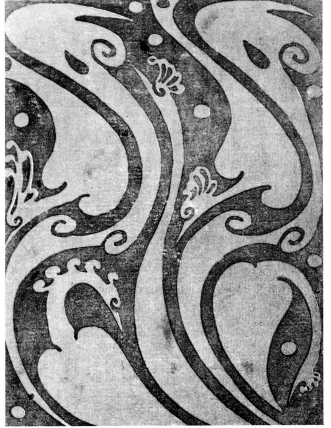

7

other and blend, but in works of high quality they are developed individually, in all their purity.

The character of linear Art Nouveau that occurs in the surface has already been discussed: its line must not be understood in the geometrical sense, but in a broader context. We are indeed dealing here with lines that can vary in width from that of a hair to that of narrow strips of uneven width, somewhat in the sense of the so-called "Belgian" line. "Three-dimensional" Art Nouveau reveals itself, on the other hand, in surfaces, in terms of "surface-bodies," smoothly closed elements of form the nature of which is in itself homogeneous and reminds one of intarsia work as it develops, almost seamlessly, so to speak, into the next such element of form in a given series. Besides, these "surface-bodies" are nearly always complementary. No form and, consequently, no "surface-body" lies on a neutral ground, each "surface-body" being integrated within the ground of the surface itself. The surrounding surface thus becomes, in turn, a closely connected "surface-body" too, its shape being determined by the edge of the adjoining "surface-body" or surface-section. Again, we find an unrivaled example of this in the blue and green endpapers designed by Emil Rudolf Weiss (plate 7), where the frontiers of the various areas are distinguishable from both points of view. The light green forms as well as the darker blue ones are punctuated by dark or light dots or drops and are so interwoven that one can never be sure whether the small spirals, like rounded meanders, are green and penetrate into the blue, or whether the opposite is true. However, the pattern is not entirely abstract but only represents strongly abstracted or, as the period called it, "stylized," peacocks which are barely possible to recognize in the light forms, inasmuch as they are the "intended" ones and dominate the darker connecting forms. But the principle of the desired alternative effect is not affected thereby. The "surface-bodies" here refrain from having separate linear contours. Yet the force of the line makes its influence felt also in "three-dimensional" Art Nouveau, whether it expresses itself as a surface or in space. The uninterrupted jointless cohesion of the "surface-bodies" indeed produces a kind of "negative" line in the continuous margin between the lighter and darker areas. This is a subtle device particularly characteristic of those forms of "three-dimensional" Art Nouveau which find their development either as defined bodies or in purely spatial areas. In both instances the completely closed form, whether as a unit or as a detail, with its smoothly flowing margins—on which it would seem that space has no hold at all—assumes, in turn, an indirectly linear function.

For surface, body, and space, "three-dimensional" Art

6 MARCUS BEHMER *Drawing from Oscar Wilde's "Salome"* (1903)
7 EMIL RUDOLF WEISS *Endpaper for "Gugeline"* (1899)
8 LOUIS COMFORT TIFFANY *Glass bowl* (before 1896)

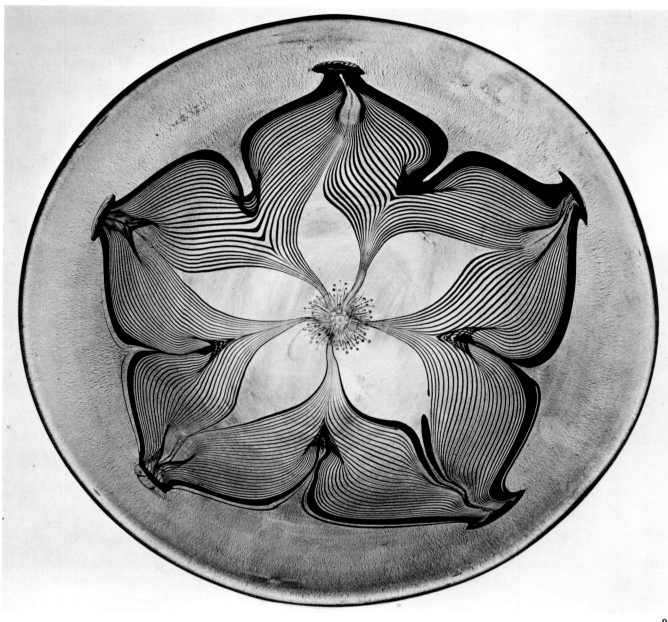

Nouveau manages practically without any articulations. On the other hand, linear Art Nouveau cannot always avoid them, as for instance, due to reasons of construction, in architecture. But in such cases the articulations have an ''elastic'' character. The peacocks in the paper designed by Weiss seem to have no skeleton and no joints, and glide like darting flames, magic fire, or whirling waves.

By its very nature, ''three-dimensional'' Art Nouveau—whether in surface ornament or in figurative decoration—always had a strong tendency to become more abstract than linear Art Nouveau, which on the whole preceded it chronologically. An example of this is Toulouse-Lautrec's *Loïe Fuller*, which is stylized and simplified to the point of becoming an abstract pattern

(colorplate I). The homogeneous surface, the large closed form, its smooth simplified limits without which neither the complementary attitude nor the ''surface-bodies'' would have been possible, all require a large and simple form and do not lend themselves to figurative representation.

Body and Space

The qualities characterizing the surface designs of Art Nouveau can also be found, appropriately modified, in its conceptions of bodies and of space. Linear Art Nouveau is indeed capable of producing, on its own, both sculptural and spatial elements, bodies and architectonic structures. A door handle designed by Horta takes

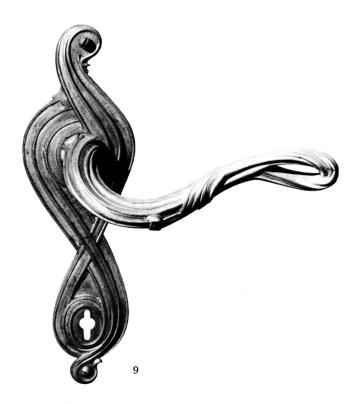

9

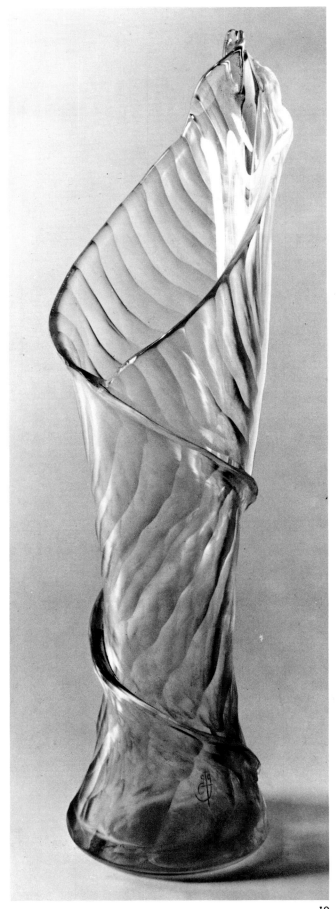

off from the surface of the door as if its line had sprung
into space (plate 9). Horta's lighting fixtures radiate in
space with luminous lines like frozen fireworks; lines or
sheaves of lines twist like spirals, and luminescent rays
of solid substance end in flowers of light (plate 11).
Tiffany's vases reach up in whirling lines, like bodies in
space, as if the flower design of his glass bowl, for in-
stance, had escaped from the confines of its surface (plate
8). As it penetrates the third dimension, linear Art
Nouveau is obliged to assume "substance"; generally
it also did this in terms of surface, as for instance in a
Ricketts bookbinding where the lines are vitalized by an
organic substance (plate 135). This transubstantiation,
this developing of linear body characteristics and dimen-
sions, can be achieved in different ways. In the aston-
ishing serpentine vase by Camille Gauthier (plate 10),
the space element in the lines is achieved by a kind of
pleating in the glass.

Even in Art Nouveau architecture two different con-
ceptions are again confronted, those of line or of volume.
Art Nouveau architecture grows from the inside to the
outside, from the interior and from the relationship
between the rooms and floors of a building to its exterior
structure, where the disposition of the rooms and the
intentionally conceived differences of their levels can be
detected. Just as such a plan of the inner arrangement
can be seen from the outside of the building, so also can
its construction as such become visible. The structural

9 VICTOR HORTA *Door handle in the Solvay residence, Brussels*
 (1895–1900)
10 CAMILLE GAUTHIER *Vase (circa 1900)*
11 VICTOR HORTA *Detail of the main chandelier in the dining
 room of the Solvay residence, Brussels (1895–1900)*

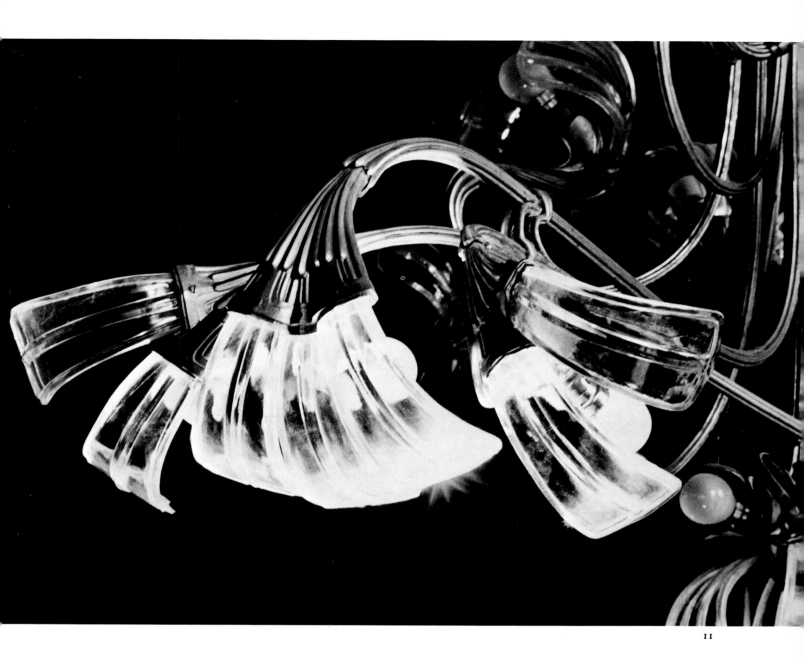

parts are, as with Horta, either clearly revealed (plates 69, 76), or, encased in stucco, are then interpreted as an abstract and ornamental moment radiating great energy, as in Van de Velde's dynamic symbolism (plate 12).

Horta was truly a master in knowing how to achieve the possibilities of linear Art Nouveau. His buildings—linear structures, forms, or rooms—develop like flower stems, spider webs, or the wings of dragonflies (plates 3, 70). The iron framework, borrowed from hothouse construction, provided the technical basis for the glass-roofed railroad station, the covered municipal market, the exhibition hall, and was even applied to the private home. The functional element, however, transcended all material necessity and was transformed into a decorative symbol. The linear rooms, bodies, and structures of Art Nouveau not only tend to give an impression of flexibility

or impermanence, but also one of transparency. The whole façade of the *Maison du Peuple* is thus reduced to a linear framework filled with glass surfaces (plate 77). In the Solvay residence, the main floor is literally constructed of glass: glass partitions separate the drawing rooms from each other and from the staircase that also has a glass roof. This use of glass allows one to see through a building in vistas which give a labyrinthine character to the total disposition of the rooms. A confusing opacity is thus achieved which, in spite of the actual transparency of such a building, is again characteristic of the ambiguous intentions of Art Nouveau.

The polarity between linear and "three-dimensional" Art Nouveau appears perhaps in its most extreme form in architecture, which is concerned with volumes and where the whole building, each room and every detail,

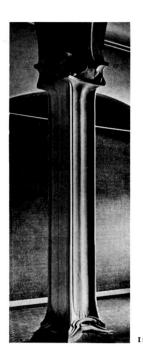

must be conceived almost as a sculpture, as something modeled out of the mass. The most important representative of this tendency is Antoni Gaudí. His buildings are massive sculptural bodies in which the rooms, like caverns, represent, so to speak, negative sculptural bodies. Because walls, supports, and domes are all treated as if formed of a soft substance which can be molded at will, such a style can produce grandiose swinging effects both in the ground plan and in the vertical or horizontal planes (plates 13, 201). The architecture of linear Art Nouveau could metaphorically be likened to flower stems or to the extended wings of a dragonfly, but the plastic quality of Gaudí's buildings makes us think of caverns or dunes, of organic substances, and forms that the wind creates in sand or that the water erodes in rocks.

12 HENRY VAN DE VELDE *Column on the staircase in the Folkwang Museum, Hagen (circa* 1900)

13 ANTONI GAUDÍ *Balustrade of the terrace in the Park Güell, Barcelona* (before 1906)

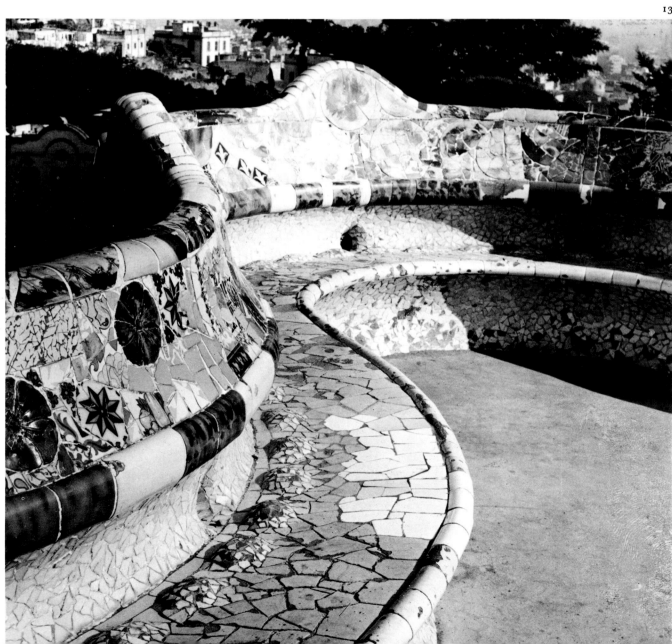

EARLY ART NOUVEAU

The Japanese Style

> "In the citron wing of the pale butterfly,
> with its dainty spots of orange..."
> James McNeill Whistler
> *Lecture at Ten O'Clock in the Evening*

"We must gratefully remember Japan, a land whose wonderful art . . . first pointed out to us the right path. But," Otto Eckmann's preface to a series of *Jugendstil* designs then adds, "only England knew how to assimilate and transform this wealth of new ideas and to adapt them to its innate national character, thus deriving real profit from the Japanese style . . ."

How this came about has been told many times: how the engraver Bracquemond discovered some Japanese colored woodcuts in 1856 which had been used as wrapping paper; how he communicated his enthusiasm to Baudelaire, Manet, the Goncourt brothers, and Degas; how Whistler who, until 1859, had studied in Paris, then brought to London his love for Japanese art and, around 1863, painted the *Princesse du Pays de la Porcelaine* (colorplate IV), a major work among his *japonneries*. In 1862, Manet had painted Zola against a background of Japanese decorations and colored woodcuts which later appeared also in paintings by Degas, Gauguin, and Van Gogh. In 1862, shops dealing in Japanese and Chinese objects were first opened: *La Porte Chinoise* in Paris, and Farmer and Rogers' Oriental Warehouse in London. Farmer and Rogers had taken over the stocks that Japan had sent to London for the International Exhibition of 1862—the first Western exhibition where the Japanese Empire was represented.

On the advice of his friend William Morris, the manager of Farmer and Rogers, Arthur Lasenby Liberty, then founded his own firm in 1875. The new firm was successful, mainly on account of its Oriental and Oriental-inspired fabrics with their light colors and flat, stylized patterns. Its success was so great that in Germany, "national lamentations were to be heard concerning the mass importation of English materials for decoration." And in Italy, where Art Nouveau was never really able to gain a footing and remained an imported style, the term *"Stile Liberty"* was invented. S. Bing, whose shop in Paris, *L'Art Nouveau*, gave its name to the whole style, had likewise begun as an importer of Japanese arts and crafts. He was also the owner of one of the most important private collections of *japonnerie*, and, after 1888, published the series of his *Japanischer Formenschatz* in German, French, and English. To those "who feel an interest in the future of our applied arts"

or who "are doing creative work" in this field, Bing promised, in the preface, that "among these forms, they will find examples worthy in every respect of being followed."

The Japanese element became so inherent to the mature style of Art Nouveau that only in rare cases can one distinguish or separate it from the entire movement. In 1888, Louis Gonse wrote on Japanese art: "A drop of their blood has mixed with our blood and no power on earth can eliminate it." Even where Art Nouveau refers directly back to Japanese art, it is at the same time founded on works of an intermediate phase in which, during the process of long years, a synthesis of the Japanese and the European elements had been achieved and remained decisive in every respect.

James McNeill Whistler

The composition and style of Beardsley's drawing *The Peacock Skirt* (plate 128), an illustration for Wilde's *Salome* of 1894, can certainly be interpreted only as having sprung from a knowledge of woodcuts by Utamaro and other Japanese artists of the eighteenth and early nineteenth centuries. This type of asymmetrical distribution of masses, these curving lines, this absence of compactness, space, or light and shadow in the picture, all indeed come from Japan. Here, however, a direct influence blends with an indirect one: Beardsley's work is already founded on the Japanese style of James McNeill Whistler (1834–1903). In 1891, Beardsley had seen Whistler's famous *Peacock Room,* created in 1876–77 (colorplate IV). The pattern of the peacock feathers in the tail and the scale-like pattern in the plumage occur in numerous variations in Whistler's *Peacock Room* as well as in Beardsley's *Peacock Skirt*. The deliberate ambiguity of design and background, so typical of Art Nouveau, also appears in the works of both these artists. In Beardsley's *Salome,* designed with clear-cut lines in black and white, this ambiguity is achieved in the train of the cape; on Whistler's painted walls and shutters, the golden design on a blue ground alternates with a blue design on a gold ground. In the same manner, Japanese colored woodcuts with black outlines enclosing interior surfaces that are printed homogeneously in white and in colors frequently leave spaces forming decorative fabric patterns that also reappear as positive designs in white against a colored ground.

In Whistler's sketch (plate 15), where peacocks are distributed in space in an entirely un-Occidental manner, and in sizes quite as unusual, there appears, as a novelty, the device of filling up certain areas of

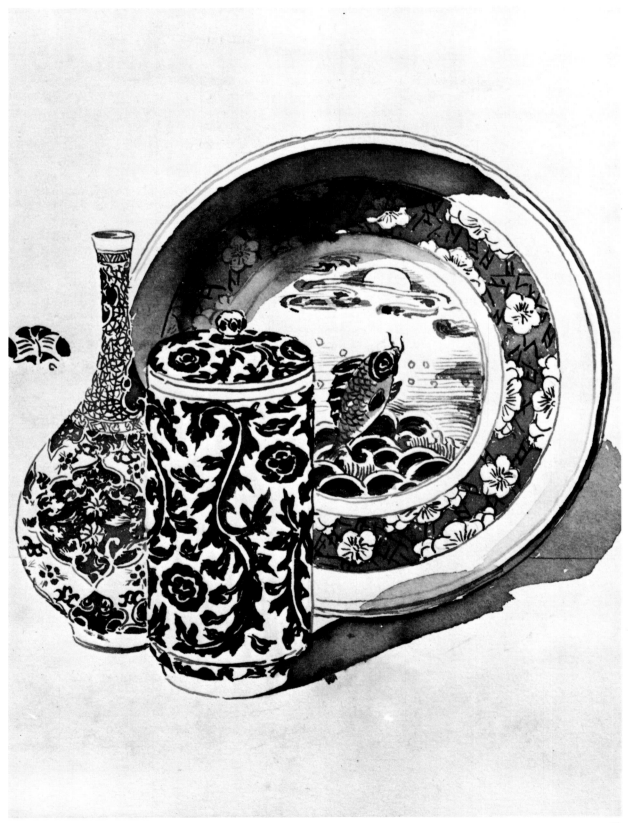

pure linear design with solid black. Beardsley carried this method further. With acrobatic virtuosity, he developed the asymmetrical distribution of the areas of white and the contrast of black spaces by using small over-rich ornaments. Even Beardsley's characteristic stippled or dotted manner (often compared to that of Celtic and Irish manuscripts) had been anticipated by Whistler: similar concentric circular arcs and scales designed in dotted lines, so as to form the spread tail of the peacock on the back of Salome's cape, are to be found in the woodwork of the bookshelves and wall panels of the *Peacock Room.*

Whistler's admiration for Japanese art and applied arts is already reflected in the pictures he painted during the sixties: *Princesse du Pays de la Porcelaine* (1863–64, colorplate IV), *Purple and Rose: The Lange Lijzen of the Six Marks* (1864, plate 17), *The Golden Screen* (1865), and others which are all filled with complete still-life arrangements of Japanese *objets d'art* (plate 17). Besides, the girls who dwell among these screens, fans, and vases are always clad in gorgeous kimonos. These exotic accessories are no doubt included in the picture for their own value and are depicted with an Occidental artist's means; but, even in these early works, the spirit of an alien art had already been clearly grasped. Soon Whistler refrained more and more from representing Japanese objects, penetrating instead into the substance of Japanese art in order to make its essence his own.

In his *Old Battersea Bridge: Nocturne in Blue and Gold,* painted about 1865 (plate 16), a theme taken from everyday life in London is filled with poetic enchantment and seen entirely as if through the eyes of a Japanese artist. No doubt Hiroshige's paintings of bridges inspired it, but the whole picture's generally Japanese character is more important. However, it becomes apparent, both from the impressionistic attitude and from the fact that "all lies so far behind the window of the frame and is so bathed in air,"[4] that, much as Whistler's pictures may be related to Art Nouveau, there is still much that distinguishes them from it.

But, even as an Impressionist, Whistler painted differently—closer to the Japanese and to the Art Nouveau style—than his contemporaries in Paris. An Impressionist of the night, of dusk and of mist rather than of daylight, he removed his landscapes and his portraits to a distant and poetical unreality, at the same time allowing them to be used as elegant decorations: "And when the evening mist clothes the riverside with poetry, as with a veil, and the poor buildings lose themselves in the dun sky, and the tall chimneys become campanili, and the warehouses are palaces in the night, and the whole city hangs in the heavens, and fairy-land is before us. . . ." So runs the most celebrated passage of Whistler's *Lecture*

15

at Ten O'Clock in the Evening that he gave in London, Oxford, and Cambridge in 1885 and had the honor of later seeing adapted into French by Mallarmé. Instead of dissolving in a flurry of brushstrokes, Whistler's painting now consisted of large and homogeneous blots grouped around a skeleton of tracks and ridges. Especially in his Thames Nocturnes (being fully conscious of their attractiveness) he worked around empty and almost monochrome areas. At the same time, he carried the decorative and impressionistic element to a point where he anticipated Kandinsky's "absolute painting" by more than three decades. About 1874, Whistler created what, visually speaking, might well be called the first abstract painting: *Nocturne in Black and Gold: The Falling Rocket* (colorplate III). In the Grosvenor Gallery, which was above all a rostrum for Whistler and Burne-Jones and where the ladies of the Aesthetic Movement wore Pre-Raphaelitic gowns— since, after all, they could not dress as a Nocturne—this painting aroused Ruskin's fury, causing him to declare that it was like "flinging a pot of paint in the public's face." The outcome of this was a lawsuit in which Whistler sued Ruskin in the first recorded legal proceedings concerning the value (or the worthlessness) of a work of art; and although Whistler won this suit, he was awarded damages of one farthing which led to the temporary ruin of the artist.

In *Nocturne in Black and Gold: The Falling Rocket* (the title also is almost abstract), Whistler's fundamental attitude to his art is made clear: it is decorative, ornamental, and musical. The picture is transformed into a sort of rhythmically formless ornament. In spite of its entirely pictorial treatment, it suggests a "complementary attitude" through light and dark forms. Owing to the unique way in which "impressionistic" and ornamental or graphic qualities unite in the art of the Far East, the latter could inspire both the Impressionists and the pioneers of Art Nouveau. Both of these components become equally effective in Whistler's art. However, most nineteenth-century painters were not at all concerned with the frame enclosing their works; the Impressionists, and even the Cubists, continued to use Baroque or Rococo frames for their paintings. In

14 JAMES McNEILL WHISTLER *Study of blue and white Mankin porcelain* (n.d.)
15 JAMES McNEILL WHISTLER *Preliminary sketch for a decoration for "The Peacock Room"* (1876)

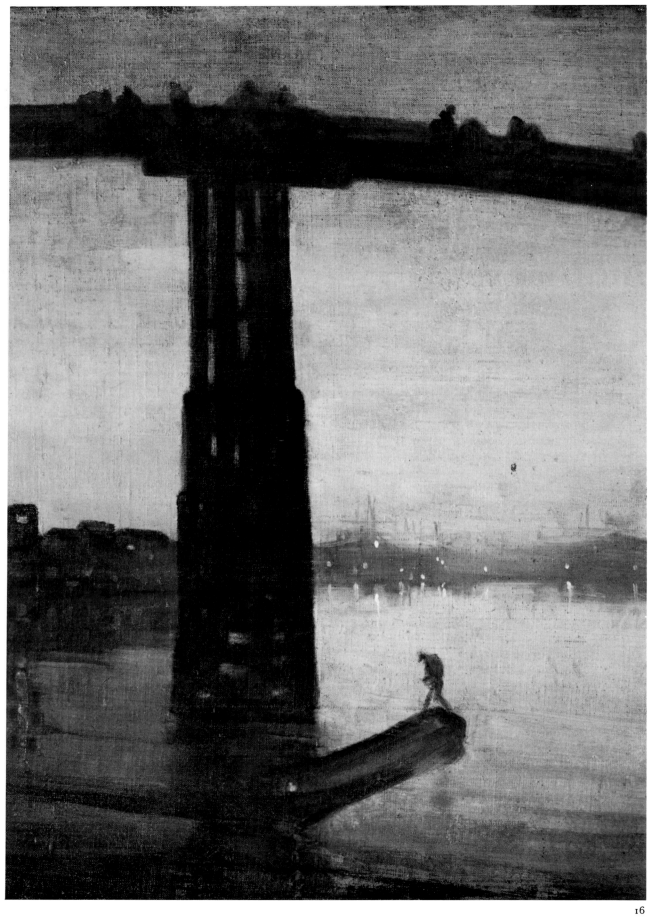

Art Nouveau, however, the frame became of primary importance too, and was designed in harmony with the picture and understood as a "field of approach" to the picture, or even as a kind of ornamental border for a printed page (compare plates 91, 168, and 175). Following the example that Rossetti had set as early as 1849, Whistler began to design simple, rectilinear frames with parallel moldings, sometimes even repeating on them a corresponding pattern in the main color harmonies of the picture. *Old Battersea Bridge,* seen with almost Japanese eyes, is thus framed with a Japanese scale pattern in dark turquoise-blue on gold (plate 16). In the *Peacock Room,* Whistler went so far as to treat a whole room as an enlarged frame for his *Princesse du Pays de la Porcelaine* and to adapt the form and color of the room to this painting, even though the old and valuable Spanish leather on the walls had to be painted over, and the border of a Persian rug had to be cut away as the colors were unsuitable. Before Whistler, Rossetti and Morris had already put forward the idea of coordinating a picture, its frame, and the artistic effect of a whole room in a single unit, although their conception of the latter was less fully integrated. The example of the entirely coordinated unity of a Japanese room reinforced this conception, and Art Nouveau then adopted it as a basic principle.

Whistler, the most consistent advocate of *l'art pour l'art,* dined off "blue-and-white china" (plate 14) and launched it as a fashion; like Christopher Dresser and many others, Wilde also, of course, had to have his collection of "blue-and-white." With his yellow table napkins, Whistler likewise introduced the yellow tint of the brimstone (or Cloudless Sulphur) butterfly which later, through Beardsley's *Yellow Book,* was to give the name of "Yellow Nineties" to the whole Beardsley epoch. Whistler's yellow napkins were embroidered with the same butterflies in the Japanese style as those that he also used as a signature and that fluttered asymmetrically over the borders of the book pages designed by him according to Japanese notions of proportions. The floors of his rooms were covered with Japanese *tatami* mats, the walls of the winding staircase in the *White House,* which Godwin had built for him (plate 24), were covered, according to Japanese taste, with gold paper and, except when meals were served, a single lily or a Chinese bowl with a goldfish swimming in it was always on the dining-room table. On their white or egg-yellow walls, only a few pictures or drawings were framed with very wide mats in the narrowest of black frames. A few simple pieces of antique furniture were asymmetrically distributed throughout the room and shifted from time to time. The backgrounds of many of Whistler's portraits show his method of decoration, so fundamentally differ-

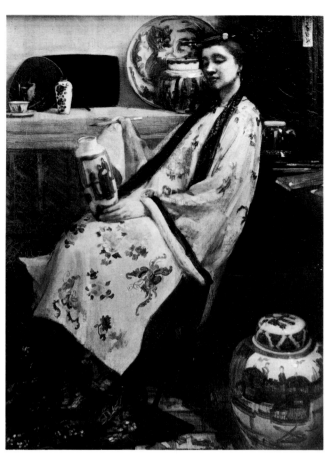

17

16 JAMES McNEILL WHISTLER *Old Battersea Bridge: Nocturne in Blue and Gold (circa* 1865)
17 JAMES McNEILL WHISTLER *Purple and Rose: The Lange Lijzen of the Six Marks* (1864)

ent from the chocolate brown and dark red, the heavy acanthus patterns of the wallpapers, and the somber splendor of late Victorian interiors. Whistler anticipated the *amor vacui,* the refined sparseness, the white and the light colors that were introduced around 1900 by Mackintosh and Voysey together with a new style of ornament and in fascinating contrast to Whistler's own conceptions.

The Japanese Style from Rossetti to Beardsley

A deliberate dandy, Whistler was certainly conscious of a desire to *épater le bourgeois.* He is thus remembered as the first and most brilliant promoter of the Japanese style in London. Rossetti's interest in Japanese art, not being quite so one-sided, attracted less attention. Yet, in 1865, Rossetti also dressed one of his voluptuous feminine figures, *The Beloved,* in a rich gown embroidered with Japanese bamboo leaves; moreover, this fair and utterly English bride illustrating the *Song of Songs* wears in her hair a fantastic Chinese ornament made of gold and red enamel. Stimulated by Whistler, Rossetti, in the sixties, also began to collect Chinese porcelain and Japanese woodcuts. Long before Whistler and Morris thought of illustrating books, Rossetti thus designed in 1865 the binding for Swinburne's drama, *Atalanta in Calydon* (plate 18), in Japanese style, so that by virtue

18

19

of its striking binding alone the book would attract the attention so greatly needed by the still unknown poet.

The balance of this design, its effective use of space, the circular ornaments arranged near its edges, the theme of the two disks partly covering each other, and of the peacock feathers with their contrasted curves, are all inspired by Japanese lacquerware.

Did this bookbinding have an immediate influence? It strikes one as too alien to its period, though not to Rossetti's art. With the frame for *Ecce Ancilla Domini*, Rossetti had indeed come surprisingly close to the Japanese style on his own, even though the specific flavor of the latter was still lacking. But this binding design has such a flavor, as well as the delicately worldly elegance that belongs to all English creations in the Japanese style which later influenced the more cosmopolitan or metropolitan style of Art Nouveau. In the binding that Rossetti designed in 1881 for the first edition of his own *Ballads and Sonnets* (plate 19), he developed even further the decorative principles set forth in the binding for Swinburne's poems, except that rectangular patterns formed of small circles now take the place of disks, as also in the patterns of the frames of Whistler's paintings (plate 16). Burne-Jones likewise combined Pre-Raphaelitism and the Japanese style and, here and there, seems to have imposed a Japanese rhythm on his flamboyant Gothic flowers and shrubs. A timid early form of Art Nouveau can even be detected in his Oxford pencil drawing of 1875 (plate 20).

Even Greek elements can blend with Japanese ones: to the Japanese style of his binding for Swinburne's *Atalanta in Calydon* (plate 18), Rossetti not only added a Celtic ornament in the shape of a circular form at the top right, but Greek patterns too. The palmette inscribed in the disk at the bottom right is borrowed from Attic vases of the fifth century B.C. The example of this unexpected combination was followed in subsequent English design, where it finally leads into Art Nouveau. In many of Whistler's pictures, above all in his *Symphony in White, No. IV: The Three Girls* (1876–79, plate 21), we find young girls with a distinctly Greek type of beauty, their hair arranged in Attic fashion, wearing draped chitons and posing in Greek attitudes. But the chitons are narrow and simplified and the maidens, holding parasols, are standing on Japanese mats with cherry-tree branches blossoming near them. The *Ten O'Clock Lecture* of 1885, a confession in which every word had been carefully weighed by Whistler, winds up with the words: ''The story of the beautiful is already complete—hewn in the marbles of the Parthenon—and broidered, with the birds, upon the fan of Hokusai—at the foot of the Fusi-

18 DANTE GABRIEL ROSSETTI *Binding for "Atalanta in Calydon"* (1865)
19 DANTE GABRIEL ROSSETTI *Binding for "Ballads and Sonnets"* (1881)

Yama (*sic*)." Edward William Godwin, the architect of Whistler's *White House,* who also decorated the interior of Oscar Wilde's house, not only staged Greek dramas, but also, ever since the sixties, had designed "Anglo-Japanese furniture" (plate 25) and "Greek chairs" which look more Japanese than Greek. As early as 1862, he hung Japanese woodcuts on the walls of his own very un-Victorian, simple, bare rooms, and dressed his wife and daughter in Japanese kimonos; but, in the midst of all this, he also added a copy of the Venus de Milo.

We know that Beardsley combined Japanese elements with stylistic and ornamental features which he found in pictures painted on vases by the Attic vase painter, Douris. Beardsley could not avoid responding to the Greek technique of linear silhouettes, to the sharp, precise, and streamlined contour of the shadowless and spaceless pictures that decorated Greek vases. In his illustrations to *Lysistrata,* Beardsley enriched erotic themes borrowed from Attic vases with similar ones borrowed from Utamaro; he thus "perverted" a Greek subject by treating it in the Japanese style. This "perversion" must not be understood only in the sense of *fin de siècle* decadence; its more profound justification is to be found in the principle of the "pleasant estrangement"[5] on which Art Nouveau is also founded to a great

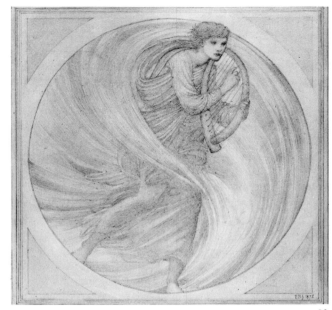

20

20 EDWARD BURNE-JONES *Orpheus* (1875)
21 JAMES McNEILL WHISTLER *Symphony in White, No. IV: The Three Girls* (1876–79)

21

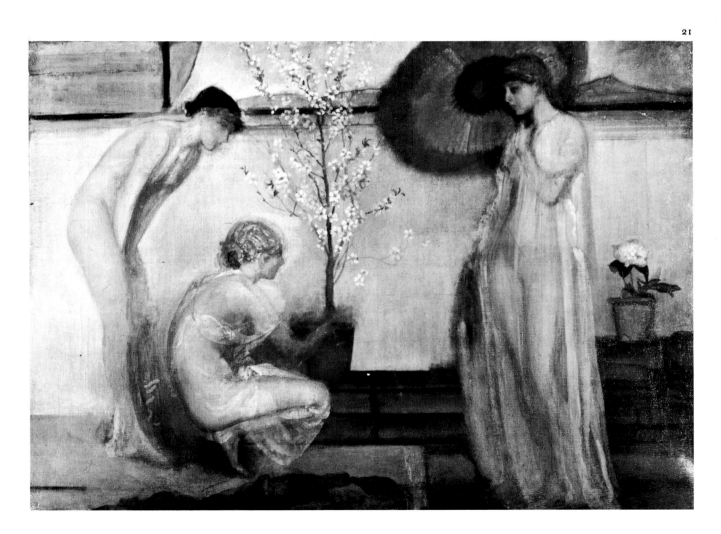

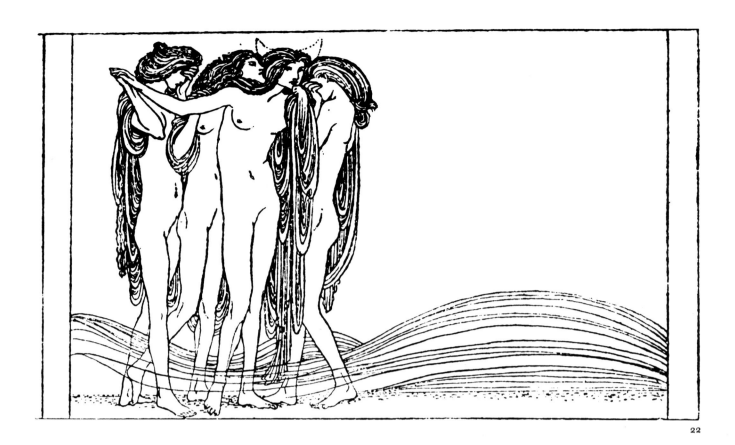

extent. Similar features can be seen in the work of
Charles Ricketts, for instance in the illustrations and
the binding of the book that he designed for Oscar
Wilde's poem *The Sphinx* in 1894 (plate 22). The rep-
resentation of the room in which Chloe is pining for
Daphnis (plate 23), with its refined bareness and its
distribution and proportions that remind one of Le
Corbusier, could scarcely have been conceived without
some Japanese influence.

Edward William Godwin

Chloe's room might have existed in Whistler's *White
House,* whose architect, Edward William Godwin (1833–
86), was, with Whistler, the first of the English artists
to learn from Japan and to employ significantly what he
learned. He knew how to combine Japanese qualities
with English taste, a sense of flat surfaces and a lack of
architectonic structure, lightness, narrow proportions,
and long, linear, straight forms. English and Japanese
art also have in common a propensity for a cool atmo-
sphere and for understatement.

In Godwin's *White House,* built in 1877 for his friend
Whistler in Tite Street in Chelsea (plate 24), the Japa-
nese note did not immediately meet the eye, but ex-
pressed itself rather as purism or as understatement.
Without the cornices that had to be added later, as a
result of a regulation of the building authorities, the
outside of the house appeared at first as a cubic block of
closed form: a kind of box with delicate surfaces and

receding articulations, as if it had renounced any tradi-
tional Occidental notion of tectonic arrangement. The
horizontal rectangle of the façade is subdivided by a per-
pendicular edge which, according to the English tradition,
is emphasized by an exposed gutter, so that it seems as if
two small houses had been built together. A predilection
for asymmetry and a pretended fortuitousness determine
the sensitive rhythm in the disposition of the strongly
simplified doors and windows; one has the impression
that the distribution of the various rooms is thus in-
dicated, and that they are built at various levels. But the
horizontal strip between the main floor and the top
floor and the rounded ledge of the slightly protruding
top floor (neither of which is functionally justifiable)
reveal that this is a matter of form for the sake of form,
in fact an entirely new decorative detail that comes close
to modern reinforced concrete architecture.

One can well understand that this house must have
seemed ghost-like in its time: strange, without being
really Japanese, since Japanese houses were known to be
quite different. But here lies Godwin's true achieve-
ment: he did not borrow prefigured forms, as even
historicism finally did, from the Japanese style too; it is
more as if the Far Eastern element had sent out some

22 CHARLES RICKETTS *"The Moon-Horned Io" from Oscar
Wilde's "The Sphinx"* (1894)
23 CHARLES RICKETTS *"Chloe" from "Daphnis and Chloe"*
(1896)
24 EDWARD WILLIAM GODWIN *White House, London*
(1877)

23

individuality.''[6] The *White House* has nothing in common with the fluctuating line of Art Nouveau, but it already reveals definite symptoms of late Art Nouveau. Its cubic construction, its great economy in decoration and molding and, last but not least, its labyrinthine asymmetry and interlacing were adapted by others decades later, but most specifically by Mackintosh, who knew how to employ these features to their greatest advantage.

In the sixties, before creating these works of architecture, Godwin made designs for ''Anglo-Japanese furniture,'' as he repeatedly calls it in a kind of illustrated catalogue of 1877 (plates 25, 26). Godwin is radical in liberating the form of all conventional aspect and reduces a piece of furniture to the basic rule of its construction. The construction thus appears in its cage-like purity. On the one hand, the contrast between the framework and the full planes may be emphasized; on the other hand, it may paradoxically be understated. The parallelism between the rectangular structure and the concise relationships of structure and surfaces of the cabinet unite its heterogeneous elements in a whole. In Godwin's big sideboard (plate 25), even the silver-plated hinges lie flush to the surface of the black wood, looking like an ornamental incrustation; like the delicate handle rings, they are a pure and functional ornament. Seen next to

radiation so as to alter the very essence of the structure. Yet the building also follows the tradition of the English town house, refined and simplified since the eighteenth century, with its flat front finished off horizontally by its attic pediment and enlivened only by its proportions, the size of its windows, and the carefully weighed relationships between the apertures and the walls. The use of white paint on such façades even dates from the period when Nash built his houses in late neo-Classical style. Only England has known how to ''assimilate the Japanese element and blend it with its own innate national

24

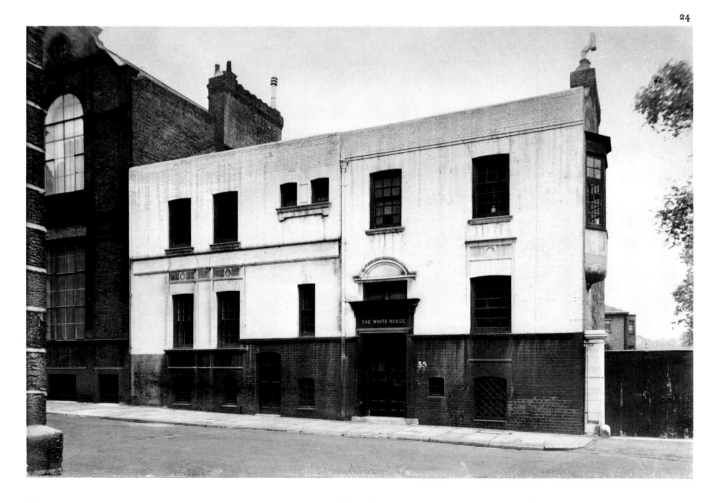

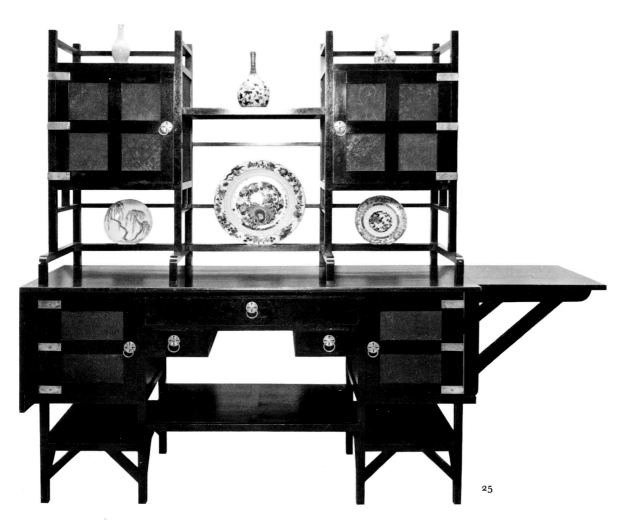

25

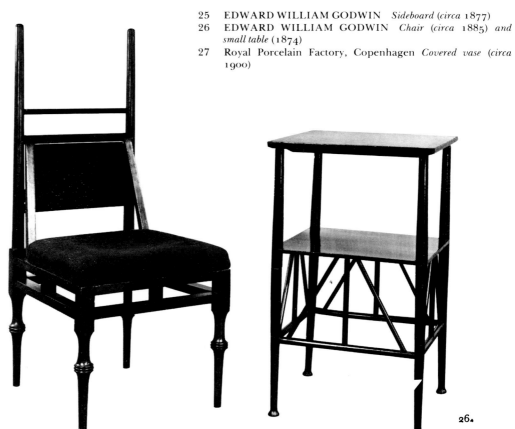

25 EDWARD WILLIAM GODWIN *Sideboard (circa 1877)*
26 EDWARD WILLIAM GODWIN *Chair (circa 1885) and small table (1874)*
27 Royal Porcelain Factory, Copenhagen *Covered vase (circa 1900)*

26.

one of Godwin's box-like forms in straight lines, Berlage's writing table in Dutch *Jugendstil* (plate 101) looks like its younger brother; one could scarcely guess that they are a quarter of a century apart.

After the elimination of all the European accessories of historicism, a new kind of intricacy could at last be developed on the newly recovered foundations. The proportions are then so well calculated, in every case, that the forms appear weightless, as if they indeed consisted of lines. Beardsley understood this when, like Godwin, he exaggerated the lines of the furniture in his pictures, without however making it appear improbable (plate 129). For all their playfulness, grace, and apparent fragility, Godwin's pieces of furniture are strict, serious, and carefully considered. They can even be understood as an engineer's constructions in wood. Out of these structural combinations Godwin, who had also designed wallpapers in the Japanese style for industrial purposes, developed a world of virile and graceful forms.

In 1859, books began to appear in England dealing with every aspect of Japanese life and Japanese art. As early as 1869, *Hints on Household Taste*, Charles Eastlake's influential book on English interior decoration, called attention to Japanese models. Japanese rules for arranging flowers, unfamiliar until then in England, were constantly discussed in periodicals, so that the work of the most important ''artist-designers'' was inspired by Japanese examples, as can be quite unmistakably felt in the creations of Mackmurdo (plate 54).

In 1876 Christopher Dresser went to Japan as an official representative of the British government. He then published, in 1882, the most important among the books that were meant to make the public more familiar with the East: *Japan, Its Architecture, Art, and Art Manufactures*. Dresser designed furniture, fabrics, and wallpapers of comparatively lesser interest; but he achieved remarkable results in the designing of pitchers, vases, and other vessels (plates 38, 39). Between 1879 and 1882 there appeared the first undecorated Art Nouveau vases and vessels which, although ornaments in themselves, were at the same time conceived in terms of their function.

The technique of the old Japanese handicrafts which, compared to those of Europe, had developed to an ''unbelievable, mysterious degree of technical and aesthetic perfection,''[7] also imposed some renewed consideration or re-evaluation. Under Japanese guidance the technique of production, the materials, and even the ultimate function of the object became sources of inspiration or invention.

If England was leading in the art of surface-decoration and furniture designing, the European continent and North America achieved remarkable results in the field of ceramics, thanks to their acquaintance with Japanese forms and Japanese methods of production. Tiffany in New York and Gallé in Nancy both produced glass objects which became prototypes of Art Nouveau. Both these artists, moreover, went through periods when they were influenced by Japanese styles. The Royal Porcelain Factory in Copenhagen owed its revival and success to the influence of Japan (plate 27). Since 1888, long before High Art Nouveau had spread as a general style, the Danish factory's china belonged to the few things of the time that could be admired by the aesthetes, who ''quivered with enthusiasm down to their innermost being'' as Van de Velde remarked. The most important Northern European manufacturers, Bing and Gröndahl's porcelain factory in Denmark, Rörstrand in Sweden, and the Rozenburger factory in The Hague, followed the Japanese example set by Copenhagen. As early as 1890, the Royal Porcelain Factory in Berlin came close to *Jugendstil* with its Chinese and Japanese forms and glazes. The Rockwood Pottery Company of Cincinnati owed its success to the collaboration of Japanese-born specialists, and the masters of French ceramics in Art Nouveau style, Jean Carriès and Auguste Delaherche, were among the first to ''seek to revive stoneware under the influence of Chinese and Japanese examples.''[8]

England not only preceded other countries by several decades in accepting the example offered by Japan, but also underwent its influence over a much longer period. This was possible because a decorative universalism existed in England before the discovery of Japanese art. Rossetti and his friends Burne-Jones, Morris, and, for a while, Whistler too, were among the first painters who, disagreeing with the accepted notions of their times, took an interest in objects of daily use and set out to confer harmony on all aspects of life. This attitude later became typical of all the artists of Art Nouveau, many of whom had originally been painters who then gave up painting entirely. The former Post-Impressionist Van de Velde designed embroidery patterns for the Pre-Raphaelitic kimono-like gowns of his ladies and—making us feel as

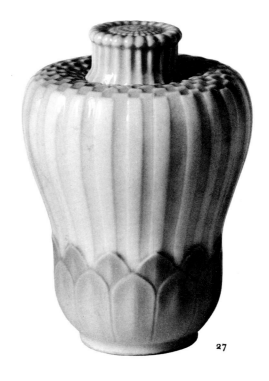

27

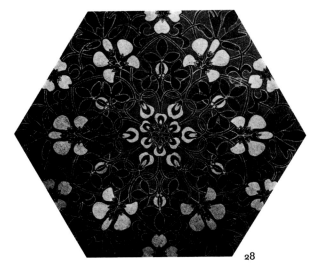

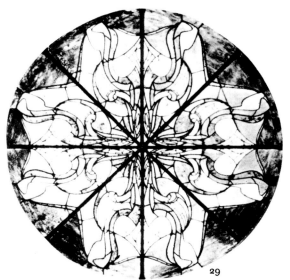

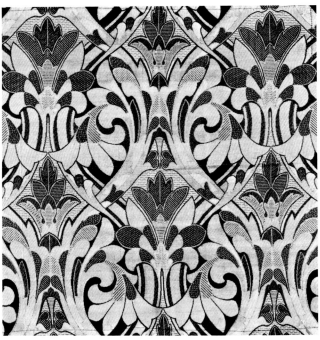

if we were in Godwin's or Whistler's house thirty years earlier—hung Japanese stencil prints on his walls (plate 83) which demonstrate one of the sources of his "Belgian" line. Such prints were reproduced in Bing's *Japanischer Formenschatz*; in 1899, *Ver Sacrum*, a Viennese periodical, devoted a whole issue to them and, beginning with its first issue in 1895, *Pan*, in Berlin, protected its color prints with imported Japanese tissue papers decorated with patterns of wavy lines, rhythmically distributed dots, and rosettes: wavy lines in the taste of High Art Nouveau and stylized concentric flower rosettes in the taste of late Art Nouveau. Once again, the close relationship and the joint origin of the organically animated High Art Nouveau and the geometrical late Art Nouveau are clearly demonstrated.

THE MASTERS OF INDUSTRIAL DESIGN

Independently of the Pre-Raphaelites and of the adepts of the Japanese influence, who wished to surround life with an artistic setting, England became, toward the middle of the nineteenth century, a battleground for those who set out to educate and transform the public's taste and to liberate the form and the decoration of useful objects from their traditional designs—in other words, to help a new style to establish itself.

On the occasion of the World Exhibition of 1851 and its utter pandemonium of conflicting styles, Henry Cole wrote: "The absence of any fixed principles in ornamental design is apparent . . . " The young William Morris (1834–96) turned away in horror from products that were machine-made but were inspired in their design by the richest and most decadent styles of the past. He came to the conclusion that machine work had to be entirely avoided. Like Ruskin, he considered the problem of form from an ethical point of view; he then put Ruskin's theories into practice, becoming an artisan or craftsman in the sense of those of the later Middle Ages.

The conclusion that Morris drew from the aesthetically doubtful and often technically bad quality of contemporary industrial arts and crafts (namely, to renounce the use of machines) was not altogether logical, since machines were not responsible for the choice of form and design. Still, the Art Nouveau artists directly or indirectly followed the example of Morris, even though around 1900 his theories were scarcely applied any longer. With the exception of textiles, wallpapers, and book illustrations, practically all works of Art Nouveau were made by hand, frequently by the designer himself. Every vase and every piece of furniture by Gallé was called an *étude* and signed by the artist himself. Every piece of glass by Tiffany was an individual, unique work of art. Tiffany even

28 KATE GREENAWAY *Design for a tile* (1864)
29 HENRY VAN DE VELDE *Glass skylight in the Folkwang Museum, Hagen* (1901)
30 OWEN JONES *Damask (circa* 1870)

introduced the term *favrile* glass, derived from the Latin *faber* (artisan). Gaudí's ironwork, Obrist's embroideries, Horta's or Guimard's furniture were not conceived for industrial mass production. Art Nouveau adherents wanted to transform every object of daily life into a work of art. Its very style was based on the conception of the decorative arts as the equals of the ''free'' arts. Not only was a high standard of craftsmanship a technical requirement in Art Nouveau, but also one of the very sources of its forms and its style, which explains the deterioration of its quality wherever Art Nouveau was produced industrially and in large quantities.

Henry Cole and the "Schools of Design"

In addition to the more aristocratic path that Morris chose, there existed other trends which aimed rather at a broad and more anonymous diffusion of their tastes and ideas and even tried to make the best of inevitable compromises. In order to react effectively against the chaos of forms which appeared in such profusion in London's Great Exhibition of 1851, Henry Cole founded the South Kensington Museum (from which Morris derived many ideas) as a kind of instructive exhibit of the most remarkable products of the applied arts of all times and peoples. For, as it was said in 1901, ''one had begun to realize in London that what one had retained of the techniques of the crafts of previous centuries was indeed far less than all that one had forgotten.''[9] The collections in Cole's museum were not meant to suggest models of styles that were to be imitated; they were to offer didactic examples of ways and means of achieving one's own ideas. They were also built up in the hope of educating the taste of the public and of artists by exhibiting objects of the highest quality in the field of the applied arts so as to establish more ambitious criteria.

In order to give a systematic schooling to those who would later work for industry, Henry Cole created the ''Schools of Design'' which were attached to the South Kensington Museum in 1857. George Moore wrote, not without irony: ''The schools were primarily intended as schools of design where the sons and the daughters of the people would be taught how to design wallpapers.'' But these schools soon enjoyed extraordinary success: ''As early as 1860, the number of French designers employed in English industry·had been reduced by a half; a few years later, France had been entirely driven out of this field.''[10] This newly gained independence from the historical conception of French designers who mostly thought in terms of ''Louis styles'' was attributed exclusively to the ''Schools of Design.''

Kate Greenaway (1846–1901), who later became so famous for her children's books, offers us an example of the style taught in these schools. For an examination in 1864, she had to submit designs for glazed tiles and won a prize for one of them (plate 28). In a symmetrical circular ornament, flowers, tendrils, and leaves are reduced fully to a surface-design and, rigorously abstract, represented in lines and two-dimensional bodies with an obvious sense for the complementary relationships of forms and intervals. This sketch illustrates moreover what George Moore, who kept on the side of the Impressionists, said ironically about the schooling during the sixties: ''The harder and finer the outline, the more the drawing looked like a problem in a book of Euclid, the more the examiner was pleased.'' Indeed, the painterly element is as absent from this work as all representative or narrative realism. Without great expenditure of imagination, the young Kate Greenaway produced a pattern which is typical of the style of the schools and indicates that an early English Art Nouveau began also to develop in the sixties outside of Rossetti's domain. A comparison with a work by Van de Velde (plate 29) shows what the two artists have in common and what separates them: seen beside Kate Greenaway's ornamental design of 1864, so obedient to the rules and so void of expression, Van de Velde's kaleidoscope-like window unfolds with both infinite force and delicacy. Forms which remind us of both butterfly wings and flower-like shapes seem to pass through metamorphoses that lead them from the crystalline ornament to animated organic life. The transformable structure has found an ideal medium in the stained glass through which the light filters. Yet, in the realm of Victorian taste, Kate Greenaway's design is extremely progressive: it is flat, linear, simple, easy to understand, and free from any attempt to imitate reality.

Owen Jones and The Grammar of Ornament

Kate Greenaway's ornament corresponded to such theoretical demands as Owen Jones (1809–74) had formulated in his *Grammar of Ornament*. ''All ornament should be based on geometrical construction . . . '': this was aimed as a blow to illusionistic naturalism. ''All junctions of curved lines with curved (lines), or of curved lines with straight (lines), should be tangential with each other . . . '': a blow at intersections in perspective. ''Colour is used to assist in the development of form, and to distinguish objects or parts of objects one from another . . . '': a blow at painterly or confused tonalities. Jones' *Grammar* and its theses which exercised an enormous influence on the taste of his times were among the basic teachings of the South Kensington schools. Owen Jones never tired of advocating flatness in decoration. It was a world of faded reliefs, in which heavy flowers bloomed on wallpapers and carpets, and where most of the floor coverings resembled a jungle of forms in which one's feet seemed to sink as one waded through the thickets of woven foliage. However, as early as 1856, opinions like the following began to be expressed: ''A carpet, whilst it covers the floor, is also the ground from which all furniture [arises] . . . it should therefore be treated as a flat surface.''[11]

Whatever its rational·motivation, a new and absolutely different style was trying to impose itself. It was therefore natural that, in *The Grammar of Ornament*, the

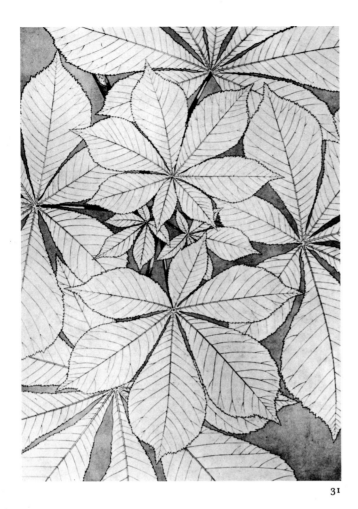

31

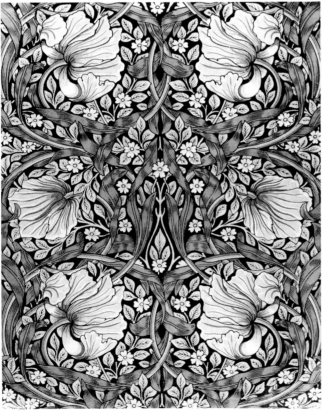

most important work on decoration published in the middle of the century (in 1910 it had gone through nine editions), the flat ornament in the Oriental style should play a preponderant role. Flat ornaments of Chinese, Indian, Persian, or Moorish origin are represented in the *Grammar* in dozens of plates. Egyptian decorations are cited too, and the linear ornamentation of Greek vases is distinctly preferred to the more three-dimensional style of the Romans. An opinion is always given as to the value or the nonvalue of the ornament, and it is always in favor of a sign or symbol which is developed on the plane of the surface without any attempt at depth. Prehistoric decorative forms are shown as well as many examples of Celtic book ornaments, while the traditional Western styles, from the Gothic to the Baroque, take up comparatively little space. "The world has become weary of the eternal repetition of the same conventional forms which have been borrowed from styles which have passed away." It was not in 1896, but in 1856 when that statement was made, as well as the following: "The principles discoverable in the works of the past belong to us; not so the results."[12] In the domain of High Art Nouveau, Samuel Bing makes the same claim: "We must seek the spark of new life beneath the ashes of older systems."

Owen Jones, an industrial designer and interior decorator as well as an architect, conducted his fight against three-dimensional ornament in decoration of the flat surface with two weapons, one of which was the complement of the other. In addition to his theoretical demands and their illustration in instructive examples, he introduced sketches for actual use. True, the silk fabrics of the period around 187c (monochrome blue on blue, in a damask weave, plate 30) clearly reached back to the Gothic style, but, as an independent development, they shift from historicism, as understood in the fullest sense of the word, and point distinctly in the direction of Art Nouveau.

On the subject of forms borrowed from nature, *The Grammar of Ornament* insists on demonstrating that "in the best periods of art all ornament was rather based upon an observation of the principles which regulate the arrangement of form in nature than on an attempt to imitate the absolute forms of these works." Jones attaches great importance to the relationship between forms, to their structure and their natural development, and refuses to pursue the imitative representation of existing examples. He demonstrates this principle in a design of chestnut leaves (plate 31) which are not an ornament in themselves but can be used as the starting point for an ornamental pattern: spread out flat, with precise outlines and stressed rhythm. Here we see the beginnings of a

31 OWEN JONES *"Horse Chestnut Leaves," from "The Grammar of Ornament"* (1856)
32 WILLIAM MORRIS *"Pimpernel" wallpaper* (1876)
33 ARTHUR HEYGATE MACKMURDO *Decorative fabric* (1883)

32

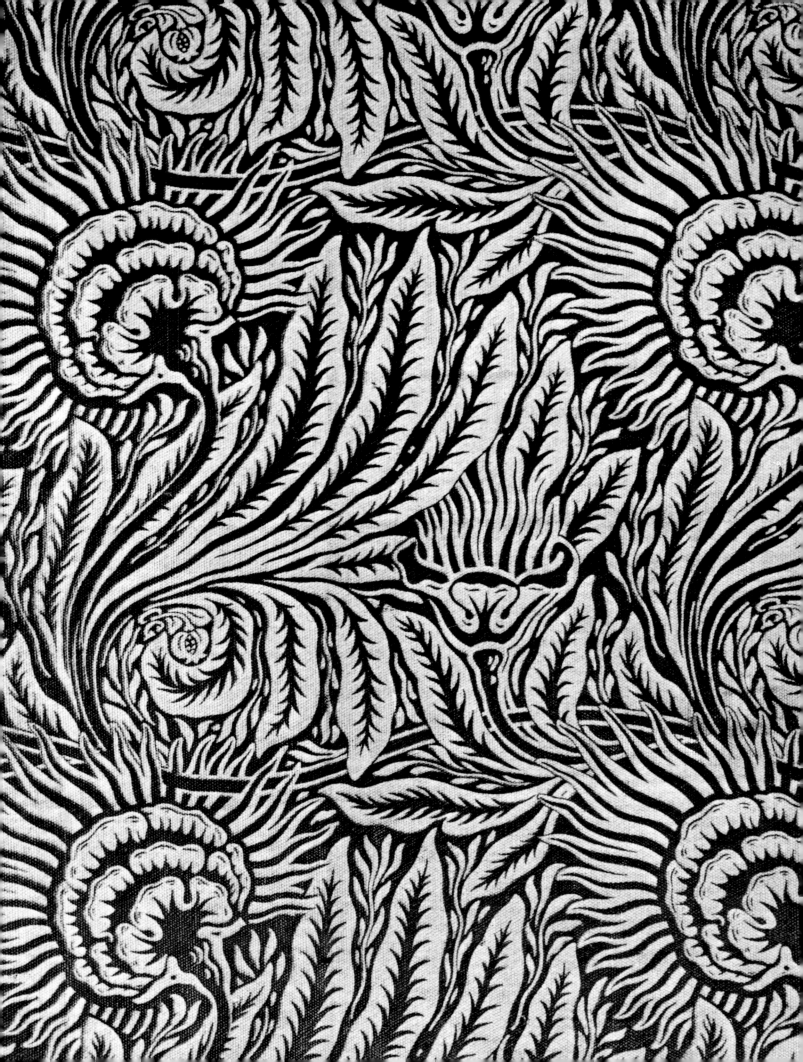

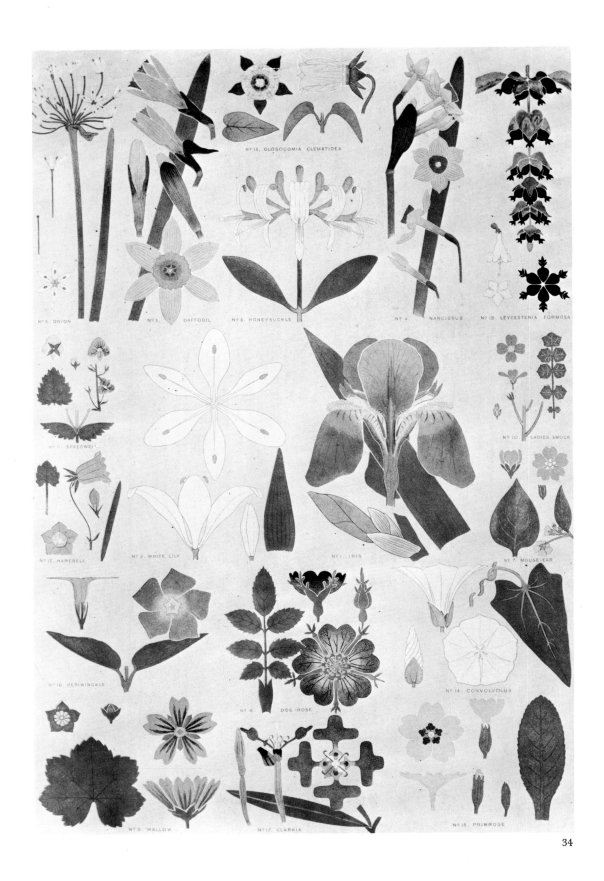

34

34 CHRISTOPHER DRESSER *"Plans and Elevations of Flow-ers," from "The Grammar of Ornament"* (1856)
35 PHILIPP OTTO RUNGE *Geometric drawing of the cornflower* (1808)

development at the culmination of which we find Van de Velde's stained-glass window, Voysey's wallpapers, or other works of Art Nouveau. At the same time, there is an anticipation of the Japanese style of the nineties in Jones' design of chestnut leaves which shows how early this type of Eastern style had taken root in English design, thereby preparing the way for its full flowering almost four decades later.

Nor did Morris (who frequently consulted *The Grammar of Ornament*) copy anything existing, even though at first sight his fabrics and his wallpapers look surprisingly rich, in the Victorian way (plate 32). He likewise derived his forms more from the essence of the figure than from its appearance. Plant patterns, arranged in front view or in profile, are transformed into ornaments by clearly curving lines. Art Nouveau was already contained in Morris' designs and all that his disciples had to do was to lift his style out of its intricate weave of small parts in order to transpose it from a polyphonic orchestration into a tune for a single voice (plates 33, 144, and colorplate V).

Christopher Dresser

Christopher Dresser (1834–1904), like Henry Cole and Owen Jones, was primarily concerned with exerting an educational influence. Since 1859, he had been on the staff of teachers at the "Schools of Design" attached to the South Kensington Museum. At first he gave lectures and wrote works on botanical subjects; later, from 1862 (when his book *The Art of Decorative Design* was published) until the eighties, he wrote a great number of works on the principles of decorative and ornamental design. But in opposition to Cole and Jones, Dresser devoted himself mainly to practical work. His designs for furniture, ceramics, glass, metalware, wallpapers, and fabrics range from the strictly functional to the somewhat eccentric. Now and then, we find him bound by close ties to historicism; elsewhere, he achieves pure Art Nouveau.

The colorplate with "Plans and Elevations of Flowers" (plate 34) that Dresser designed for Jones' *Grammar of Ornament* was intended to demonstrate that "the basis of all form is geometry."[13] In contrast to the painterly and soft forms of Victorian surface-decorations, with their illusionistic renderings of bodies and space, here a closed and clearly discernible form is predicted, by reducing the forms of nature to a structure system. The elements of an ornament like an emblem or signature are already contained and developed in this system. Dresser's basic principle was this: "Flowers and other natural objects should not be used as ornaments, but conventional representations founded on them."[14] The natural form therefore had to be transposed into an ornamental form of art. Much as Runge had already done in a flower sketch (plate 35), Dresser's page of flower patterns established a geometrical rule for the structure of the design. Compared to Dresser's later and truly artistic designs, this page, lacking sensuousness and emotion,

35

offers a kind of hygienic instruction in design rather than anything artistic or ornamental.

In the work of Christopher Dresser, who had studied botany at the University of Jena, one may perhaps detect the starting point of the preference that Art Nouveau revealed for floral patterns. In 1859, Dresser published *Unity in Variety*, the fundamental idea of which is to lay bare the one element that all plants have in common, in their habitats, in the way they grow, and in the principles of their structure. The patterns, ideal figures, and essential forms of his illustrations are true precursors of the symbolic and sign-like ornaments of Art Nouveau; in fact, symbols of organic life. Dresser himself, in his decorative designs that soon followed this book, refers constantly back to the book's patterns of botanical structure. As early as 1862, he then recognized the "line of life" in the energy-laden curves and the linear rhythm of nature and, in 1859, in the preliminary remarks of one of his publications, he stated that plants are organized living creatures, endowed with the power of growth. This view both anticipates and establishes the dynamic views and symbolism of Art Nouveau. To give preference to the general pattern rather than to the particular visual appearance of the different kinds of plants or indeed of "individual" flowers is much more typical of Art Nouveau than the more superficial use of certain forms of flowers and their representation, however stylized, even if this may at times have determined the more floral character of Art Nouveau.

In 1870, an unusual ornamental design was published under the perhaps even more unusual name of *Force and Energy* (plate 36), a title that reminds us of Van de Velde; Dresser attempted here, above all, to embody the idea of force, energy, power, and vitality.[15] Conceived in about the same period as Owen Jones' fabric (plate 30) and likewise based on the Gothic style, Dresser's design, instead of creating a pattern that is harmoniously balanced, strives rather to elucidate the rays of energy, "lines of life," or motive powers of organic growth. The subject itself and the preference of the times for historicism determined to some extent this regression to the Gothic style. Frank Furness (plate 210), Louis Sullivan (plate 209), and Gaudí (plate 206) also developed their dynamic botanical Art Nouveau forms from the plant-like vigor of the Gothic style; Furness and Sullivan were

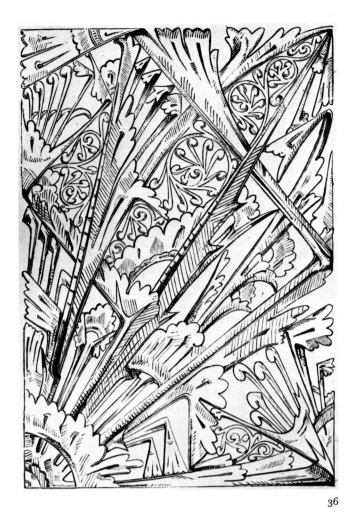

36

These ornaments do not reveal a return to any historical style, but proceed from forms that exist in nature and are subsequently developed into forms of art. They still lack, however, the true elements of Art Nouveau, for instance that graceful flow from line to line, though Dresser had postulated it as early as 1862. The softly rounded curves and forms that are otherwise so easily to be found in the surface-patterns of early English Art Nouveau, especially in the works of Morris and Jones, nevertheless are achieved by Dresser in three-dimensional bodies rather than in the surface-plane. His glassware and ceramics and his glass pitcher in its metal setting (plates 38, 39) are the first real Art Nouveau three-dimensional

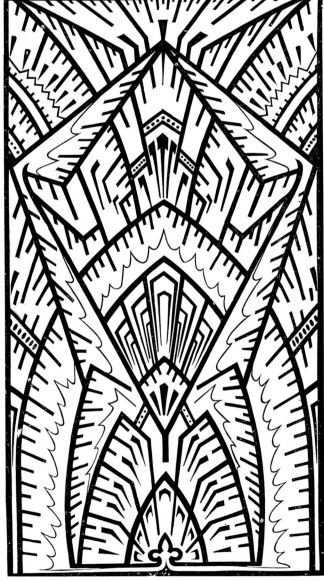

37

almost certainly influenced by Dresser, presumably Gaudí too.

From 1874 to 1876, Dresser's *Studies in Design* were published simultaneously in London, Paris, and New York, as a series of folio volumes with fine color lithographs, in a way the continuation of Jones' *Grammar of Ornament*. Although, without exception, the forms are all transposed into the flat surface—inasmuch as historical examples of two-dimensional forms have not been altogether preferred—and although Dresser stresses in the text the fact that in all cases it was a matter of expressing his individual feelings, he still remains faithful, in a broader sense, to historicism. But, here and there, we already find a few plates defined as ''a frieze in the new style,'' ''two circular compositions in the new style,'' or ''marginal ornaments in the new style,'' though this style remains very close to Kate Greenaway's tile ornament (plate 28). Art Nouveau indeed reveals itself here in the same irresolute and feeble manner, with all the shyness of an early phase. Dealing with ornaments and repeated patterns that refer back to frost flowers on iced window-panes, Dresser writes about the origins of this ''new style'': ''For some eighteen years I had been in the habit of sketching designs of the frost as it generally appears in

objects. Their simplified and completely closed forms have curved and unbroken outlines; ideal and smoothly flowing forms are not only dominant here in molded or blown glass, but also in objects made of metal and ceramics. With their extraordinary simplicity and their smooth, undecorated surfaces, where the ornaments are only due to the structure and spring from the technique of fabrication, these vessels stood in absolute contrast to those produced in mid-century.

Arthur Heygate Mackmurdo

In the early eighties, Arthur Heygate Mackmurdo (1851–1942) followed similar paths in the realm of furniture. Among the pieces of his furniture that have survived, the small writing desk (plate 40) in the Morris Gallery is probably his most original work. Utterly simple and lacking any outward adornment, owing to its clearly displayed structure and unusual proportions, it is as though this desk was an ornament in itself. The exaggeratedly long legs are intended to raise and feature the top portion of the desk. This theme of concentrating the mass of the writing surface (which ends in a protruding ledge) is repeated again in the construction of the drawers and pigeonholes. The supports extend upward throughout the unit at the rear to bring about an even closer integration of the upper part and the writing surface itself; projecting square plates cover the terminals of the supports like the capitals of columns. This idea of Mackmurdo's then reappears in works of Mackintosh (plate 229) and, more or less modified, in the Continental High Art Nouveau, as Mackmurdo's influence can, in general, certainly be traced in works of Serrurier-Bovy and Horta.

With the exception of the circular drawer pulls, right angles prevail throughout Mackmurdo's writing desk, together with the shifts from the horizontal to the vertical of the sharp-edged shafts of the extended supports with the flat surfaces that serve as limits to the cabinetwork. Typical Art Nouveau curves or rhythms appear only in the diminishing line of the legs and the abrupt flaring out of the knobs at its feet. Most of Mackmurdo's pieces of furniture are of the rectangular, straight-lined kind that anticipates late Art Nouveau. In his famous chair (plate 41) of 1881 (known to us only from its reproduction in the 1899 issue of *The Studio*) the characteristics of the style, though it heralds the beginning of High Art Nouveau, are limited to the openwork ornamentation of the back of the chair. Apart from this, its form is simple and conventional, corresponding perhaps to the Queen Anne style that was still the ideal of the time. From a base that

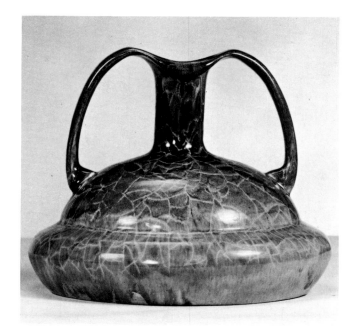

38

39

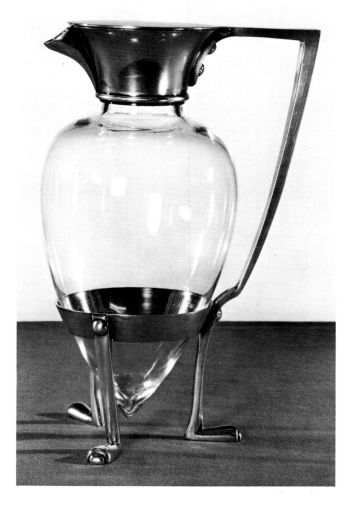

36 CHRISTOPHER DRESSER *Force and Energy* (1870)
37 CHRISTOPHER DRESSER *Design for a stained-glass window* (1873)
38 CHRISTOPHER DRESSER *Vase* (1892–96)
39 CHRISTOPHER DRESSER *Pitcher* (1879)

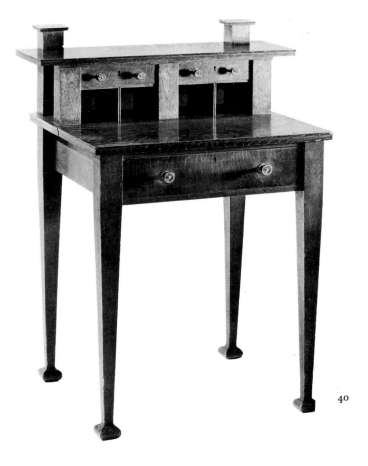

40

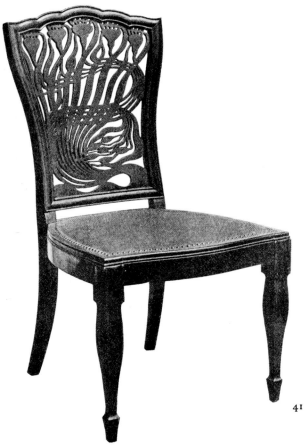

41

suggests the design of waves, an asymmetrical climbing plant swings boldly upward, its stems unfolding like a fan and sending out almost parallel shoots. This fan of wave-like shoots is crossed several times by a second sheaf of shoots originating from the same stem and swinging over the whole surface in an S-shaped movement which rises to the top of the chair back with blossoms or darting leaf ends and then turns downward again. An exemplary feature is that form and counterform complete each other, that they are developed from dark areas and intervals entirely in a graphic sense in the same way, as two years later, Mackmurdo designed with graphic means the title page of his book *Wren's City Churches* (plate 42). Mackmurdo achieved what Owen Jones had demanded in theory in 1856: ''Beauty of form is produced by lines growing out one from the other in gradual undulations. . . .'' Owen Jones also declared: ''In surface-decoration all line should flow out of a parent stem. Every ornament, however distant, should be traced to its branch and root.'' The abstract character of the chair back ornament is indeed so obvious that there is only one small step missing between this floral ornament of Art Nouveau and the abstract ''Belgian'' line. If Art Nouveau expresses itself simply, powerfully, and with an almost ascetic note in the works of Dresser, Mackmurdo handles it luxuriantly, with a more powerful imagination and with the hedonism of the later Continental Art Nouveau.

Mackmurdo came of a Scottish family. As in Morris' case, fifteen years earlier, Ruskin's prominent personality gained a decisive influence over Mackmurdo during the years of his studies in Oxford. In 1873, Mackmurdo joined the staff of an architect's studio in London and made friends with Philip Webb and Norman Shaw, the latter being the leading architect working in the Queen Anne style. Mackmurdo's house soon became the meeting place for a whole group of artists. The poets Laurence Binyon and William Butler Yeats, both of whom wrote definitive works on the art of William Blake, were regular visitors; Mackmurdo discovered and encouraged the painter Frank Brangwyn and offered him a studio. Charles Annesley Voysey, in the early eighties, worked under Mackmurdo's direction. Mackmurdo knew Whistler and Oscar Wilde, and was even so deeply impressed by Whistler's ideas concerning decoration and colors that his stand at the Liverpool Exhibition of 1886 was painted in bright yellow, Whistler's favorite color. The different currents of early Art Nouveau and of the initial phase of High Art Nouveau were everywhere connected in England. Just as between Whistler and Rossetti, there also existed a relationship between Mackmurdo and Whistler and the Japanese style, and another one between Mackmurdo and Morris and the Pre-Raphaelites. Like Dresser, Mackmurdo was stimulated by his studies of nature; for his rare architectural works he even wrote he had

40 ARTHUR HEYGATE MACKMURDO *Writing desk* (1886)
41 ARTHUR HEYGATE MACKMURDO *Chair* (1881)

been greatly helped by his studies of organic structure in plants, animals, and the human figure. In 1882, Mackmurdo founded the Century Guild, a workshop for interior decoration, in order ". . . to render all branches of art the sphere no longer of the tradesman but of the artist. It would restore building, decoration, glass-painting, pottery, woodcarving and metal to their right place beside painting and sculpture." Here again is an endeavor to place the applied arts or crafts on the same level as the "free" arts of painting and sculpture. In friendly competition with the Morris Company, the Century Guild pursued similar aims, though its forms owed much less to the Gothic Style. Herbert Horne, Selwyn Image, Frederick Shields, and Clement Heaton, an artist who worked in metal and enamel, were among the founders; the potter William de Morgan and the many-sided Heywood Sumner were also associated with the Guild.

Arts and Crafts

During the whole second half of the nineteenth century, not only Morris but a number of other "artist-designers" were thus at work; they were not industrial designers, but independent artists with manifold capacities and interests, men who were all opposed to industrial production and to historical imitations. As the years went by, they became increasingly conscious of the force that drove them to create a new style. The last quarter of the century was then dominated by these artist-designers, who brought about a noticeable change in industrially produced wares for daily use; the style they had invented subsequently gained influence until it dominated all of Europe.

The individual currents, in many ways already connected with each other, and the activity of more or less independent masters like Dresser, finally fused in the Arts and Crafts Exhibition Society, founded in 1883. Its very successful exhibitions greatly reinforced these attempts. It was indeed the Arts and Crafts that later became so popular on the Continent, bearing fruit, above all, in Belgium. But, during the nineties, the same Arts and Crafts rather discouraged High Art Nouveau in England, being less concerned with the solution of aesthetic and formal problems and concentrating its attention somewhat on the narrow field of artisan virtues as Ruskin had understood them: simplicity, usefulness, and functionality. The Arts and Crafts thus already carried in themselves the seeds of certain tendencies toward a modern objectivity, which finally transcended High Art Nouveau. The shelf and cabinet style of Arts and Crafts was in turn influenced by the atmosphere of cultivated simplicity which surrounded Morris and Webb, and doubt-

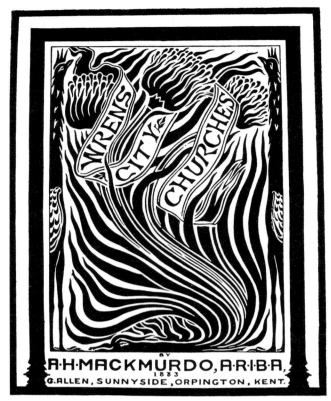

42

43

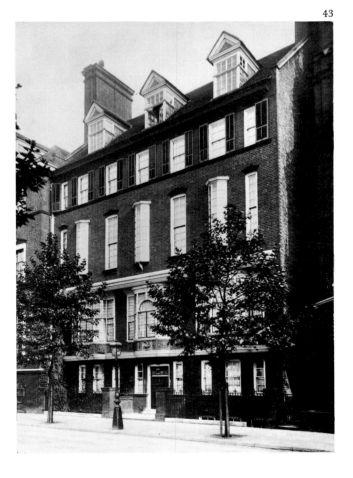

42 ARTHUR HEYGATE MACKMURDO *Title page for "Wren's City Churches"* (1883)
43 RICHARD NORMAN SHAW *Old Swan House, London* (1876)

less also by Godwin's elegant Anglo-Japanese furniture with its transparent structures; in the seventies, the Queen Anne style certainly had its effect on Arts and Crafts too. This return to the simplicity and comfort of the English house of the beginning of the eighteenth century, long before the styles of Chippendale and Rococo, was initiated in architecture with Richard Norman Shaw (1831–1912) as its most important advocate. His style is purest in the *Old Swan House*, which he built in Chelsea in 1876 (plate 43) and which, with Webb's *Red House*, built for Morris, and Godwin's *White House*, built for Whistler (plate 24), is one of the most original works that English architecture produced during the second half of the century. Shaw, like the other two above-mentioned architects, in no way turned his back entirely on tradition, but likewise referred back to the English town house of the early eighteenth century, though avoiding exterior imitations of style and deriving from the valid principles of the past a quality that was peculiar to himself and belonged to his own time.

Though the *Old Swan House* never suggests any of the swinging curves of High Art Nouveau, it yet reveals influences of a trend that ran parallel to it in England and was represented by the architects Mackmurdo, Voysey, Ashbee, Baillie Scott, Lethaby, and, last but not least, by Mackintosh and late Art Nouveau. Several brick wall surfaces that have been left bare of any revetment are superimposed or protrude so as to suggest terrace effects in the façade; they all seem to consist of thinly stretched membranes, revealing a structure of new and slightly exaggerated proportions which suggest Art Nouveau only in a broader sense. The unusually tall and narrow windows on the main floor, the broad wall surfaces between them, the shaft-like, angular bay windows that protrude over delicate corbels like shelves in a piece of cabinetwork, the upper story laid out in a horizontal band of windows, and, finally, the sharply protruding and cubic dormer windows reaching round the corner, all these are very characteristic features. The pure forms of simple geometry which determined Shaw's effects, and the forms of the details, as well as of the whole, remain closed; one's general impression is thus of coolness, objectivity, sobriety, with something slightly bizarre, however, inherent in the proportions, which seem to suggest that the house was built for the phantoms represented in Rossetti's and Burne-Jones' pictures rather than for human beings. Indeed, the rooms of Shaw's building were originally full of paintings by these two masters and decorated with wallpapers, carpets, and other elements designed by Morris, as well as with furniture created by the Morris Company.

Since the nineties the tradition of the English house was felt to be an example to be followed on the Continent too (plate 81), especially when the influence of High Art Nouveau (with its curves) began to decline. A fine testimony to this appreciation was given by Hermann Muthesius in *English Contemporary Architecture* (1902) and his three illustrated volumes of *The English House* (1904–05).

THE INFLUENCE OF WILLIAM BLAKE

Our search for the origins of Art Nouveau leads us back to the turn of the eighteenth century, to the visionary painter-poet William Blake (1757–1827), who anticipated the leitmotiv of Art Nouveau completely. An extended flowing movement, singularly gliding rhythms, as well as asymmetry and a closed graphic form, all these appear everywhere in his drawings or illustrations.

Many elements fuse in the art of Blake, which yet remains original to such a degree that only recently has one begun to detect the presence there of certain influences. All that is essential is genuine, especially in his form. There is not a single feature in his work that does not bear the sign of exaggeration—"exuberance is beauty"—and only seldom is a disconcertingly amateurish trait missing. Art, for him, was "a means of conversing with paradise"; in his pictures one breathes the atmosphere of an undiscovered planet. Like his poems, they are visions and, as an art, imaginative to the highest degree, springing from within and nourished on the elements of another world. But Blake's fairy-like, ecstatic world of images is at the same time ruled by a strange elegance and an instinct that delights in ornament and decoration.

After his death in 1827, William Blake was forgotten for more than twenty years. His visionary art seemed episodic; he himself was considered mad. His anticipation of Art Nouveau remained, for the time being, without any consequence. Dante Gabriel Rossetti was the first to rediscover Blake's genius. Rossetti admired the *Songs of Innocence* and was looking for originals by Blake when, in 1873, the *Notebook* (later called the *Rossetti Manuscript*) was offered to him for purchase—a paper-covered book filled with a great many poems, notes, watercolors, and sketches. At first, Rossetti felt it confirmed his own convictions, seeing Blake's violent rejection of Baroque painting and his fierce attacks against Rubens, Rembrandt, and Reynolds, all of them "balsam to Rossetti's soul and grist to his mill,"[16] and it is well to note that Rossetti bought Blake's *Notebook* two years before he painted his own first pictures. In addition to the notes, the sketches in the manuscript may have helped Rossetti to form his conceptions of a style entirely opposed to Baroque, with its forms developing upon a flat surface and merely outlined. Just as a strong influence of Blake's poetry is to be felt in Rossetti's poem *The Blessed Damozel* of 1847, so also do his early paintings reveal analogies to Blake's style and subjects.

During the fifties and sixties, this kind of rapport between Rossetti and Blake's ideas and art continued uninterrupted, if only in the themes and details borrowed by Rossetti from Blake. The angel inserted by Blake in a corner of a cloud is repeated in one of Rossetti's works in almost every detail, though Rossetti's figure is more three-dimensional. Blake's phantoms here assume flesh and color and, to a certain degree, acquire physical weight. But the general theme remains the same in both Blake and Rossetti: the gesture of the angel's arms, the

turning of the head, the level profile, and the enclosing wings, with their tips crossed in front of the body.

Not only was Rossetti receptive to the entranced atmosphere, the disposition of the forms in the flat surface, and the narrow scene of action of Blake's picture, but he also understood Blake's idea of conceiving the human figure as an ornament in itself. Rossetti integrated these conceptions into his own work which was more objectively presented and more realistic in its details; long after him, in fact up to Mackintosh and the Macdonald sisters, increasingly abstracted human-figure ornaments became more and more important in Art Nouveau. In several variations, Rossetti created ornamental friezes of uniform figures arranged on a level with the picture's surface, something that since the age of Mannerism had ceased to occur. He was altogether fascinated by Blake's love of parallelisms (plates 44, 45): the parallel character of limbs, of outlines which made the form appear as a narrow, ribbon-like, two-dimensional body, and the parallelisms too between the movements of different figures. The unbroken and flexible axis and long, flowing garments made the human figure particularly fit for the expression of ornamental gestures. Blake's way of disposing the profile and the axis of an inclined head horizontally

became typical of Rossetti's art too (plate 46). This bend of the head in a strange and almost gliding movement (plate 20) was then considered essentially Pre-Raphaelitic, until it was also generally adopted by Art Nouveau artists on the European continent.

Rossetti introduced the members and friends of the Pre-Raphaelite Brotherhood to Blake's work. Their age thus became haunted by Blake, merely because Rossetti had rediscovered him.[17] Moreover, Blake produced this effect in a dual manner: on the one hand, by being felt in Rossetti's very influential work, on the other hand, through his own work which also had been made known by Rossetti.

The *Design for a Gothic Window* (plate 47), which John Everett Millais drew in 1853, when he most closely emulated Rossetti's style, reminds one of Blake's watercolors such as *Angels Hovering over the Body of Jesus* (plate 48). Millais' sketch reminds us of Blake's symmetrical arabesques of floating and loosely connected figures, of his unbroken Art Nouveau rhythms, and of the synthesis he achieved out of the neo-Classical and neo-Gothic styles.

44 DANTE GABRIEL ROSSETTI *How Sir Galahad, Sir Bors and Sir Percival were Fed with the Sancgreal; But Sir Percival's Sister Died by the Way* (1864)

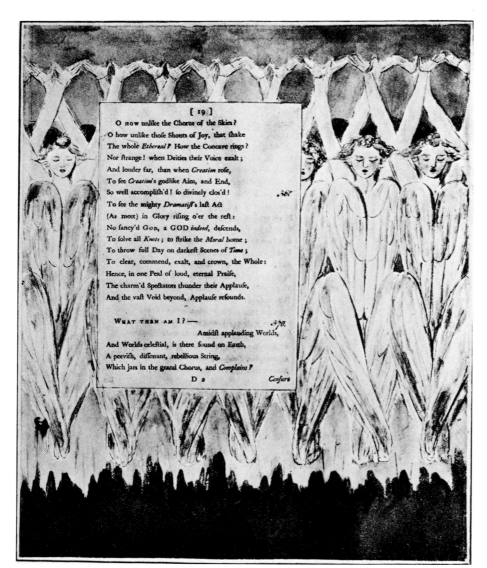

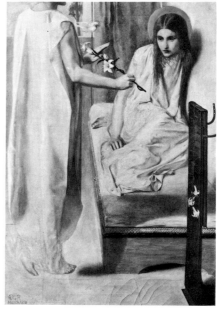

45 46

Millais' design had been conceived for a real stone window, but Blake, too, had written that he wanted some of his drawings to be carried out on a large scale in fresco, as murals to decorate the altar of a church.

Edward Burne-Jones, the most highly paid painter of the sixties and seventies, shared Rossetti's admiration for Blake. In many elements that he borrowed from the great visionary, one can feel their close affinity at both the formal and the intellectual level. In the whirl of delicate lines which the lamenting Orpheus traverses, and in the liquid loops and spirals which flow around him (plate 20), Burne-Jones embodied (artistically smoothed out and less violent) a motif suggesting the storm out of which the Lord speaks to Job (plate 49). In 1875, Burne-Jones' *Orpheus* series already reveals features of early English Art Nouveau. In one of his most famous paintings, *The Golden Stairs* (plate 50), a picture filled with mysticism, symbolism, and a strangely asceticized sensualism, the spiral construction could scarcely be imagined without some influence of Blake's watercolor, *The Dream of Jacob* (plate 51), with its spiral of Jacob's ladder and of the small figures descending and ascending, all clad in long, flowing robes.

In 1868, after long preparatory studies, Algernon Charles Swinburne completed his important essay on Blake in which he speaks of the "flame-like impulse of

45 WILLIAM BLAKE *The Chorus of the Skies* (1796)
46 DANTE GABRIEL ROSSETTI *Ecce Ancilla Domini (The Annunciation)* (1850)
47 JOHN EVERETT MILLAIS *Design for a Gothic window* (1853)
48 WILLIAM BLAKE *Angels Hovering over the Body of Christ* (1808)

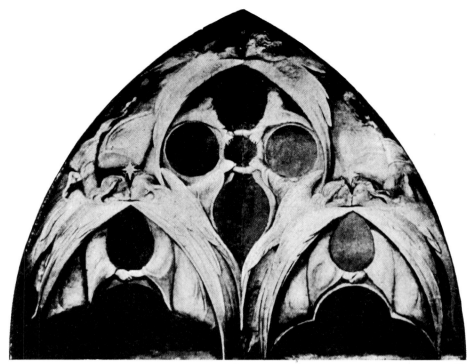

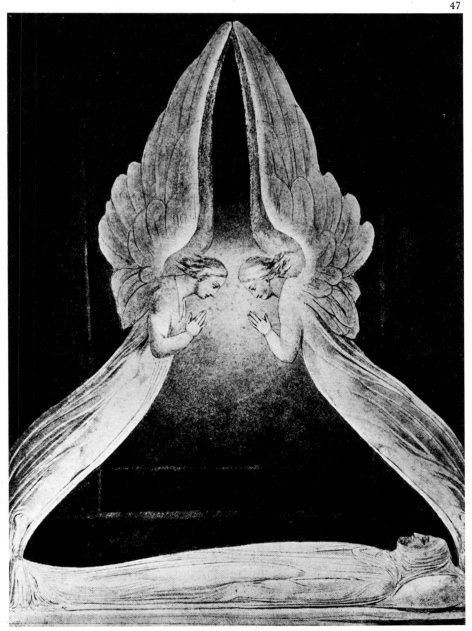

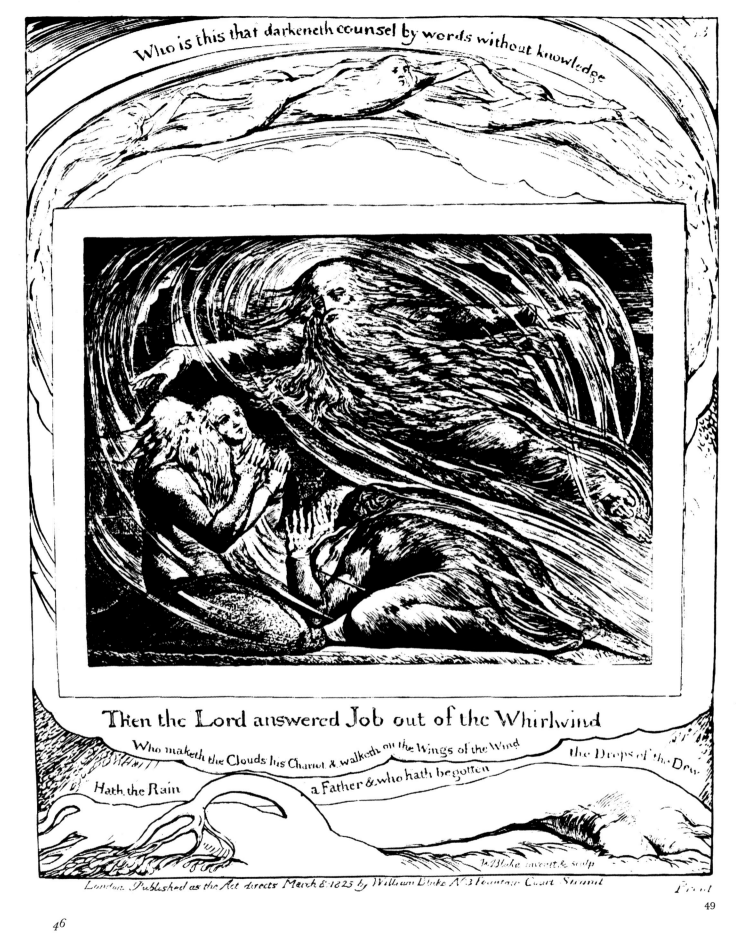

Who is this that darkeneth counsel by words without knowledge

Then the Lord answered Job out of the Whirlwind

Who maketh the Clouds his Chariot & walketh on the Wings of the Wind

the Drops of the Dew

Hath the Rain

a Father & who hath begotten

W Blake invent & sculp

London. Published as the Act directs March 8 1825 by William Blake N 3 Fountain Court Strand

Proof

49

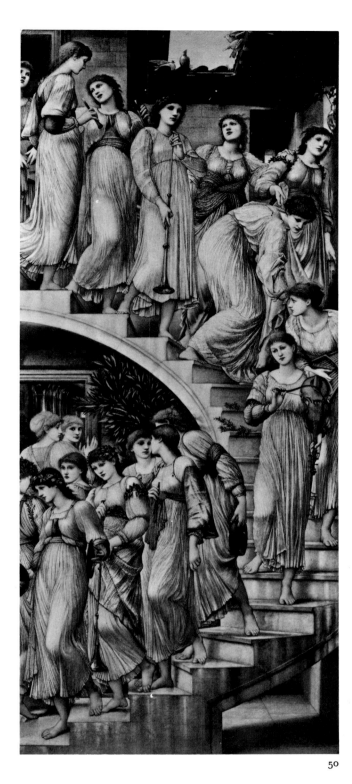

the idea'' in Blake's work. Swinburne had the binding and the title page of the essay decorated with fascicles of flames and small figures borrowed from the margins of Blake's *Jerusalem*. Again, the initiative for this essay came from Rossetti, without whom Swinburne, as founder and promoter of English literary Symbolism, would never have written his brilliant essay on Blake, without which Blake would never have become an ideal for a whole school of poets and writers.[18] Since then, studies on Blake have become increasingly important so that his paintings now arouse as much interest as his poetry and prose.

In 1880, a new edition of Alexander Gilchrist's *Life of William Blake* became necessary. Frederick Shields, who also wrote on Blake and later worked with Mackmurdo, designed the binding (plate 52). English Art Nouveau began thereby to acquire a certain continuity as a result of its individual mature solutions to various problems. On the one hand, this binding clearly imitates Blake (plate 53); on the other hand, it satisfies the demands of Art Nouveau even in the ambiguous relationship of the gold design to its purple ground, or of the purple design to its golden ground. Yet one still detects here a certain hesitation: lettering and decorative design remain separate in their juxtaposition, and the play between form and counterform is uncertain. We still miss the simplicity and concision of the emblematic designs that distinguish the masterpieces of High Art Nouveau.

All the qualities that were still lacking in this binding appeared in their full perfection in the works of Mackmurdo, for example in his chair of 1881 (plate 41), in the back of which there flicker the same flaming flowers as in the binding of *Wren's City Churches* of 1883 (plate 42).

51

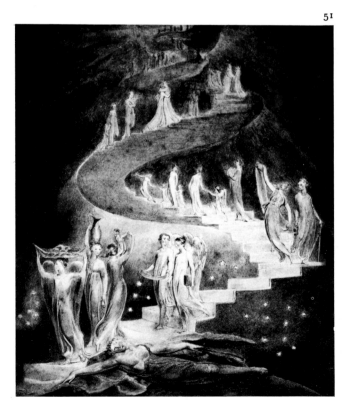

50

49 WILLIAM BLAKE *Then the Lord answered Job out of the Whirlwind* (1825)
50 EDWARD BURNE-JONES *The Golden Stairs* (1880)
51 WILLIAM BLAKE *The Dream of Jacob* (1808)

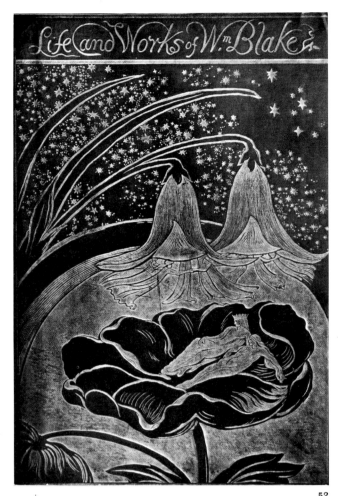

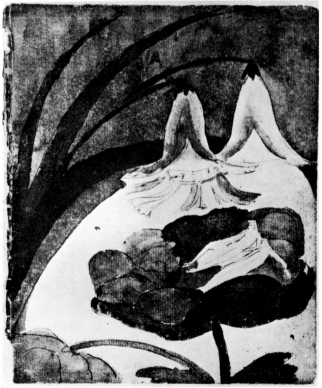

A style of curved and linear High Art Nouveau had thus attained full maturity in England twelve years before Victor Horta built the *Maison Tassel* in Brussels. For the first time, Blake's influence which, until then, had made itself felt only in paintings and in book illustrations, now began to extend also to ornamental design and patterns and counter-patterns. Mackmurdo used variations of Blake's flaming flower in printed fabrics, in the embroidered panels of a screen (plate 54), and also in woodwork or metal. For several years, he seems to have been truly obsessed with this theme; developed in the title page of *Wren's City Churches*, it has significance in view of the contents of the work: after the fashion of the phoenix, new life rises out of the ashes, like the churches that had been built by Wren after the great London fire.

From the start, Mackmurdo and his contributors were thus familiar with Blake's works. As early as 1882, Heywood Sumner, who was closely connected with Mackmurdo and the Century Guild, designed darting, Blake-like, flaming flowers for the binding of the score of *Cinderella* (plate 55); actually they somehow still seemed to bristle, the flow of their lines lacking real continuity. But in 1888, in Sumner's design for the binding of the fairy tale *Undine* (plate 56), English High Art Nouveau appears fully developed. Just as with Blake, but in a more organized manner, a half-illustrative, half-decorative design surrounds the lettering in a streaming movement in which all forms are assimilated. However, the lines of the draped garments flow with a more even, broad, and symmetrical sweep than those of the slender twigs and leaves of the water plants, though their forms are similar and related to each other as if the former had somehow developed from the latter. Nor was it fortuitous that the Romantic fairy tale of *Undine* inspired this design where the watersprite with the Latin name suggesting waves is represented by the "eloquent" forms of waves. Here, a decorative and illustrative design is both "surface and symbol," as Oscar Wilde claimed that it should be. Again, we see how closely English Art Nouveau, during all the time that it lasted, was connected with Romantic and Symbolist literature. In their predilection for fables and fairy tales, Blake and Art Nouveau are closely related.

The numerous children's books which Walter Crane designed, mainly with colorful illustrations, remain, together with those of Kate Greenaway, perhaps the most beautiful illustrated books for the young that the second half of the nineteenth century produced. At the very start of his career, in the sixties, Crane had known Blake's work, but then only gradually did he begin to follow his example in order to achieve a similar synthesis of image, text, and ornament. In *Flora's Feast* above all (colorplate VI), in the flaming flower-creatures that seem to be a

52 FREDERICK SHIELDS *Binding for "Life and Works of William Blake"* (1880)
53 ROBERT BLAKE *The King and the Queen of the Fairies* (1787)

52

53

48

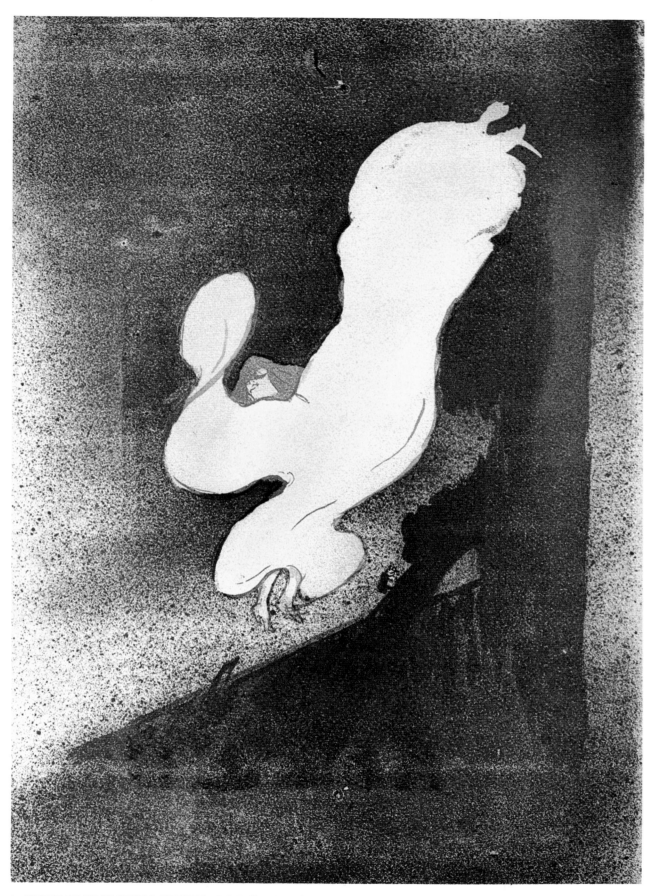

I HENRI DE TOULOUSE-LAUTREC *Loïe Fuller (circa* 1893)

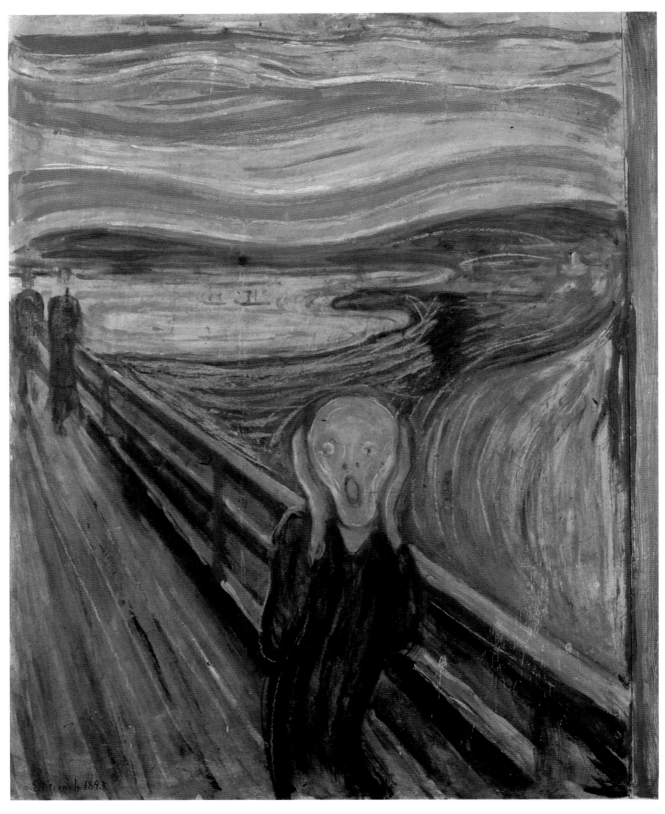

II EDVARD MUNCH *The Cry* (1893)

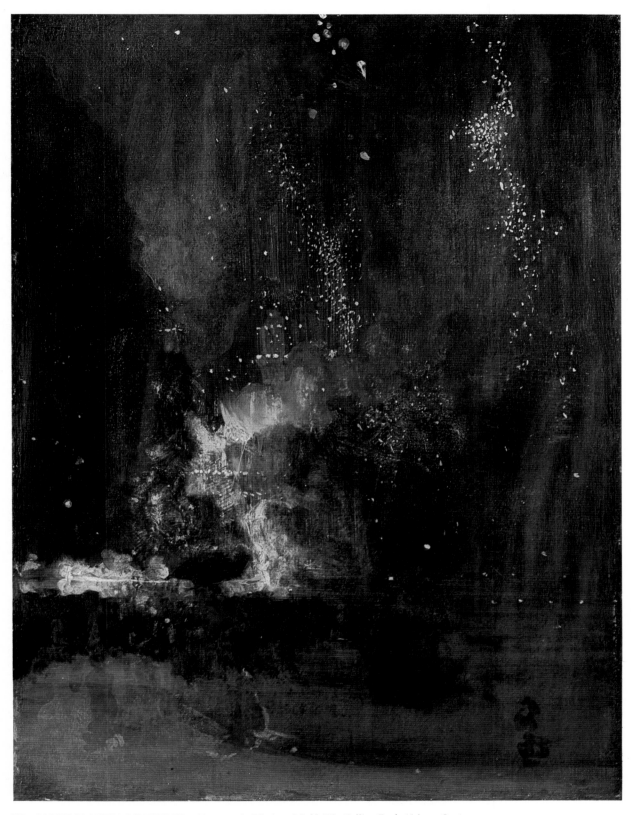

III JAMES McNEILL WHISTLER *Nocturne in Black and Gold: The Falling Rocket (circa 1874)*

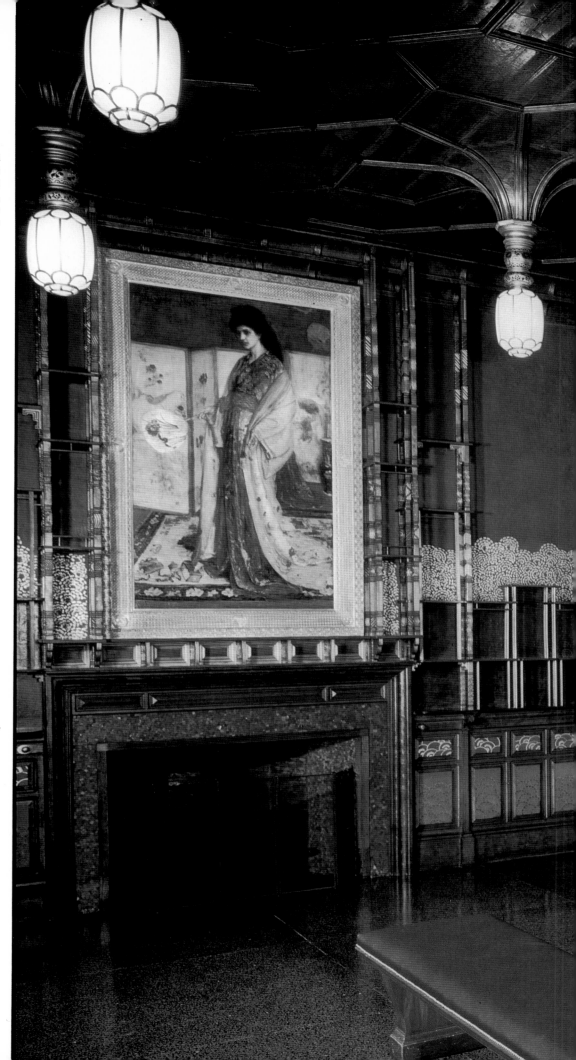

IV JAMES McNEILL WHISTLER
*Decoration for the Peacock Room of the
Leyland residence, London* (1876–77)
(Now in the Freer Gallery of Art,
Smithsonian Institution, Washington, D.C.) Left: *Princesse du Pays de la
Porcelaine*

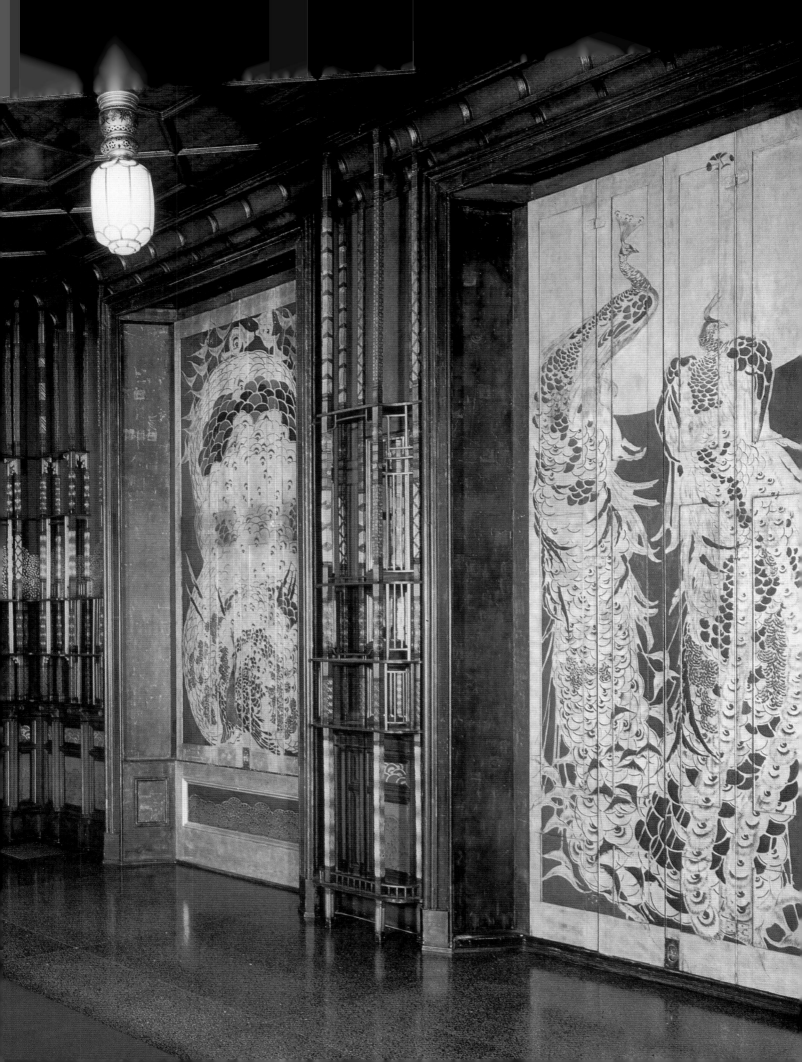

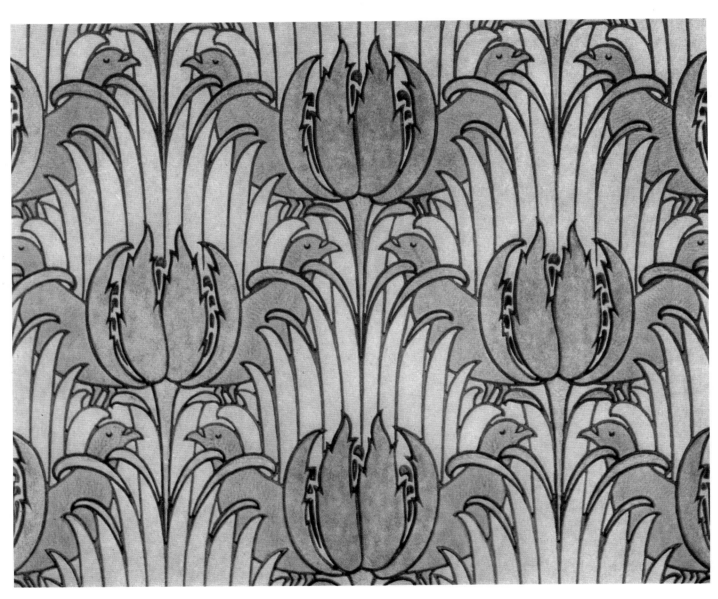

V CHARLES ANNESLEY VOYSEY *Wallpaper, "Tulip and Bird"* (1896)

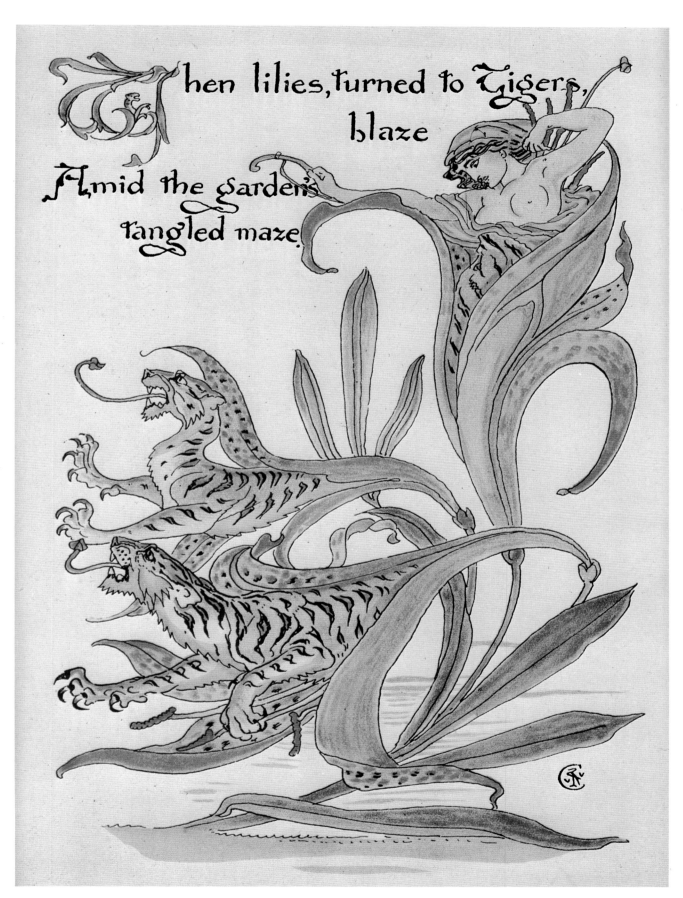

Then lilies, turned to Tigers, blaze

Amid the garden's tangled maze.

VI WALTER CRANE *Illustration for "Flora's Feast"* (1889)

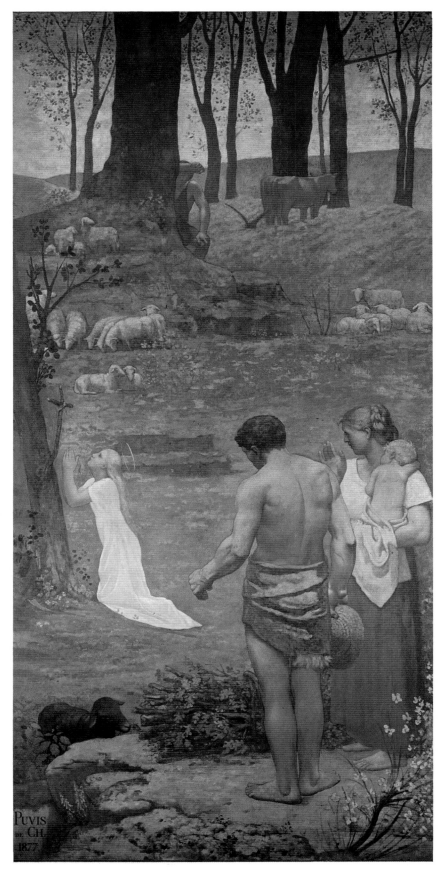

VII PIERRE PUVIS DE CHAVANNES *St. Geneviève in Prayer* (1877)

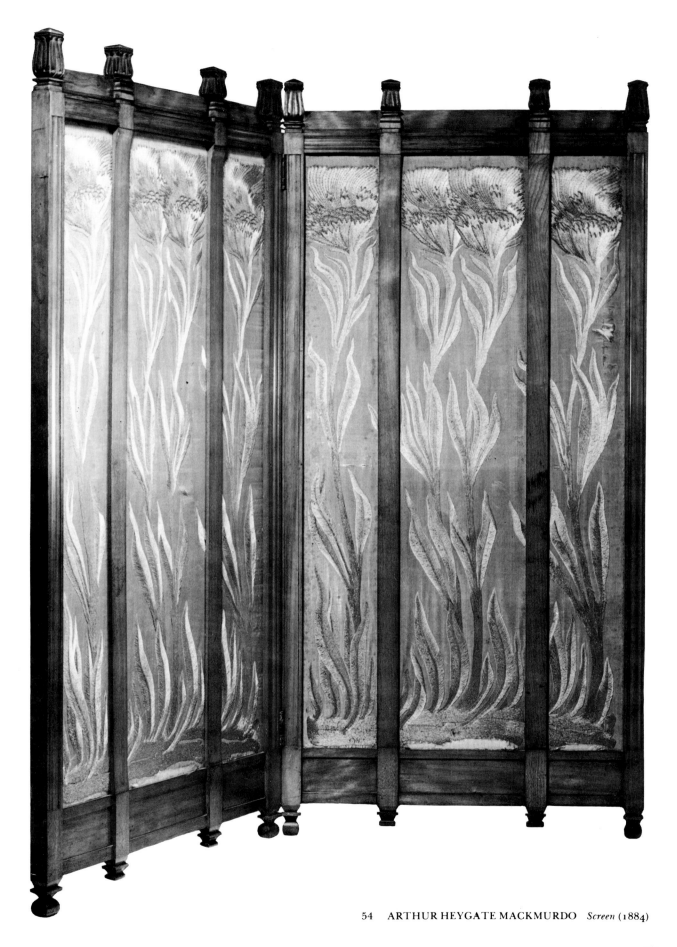

54 ARTHUR HEYGATE MACKMURDO *Screen* (1884)

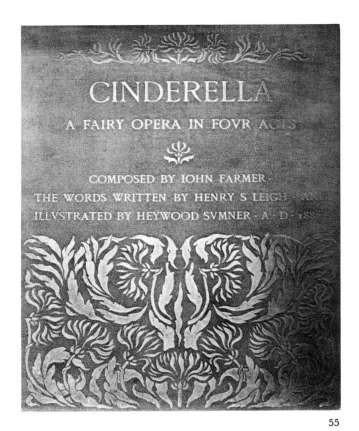

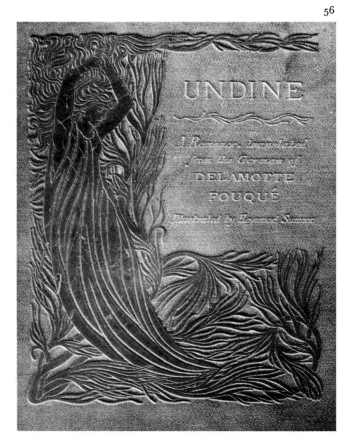

55 HEYWOOD SUMNER *Binding for "Cinderella"* (1882)
56 HEYWOOD SUMNER *Binding for "Undine"* (1888)
57 FÉLIX BRACQUEMOND *Plate* (1867)

blend of the animal and the human elements, Blake's ideas are developed by Crane, though in a less demonic manner. On the Continent, Crane was then considered the most important representative of the "English style"; in his later writings on art teaching, he never failed to express his gratitude to Blake and, for didactic purposes, likewise reproduced many of his master's designs to illustrate his own arguments.

Even Aubrey Beardsley was influenced by Blake during a period which was decisive for the development of his art. In its structure, in the relationship between image and text, in the flame-like leaves, the single ornament and the style of design and of lettering, the still somewhat juvenile drawing of 1890–91, *Dante in Exile*, is an imitation of Blake. Other Beardsley drawings from 1892 concern themselves more and more with Blake's treatment of decorative ensembles and reveal themselves often as derived in their theme from the whirlwind which is characteristic of Blake and Burne-Jones. Only a bit later, around 1892 or 1893, did Beardsley adopt his mature style of drawing, in which English Art Nouveau appears most strikingly.

In 1893, *The Studio* began to appear and its first issue was also the first periodical to publish drawings by Beardsley. The same year, Victor Horta achieved, with his *Maison Tassel* in Brussels, the first true example of Art Nouveau architecture and of Continental High Art Nouveau in general; in that year, Ellis and Yeats also published the standard work on William Blake, in three monumental volumes. The Royal Academy then exhibited a series of Blake's watercolors for Dante's *Divina Commedia*, and William Butler Yeats, the poet and spokesman of the "Celtic Renaissance," wrote articles on these illustrations, published in 1896 in *The Savoy*, a periodical that was conceived entirely in Beardsley's style.

Oscar Wilde had concluded his *Decay of Lying* as follows: "And now let us go out on the terrace, where 'droops the milk-white peacock like a ghost,' while the evening star 'washes the dusk with silver!' At twilight nature becomes a wonderfully suggestive effect, and is not without loveliness, though perhaps its chief use is to illustrate quotations from the poets." In Blake's poem *The Evening Star*, we not only find the "evening star" itself, but also the expression "and wash the dusk with silver." Both literature and art thus refer back to the man who had become the prophet of a new style.

PRELIMINARIES TO ART NOUVEAU IN FRANCE

Secured in itself by numerous cross-connections with various other movements which have already been discussed, the continuous development of the early English Art Nouveau cannot be compared with the somewhat isolated symptoms of the same style that first appeared in France. From about 1870 until the end of the century, a few initiatives in this general direction occurred in

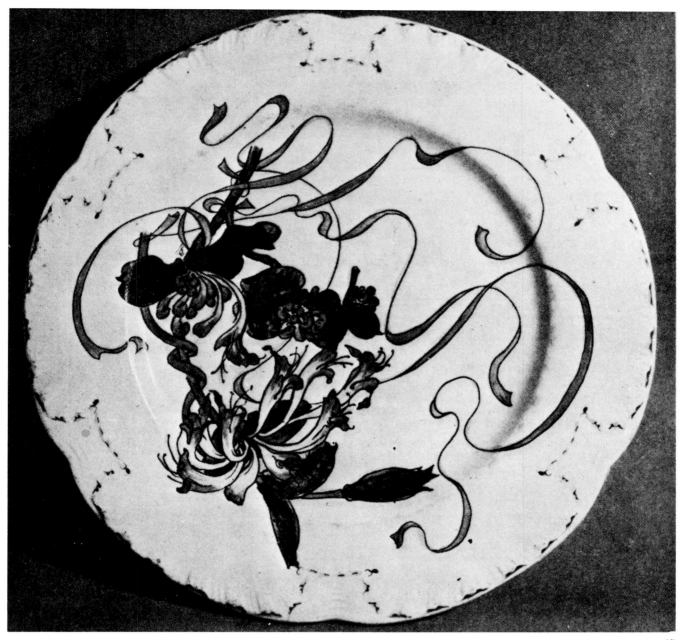

57

France, the steel skeleton buildings of the engineer-architects probably remaining the most important. Such works as Gustave Eiffel's Tower for the Paris World's Fair of 1889 and Contamin's Hall of Machines, built for the same occasion, have at least a slight connection with Art Nouveau in their swinging outline. Above all, the structure of their framework, with its apparent lack of weight and lines that are both functional and decorative, and the transparent character of these buildings that were often encased in a thin sheath of glass, are all features which they have in common with the later architecture of High Art Nouveau, with its linear conceptions of mass and space. The buildings of Horta reveal the full importance of architectural initiative. This designer adapted the techniques and the style of engineering not

only to the requirements of functional architecture, as in his *Maison du Peuple* in Brussels (plates 76, 77), but also to the requirements of private homes (plate 68), a combination which proved him to be a real innovator in his field. The steel skeleton, however, was not developed as an architectural element only in France. Paxton's Crystal Palace of 1851 certainly remains as an important example of earlier English achievements in this field; but later French examples appear to have inspired the architects of Art Nouveau more directly.

An early example of approximation to the style of Art Nouveau in French arts and crafts can be found in a glazed ceramic dish (plate 57) which the painter and etcher Félix Bracquemond (1833–1914) decorated in 1867. One can scarcely assume that these ornaments

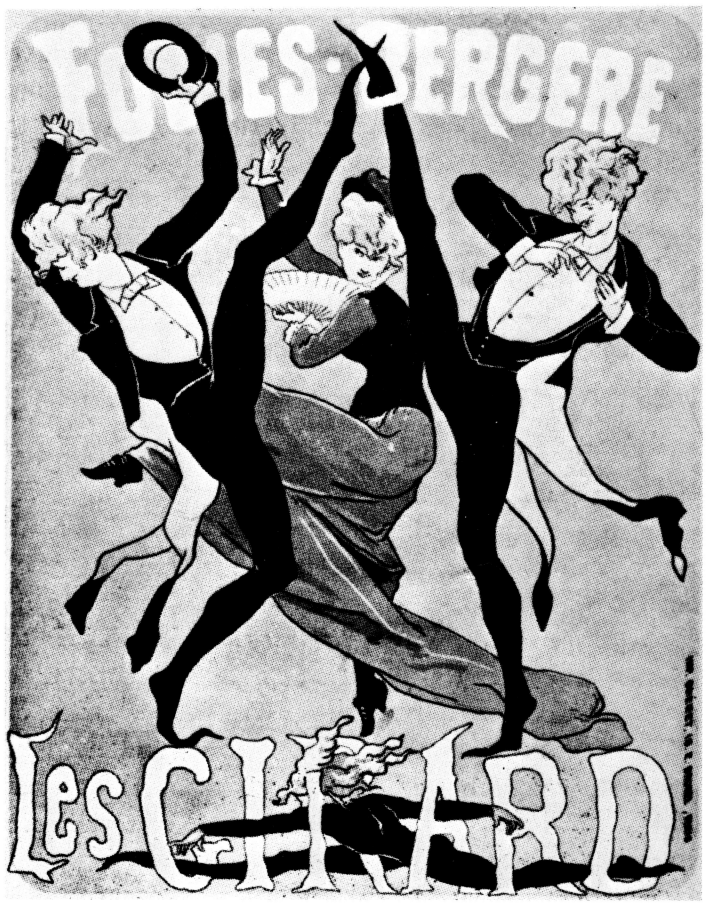

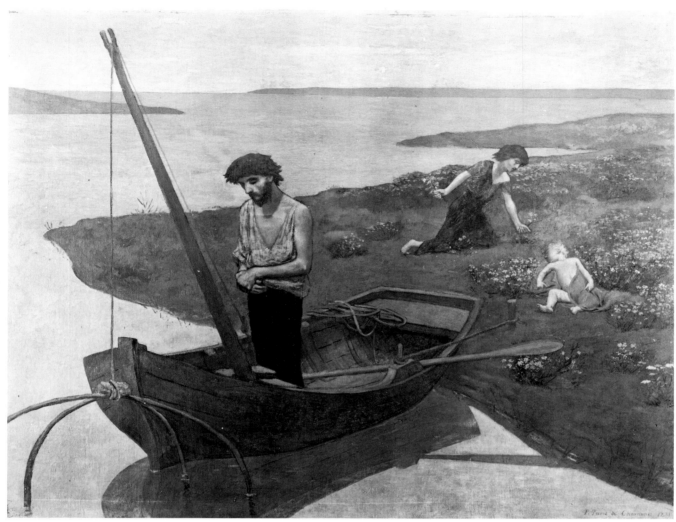

59

borrowed from plant life were copied directly from nature, even if Bracquemond himself wrote that those works which required a maximum of artistry are also the ones closest to nature, since he then adds, quite understandably, that, in order to create a work of art, more is required of an artist than the exact reproduction of nature. The border of his dish displays scallop designs in the Louis XV style in delicate relief, but the smooth outlining of the flowers is contrary to the principles of Rococo porcelain decoration, and the intentionally asymmetrical use of space as well as the choice of exotic flowers tend rather to suggest a Japanese source of inspiration. Nor would this be surprising, since Bracquemond had been the first in Europe to discover Japanese art. The flowers and their stems on his plate are thus outlined and transposed entirely in terms of surface-design, the lines of which indeed follow movement, though it still lacks the typical waxing and waning of the later ''Belgian'' line.

58 JULES CHÉRET *Poster for "Folies-Bergère, Les Girard"* (1877)
59 PIERRE PUVIS DE CHAVANNES *The Poor Fisherman* (1881)

In 1869, elements of Art Nouveau already appear in the poster designed by Edouard Manet (1832–83) for the book *Les Chats.* Nowhere else can one detect anything of this nature in the work of Manet, the very last artist whom we might suspect among his contemporaries of being at all infected with Art Nouveau ambitions. The lines in Manet's poster for *Les Chats* are continuous and gliding and all combine in an effective simplification which already makes us think of Toulouse-Lautrec. In the midst of a painterly atmosphere, the contours of the cats stand out as silhouettes, filled in with white or black, so that surface-forms of a kind are produced. Japanese woodcuts have certainly influenced this design in order to make it appear so closely related to Art Nouveau.

Even more surprising is a poster that Jules Chéret (1836–1930), who was later to become very successful and popular, designed as one of his very first as early as 1877 (plate 58). Here we find entirely un-Impressionistic figures presented in stylized simplification and arranged as closed forms parallel to the picture's surface, with even outlines, homogeneously filled flat fields of color, and a lively suggestion of movement. Later, however, Chéret's

60 MAURICE DENIS *Title page for "Amour"* (1898)
61 GUSTAVE MOREAU *Dusk* (n.d.)
62 ODILON REDON *Lady in a Shell* (n.d.)

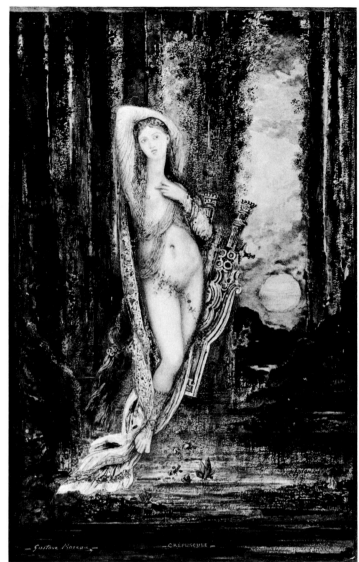

61

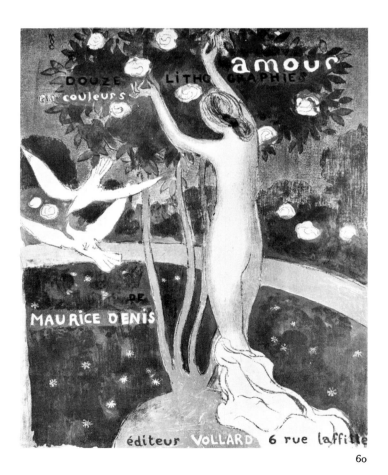

60

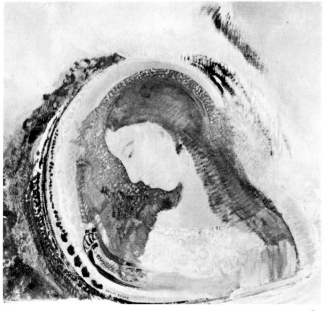

62

posters became increasingly Impressionistic, fuzzy, and painterly.

That the Art Nouveau characteristic of Chéret's posters should thus recede is all the more remarkable when one considers that the relatively new artistic field of poster art might have facilitated its more general conversion to the style of Art Nouveau. A poster's very function requires that it be clearly legible and emphatic in its formulation, and this corresponded to the aspirations of Art Nouveau. Whereas the idiom of forms in applied graphic art, with its use of perspectives in space and its hatched or shaded lettering, had, until then, always remained unsuited to the long-range effects of such an art. Actually, the poster never played a leading role in the avant-garde of Art Nouveau during the seventies and eighties. Only toward the beginning of the nineties (when the new style was already imposing itself in any case) did Toulouse-Lautrec and Bonnard produce posters (plate 116, colorplate XVI) that remain of real importance, whether as works of art or from the point of view of the history of Art Nouveau, and which then inspired numerous disciples and imitators.

In the nineteenth century, France's greatest contribution toward Art Nouveau, before its actual birth, was made by engineers and, later, by painters. Indeed, French painting remained far ahead of the other arts, in fact the greatest achievement of French art in general throughout the century. It appeared almost as if all France's artistic energies had been concentrated in this one field of art, and it would seem as though there had been less creativity before 1890 in the fields of decorative and applied arts than in England during the same period. The first of the great French painters in whose works we can detect elements of Art Nouveau are Pierre Puvis de Chavannes (1824–98), Gustave Moreau (1826–98), and Odilon Redon (1840–1916).

By and large, Puvis de Chavannes remained faithful to the linear tradition of composition which he had inherited from Ingres. But his simplification of outlines and his reduction of all details to a complex of forms presented mainly in terms of surface, especially his technique of representation that reminds one of fresco painting and makes little allowance, if any, for three-dimensional effects of space, all these features of his art indeed offered a kind of springboard for the later development of French Art Nouveau (plate 59, colorplate VII). In his choice of subjects and his mood, Puvis de Chavannes refrained, however, from turning his back on the world of Romanticism which was already imbued with Symbolism. But he tended to represent this world somewhat frigidly, in a brittle or laconic manner. This mood of dry understatement in his art later became, in the work of Maurice Denis (plate 60), more communicative or intimate, with more flowing outlines and less developed figures that, however schematic, are more in formal harmony with this newer style.

Gustave Moreau, like Puvis de Chavannes and Maurice Denis, too (among the later *Nabi* painters), remained somewhat alien to the mainstream of French painting of his time, especially as it was then represented by its more advanced or modern school, the Impressionists. His sumptuous and figuratively symbolistic painting contrasts sharply with the Arcadian classicism of Puvis de Chavannes and may indeed appear somewhat exotic or bizarre. Though Moreau refrained from selecting for his subjects, as most of the historical painters of his generation were doing, the more catastrophic moments of world history, he reveals a predilection for ancient mythology, which he represented with Orientalistic trappings, and especially for its tragic figures and its themes of disaster (colorplate VIII). His world is thus peopled with sirens, sphinxes, and other such monsters; his nymphs are borne aloft as if levitating or liberated from the laws of gravitation; in one of his works an apparently weightless female figure thus represents (plate 61) the twilight. Her dreamy expression of nostalgia and her gently soaring body, with its supple swan-like neck, would make the allegorical figure in Ingres' *La Source* (which was certainly at the back of Moreau's mind) appear almost too squat and coarse by comparison. Such refinements of mood and form were achieved by Moreau at the cost of considerable losses of substance; if only in this respect, he betrays his affinity with Art Nouveau.

As early as 1890, Arthur Symons, in England, had already defined Odilon Redon as a French William Blake. But Redon's art (plate 62, colorplate IX) is not Art Nouveau and contributed nothing toward its development, only remaining close to it. This relationship consists much less in formal similarities than in an affinity of the spirit, of its moods and attitudes, and of the artist's world of ideas and fantasies. Like Moreau, Redon was a Symbolist, though he never needed all the props and paraphernalia of Moreau's Symbolism. Originally, he had been a disciple of Corot, which might explain the quietude that his art still reflects. But the decisive influence in Redon's artistic evolution had been that of Rudolphe Bresdin's black-and-white graphic work, and Redon gratefully signed one of his earlier etchings, in 1865: "*Odilon Redon, élève de Bresdin.*"

As for the Art Nouveau artists, nature was the source of all things for Redon also, though in a very special sense. In attempting to copy a detail of nature quite minutely, he soon experienced a "boiling of the mind" that led him to more imaginative creations, so that he finally suggested a butterfly, a flower, or a seashell instead of simply representing it. Nature was his point of departure, a ferment that stimulated him, but never his ultimate aim.

From Puvis de Chavannes, Gustave Moreau, or Odilon Redon, no direct path leads one to French High Art Nouveau. Paul Gauguin (1848–1903) was the only great French painter of his time to develop, on his own, a formal idiom that is recognizably Art Nouveau. This was evolved even before the poster work done by Toulouse-Lautrec. Gauguin had begun his career as an Impressionist, clearly deriving his style from that of his friend

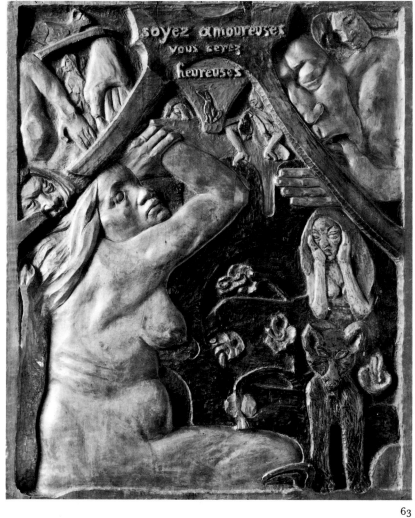

63

64

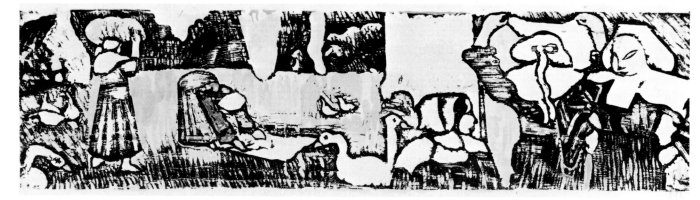

65

63 PAUL GAUGUIN *Soyez amoureuses, vous serez heureuses*
 (1890)
64 PAUL GAUGUIN *Vase with Breton designs (circa 1888)*
65 ÉMILE BERNARD *Breton Women* (n.d.)
66 AUGUSTE RODIN *Danaïde* (1885)

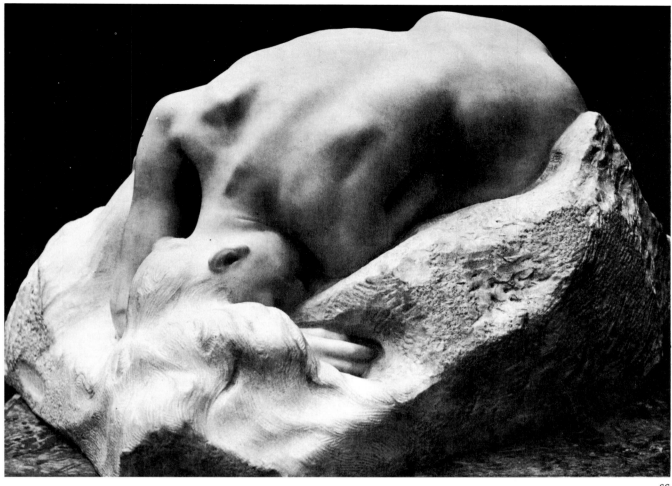

Pissarro. However, as early as 1886, Cézanne's influence can already be detected in the work of Gauguin who, in the course of the same year, retired for the first time to Pont-Aven, a village in Brittany, where he began to develop his own style: heavy outlines, simplified forms, unconventional fields of color, and principles of composition that stress two-dimensional effects of planes or of surface. Gauguin's Pont-Aven style was then formulated in close association with the painter Émile Bernard, who was twenty years younger. Because of its similarity with Far-Eastern cloisonné enamels, the artists themselves called this style *cloisonnisme* or else *synthétisme*. It is obvious to us that Japanese colored wood-block prints played a decisive part in the evolution of this style. However, the refinement and delicacy of Japanese graphic art is transformed under Gauguin's hand into something that seems more coarse or rustic.

From the point of view of Art Nouveau, the unstable, curving, asymmetrical, and intentionally decorative composition of this style of painting is one of its important characteristics. Perspectives of air or of light are neglected, and the different zones of space seem superimposed as receding planes or surfaces. As a result of the elimination of small details that might be reproduced in a naturalistic manner, a structure of concise juxtaposed forms is produced, like intarsia or cloisonné work. The artificial colors, both symbolical and decorative, reinforce this impression by making it difficult for the observer to situate the subject of the picture in terms of the three-dimensional world.

Gauguin's interest in the applied arts would alone prove his affinity with Art Nouveau. But his wood sculpture, his neoprimitive furniture, and ceramics also reveal a number of characteristic features of Art Nouveau (plate 63). In a vase of a clear, cylindrical and almost timeless form (plate 64), the decoration—Breton peasant women who seem to emerge from Gauguin's and Bernard's paintings of the same period, and a tree, the branches of which curve after the fashion of *Jugendstil*— appears to be a link with Art Nouveau. As always with the school of Pont-Aven, there is here, however, a touch of the barbaric or of brutality which even makes itself felt in the way the medium is treated. The roughness and vigor of Bernard's *Bretonnes* (plate 65) spring partly from the disguised traces of the wood block; Gauguin's relief *Soyez amoureuses* (plate 63) opposes the smoothed parts of

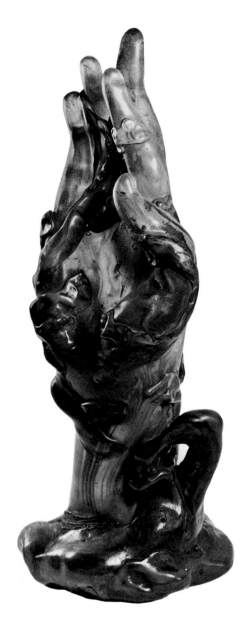

67 ÉMILE GALLÉ *Vase with a design of aquatic plants (circa 1900)*

ceding civilization, while Art Nouveau always remained in a highly civilized world. Thus the line that reaches from Gauguin to modern art leads, narrowly escaping Art Nouveau, to Fauvism, Expressionism, and to the barbaric works influenced by African Negro art of early Cubism. Far closer to Art Nouveau are the paintings of the *Nabi* artists (through Sérusier, likewise influenced by Gauguin), especially in certain works by Bonnard and Denis (plate 60). The hedonistic, refined outlook of the *Nabis* and the softened glow of their colors had more affinities with Art Nouveau than Gauguin's rough power. Whenever a similar vitality appears in the work of Edvard Munch—another great painter who similarly stands in opposition to Art Nouveau—one discovers there a real distance from the world of *Jugendstil;* and, finally, this is true of Van Gogh, too. The energetic thrust and the abruptness of Van Gogh's brushstrokes create a gulf between his paintings and Art Nouveau, although their lurching outlines and their composition that is almost askew, especially in the landscapes, remind us of it. Art Nouveau understood nature from a biological point of view and used it as decoration. Van Gogh saw it from a religious point of view and painted it heroically.

Sculpture plays a comparatively unimportant role in Art Nouveau, where it appears (only in the nineties) in the work of Auguste Rodin (1840–1917). In Rodin's titanic achievement, orgiastic processions of nymphs and fauns, of lovers and of the damned, the upright human figure no longer occupies a central position. A flow of forms is created, not only between the different figures of a group, but also between the individual formal details. In the play of light and shadow, the broken surfaces flow together like melting wax, reminding us of the impressionistic, blurred forms of Medardo Rosso, who actually modeled many of his sculptures in wax. With Rodin, the nervously quivering outline is wonderfully simplified (plate 66) and, more than with other sculptors, a complementary "negative" form of space is thus created.

In many works of Rodin, the human or humanoid figure is still half-imprisoned within an amorphous substance—a symbol of all forms and degrees of biological life. This primitive matter of life, from which the form seems to have only just freed itself, is to be found in Rodin as in Art Nouveau. In the palm of Gallé's glass *Hand* (plate 67) which looks as if seaweed were growing all through it, and as if it were studded with shells, one recognizes a human figure, so that the work gives the impression of being a parody of Rodin's *Hand of God*.

the human bodies to the roughly carved frame and ground of the relief, in a contrasting effect of matter and form that Rodin too knew how to exploit.

In spite of all affinities, there is a fundamental difference between the forceful vitality of Gauguin's art and Art Nouveau. Gauguin was interested in the origins pre-

HIGH AND LATE ART NOUVEAU

BRUSSELS

On the Continent, Brussels was the city where High Art Nouveau first assumed a clearly defined form. It was here that English examples had their first impact. This stimulus, together with the quite different approach of France to Art Nouveau, formed a very fruitful synthesis. Brussels thus acted as a mediator between England and the Continent, when its own Art Nouveau, which had been essentially bound to two-dimensional art, also developed three-dimensionally in terms of space. However much the Brussels style may have been inspired by London or Paris, it expressed itself with complete originality, allowing an exceptional range of individual creative possibilities within the general scope of its own Belgian style.

In the eighties and the nineties, Brussels was the most active place of exchange for the ideas of avant-garde art. Its most important initiator and promoter of novel ideas and styles was Octave Maus who, in 1881, founded the review *L'Art Moderne* and, one after the other, created also the *Société* or *Cercle des Vingt* (1884–93) and the association *La Libre Esthétique* (1894–1914). In his book *Trente années de lutte pour l'art* (1926), the yearly exhibitions, concerts, and lectures given by these organizations come to life again. One is surprised to see at what an early date many works representing the newest trend or of the most prominent new artists were then shown in Brussels: in 1884, Rodin, Whistler, Khnopff; in 1886, Odilon Redon and Georges Minne; in 1887, Seurat; in 1888, Toulouse-Lautrec and Signac; in 1889, Gauguin. In the same year, Van de Velde became a member of the *Vingt*; in 1890, they were joined by Cézanne and Van Gogh and by Toorop, Khnopff, and Redon, as representatives of the group that sought to transpose into art its emotions, dreams, symbols, and poetic memories. Imported from Paris, the doctrine of the Symbolists penetrated Belgian literature, painting, sculpture, even architecture and decorative arts. Increasingly, artists submitted to the battle cry of the *Nabi* painters who proclaimed: "There are no paintings, only decorations," to quote the Dutch *Nabi*, Verkade. Works of Walter Crane, who was the most popular Morris pupil and representative of Pre-Raphaelitism throughout the Continent in the field of applied arts, were thus exhibited in Brussels in 1891. In the same year, Georges Lemmen, who later created works of Art Nouveau himself, wrote a comprehensive essay on Crane in which he stressed the importance the English artist attached to the capacity of expression contained in forms, lines, and arabesques. Again, in 1891, as we are told by Octave Maus, the Maison Dietrich, the first bookshop in Brussels to sell art books, offered for sale large-size photographs of works of Burne-Jones and Rossetti. In 1894, there followed exhibitions which, under the title *Libre Esthétique*, showed, among other things, Ashbee silverware, Morris fabrics and carpets, Beardsley designs, and also, in 1895, examples of Voysey's architecture.

Victor Horta

The greatest Art Nouveau artist who was active in Belgium was certainly Victor Horta (1861–1947), an architect who also took charge of the interior decoration and furnishing of his houses, down to the most insignificant detail. The works which made him famous begin with the *Maison Tassel*, on what was formerly the Rue de Turin, a house planned in 1892 and finished to the last item of decoration in 1893 (plates 68, 69). For a long while, the date of this house was reckoned as that of the birth of Art Nouveau; it was also the year in which the first issue of *The Studio* was published, introducing Beardsley to the public. Though the beginning of High Art Nouveau now has to be antedated by ten years, on account of developments in England—to say nothing of early Art Nouveau in London, of Gaudí in Barcelona,

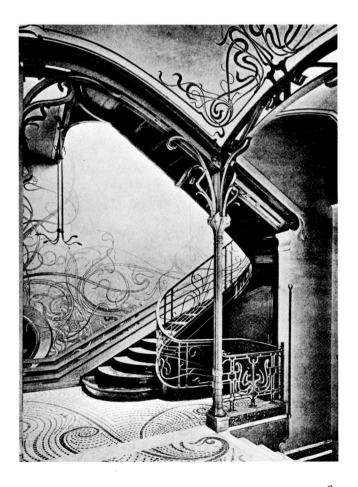

68 VICTOR HORTA *Staircase in the Tassel residence, Brussels* (1892–93)

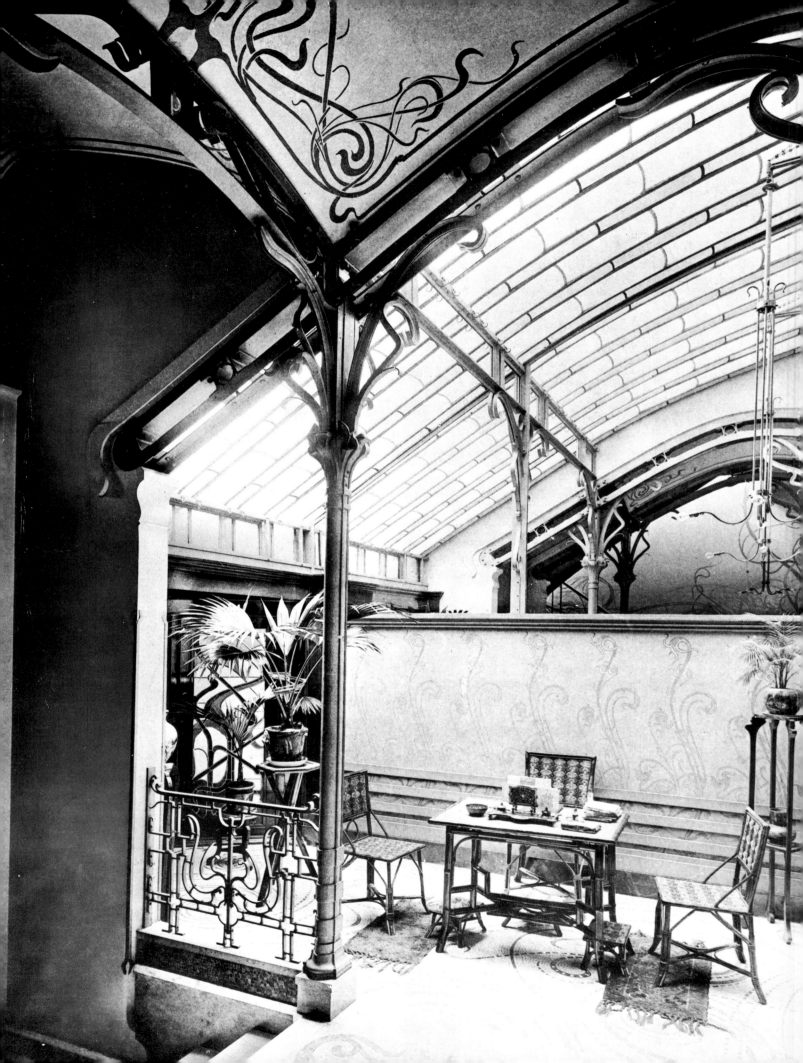

and of Furness and Sullivan in the United States—it remains a fact that Continental High Art Nouveau found its first and most complete expression in the *Maison Tassel*, inasmuch as it combined architecture and decoration, structure and ornament, the two-dimensional and the three-dimensional, in other words the total work of art.

Certain of Horta's ornaments are surprisingly similar to those on an 1888 bookbinding by Heywood Sumner, a member of the Mackmurdo circle (plate 56). This allows us to assume that the world of Horta's forms was inspired by English book decoration. On the walls of the staircase in the *Maison Tassel*, the wide curves are interlocked with wavy, star-like flowers, revealing that abstract forms originate in those of plants. These star-like ornaments are related to the wide curved ribbons much as Undine's whirling locks in Sumner's binding, seen in the smallest detail, are related to other lines that swing on a wider scale. In both cases, we feel the characteristic rhythm of Art Nouveau; the linear ribbons move in the sense of what was later called the "Belgian" line, which had already been expressed by Sumner. Though Horta's mural paintings scarcely invite interpretation, anyone who might ever feel an urge to interpret them would think, first and foremost, of a bower of undulating water plants on the floor of a transparent sea; thus, even in pattern and theme, there is complete harmony or conformity between Horta's style of decoration and his English sources.

Van de Velde has written about the close relations between Belgian and English artists during the decisive years. A. W. Finch, a Belgian painter of partly English extraction who later became a ceramist, was the first to become aware of the English revival in the applied arts and crafts. This happened around 1890, when he began to purchase a few objects which greatly impressed his Belgian friends. Soon Gustave Serrurier-Bovy in Liège also began to design and make his first pieces of furniture under English influences. Within a short while, wrote Van de Velde, the English style had thus become transformed into something original and Belgian. In the series of exhibitions organized, after 1884, by the *Société des Vingt* in Brussels, products of applied arts were shown for the first time beside avant-garde paintings; they included books illustrated by Herbert Horne and Selwyn Image, who were friends of Mackmurdo's and contributed to the *Century Guild* and to the *Hobby Horse*. Such decorated books had long been appreciated on the Continent as an English speciality. Thus, Kate Greenaway's *Under the Window* appeared in 1880 in German, and in its French edition finally sold more than 100,000 copies. As early as the beginning of the eighties, the Museum for Arts and Crafts in Hamburg purchased books illustrated by Walter Crane. Crane himself wrote: "The revival in England of decorative art of all kinds culminating, as it appears

to be doing, in book design, has not escaped the eyes of observant and sympathetic artists and writers on the Continent. The work of English artists of this kind has been exhibited in Germany, in Holland, in Belgium, and France, and has met with remarkable appreciation and sympathy. In Belgium particularly . . . the work of the newer school of English designers has awakened the greatest interest."

In the history of art, minor works or designs had often acted previously as a stimulus on great art; one need but think of the patterns suggested by antique gems and coins to Western European sculptors in the Middle Ages, or of the influence of Dürer's woodcuts on sixteenth-century Italian painting. Around 1900, houses with Art Nouveau façades were mockingly described as "book-decoration architecture"; Crane, on the other hand, once spoke of a "book like a house" as his ideal in decoration and goes on to discuss a frontispiece as a façade and an endpaper as a garden. A prophetic note seemed indeed to have been struck when in 1856 Owen Jones wrote in *The Grammar of Ornament* that a new style of ornament ought to be devised independent of any new architectural style, and that new ornamentation would be the most effective means of introducing a new style, since architecture borrows ornament and adapts it, but never develops it independently, on its own. This is exactly what began to happen. In terms of space and structure, the forms of Horta's staircase fulfilled their purpose and corresponded to the materials used without being determined by them. But the style and decorative themes of the staircase are not developed from the elements of cast-iron construction, which was a recent innovation; on the contrary, the cast-iron structure borrowed its idiom of form from other sources, all very appropriate to the linear character of the skeleton structure, and developed this idiom further in terms of space.

The assumption that this ornamental style originated in England, particularly in the Mackmurdo circle, has been confirmed by Henry-Russell Hitchcock.[19] The use of cast iron for purposes of structure and expression, characteristic as it may be in Horta's Art Nouveau architecture, was inspired on the one hand by Gustave Eiffel's great engineering constructions, culminating between 1887 and 1880 in the Eiffel Tower, and on the other hand by the theories and illustrations contained in Viollet-le-Duc's *Entretiens sur l'architecture*, which appeared in 1872. But even if Viollet-le-Duc's projects encouraged Horta to use and display the combination of cast iron and stone in construction, this influence, according to Hitchcock, scarcely explains the new ornaments that Horta then introduced, nor the homogeneity that his ornamental style immediately assumed in his *Maison Tassel*. Moreover, Hitchcock has discovered that Horta used English wallpaper between visible ornamental cast-iron structural elements in the dining room of the *Maison Tassel*; he therefore thinks it is extremely likely that Horta already knew English decorative work when he designed the house in 1892.

69 VICTOR HORTA *Staircase in the Tassel residence, Brussels*
 (1892–93)

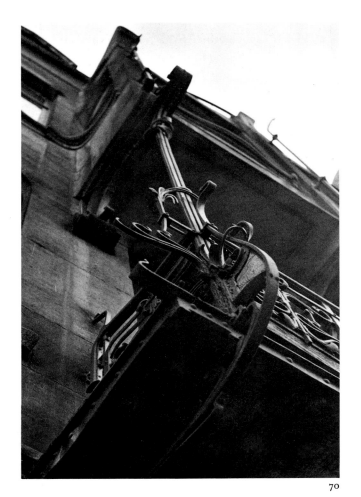

70

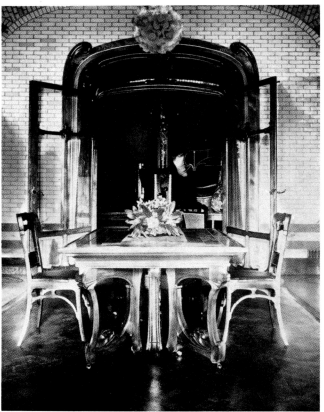

71

These were probably the tulip-pattern wallpapers of Heywood Sumner, whose bookbinding of 1888 had already been decisive in forming Horta's style. Besides, Van de Velde wrote that Sumner was "well known ever since his unusually beautiful wallpaper, *Tulip*, had first been printed by Jeffrey."

The stimulus coming from England, the typical Art Nouveau curve with its whiplash rhythm, was first developed in terms of space and structure by Horta. In the staircase of what was formerly the *Maison Tassel*, the linear Art Nouveau style of English wallpapers and bookbindings was merged into an architectural and ornamental unit, a total work of art of a perfection that even Horta was never able to surpass. A single leitmotiv expresses itself here both in two- and in three-dimensional terms. At the foot of the stairs, a slender iron support rises freely like the stem of a flower and its "capital" sends out into space plant-like ribbons such as we find on top of Blake's pillars. Their rhythm is echoed in the brackets and openly displayed iron supports, and more freely repeated in the metal bands that are twined around the banisters of the staircase. Like expanding circles in water formed by a thrown pebble, these ornaments spread from the supports over the ceiling to the walls; their flow even continues onto the mosaic floors. But each form is individual and the pattern is not endlessly repeated as in a wallpaper, which seems to confirm the assumption that Sumner's bookbinding had acted as a stimulus.

An exciting novelty in this building was that metal structural supports were displayed both in the interior and the exterior of a luxurious private home. The basic construction, in contrast to one of massive masonry, allowed for a relatively free and unconventional ground plan with rooms opening into one another and distributed in a novel manner. This interior rhythm of space found itself repeated, moreover, in the swing of the façade: the curve of the walls, certain sculptural details, the protruding of the central windows which appears as a transparent linear framework on which is stretched the membrane of the surface. Cast iron is not only displayed in the grilles and the slender window ledges, but also in the supporting horizontal beams. Horta thus adapted to an elegant town house features that make us think of riveted metal plates on cargo ships or of a factory's machine rooms. Horta was not unreceptive to this contrasting effect, as we shall see elsewhere: in the same way, he also banished all artificial decoration from his own house (plates 70, 71), such as lamps that electric blossoms and pleated frills transform into a glass bouquet; instead of this, he treated his ceiling like the

70 VICTOR HORTA *Detail of the balcony of the Horta residence, Brussels (1898–1900)*

71 VICTOR HORTA *Dining room in the Horta residence, Brussels (1898–1900)*

72 VICTOR HORTA *Solvay residence, Brussels (1895–1900)*

vault of a subway station and coated his walls with brightly glazed tiles.

In the series of private homes and public buildings which Horta built in Brussels after the *Maison Tassel,* the most outstanding is certainly the Solvay residence (*Hôtel Solvay*) on the Avenue Louise (plate 72). The swinging lines of the façade have become more ample and, while the lateral bow windows protrude, the central part seems to recede. The same movement expresses itself vertically, for instance in the gliding transition from the wall to the cornice, with its low-relief sculptured ornamentation of the soft corbels. The dominant note, however, is the impression of delicate lines and great expanses of glass. Stone, which at accentuated points is handled ornamentally, iron and its interposed membranes of glass, achieve a symbiosis seeming to live and breathe.

The interior of this house has been well preserved and was designed down to the slightest detail by the architect. It is a real masterpiece of a perfectly articulated distribution of rooms in space. From the driveway, one enters the hall "where a wonderful swelling space surrounds the visitor, warmed by a multitude of caramel and golden apricot hues."[20] Here, as everywhere, the slender metal elements are freely displayed. From these emerge ornamental ramifications which frequently end in electric chandeliers whose tufts of flower-shaped bulbs radiate light (plate 11). The broad, curving staircase, made of heavily veined marble, leads to the main floor; there, the rooms (of which the dining room, plates 73, 73a, overlooks the garden and the three drawing rooms the street) are separated only from the glass-roofed staircase by glass partitions. These partitions, some of which can be removed, consist of wooden frames, which also have a linear effect; their lower parts are set with panes of opaque colored glass or slabs of real onyx or alabaster, while their upper parts are set with transparent glass, so that the central staircase, with its translucent glass roof, is visible from all the rooms. Nothing is heavily massive or enclosed; everything remains flexible, movable, transparent. With the endless variety of its Art Nouveau lines and forms, the house, seen from the first floor, makes an overwhelming impression; the light brown tones of the rare woods, the ormolu fittings, the marble and the brocades, the ornamentation of walls and ceilings, the furniture, the paneling, and the inlaid parquet floors, even the keyholes, door handles, and hinges, all these are conceived in one style and emanate from a single movement (plates 9, 74, and 75).

True, the Art Nouveau style of the *Hôtel Solvay* is less pure than that of the *Maison Tassel.* If Gothic, Baroque, and Rococo traces had been present only in the façade of the latter, elements of Rococo, both inside and outside the entire *Hôtel Solvay,* cannot be overlooked. It was no doubt natural to design furniture, fixtures, woodwork, balconies, and banisters; in other words the whole intimate, sociable salon atmosphere of the house, in a manner reminiscent of eighteenth-century forms

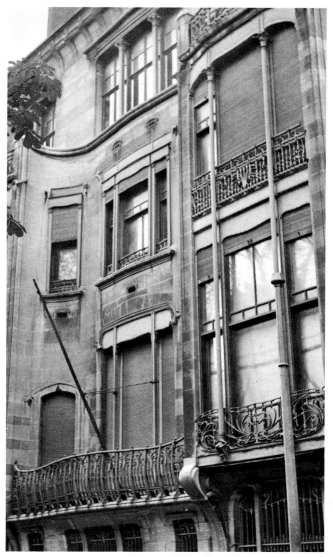

72

created for the same purposes, so that Art Nouveau, which in its beginnings with William Blake had derived its pulsating rhythm and plastic substance from the Rococo style, now reverted to the traditions of French Second Empire Rococo of the nineteenth century. But this was no longer neo-Rococo in the sense of historicism; instead, it was a new Art Nouveau Rococo which was subsequently destined to play an important part in French Art Nouveau.

The *Hôtel Solvay* was begun in 1895 and took some years to complete. Among Horta's early private homes, his *Hôtel van Eetvelde* (1897–99) and his *Hôtel Aubecq* (1900) display particularly beautiful and original glass domes. Arched above staircases and central halls, Horta's greenhouse roofs are composed of membranes of glass that remind one of the veinings on butterfly wings, a special feature of Horta's art in which the graphic effects reveal his individual conception of Art Nouveau (plate 3).

In contrast to these luxurious private mansions, Horta

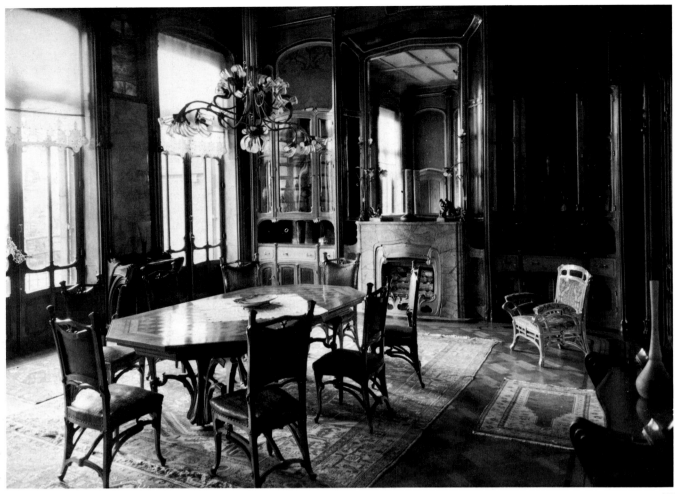

set himself a social task, practically unique in the realm of Art Nouveau, when he also built the *Maison du Peuple* (plates 76, 77). Its façade consists of an irregular succession of curves that give the building an appearance of elasticity. Built mainly on a steel frame which remains visible through great surfaces of glass, it carries out to the utmost the conception of a structure composed of a skeleton and membranes. Here, Art Nouveau is exceptionally simplified, achieving real greatness. The rhythm is embodied in the basic form of the building, its structure being in itself linear Art Nouveau. Ornamental details have lost importance; for instance in the balcony railings, the edifice is related to Rococo and, compared to Horta's early works, cannot be called original. The vertical linear metal structures are all straight and only a few horizontal undulating movements are added to the alternately concave and convex movements of the façade: in the *Maison du Peuple*, the attractive elegance of Horta's luxurious mansions has given way to harsh and rigid lines. Though all the designs for his private homes remain consistently sober, the functional quality of Horta's *Maison du Peuple* is so severe that it reminds one of the interior of a factory or the hold of a cargo ship. After ascending stairways which confirm the impression of shipbuilding, one reaches the great auditorium under the roof of the building. The columns supporting the side galleries are as graceful in form as they are necessary requirements of the construction while the railings of the balustrades hark back to Rocaille ornamentation.[21] In this linearly arranged room the walls and the side parts of the ceiling are also enclosed with glass membranes or with thin panes.

Indeed, Horta interpreted his metal structures (in the sense of Art Nouveau) as something plant-like; technology was thus conceived by him in terms of biology. After 1900, his creative energies weakened surprisingly. He then left it to others to imitate and commercialize his own style and its formulae.

73 VICTOR HORTA *Dining room in the Solvay residence, Brussels* (1895–1900)

73a VICTOR HORTA *Buffet in the dining room of the Solvay residence, Brussels* (1895–1900)

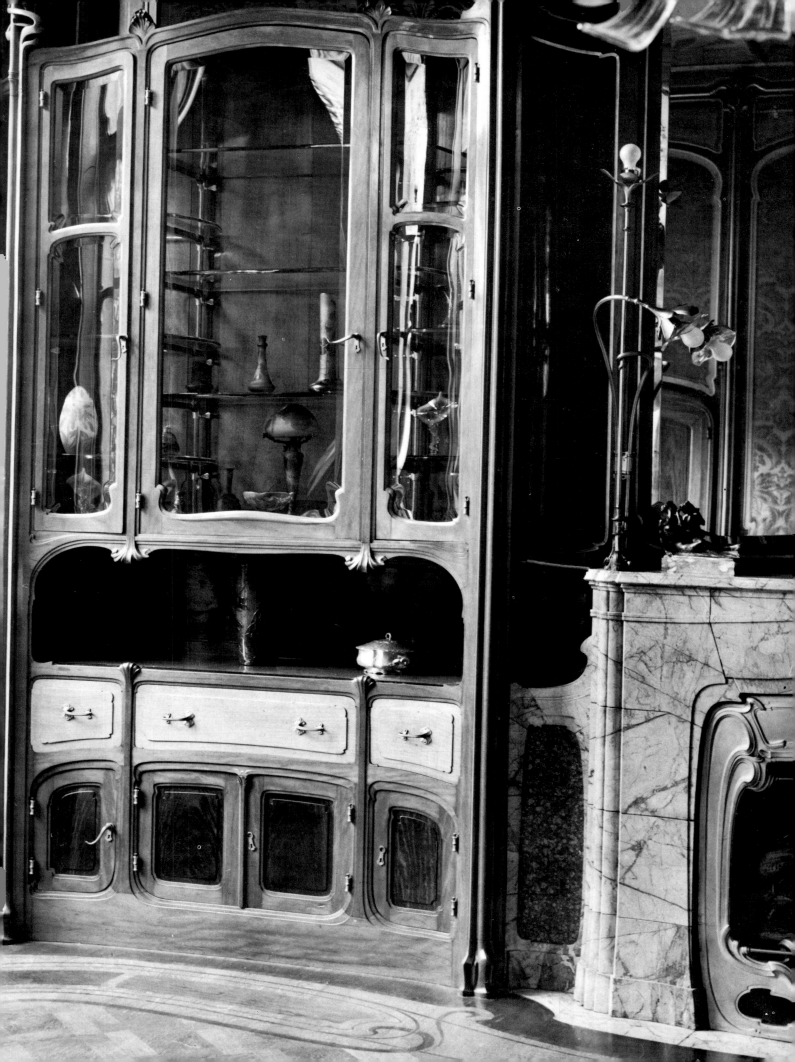

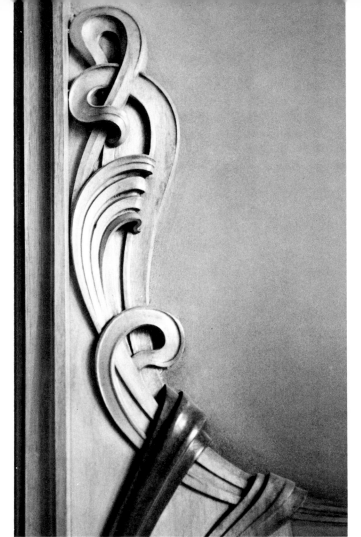

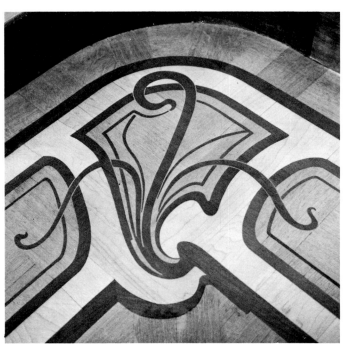

74 VICTOR HORTA *Detail of a door in the Solvay residence, Brussels (1895–1900)*

75 VICTOR HORTA *Inlaid floor in the Solvay residence, Brussels (1895–1900)*

76 VICTOR HORTA *Auditorium of the Maison du Peuple, Brussels (1896–99)*

77 VICTOR HORTA *Façade of the Maison du Peuple, Brussels (1896–99)*

74

75

76

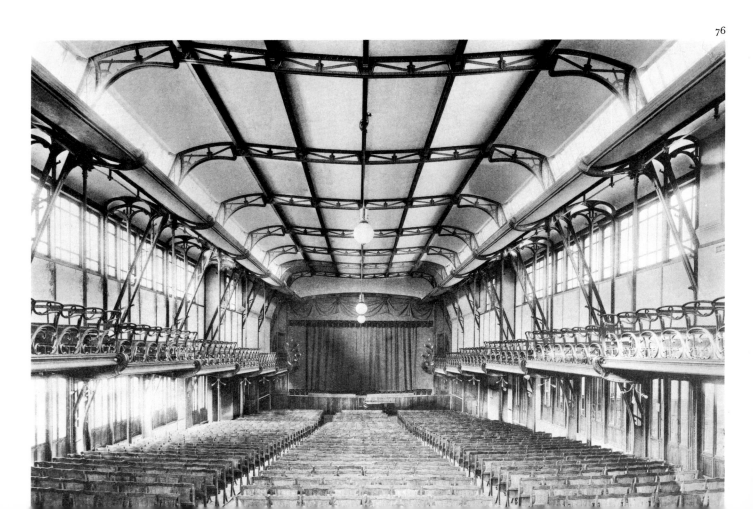

Horta's dynamic and abstract idiom, if not his suggestions of plant-like forms, can also be found in the work of Henry van de Velde (1863–1957). Van de Velde's significance lies less in his architecture than in his furniture, interior decorations, ornamental or graphic designs, and theoretical writings, in fact in his universalism. His Art Nouveau shows no trace of unassimilated historical examples of style; it is entirely based on the structure of the skeleton, as his English predecessors had, above all, developed it in their furniture. After having abandoned Post-Impressionist painting, Van de Velde turned mainly to English influences, to Ruskin, Morris, and their successors.

The Belgian artist Gustave Serrurier-Bovy (1858–1910), of Liège, was also of importance to him. Serrurier-Bovy had been among the first to be stimulated by the English movement. When the group of the *Vingt* exhibited in 1894, Serrurier-Bovy contributed a writing desk "inspired by English taste." He was also the first in Belgium to use Morris wallpapers and materials in his interior decorations (plate 78), and from these stimuli, which included England's Japanese style, he developed his own ornamental style. His furniture designs, though inspired by the Arts and Crafts movement, nevertheless strike a new Belgian note. With far greater economy of detail than Horta, Serrurier-Bovy mainly stressed the constructive element, which he revealed with scarcely any ornamental additions. Furniture in itself thus became

ornamental, by its structure, like Godwin's (plates 25, 26); but even more than the latter, Serrurier-Bovy worked with straight or curved supports which do not always exercise a structural function and often assume an independent role. The relatively simple basic form of his furniture is contained and framed by these freely developing lines.

Van de Velde seized upon such features, and his own designs are based chiefly on the conscious interplay of curved lines and empty spaces (plate 181). In one of his masterpieces, the writing desk of 1898 (plate 79), a line, sometimes swinging freely in "interlacings," leads around the whole piece of furniture, the outer edges of which are, moreover, turned inward. The impression of a closed unit is thus reinforced in spite of the numerous component parts and joints of the desk. It is also typical of Van de Velde's style, inasmuch as its dynamic symbolism and expressionism exaggeratedly stress the structural element. Much more strength than necessary has been used, quite apart from the fact that Van de Velde's principles concerning functional forms are carried out in appearance only. If one tried to write at this desk, the available space would be very restricted and one would wonder how much space is actually left for one's elbows. A strict functionality, which as such already reaches beyond the sphere of Art Nouveau, is more clearly achieved in Van de Velde's straight chairs and easy chairs, where dynamism is symbolically expressed in ornament; these chairs are linear, conceived

77

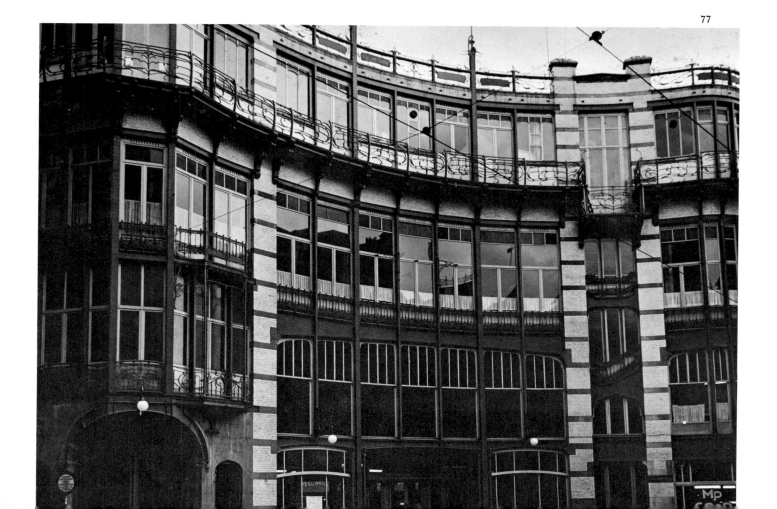

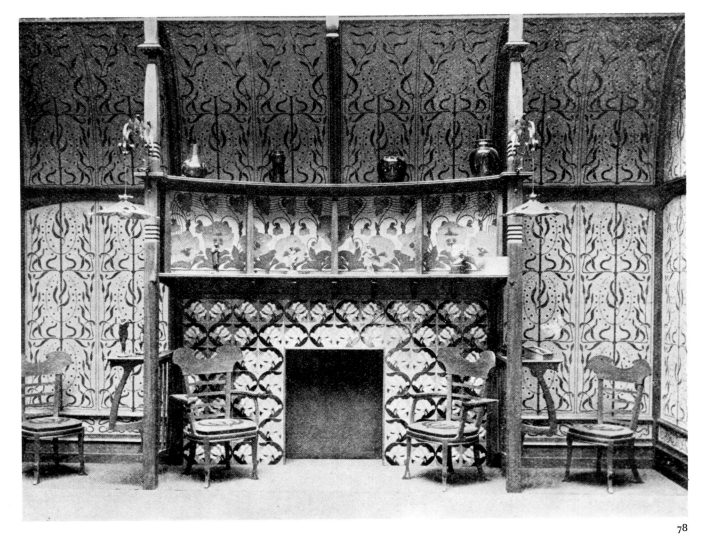

78

78 GUSTAVE SERRURIER-BOVY *Interior display for an exhibi-
tion* (between 1894 and 1898)
79 HENRY VAN DE VELDE *Desk* (1898)
80 HENRY VAN DE VELDE. *Music room in the Folkwang
Museum, Hagen* (1902)

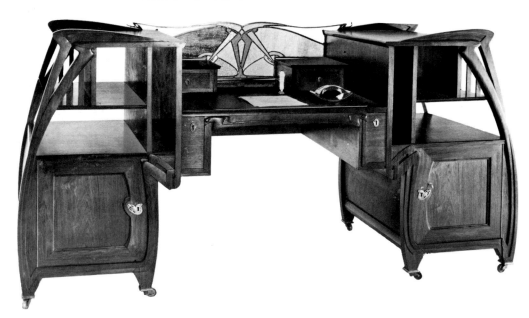

79

as a structure of lines and, in spite of a few rustic or handcrafted features, achieve a personal "functional" elegance.

The capacity for synthesis which so clearly emerges from Van de Velde's writing desk is to be felt in groupings (plate 80) as well as in the individual pieces. All his pieces of furniture seem to be dissolving into each other, as if united by walls and doors into great swinging curves. Wood is indubitably Van de Velde's most successful medium even though he also worked with metal, glass, ceramics, porcelain, and stone, and designed carpets, fabrics, wallpapers, books, and leather bookbindings (colorplates X, XI).

Van de Velde's architecture is only of secondary importance during this period. Without having been trained as an architect—as so many other excellent architects, in Germany particularly, who were first and foremost painters—he built, in 1895–96, his own house named *Bloemenwerf* in Uccle, near Brussels (plate 81). He furnished it himself with some of his best pieces, such as the chairs and table (plate 82). Every detail being of importance to him, he also designed appropriate dresses for his wife (plate 83) and went so far as to concern

himself with the color composition of the foods served: tomatoes, for instance, were served on green plates that were complementary to tomato red. S. Bing, Meier-Graefe, and Toulouse-Lautrec came to see this house and Van de Velde then created some ensembles which were shown in Bing's *L'Art Nouveau* gallery and in Dresden in 1897. In Paris, the Goncourt brothers launched the term "Yachting Style," alluding at the same time to the part played by English inspiration in this development. Van de Velde's creations met with the greatest enthusiasm in Germany; most of his patrons were Germans and, after 1899, he worked exclusively in Germany.

Just as Horta derived his three-dimensional Art Nouveau creations from flat surface-art, Van de Velde developed his own particular Art Nouveau style not only from English furniture and Serrurier-Bovy's manner. In Van de Velde's case too, Art Nouveau was originally two-dimensional. A painting dated 1893 (plate 84)—a relatively late work from the period when he was active as a painter, and which he had begun to abandon some years earlier—shows that the roots of his style lay in painting and drawing. We sense here the influence of

80

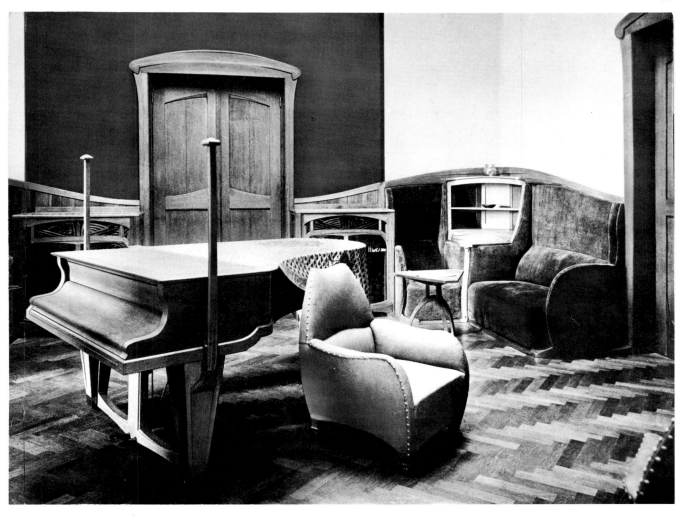

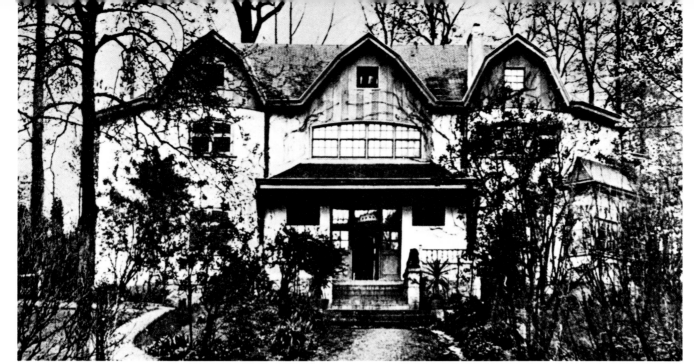

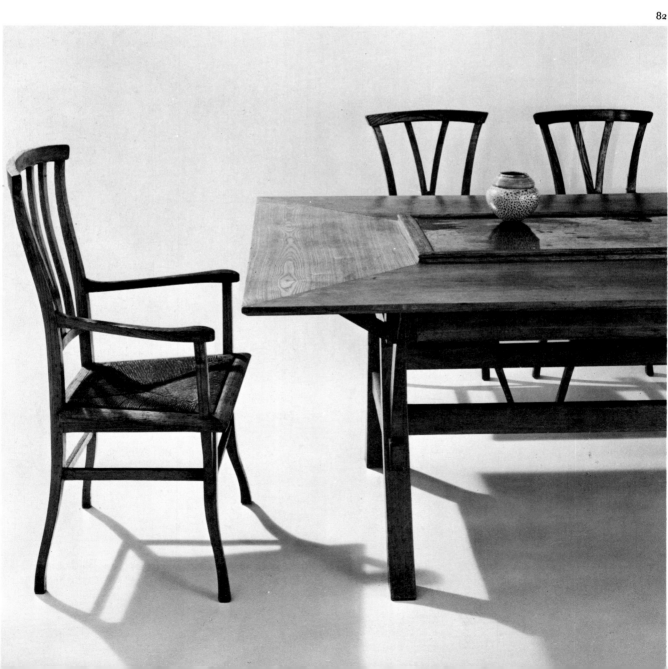

Millet, the Post-Impressionists, and, above all, Seurat. But Van de Velde translated all this into two-dimensional and almost poster-like figures that not only appear in color but are treated homogeneously according to their consistency, with concentric parallel lines in an entirely unnaturalistic manner. This theme returns in Van de Velde's subsequent *Tropon* poster of 1898, one of the best posters of Art Nouveau and certainly its best abstraction (colorplate XII).

Georges Minne

Among Belgian Art Nouveau artists, Victor Horta represented the French ethnic or cultural element and was thus the one to whom Paris was the most receptive. Van de Velde, the conscientious craftsman, with his honest work, his dynamic expressionism, his systematic theories propounded with a certain heaviness and lack of charm, was bound to appeal more to the Germans. Georges Minne (1866–1941) was of Flemish origin; in his work, the proximity of Holland is most strongly felt, reminding one clearly of Toorop, with whose art Minne was certainly acquainted.

As far as compactness, narrow shaft-like figures, and sensitive rhythm are concerned, Minne was probably the purest sculptural artist of Art Nouveau. The human body, particularly that of youths, is his one and only theme. As Meier-Graefe expressed it so rightly in *Pan*, human bodies transformed themselves for Minne into plastic ornaments. Basing his conception of form on Gothic art, Minne stylized his overslender, introverted, and austere youths and maidens who seem consumed by some extreme inward grief. One of his most outstanding achievements is the fountain designed by him in 1898, with five naked boys kneeling on the pool's edge; this design, slightly modified, was carried out for the Folkwang Museum (plate 85). As a composition, it shows very clearly that even as a sculptor Minne is exclusively concerned with the outline. The ornamental element of the forms, which are both expressive and symbolical, cannot be overlooked. Through the fivefold repetition of the same figure, an "infinite regress" is suggested which, in the circle round the fountain's edge, returns ceaselessly to itself.

Not only Gothic art, but Rodin too exerted an influence on Minne. "What attracted him in Rodin's work was its amazing faculty of expression combined with a very summary treatment, the gift . . . of creating life through movement, through a very arbitrary but most purposeful and even profoundly calculated arrangement of the limbs which, with all its audacity, may have been the imperative desire to find an artistic language of its own. No wonder that all this attracted an artist struggling to express rhythm." There is much that Minne borrowed from Rodin. "The budding effect, inherent in Rodin's marble, can also be found in Minne's figures of youths; the poetic character of still undeveloped limbs, the suppleness of flawless flesh. But any notion of sensuality is excluded here; the perverseness sometimes

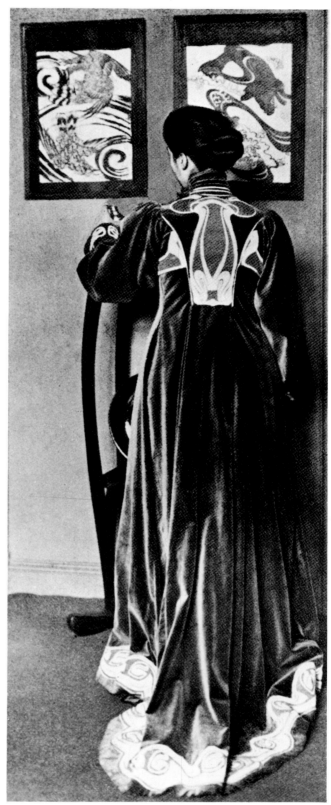

83

81 HENRY VAN DE VELDE *Bloemenwerf residence, Uccle, near Brussels* (1895–96)
82 HENRY VAN DE VELDE *Dining room furniture* (1895)
83 HENRY VAN DE VELDE *Woman's dress* (circa 1896)

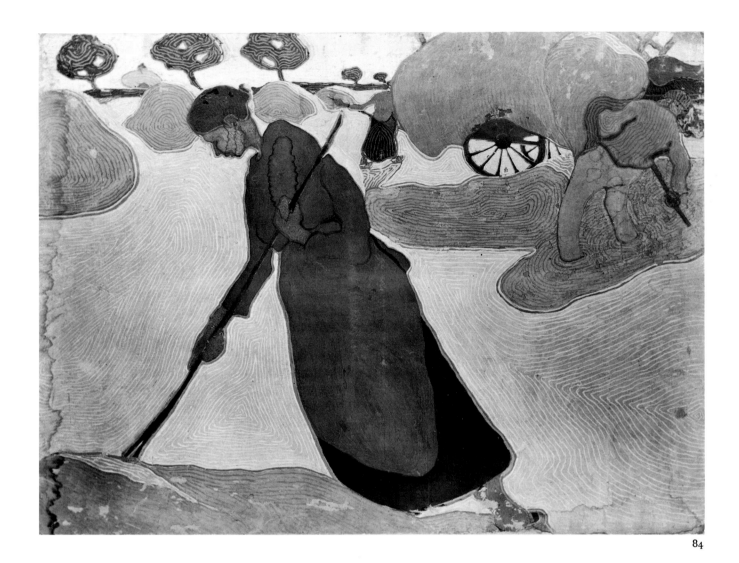

84

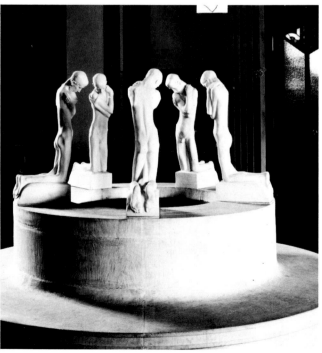

suggested in Rodin's work is considered too complex by Minne—or not sufficiently differentiated.''

Minne's graphic work is also of importance (plate 86). He illustrated Maeterlinck's volume of poems *Serres chaudes* (plate 87); this early drawing of 1890, ''with which the periodical *Van Nu en Straks* (which was great within its limitations) introduced the artist to a very small circle of art lovers, and also revealed the future master.'' In this drawing, the flowing diagonal and the asymmetry of the whole group are particularly characteristic of Art Nouveau.

After 1886, not only did Minne exhibit with the *Vingt* in Brussels, but he was also one of the members of the first exhibition held in the *Art Nouveau* gallery in Paris in the winter of 1895–96. A model of his fountain, which may be regarded as the culminating point of his creative art, was exhibited by the *Libre Esthétique* group which then succeeded the *Vingt*.

84 HENRY VAN DE VELDE *Haymaking (circa* 1893)
85 GEORGES MINNE *Fountain with five kneeling boys* (1898–1906)

85

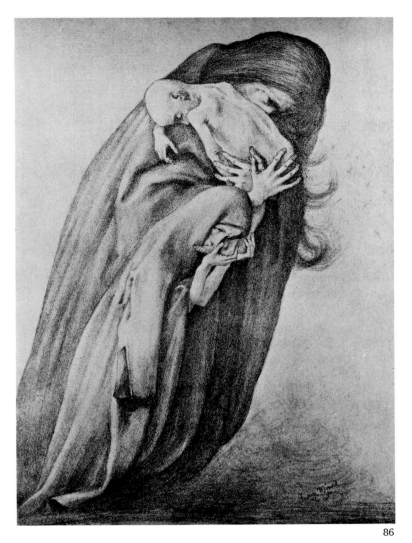

86 GEORGES MINNE *Drawing* (1890)
87 GEORGES MINNE *Illustration for Maurice Maeterlinck's "Serres chaudes"* (1889)

86 87

Fernand Khnopff

The world of Fernand Khnopff (1858–1921) is entirely different. To a certain extent, his forms anticipated those of the late Art Nouveau of Glasgow and Vienna, although his Symbolist painting and his decorative graphic art began to develop early in the eighties. His personal style was formulated in the painting, *L'Art,* of 1884, representing a youth before a crouching sphinx. The Pre-Raphaelite feminine type, with its tall slender figure, angular profile, sensual lips, heavy chin, and sea-green eyes, recurs in many of his drawings. He was indeed so powerfully impressed by the paintings of Rossetti and Burne-Jones which were exhibited at the World Exhibition of 1878 that their work, together with that of Gustave Moreau, became the foundation for his own future creations. Khnopff frequently gave his pictures English titles such as *I Lock My Door Upon Myself,* of 1891 (plate 88), or *Britomart and Acrasia* (1892). In his house, which he furnished entirely according to his own very unusual taste, there was an empty room with walls covered with Japanese brocade in which were set two bronze rings engraved with the names of Burne-Jones and Moreau.

In the interior of this house, where no Art Nouveau curves are to be found, Japanese influences make themselves strongly felt in the simplicity and the utter bareness of the rooms. Confined to the rectilinear and rectangular in every detail, the inside of the house is formed of box-like chambers, long corridors, and asymmetrically displaced passages. The same Japanese influence shows also in the lettering and typography created by Khnopff, who was a member of the *Vingt,* for the first catalogue of their exhibition of 1884. Art Nouveau elements are revealed in their purest form in Khnopff's graphic work, in his designs for bookplates (plate 89), book illustrations, and title pages, all of which are important fields of his activity as an artist.

It was not merely by chance that Khnopff, who was an excellent writer on art, should have written about the personality and the work of the Viennese architect, Hoffmann. Outside of Belgium, Khnopff was first and best understood in Vienna and, in 1898, the first year of publication of the periodical *Ver Sacrum,* a special number was devoted to the Belgian painter. "Fernand Khnopff, in his paintings, wishes to turn away from everyday life, from the present, and invokes the deepest

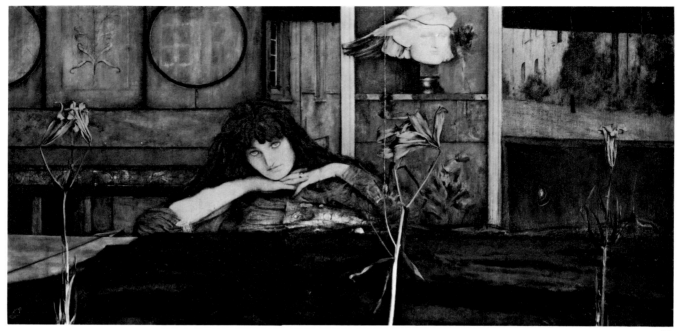

88

feelings, reminders of eternity. When we see his motion-less calm figures, we think of Maeterlinck, from whose poems Khnopff often borrowed themes, or of Hof-mannsthal . . . Like this poet, he is a painter of inner life. The words of William Blake, the painter-poet, apply to these figures too: 'I am only the secretary, the authors are in eternity.' Khnopff too seems to note what is dictated to him by the secret voices of eternity."[22]

HOLLAND

Entirely different from the Belgian style which bears the mark of Victor Horta, the Dutch version of Art Nouveau mainly reveals a character of austere reserve, with no sign of Rocaille or of an aristocratic drawing-room atmo-sphere. As in England, whence the Arts and Crafts movement had influenced Dutch furniture and utensils, all forms and techniques of historicism, with the latter's relationship to an aristocratic style of living that was decisive both for Horta and for the Parisian artists, were abandoned in Holland. The style of Holland, like that of other Nordic countries, is consciously middle-class. With the exception of the eloquent, somber, unadorned but grandiose Amsterdam Stock Exchange, Dutch interiors and objects in *Jugendstil* often seem *petit bourgeois,* laconic, intimate, craftsmanlike, all of which, strange to say, does not exclude an exotic, Javanese, and sultry atmosphere.

Jan Toorop

Jan Toorop (1858–1928), the most important Dutch creator of form of his period, developed, however, an unmistakably Dutch style of Art Nouveau to unrivaled heights of poetic intensity. Beginning toward the end

88 FERNAND KHNOPFF *I Lock My Door Upon Myself* (1891)
89 FERNAND KHNOPFF *"On n'a que soi," bookplate* (1898)
90 JAN TOOROP *Sketch for "The Three Brides"* (1892)
91 JAN TOOROP *Song of the Times* (1893)

89

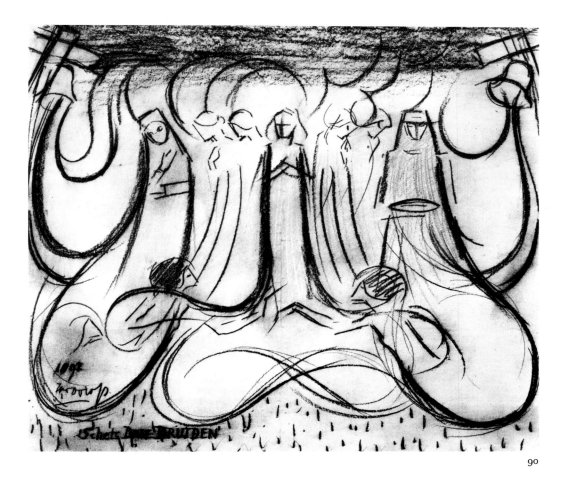

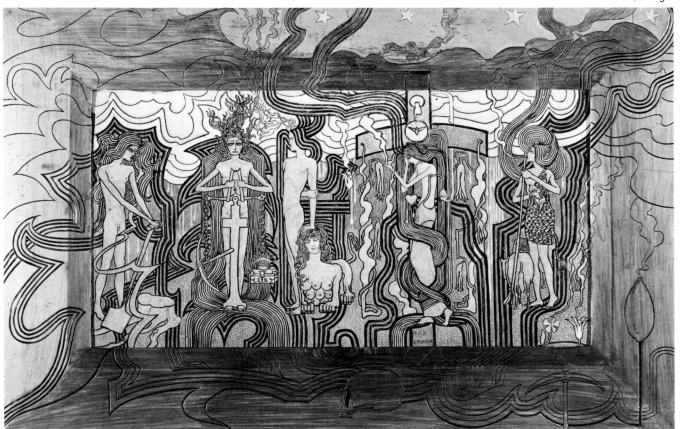

of the eighties and under the influence of the Belgian poet Maeterlinck, Toorop turned toward Symbolism, though his technique of painting remained Post-Impressionist. Contemporary with his Symbolist drawings, there are also Post-Impressionist pictures which he painted throughout the nineties: bridges, interiors, the sea, and dunes that are certainly related to the pointillistic art of Seurat and Signac, but not at all to Art Nouveau. This splitting of his artistic personality as both an Impressionist painter and a Symbolist draftsman reveals, even more clearly than in the case of Toulouse-Lautrec or Khnopff, that it was primarily through his graphic work that Toorop was connected with Art Nouveau. Even though there existed genuinely Art Nouveau painters like Hodler, Munch, and Klimt, oil painting, always independent and isolated, remained on the whole inaccessible to Art Nouveau. From its beginnings with William Blake, graphic art had always been more in tune with the aspirations that characterize Art Nouveau, because design is closer to poetry and more abstract by nature, following thought more freely.

In 1891, Toorop's mystic style appears fully developed in the design *Decline of Faith,* a work of hermetic content which reason alone cannot easily explain, just as it is impossible to disentangle the confusion of emaciated limbs and heads of every size, with faces sometimes doll-like, sometimes frighteningly expressive and almost demented. Inextricably entwined as in Celtic line ornaments or Irish book illuminations, a comparatively homogeneous pattern is achieved here, a structure of long narrow forms of heterogeneous significance: gun barrels with bayonets, a bell, a rope, a piece of Gothic architecture, and, everywhere, bodies with limbs as soft as amoebae or as rigid as bones.

In 1893, the first issue of *The Studio* reproduced Toorop's *The Three Brides,* a painting which probably exerted an influence as far as Glasgow, where Mackintosh and the Macdonald sisters were developing their not unrelated style. This "strange, fantastic, sibylline work," as *The Studio* called it, shows, between the Bride of Christ on the left and the courtesan on the right (the Good and the Evil of eroticism), the veiled "human bride," swathed in roses and their fragrance, surrounded by hosts of disembodied beings, by swinging bells, visible waves of sound, masses of flowing locks, lilies, butterflies, and thorns. Yet the picture is conceived as an arabesque; it can even be proved that this ornament, in this case symmetrical, had served as the starting point for the painting; on account of its almost abstract design, one of the first drafts (plate 90) can be considered as a sort of shorthand or notation for choreography. In a typical Art Nouveau spirit, Toorop, so Ricketts tells us, designed an almost abstract ornament, a kind of formal "vessel" which only later was filled with figurative elements that explained its meaning and translated it into terms of concrete illustration. The incorporeal phantoms, such as the figures in the foreground, retain the character of an ornament.

But what is most amazing are the strands of hair arranged in parallel bands, which come flowing out of bells. No other artist of Art Nouveau in which, in addition to swans and lilies, feminine hair plays such an important part, has paraphrased with so much imagination a motif that, as so much else in Toorop's art, was borrowed from Rossetti. In related Romantic and Symbolist poetry, we find the same fascination for women's hair everywhere, in poems by Rossetti and Baudelaire, in Mallarmé's *Hérodias*—"to live in the horror that I feel for my hair"—up to the hair fetishism in Maeterlinck's *Pelléas et Mélisande,* or in Wilde's *Salome*:". . . It is thy hair that I am enamored of, Jokanaan . . . the long black nights, when the moon hides her face, when the stars are afraid, are not so black as thy hair. The silence that dwells in the forest is not so black. There is nothing in the world that is so black as thy hair. . . ."

Bundles of lines of a similar nature as those in *The Three Brides* stress the single, hieroglyphic forms in Toorop's *Song of Times* of 1893 (plate 91), and give to the entire work a consistency of wickerwork, parts of which seem to be almost geometrical. But, more than that, abstract rhythms invade the picture frame itself, together with lines which designate objects. Like *The Three Brides,* this picture, drawn on brown paper with pencil, charcoal, and chalk highlights, finds its continuation in the frame. With Toorop, the frame is indeed part of the painting and becomes a "field of approach" in which the black lines, emerging from brown and white, green and orange, change over to a golden ground and appear in relief. Frame and painting grow into an undivided whole, the frame being drawn into the picture as the imaginary closed-in world of the picture also extends to the objective reality of the frame and thus into the reality of daily life. One feels here an attempt to achieve a complete work of art and to "transpose into ornament," as far as this is possible, the shapes of life, even of daily life itself.

92

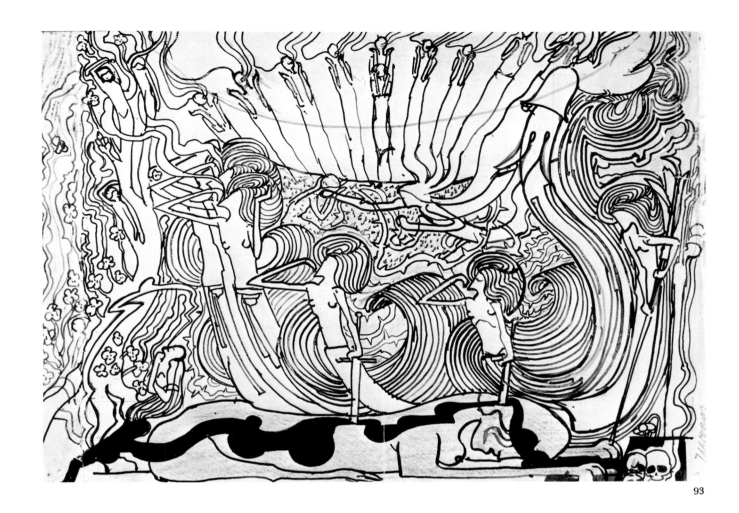

But, besides thus crossing aesthetic frontiers, Art Nouveau always strives toward a strictly defined technique, toward stressing flatness as such in the two-dimensional, in fact toward precision of line and sharp delimitation of two-dimensional bodies. Every trace of plastic form, of the illusion of space, of light and shadow, every hint of a material surface and its attractions is abolished. With great restraint in the handling of form and with strict homogeneity, as well as with an ascetic use of color, Toorop brings his style to the point of perfection. In his vignette for the periodical *Van Nu en Straks* (plate 92), condensed and concise as a signature, a great economy of expression appears. The black two-dimensional body of the filled space, together with the little dots, is related to the forms used by Beardsley (plate 128). Toorop had much in common with this English artist, for instance the "grain" of hair (plate 93), like that of wood; by 1893 at the latest, he must have known Beardsley's work. Both Toorop and Beardsley expressed the purest linear Art Nouveau, and the *morbidezza* style is typical for both

92 JAN TOOROP *Vignette from "Van Nu en Straks"* (1893)
93 JAN TOOROP *Preliminary study for "The Three Brides"* (1891 or 1892)

of them. In spite of all their renunciation of space, gravity, plasticity, and stability, there is in Toorop's art nothing of Beardsley's elegant impudence, erotic arrogance, and irony, nor of the dandy's pose. In spite of the graceful and delicate element in his work, Toorop's art is laden with seriousness and meaning, and is thereby more closely related to German *Jugendstil*, which said of itself: "And soulfulness oozes out of every corner."[23]

Toorop's "mystic style" is founded upon a variety of inspirations. The first eleven years of his life had been spent in Java; the influence of these surroundings is clear enough in his art. The little figures, derived from Javanese shadow puppets, seem to glide stiffly along the wavy lines of his paintings and to fill them with their gracefully affected gestures and their somewhat remote daintiness. Not only for Toorop, but for the entire Dutch *Jugendstil*, Java partially assumed the role that Japan had played elsewhere in Art Nouveau. True, the sleek contours of Japanese woodcuts appear also in the Netherlands and, most of all, in Toorop's work. But we also find here a particular Dutch feature: the rhythm of the pointed arch, a more rigid structure, and the lace-like interior pattern of Javanese shadow-play puppets. This may be seen, for instance, in the nonfigurative ornamentation of

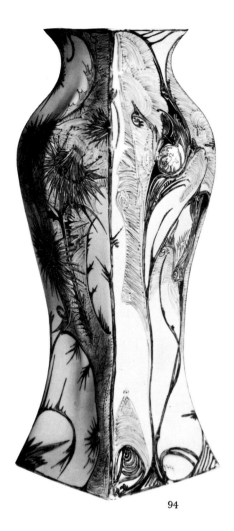

94

94 J. JURRIAAN KOK and J. W. VAN ROSSEM *Vase (circa 1900)*

95 CHRISTOPHE KAREL DE NERÉE TOT BABBERICH *Benediction* (before 1909)

96 JAN TOOROP *Under the Willows* (n.d.)

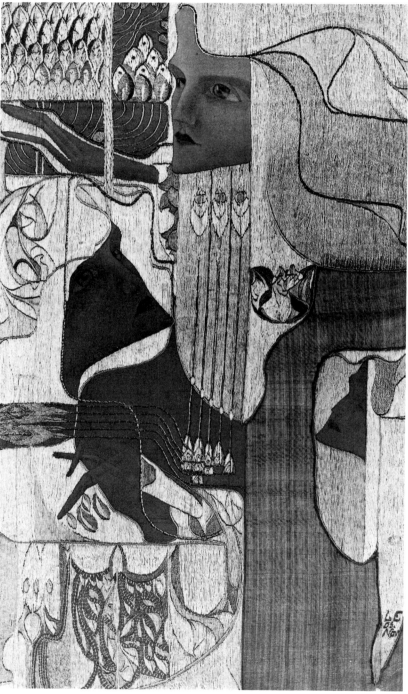

95

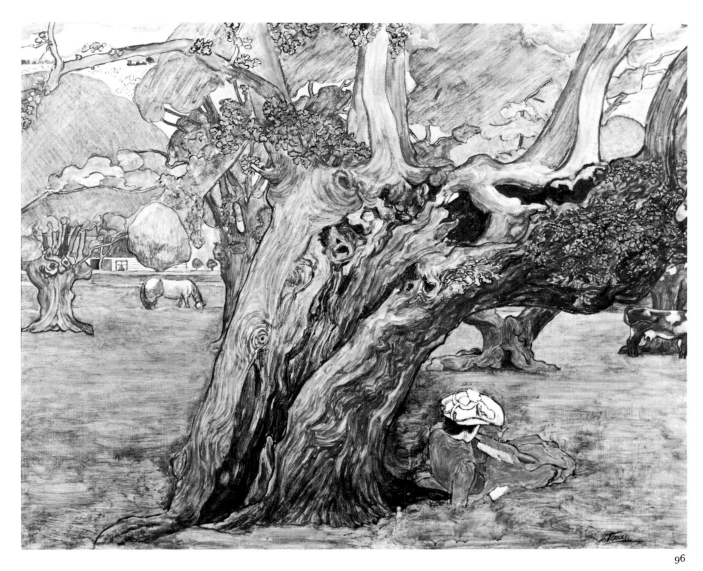

delicate, beautiful vases such as the Rosenburg firm produced in porcelain as thin as paper (plate 94).

Toorop lived in Holland but maintained close connections with Brussels where, after 1887, he was a member of the *Vingt* group. When he turned to Symbolism, he borrowed some of Fernand Khnopff's fantastic forms (plate 88); indeed, the latter's sensitive but heavy-chinned faces appear here and there in Toorop's early pictures. But what probably appealed to him most were Minne's woeful figures (plate 86). However, Toorop's closest connections were with England. Like Khnopff and Obrist, Toorop also had a British mother. In 1884, when he went to London for the first time, he met his future wife, an Irish girl who (as a spiritual dowry) brought him the "Celtic" element. Between 1885 and 1889 he spent his time partly in Brussels and partly in London, and was thus able to study at firsthand what interested him in the Pre-Raphaelite tradition.

He borrowed from Rossetti the idea of the frieze of juxtaposed figures (plate 44) which fills the background in *The Three Brides*. The strange motif of the thorny scrub covering the ground in the same picture appears in Rossetti's watercolor *St. George* of 1851. The typical, concave half-profile of the Pre-Raphaelite maiden with her dreamy eyes and protruding chin, who is leaning her head against that of the knight, appears in threefold repetition in a piece of Dutch appliquéd embroidery designed by Nerée tot Babberich (plate 95). But as these features were the common property of the entire Pre-Raphaelite school it need not necessarily have been borrowed from any particular work of Rossetti. The style of this embroidery already belongs to Late Art Nouveau, the only phase of Art Nouveau to exist in Holland, and shows a very close relationship to Klimt (plate 242, colorplate XIII). This proves anew the importance of Rossetti's invention of crowding the picture surface with abstract ornamental details so as to produce a surface with an irregular pattern like that of marquetry work, which could easily be developed for entirely ornamental effects. In the ornamental surfaces of works by Nerée tot Babberich and Klimt, only hands and faces stand out with three-dimensional reality, as in Russian icons, where the hands and faces alone stand out from the surrounding covering of precious metals.

We can trace the sources of Toorop's art even further back, and Nikolaus Pevsner has suggested its possible origins in Blake.[24] Indeed, it seems most unlikely that Toorop, with his ribbons of soaring genii, his ornaments of stylized and immaterial figures, his symmetrical structures, and his frames that extend and paraphrase the picture (plate 91, colorplate XIV), should have been unacquainted with Blake's similar ideas (plate 49, colorplate XV). If Charles Doudelet in Belgium took over certain motifs, which could only stem from Blake, in such a literal way that we might be entitled to substitute visible proof for literary evidence, this would be even more legitimate for Toorop.

But what could French Art Nouveau offer to Toorop? At any rate, Brussels and the exhibition of the *Vingt* allowed him to discover Gauguin's art and to enter into its spirit, as is revealed in a work (plate 96) in the Amsterdam Stedelijk Museum. In a less sophisticated way, the style and themes of Pont-Aven reappear in this Toorop painting: the landscape background is created of superimposed planes with only a minute piece of sky, the ornamental interweavings of trunks and branches of trees, the reclining female figure whose hat is a variation of Breton peasant women's winged bonnets, the stressed contours, and the homogeneous planes of color.

But there is no doubt that Toorop, in his "mystic style," preferred English examples, though he was also addicted to French Pointillism. Toorop's world was one where reality played no part in the content of the picture, but where figures and symbols were refined instead by eclectic tradition. Blake's visionary creations, Rossetti's artificiality, and the decorative graphic manner of early High Art Nouveau in London were much more suitable as sources for the somewhat schematic appearance of the ghost-like apparitions of Toorop's nostalgic inner visions.

Johan Thorn Prikker

Another outstanding painter of Dutch *Jugendstil* was Johan Thorn Prikker (1868–1932). Like Van de Velde, Van Rysselberghe, Lemmen, and Finch in Belgium, Prikker also began as a Post-Impressionist and, inspired by Maeterlinck's and Verhaeren's poetry, developed Symbolist and Christian themes first in easel painting, then in murals. Once again, Japanese woodcuts (not Javanese shadow puppets as in Toorop's case) were a decisive influence. In addition, we are conscious of those French paintings closely related to Art Nouveau, particularly of Gauguin's art that aims at a synthesis. Thorn Prikker's style, compared to that of Toorop, thus seems more generous in form and contour, more spacious, and more monumental. In spite of its flatness, his painting, like Gauguin's, displays a compact quality, a solidity, and density of color. But his unnatural colors, with their intense brilliance, lack the glow of Gauguin's pure pigments. *De Bruid* (*The Bride*, plate 97) glimmers in soft blue-green, mauve, and gray; her veiled figure,

strangely metamorphosed, appears as a tall, shaft-like, closed silhouette. Next to her, similarly lacking joints or limbs, supple and stylized, all but distorted, the crucified Christ is seen, His crown of thorns mingling with her myrtle wreath. The half-averted faces are featureless. The main figures of the picture, enveloped by a whirlwind of lasso-like lines and almost unidentifiable, retire into the world of forms that surrounds them—one of Rossetti's devices—composing with it a sort of flat marquetry with an irregular pattern in which the detailed forms are sharply juxtaposed and vigorously outlined. In the upper left-hand corner, slender, vertical shapes predominate, like icicles or wax tapers, whereas at the bottom we see large rounded oval forms of sturdy buds intermixed with bunches of white orchids, vaguely recalling skulls. The crucified Christ and the Bride, Death and Life, are thus transposed as ornamental emblems which lend themselves to a variety of symbolical interpretations.

Since 1904, Thorn Prikker had lived, taught, and worked mainly in Germany. But even when he was still living in Holland, he had not limited his artistic activity to painting; like Van de Velde, in Uccle, and the German *Jugendstil* artists, most of whom had started as painters, Thorn Prikker likewise took an active part in the applied arts and "decorated the interiors of houses and shops, thereby simplifying Van de Velde's style in his own individualistic manner." Besides, Thorn Prikker also designed fabrics and wallpapers which sought their inspiration in the batik techniques of the East Indies.

Ornamentation inspired by batik is a special feature of Dutch Art Nouveau, which is altogether influenced to a great extent by Javanese art (plate 98). The East Indies had belonged to the Netherlands ever since 1596, but their art was only now being discovered. Java was thus for Holland what Japan had been for London and Paris, a source of inspiration that helped achieve clarity in the struggle for liberation from historicism. But, contrasting with the perfection and discipline of Japanese art, with its subtle simplicity and voluptuous asceticism, there emanated from Java a heavy, exotic atmosphere of the jungle that actually produced some rare samples of High Art Nouveau in Holland. This exotic Indonesian influence made itself felt almost exclusively in ornament and surface patterns. Beginning in 1886, T. A. C. Colenbrander (1841–1930) thus created objects inspired by batik work; he applied these forms, originally designed for textiles, to ceramics (plate 99). Dutch books, designed and illustrated according to principles of *Jugendstil*, also offered examples of batik ornaments; for instance in the vignettes by the architect and book designer, Van Bazel. In other respects, Dutch book design remained very much influenced by English examples. A Dutch adaption of Walter Crane's *Claims of Decorative Art*, for instance, was decorated by Gerrit Willem Dijsselhof (1866–1924).

97 JOHAN THORN PRIKKER *De Bruid* (1892–93)

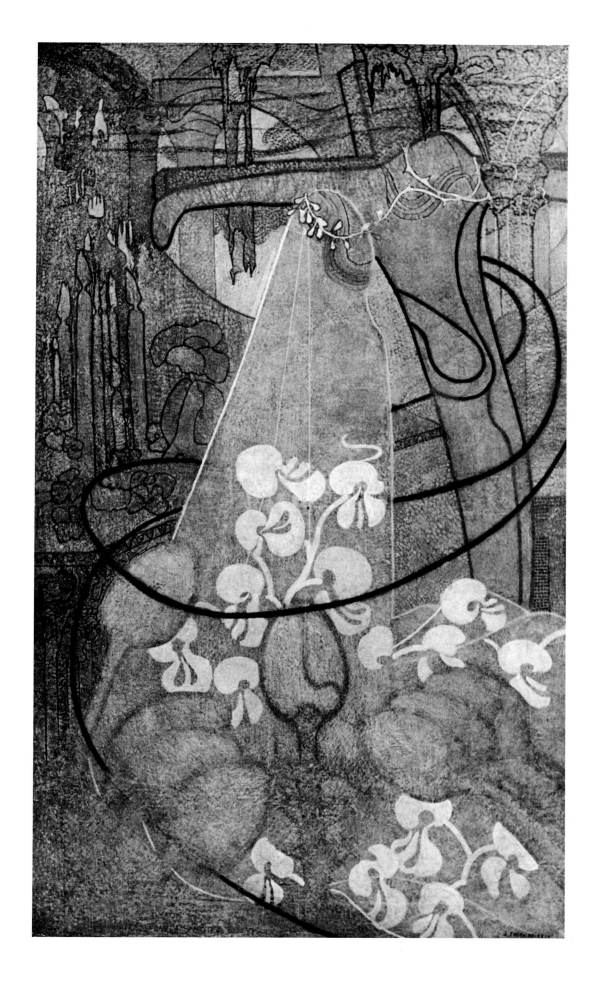

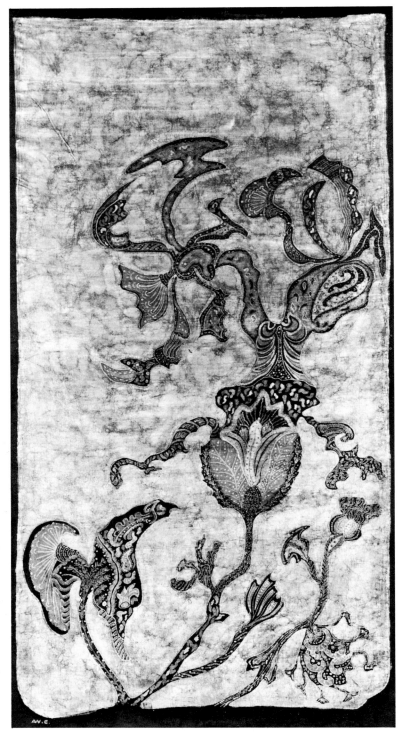

98

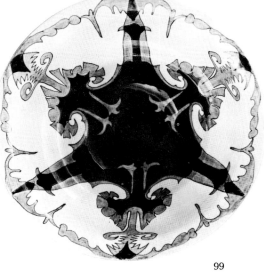

98 AGATHA WEGERIF-GRAVESTEYN *Wall hanging (circa 1900)*
99 THEODORUS A. C. COLENBRANDER *Bowl* (1886)
100 GERRIT WILLEM DIJSSELHOF *Dijsselhof room* (1890–92)

99

The *Dijsselhofkamer* designed by Dijsselhof for a private house is generally considered a masterpiece of Dutch *Jugendstil* (plate 100). The walls above the wood paneling were covered with canvas and decorated with airy yet somewhat rigid patterns of birds and plants which again were carried out in batik work. The result of this was a sort of *Peacock Room* in miniature, a room which in itself was a total masterpiece of decorative art. But Whistler's princely *Peacock Room* (colorplate IV) had now shrunk to the proportions of a middle-class Dutch *hausfrau's* front parlor, the furniture of which stresses modesty and craftsmanship, in the spirit of the Art and Crafts movement; indeed, only with a large amount of charity can it be described as Art Nouveau.

A few pieces of furniture designed by the architect Hendrik Petrus Berlage (1856–1934), one of the strongest personalities in Dutch art around 1900, are more powerfully individual and of greater artistic significance. The style of his little writing desk (plate 101), so charmingly sedate with its precise, closed, box-like form, stands midway between Godwin (plate 25) and late Art Nouveau (plate 234), but without in the least belonging to High Art Nouveau as exemplified by Gaudí, Guimard, Horta, and Van de Velde. Straight lines, right angles, and a structure founded on the idea of a framework for surfaces stretched over it like membranes also appeared in folding screens which originally came from Japan but soon became very typical of Dutch *Jugendstil*, though their unsurpassed prototype had been created by Mackmurdo (plate 54). Another peculiarity of Dutch Art Nouveau was a preference for beautiful or semiprecious metals, especially fine brass, out of which utensils and ornamental vases of sober form were fashioned. Flowers, as ornamental patterns, are but rarely seen in Dutch Art Nouveau, perhaps because they appear in such profusion in Holland's gardens and fields.

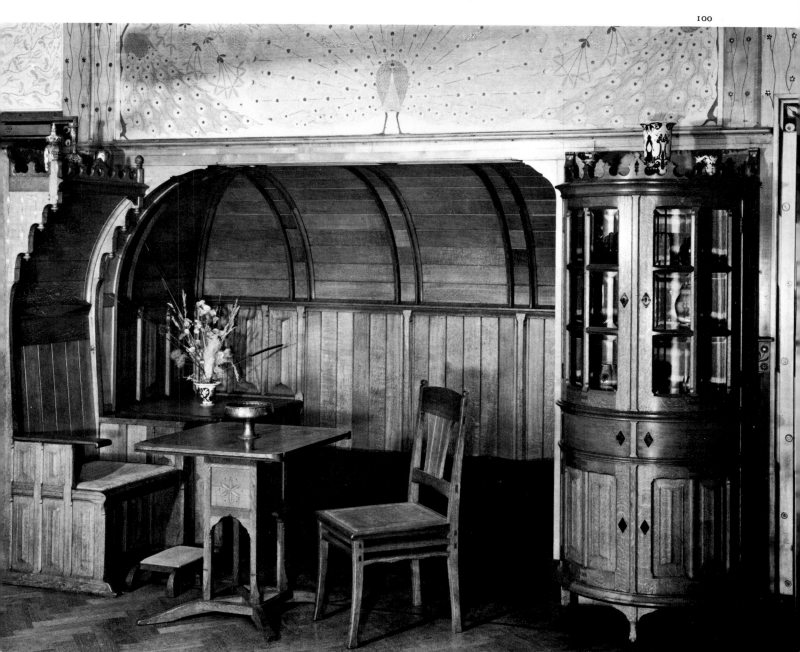

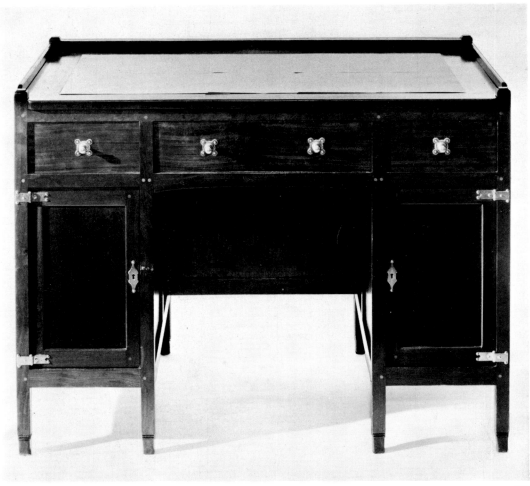

Hendrik Petrus Berlage

The Amsterdam Stock Exchange, built by Berlage (plates 102, 103), is a work of considerable greatness, not devoid of humanity in spite of its severity. Geometrical in its design, its style is closely allied to that of High Art Nouveau in other countries. Berlage was mainly concerned here with problems of architecture as sheer construction and with its aesthetic expression. His villa at Bussum (1893) had already displayed a simplicity and functionalism which are entirely based on purpose and construction, features that could be found elsewhere only in Norman Shaw's or Voysey's work in England. The Amsterdam Stock Exchange was built between 1898 and 1903, after a number of various preliminary designs in historical styles which date back as far as 1897. Despite some distinct reminders of the Middle Ages and, above all, of Romanesque, the building almost entirely lacks the pomp of these styles. In the compact, but nevertheless large, form of its mass, with its bare surfaces, its precisely placed tower, which assumes strange and even exaggerated proportions due to its tiny double windows, and the great loggia of its top floor, we see a building of clean and firm lines, free of all unnecessary ornament.

The methods of the construction, consisting of massive brick walls with steel supports for the roof, are relatively conservative, compared for instance to those of Horta's *Maison du Peuple*, which dates from the same period. Like his English colleagues, Berlage did not wish to break with the past; his intention was to free himself from the dishonesty of historicism and its masquerading. In his writings of 1895 and 1896, Berlage advises architects not to think of existing styles when designing plans for buildings. Only then, he says, can one achieve a true architecture which he qualifies as "pure functional art." Berlage was thus one of the few who not only considered that an ethical attitude in architecture was necessary but also (like Philip Webb in the *Red House* he built for Morris) actually fulfilled his demands for a purified architecture. In the main hall of the Amsterdam Stock Exchange, the construction of the roof is freely revealed. Between the glass roof with its iron framework and the supporting brick walls no illusion of synthesis is created; there is here nothing but an undisguised juxtaposition.

The character of surface is stressed in the brick walls of the hall. The architectonic components are indeed distinguished by the use of different materials: granite

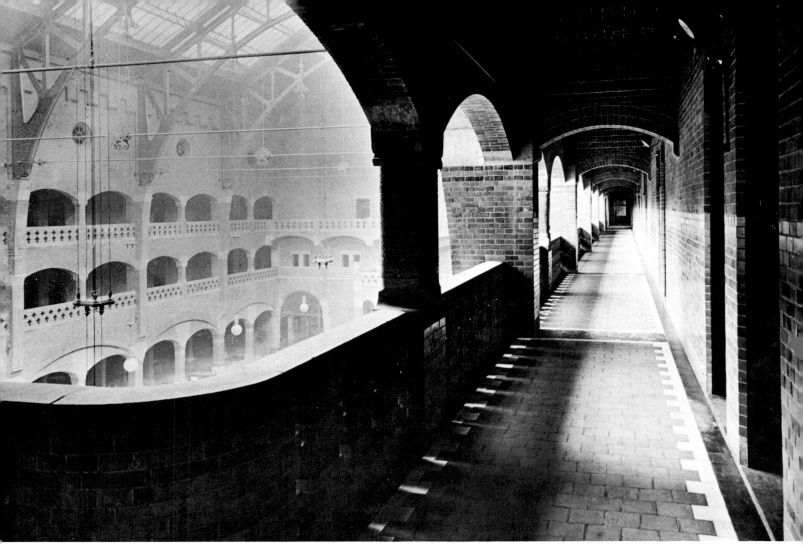

101 HENDRIK PETRUS BERLAGE *Desk (circa 1900)*
102 HENDRIK PETRUS BERLAGE *Great Hall of the Stock Exchange, Amsterdam* (1898–1903)
103 HENDRIK PETRUS BERLAGE *Stock Exchange, Amsterdam* (1898–1903)

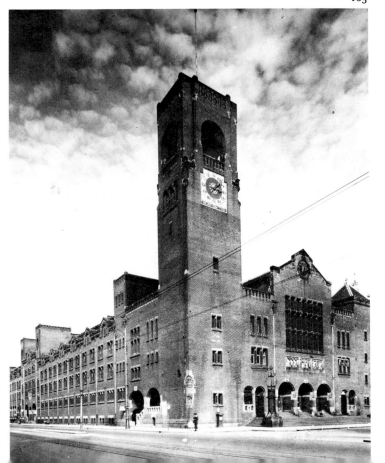

for the compact pillars and light-colored quarried stone for the capitals. But no sculptural effects are attempted here. The arcades seem to be cut out of the wall, their segmental arcs fitting closely into it. Not even the capitals of the columns protrude; they seem to be "cut off with a razor blade."[25] One thus gains the impression, so typical of Art Nouveau, of the "cutout form." Wide brick balustrades of the balconies achieve the same effects of sheer surface: as decoration, they truly produce empty spaces which, as negative contrasting forms, alternate with positive forms. When he lectured on style in architecture in 1905, Berlage said: "We must, above all, show the naked wall in all its smooth beauty . . . pillars and columns must bear no protruding capitals; the joints and nodal points must melt into the flat surface of the wall."

Dutch Art Nouveau is content with two dimensions, even in buildings and houses which, although appearing as three-dimensional cubes, are combined of seemingly two-dimensional planes. Except in ceramics, Dutch Art Nouveau created no bodies or spatial figures in curved lines and practically no sculpture of real importance. Inspired by the English style in its conceptions of structure, and by Javanese ornaments, Holland pro-

duced a highly individual Art Nouveau of an earnest, reserved character.

Paris and Nancy

Art Nouveau in France developed primarily as High Art Nouveau, revealing an entirely three-dimensional character which was due to a considerable admixture of Baroque and Rococo elements. Though the assimilation of these influences guaranteed its very plastic and vital quality, whenever this Baroque-Rococo blend was not fully achieved French Art Nouveau tended to degenerate more than in any other country into an impure Art Nouveau disturbed by elements of historicism.

It is not only because of the quality of the products of Paris and Nancy, but also because of the intentions of the artists who created them, that the decorative element and craftsmanship are so clearly stressed. Creations of this kind indeed claim to be considered independent works of art. Such a development is on the whole in conformity with the philosophy of form of Art Nouveau—though it tended in France more than elsewhere to produce precious and highly stylized small works of art, or *objets d'art*. The jeweler René Lalique (1860–1945, plates 104, 105, and 106) was thus one of the most admired masters of the nineties. With pearls, semiprecious stones, and translucent horn he made combs, brooches, and other pieces of jewelry which seem quite alien to all traditional forms. He was not interested in the rich hues of rubies, sapphires, and emeralds, nor in the cold fire of diamonds and their crystalline appearance, nor indeed in the rounded perfection of pearls; what attracted him most was the irregular shape of baroque pearls. Lalique's colors seem to have been distilled from moonlight: pale and delicate, with stones and pearls set in mother-of-pearl and milky-colored enamel. His jewelry was figurative, representing almost exclusively costly and fragile blossoms and plants in which poetic invention forms an ideal union with the function of the bauble.

French applied art was diametrically opposed to the honest craftsmanship of Morris or Mackmurdo and is extremely subtle and of great virtuosity, shining enticingly in jewels and other objects displayed in *virtrines*, or in complicated boudoir furniture. In its forms and conception we feel the connection with the eighteenth century. Seen against this background, the decadent character and tone of the *ancien régime* and *fin de siècle* in French Art Nouveau become clear, together with its aristocratic elegance and its somewhat erotic quality.

In the designing of furniture, honest craftsmanship and simple or significantly displayed construction had been, since Morris, all-important in England, where form was primarily derived from function, material, and technique, though Art Nouveau frequently developed it by exaggerating its proportions. Except for Godwin, Mackmurdo, and Voysey, such furniture is

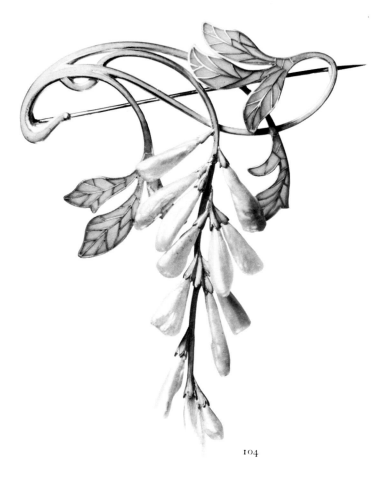

104

rectilinear, shaped like chests or cabinets and often laconically purposeful. The great French cabinetmakers, such as Gallé and Guimard, and the masters who were then greatly admired, like Majorelle, De Feure, Colonna, or Gaillard, all conceived pieces of furniture as objects of luxury in which structure and functional considerations were of secondary importance, to such an extent indeed that chairs were often first modeled in plaster and then subsequently copied from this mock-up in wood and upholstery. Contrasting with England's logically constructed furniture of the Arts and Crafts school, French furniture of this period, as that of Horta and Gaudí, seems often to have grown like a plant.

Admiration of English Style in France

In the Rossetti and Burne-Jones circle in London, ethereal and unworldly dream princesses were created, and real people then strove to adopt their appearance and manner. Paris, with its background of decorative art, fashion, and jewelry, preferred to proclaim its allegiance to the more worldly beauty of the living woman. Since the seventies, the ''aesthetic'' ladies of Kensington and Chelsea had dressed in Pre-Raphaelite fashions which included, among other things, dresses without waists; fashionable marriages, as that of Oscar Wilde and Constance Lloyd in 1884, were celebrated in Pre-Raphaelite garb. In Paris in the nineties, on the contrary, Marcel Proust writes:

''. . . one evening at the house of one of Saint-Loup's aunts on whom he had prevailed to allow his friend to come there, before a large party, to recite some of the speeches from a symbolic play in which she had once appeared in an 'advanced' theatre, and for which she

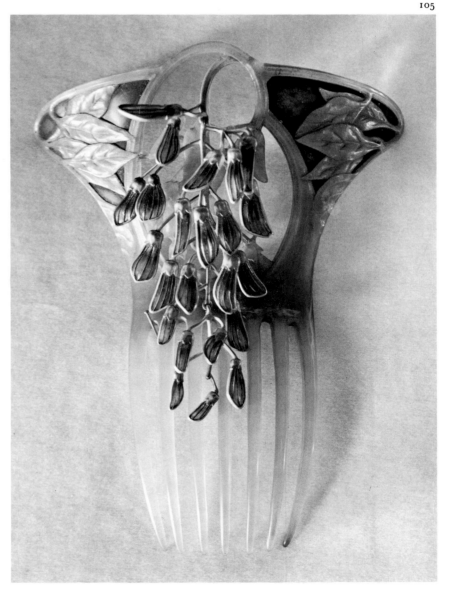

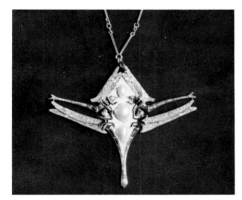

104 RENÉ LALIQUE *Brooch (circa 1900)*
105 RENÉ LALIQUE *Ornamental comb*
 (circa 1900)
106 RENÉ LALIQUE *Pendant (circa 1900)*

had made him share the admiration that she herself professed.

"But when she entered the room, with a large lily in her hand, and wearing a costume copied from the *Ancilla Domini*, which she had persuaded Saint-Loup was an absolute 'vision of beauty,' her entrance had been greeted, in that assemblage of clubmen and duchesses, with smiles which the monotonous tone of her chantings, the oddity of certain words and their frequent recurrence had changed into fits of laughter, stifled at first but presently so uncontrollable that the wretched reciter had been unable to go on. Next day Saint-Loup's aunt had been universally censured for having allowed so grotesque an actress to appear in her drawing room. A well-known duke made no bones about telling her that she had only herself to blame if she found herself criticised. '. . .'Pon my soul, Paris is not such a fool as people make out. Society does not consist exclusively of imbeciles. This little lady evidently believed that she was going to take Paris by surprise. But Paris is not so easily surprised as all that, and there are still some things that they can't make us swallow.'"[26]

A costume designed after Rossetti's best-known painting (plate 46), the lily of the Pre-Raphaelites and of *Jugendstil*, and a recitation of poems that might have been by Swinburne, Wilde, or Maeterlinck (actually, Proust was referring to Maeterlinck)! Robert de Saint-Loup had been converted to the new style. Proust tells us later that he had decorated his home with furniture designed by Bing and that Rachel, Saint-Loup's actress friend, who had at first been so unsuccessful, soon acquired great fame. This turn of Fortune's wheel is significant. In 1897, *L'Illustration*, the conservative illustrated periodical of the *grande bourgeoisie*, had, in its Christmas number, a front cover designed by Grasset with angels in the English style of Walter Crane (who designed the front cover the following year). Toulouse-Lautrec was among those who had their homes decorated by Bing in the "Yachting Style," and it is also known that Toulouse-Lautrec liked Burne-Jones' paintings and was friendly with Wilde and Beardsley. In 1896, Lautrec designed a poster for the Irish-American bar in the Rue Royale which was called *The Chap-Book*, after the small avant-garde Chicago periodical which had published Bradley's *Serpentine Dancer* (Loïe Fuller, plate 4). Lautrec also immortalized the invasion of English and Anglo-American *artistes* who suddenly appeared in the variety theaters of Paris: his posters for Jane Avril and May Milton (colorplate XVI) and his drawings inspired by Loïe Fuller (colorplate I), May Belfort, and Ida Heath bear witness to the popularity of English names. In Vienna too, world-famous Anglo-American stars such as Isadora Duncan and the Barrison Sisters inspired poets like Hofmannsthal.

The fact that fashionable society, artists, and poets were all pro-English did not yet demonstrate the influence of an English decorative style, but did create a favorable atmosphere for the importation of English objects which were meant for the leading circles of art and fashion. S. Bing, the dealer in Japanese art, toward the end of 1895 transformed his art shop in Paris into one for modern decoration and called it *L'Art Nouveau*, and also commissioned painters to design furniture and decorate rooms. From the start, he had exhibited ensembles by Van de Velde and worked with Meier-Graefe and for the Berlin periodical *Pan*; obviously, he was a man who knew what he was saying when in 1898 he wrote: "When English creations began to appear, a cry of delight sounded throughout Europe. Its echo can still be heard in every country."

But it is not always easy to prove that France followed English examples in the applied and decorative art of this period. In fact, it was mainly in Brussels that English inventions of form were first assimilated and transformed before they then spread to France. Furniture designs by Serrurier-Bovy (plate 78), closely related to those of

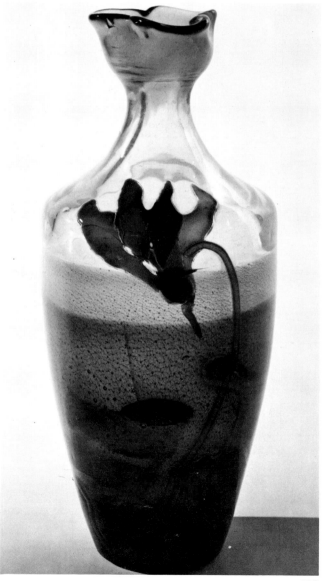

107

English Arts and Crafts, and above all Horta's creations, were accepted in France as quite exemplary. Horta had already translated the flat curves of English wallpapers into three-dimensional terms and thus enriched them with the form, dynamics, and power to transmute that characterized Rocaille. Nor is it now controversial to attribute all this to the influence of Brussels. As early as 1895, an article appearing in Paris demanded that French design become more independent of Belgian influence.

Émile Gallé

It was not in Paris but in Nancy that French Art Nouveau achieved its greatest independence, reaching the highest quality in the glassware of Émile Gallé (1846–1904, plates 67, 107, 108, and 245). As his father owned a workshop for glass and pottery, Gallé became acquainted at an early age with the materials used in his later work; like Obrist after him, Gallé first studied philosophy and botany and, in 1872, went to London. In the South Kensington Museum, he was fascinated most of all by Japanese glassware displayed there after the World Exhibition of 1862. Chinese and Japanese glassware, above all the coloring techniques used in small bottles, gave him the idea for his extremely subtle and complicated method of production and inspired his artistic style. In Nancy (where he settled in 1874 and founded his own glassworks) Gallé later became acquainted with a Japanese student, who had come there in 1885 to study botany. In addition, a Rococo element may have contributed to the evolution of Gallé's art, since Nancy's finest buildings are of that period. Cabinetmakers and gifted artist-craftsmen, such as Majorelle and Prouvé—who in the nineties founded the *École de Nancy* with Gallé, and had previously worked in the Rococo style—returned to Rococo in 1900. Pieces of furniture which had been designed by Gallé himself in collaboration with Prouvé and which are noteworthy because of their elaborate marquetry (plate 109) are likewise mostly inspired by eighteenth-century types.

Gallé had already made designs for his father's workshop. It is difficult to establish a chronology of the productions of his own workshop, so that we cannot distinguish with any certainty when his Art Nouveau period started and when he actually arrived at High Art Nouveau. But a Far Eastern touch can always more or less be felt and must certainly have already been noticeable in the works he sent in 1889 to the World Exhibition in Paris. E. de Vogue writes about Gallé in his *Remarques sur l'Exposition de 1889*, "Let us praise the whims of fate for having allowed a Japanese to be born in Nancy." Traces of Gallé's botanical studies can be found everywhere in his floral Art Nouveau; through his eyes flowers are not merely beautiful forms of nature but can be

107 ÉMILE GALLÉ *Vase (circa 1895)*
108 ÉMILE GALLÉ *Vase (circa 1895–1900)*

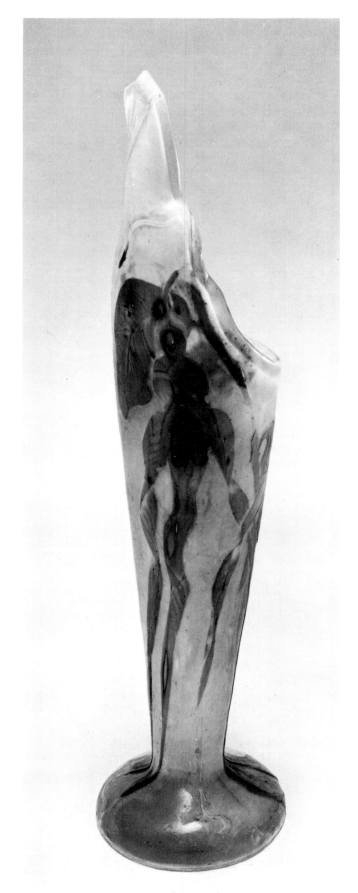

108

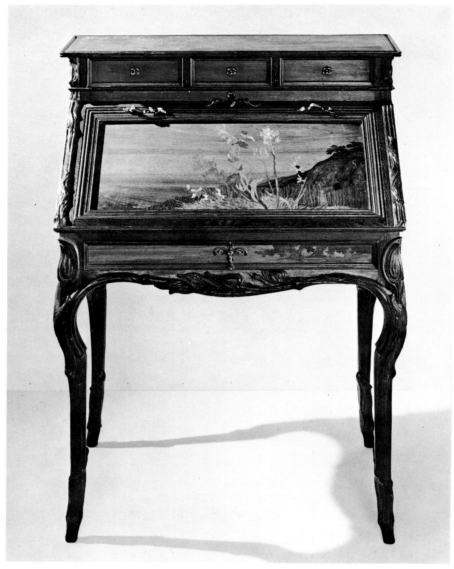

109

charged with emotion too. Gallé himself can be called a Symbolist, and often engraved or cut in the glass of his vases Symbolist verses or stanzas—quotations from Poe, Baudelaire, Mallarmé, or Maeterlinck. He also wrote scientific articles on horticulture and devoted his free time to the large garden that surrounded his beautiful home in Nancy. On the door of his workshop there was a slogan: "Our roots lie in the soil of the woods, in the moss by the rim of the pool," another statement that reveals how close Art Nouveau sought to come to the origins of life, to water, and the primitive forms of life.

Although entirely faithful to Art Nouveau, some of Gallé's works attain a degree of severe beauty which shows they are free from the bonds of style and time. The cyclamen bloom on a bottle-shaped vase (plate 107) grows like a water lily on a delicately curved stem, from the transparent layers of colored glass. The seemingly simple form of the vessel is actually extremely subtle; in it we sense the echo of a Greek amphora. Contrapun-

tally, the form encompasses the suspended blossom, its corona echoed in the curved lip of the vase. As in the case of many Art Nouveau vases, this one is sufficient unto itself, and if a flower were placed in it the effect would only become overdone.

Gallé's vases had an incredible success: from the first they were exhibited in the Bing gallery and were soon to be found in all important private collections, and later also in public collections. Gallé tried to meet the increasing demand by employing more and more craftsmen and by lowering his standards of quality (for instance by etching instead of cutting the glass); by doing this he inevitably repeated himself, no longer achieving the high quality of craftsmanship and originality of his earlier work.

109 ÉMILE GALLÉ *Woman's desk (circa* 1900)
110 HECTOR GUIMARD *Detail of a Paris Métro station (circa* 1900)

Hector Guimard

The love of Rococo, of rare bibelots, and of the boudoir style which is characteristic of all French Art Nouveau, could be discerned in the architecture of Paris and Nancy too, and not always to its advantage. Only Hector Guimard (1867–1942), an architect of the universal quality of Horta, Van de Velde, or Gaudí, rises above the mediocre. With the strangest forms, his imagination knows how to draw an entirely new value from the components of French Art Nouveau. His station entrances and pavilions for the Paris Métro, most of them created in 1900, are still landmarks of the city (plates 110, 111, 112, and colorplate XVII). True to the decorative style of Art Nouveau, they never suggest to us that they are accesses to a mechanical means of mass transportation. There is no sign of stark functionality in the orchid-shaped electric lamps that swing out from cast-iron stems painted leek-green. With their organic, soft, and sensitive forms, with the erotic associations of their details, these subway entrances appear rather as gateways to a subterranean Venusberg such as Beardsley described so vividly in his story, *Under the Hill*. A comparison with Horta's lamps that look like flowers, his curved glass roofs, and cast-iron supports (plates 3, 11, and 68) clearly reveals the source of Guimard's inspiration. Guimard's ironwork portals and pavilions rooted in the sidewalk pavement seem to be the colossal counterparts of Horta's objects. Not only in their abstract and ambivalent idiom of forms are the Métro entrances singular and magnificent hybrids. According to their origin they might belong to the field of engineering rather than to that of architectural works in the traditional sense; yet Guimard was far from considering himself an engineer. Not only did he call himself an architect, but an *architecte d'art*. Like Obrist's fountain (plate 155) or Gaudi's domed roofs (plate 2), his constructions are hybrid products of architecture and applied art, of sculpture and decoration: plastic ornaments of utilitarian nature.

Soon after Horta's creation of the Brussels *Maison Tassel*, in 1892–93, Guimard built his Parisian *Castel Béranger*, a luxurious apartment house which was started in 1894 and completed in 1898. This complex building in a traditional historical style as a whole remains unrelated to Art Nouveau, though the latter appears in such details as ironwork and the entrance hall (colorplate XVIII), which is entirely conceived as a metal cage, a structure of membrane-like surfaces which recalls Brussels Art Nouveau. But these elements do not seem to have belonged to the original plan; they were probably added at a later date. Once converted to Art Nouveau,

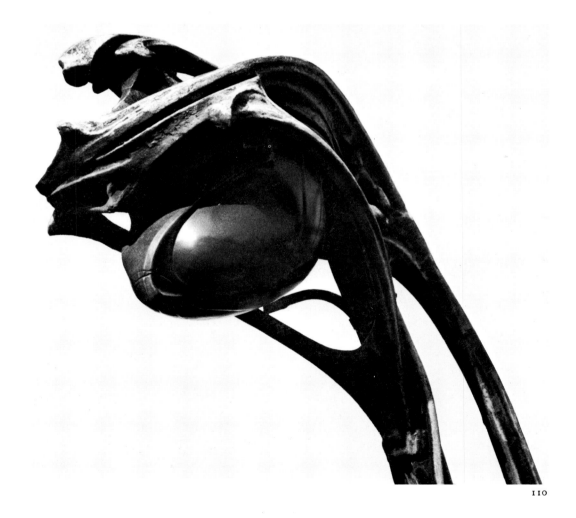

110

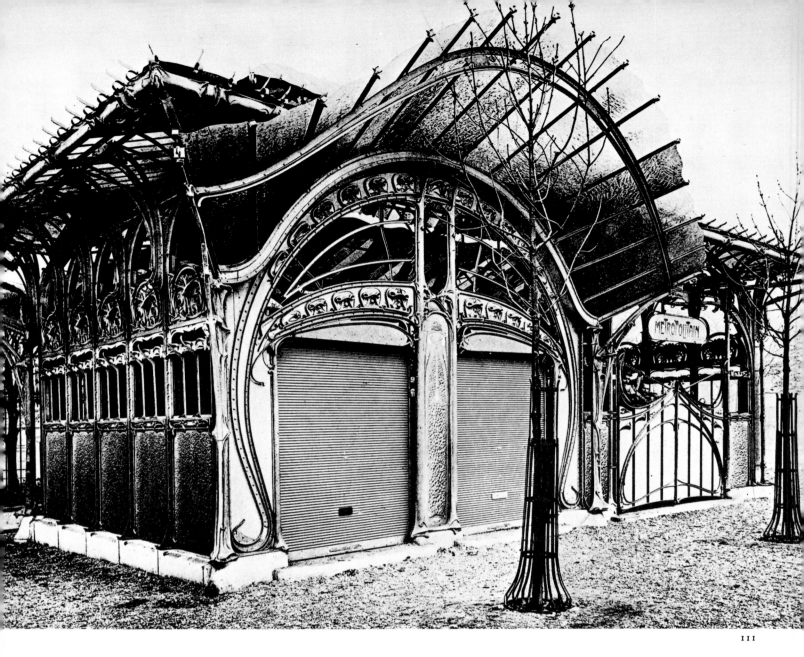

Guimard indeed created buildings that were homogeneous and ornamental units in their structure and their details.

The most remarkable detail of the *Castel Béranger* consists in the surprisingly freely conceived asymmetrical ironwork of the main entrance, where Rococo blends with flamboyant Gothic. However, the decisive force, the stimulus that sets everything in motion, again springs from the flowing lines of the curves of Japanese woodcuts in particular and Japanese surface ornamentation in general. In the application of the characteristic features of these smooth and gliding lines, Guimard outshines even Horta, whose furniture basically appears knotted and cramped as if riveted together. In their synthesis and unification, their evenness of lines, and their relationship to space, the masterpieces of the Belgian artist are surpassed by the irregularly asymmetrical staircase railing that Guimard designed as late as 1911 (plate 113).

This asymmetry, which seems to open up space and

in which Guimard surpasses Horta, is demonstrated in a desk that can be counted among the most incredible but convincing pieces of Art Nouveau furniture, Guimard's own writing table (plate 114). A "linear body," closed in itself both in the formal and actual sense of the term, and at the same time both a structure and a piece of cabinetwork, the desk gives an optical illusion of motion due to the veining of dark wooden strips. Two box-like elements are united in it by an asymmetrically extending tongue-shaped top.

The great centrally situated auditorium of Guimard's Humbert de Romans Building of 1902 (plate 115) is

111 HECTOR GUIMARD *Paris Métro station* (1900)
112 HECTOR GUIMARD *Detail of a Paris Métro station* (*circa* 1900)
113 HECTOR GUIMARD *Staircase in the artist's house, Paris* (1911)
114 HECTOR GUIMARD *Desk* (*circa* 1903)

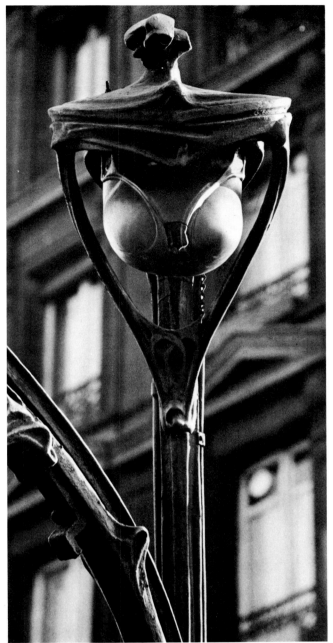

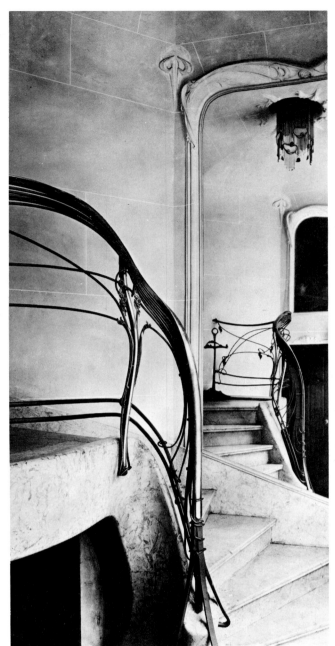

112

113

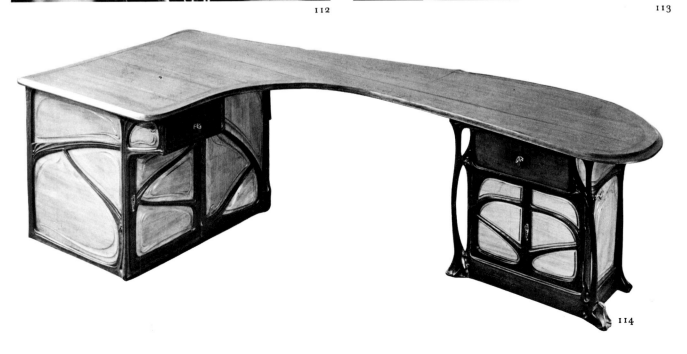

114

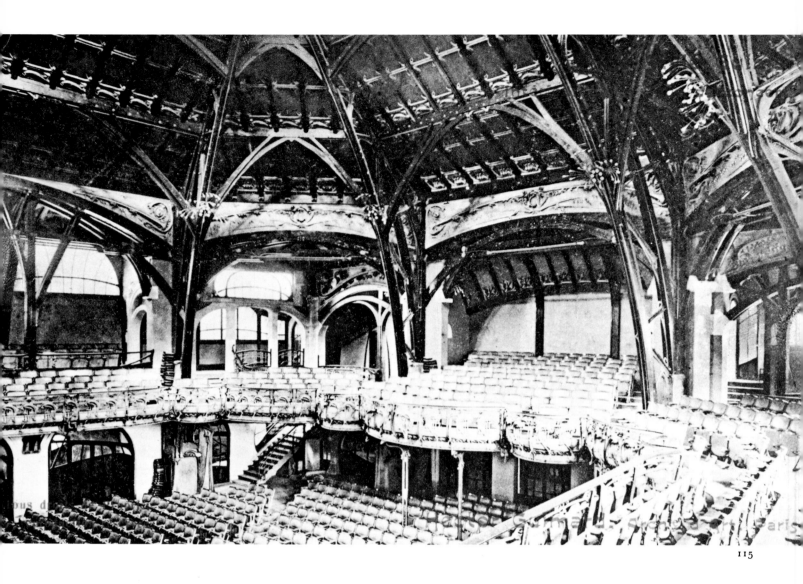

important as a constructed interior; an engineering construction reminiscent of the Eiffel Tower of 1889, but conventionally surrounded by brick walls, this hall is spanned by straight-lined ironwork. The separate girders rest on stone pedestals in which the flow of their lines terminates in an ornament. The structure of the room is entirely conceived in plant forms. The spoke-like supports radiate throughout the auditorium in a diagonal curve and rise upward to the open translucent center of the cupola, from which the electric lights spray forth in clusters as from the iron supports that Horta used in the Solvay residence in Brussels. But Guimard's hall can also be compared with the auditorium of Horta's *Maison du Peuple* (plate 76). Both these engineering constructions, Horta's long rectangular hall and Guimard's centralized hall, are of a linear nature and characterized by forceful lines and thin or transparent membranes.

French Painting and Sculpture in Art Nouveau

The decorative period of Art Nouveau lasted roughly fifteen years and corresponds to the period between the last of Seurat's pictures and the first Cubist works, when Cézanne's "classical pictures" were being painted practically without the public knowing anything about them. Georges Seurat, Cézanne, and the Cubists were as alien as possible to the conceptions of Art Nouveau.

The works of Picasso's Blue Period offer us the easiest analogy with Art Nouveau: in the sentimental content of these paintings, with their aristocratic beggars and their huddled women, in the soft and artificial coloring; in the drawing of the outlines and their importance which determines the composition in spite of the latter's high pictorial qualities; and in the almost complementary relationship between figures and background. However, in spite of Picasso's lyrical gliding lines, these works are static, immobile, steeped in the blue depths of dreams. But, even in this phase of Picasso's work, a barbaric, brutal element opposed to Art Nouveau is latent. Following the early Art Nouveau master Gauguin (whose Tahitian paintings are far less in the Art Nouveau style than those of his Pont-Aven period) the only major French painter between Seurat and the Cubists whom one can occasionally consider as belonging to the

Art Nouveau movement was Toulouse-Lautrec (1864–1901) and with him the *Nabi* group.

Toulouse-Lautrec's painting develops that of Degas, whose vision had been influenced by Japanese art; Lautrec's paintings and his unconventionally free drawings thus do not really belong to the field of Art Nouveau. However, this is not true of his posters which, as "art for the street," helped to determine the character of Paris in the nineties. Contrary to Lautrec's more or less Impressionistic paintings, the thickly drawn outlines in his posters are often filled in with homogeneous patches of color (plate 116, colorplate XVI). The colors are bright, sharp, aggressive, and, in order to make the poster more striking, limited in number, without any tonal variations or shading. As the figures of the posters often stand out against an empty and unprepared background, the impressionistic quality of Japanese art becomes more evident there, as also in works of Beardsley. In contrast to the latter, we see that, despite the rhythmical outline of the figures and the composition, Lautrec's posters (which may be compared with Gauguin's Art Nouveau) still retain a compact quality. In the exaggeratedly char-

acterized outline of his figures (colorplate I), we discover effects of foreshortening, whereas Beardsley's figures, on the contrary, with all their erotic sensuality, remain disembodied and ethereal, almost other-worldly, while Lautrec, with his personal portraits and caricatures, is always rooted in concrete reality. Pierre Bonnard (1867–1947) also owed a great deal to the art of the poster, and it is still a moot point whether his posters were influenced by those of Lautrec or vice versa. The four colored lithographs for a screen (plate 117a) which were published in 1899 are, in the arrangement of space and in their theme, a kind of parody on the large Degas painting of Count Lepic and his daughters posing on the Place de la Concorde. Once again, it is not fortuitous that traces of Art Nouveau appear in a piece of decorative furniture that is of Japanese or, at any rate, Far Eastern origin.

115 HECTOR GUIMARD *Auditorium in the Humbert de Romans Building, Paris* (1902)
116 HENRI DE TOULOUSE-LAUTREC *Troupe de Mlle. Églantine* (1896)

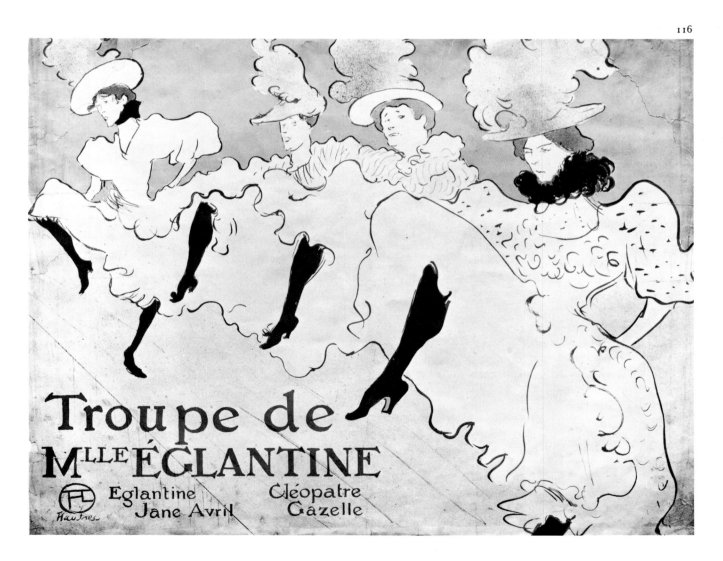

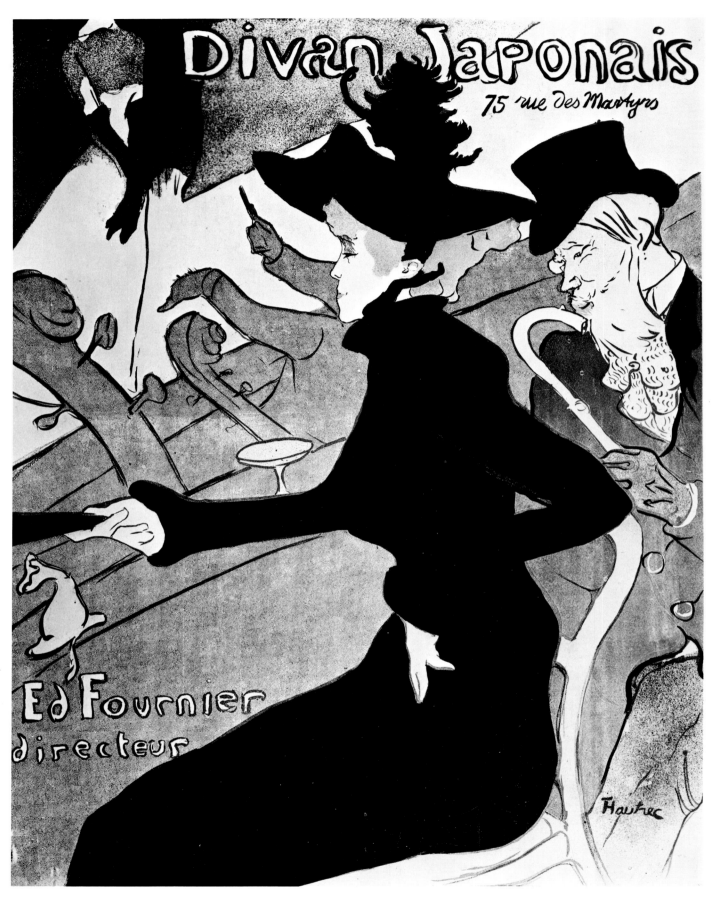

117 HENRI DE TOULOUSE-LAUTREC *Divan Japonais* (1892)

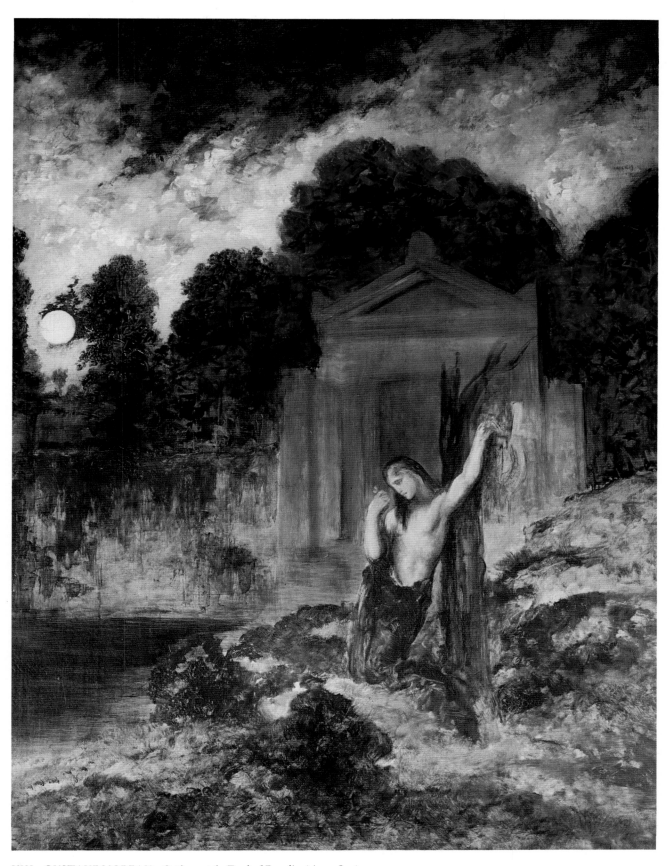

VIII GUSTAVE MOREAU *Orpheus at the Tomb of Eurydice (circa 1894)*

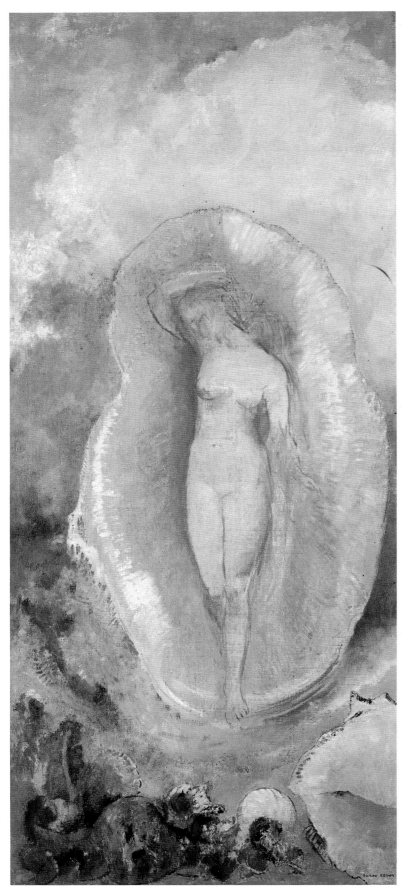

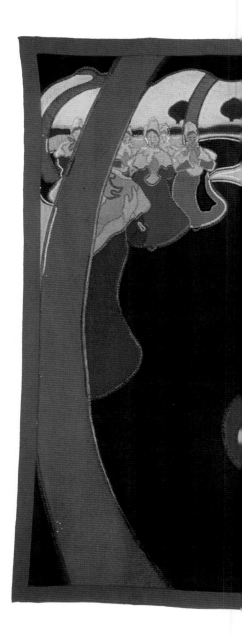

IX ODILON REDON *Birth of Venus* (1912)

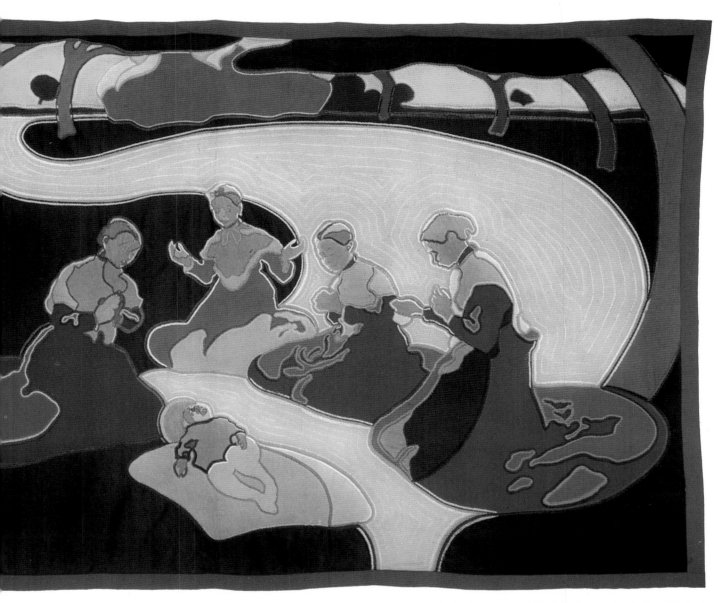

X HENRY VAN DE VELDE *Angel's Guard* (1893)

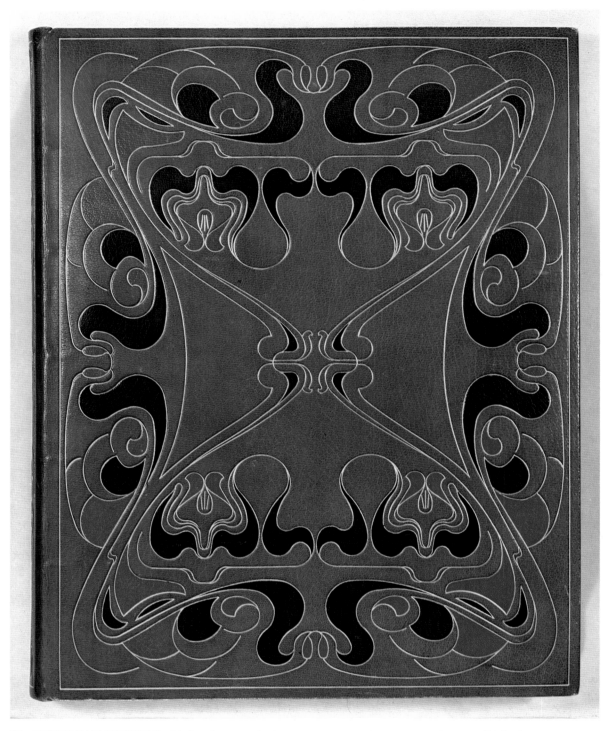

XI HENRY VAN DE VELDE *Binding for W. Y. Fletcher's "English Bookbinding in the British Museum"* (1895)

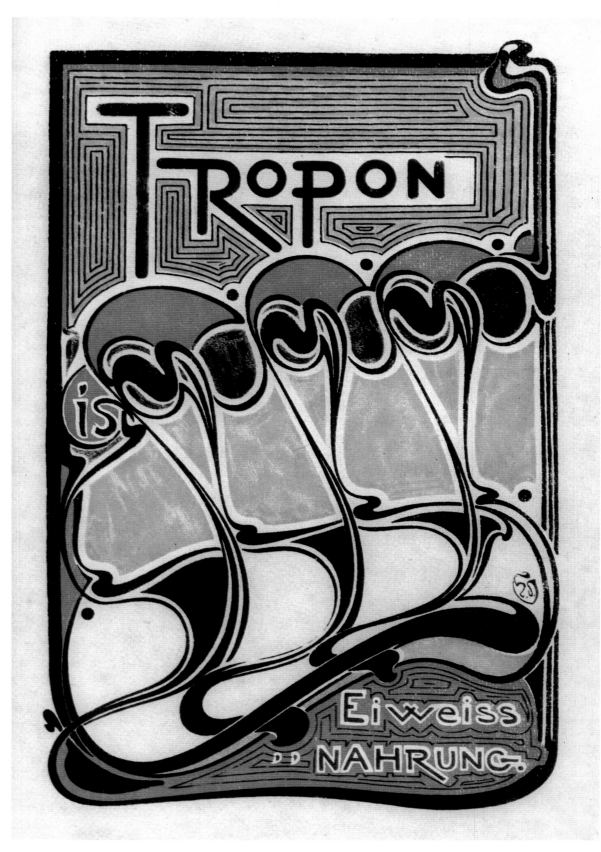

XII HENRY VAN DE VELDE *"Tropon," design for a poster* (1898)

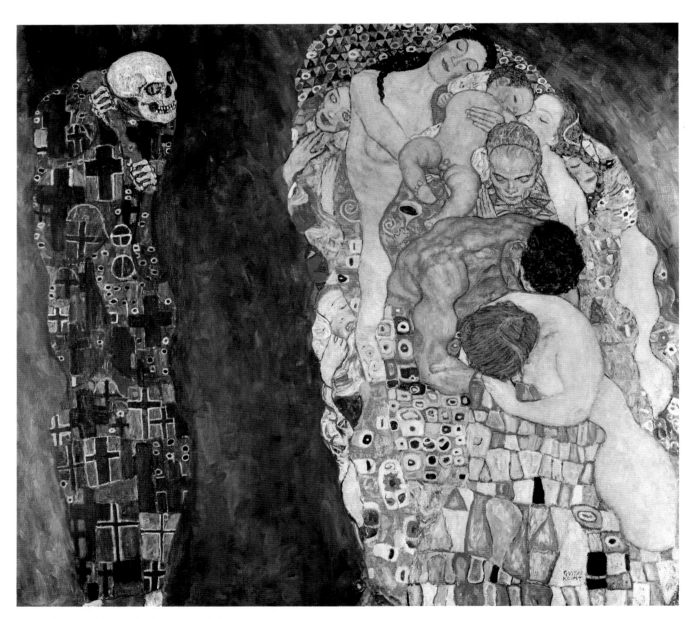

XIII GUSTAV KLIMT *Death and Life* (1911–16)

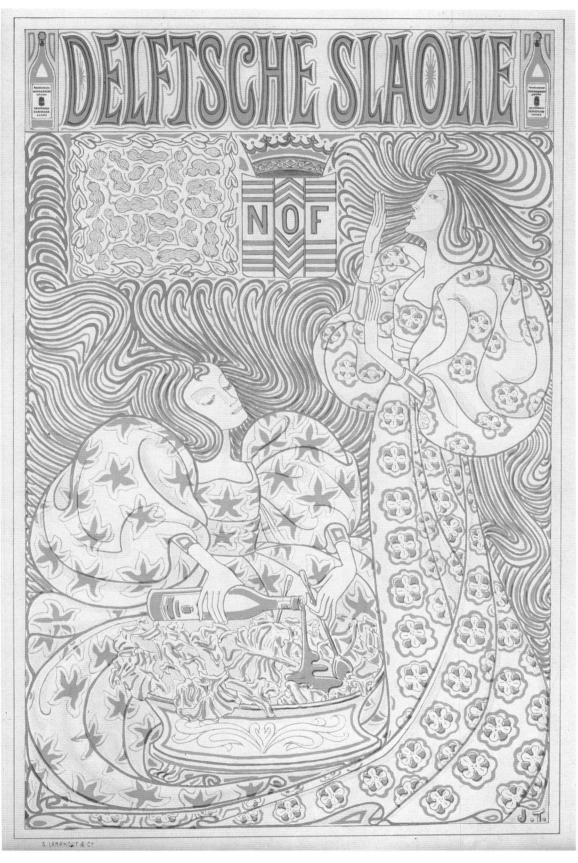

XIV JAN TOOROP *"Delftsche Slaolie," poster for salad oil (circa 1898)*

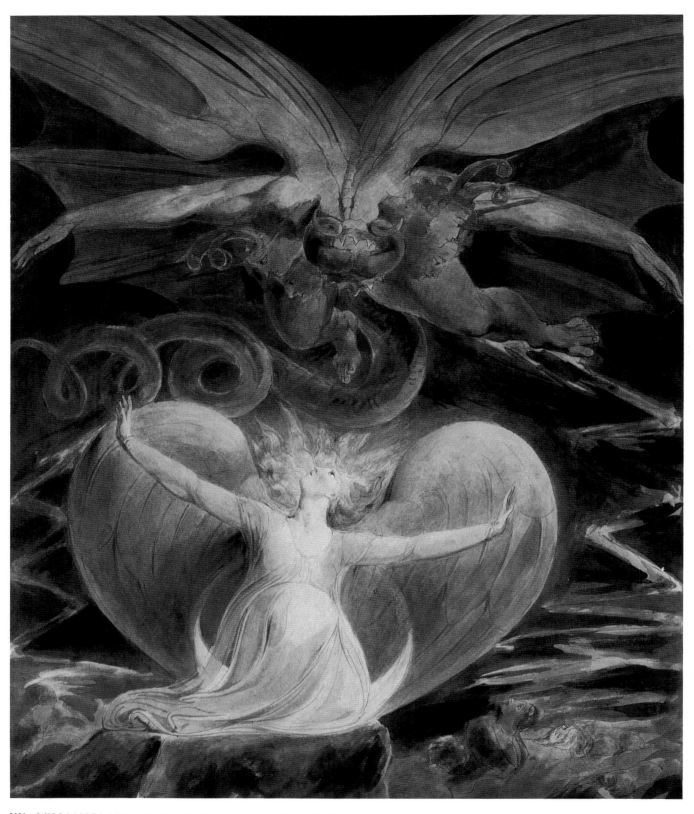

XV WILLIAM BLAKE *The Great Red Dragon and the Woman Clothed with the Sun* (1805–10)

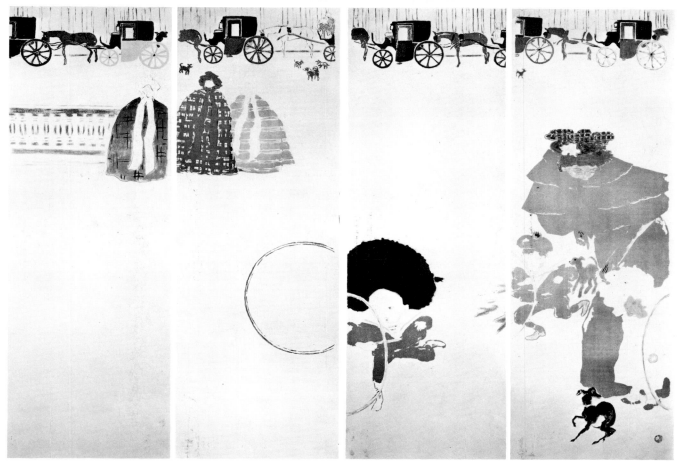

Another painter of the *Nabi* group, Aristide Maillol (1861–1944), after having made decorative designs in the Art Nouveau style in the nineties, shifted his interest to sculpture. From the first, Maillol's work in the round, in its static quality and monumental weightiness which can be seen even in his small figures, went far beyond Art Nouveau. Nevertheless, a number of his earlier works may still be attributed to this style, such as the delightful figurine of a washerwoman (plate 118), a theme he had also treated in painting. The swerve of the skirt, the smooth curves of the body, the absence of all naturalistic detail, link this work with Gallé's shell-shaped glass bowls. Although his sculptural activities began at an early period, the rigorous discipline in the art of Maillol and the architectural character apparent in the construction of his work place it in the category of the more severe late Art Nouveau.

Late Art Nouveau in France

The principle of a "framework" building which Guimard had adopted recurs in the work of the architect Auguste Perret (1874–1954). In the block of flats which Perret built on the Rue Franklin in Paris in 1903 (plate 119), he employed reinforced concrete and covered the framework with decorative tiles. Here, as in the garage

on the Rue Ponthieu he built in 1905 (plate 120), the façade of which was treated as a framed and braced surface, the skeleton membrane structure of Art Nouveau buildings is already divested of all asymmetry, curves, and organic associations. The chief examples of French Art Nouveau architecture around 1900 are these two buildings, masterpieces of Perret's style which already belong to late Art Nouveau, although not so much chronologically (since Gaudí in 1910 and Van de Velde in 1914 were still building in the undulating organic style) but rather because Perret's style belongs clearly to the rigorous geometric late phase of Art Nouveau, like Hoffmann's Brussels *Palais Stoclet* of 1905–11 (plate 240). Among these architects, Perret closely approaches the modern way of constructing in reinforced concrete and it is he too who comes closest to our own more truly modern architecture of recent decades. But the ornamental details of the building still separate Perret from the new architecture which found such a forceful expression only a few years later in Walter Gropius' Fagus Factory in Alfeld. The façade on the Rue Ponthieu is conceived by Perret as a geometric ornamental surface with a real central ornament dominating the unit in the shape of a

117a PIERRE BONNARD *Screen* (1899)

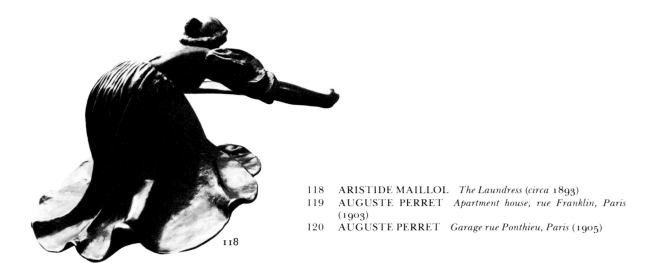

118

118 ARISTIDE MAILLOL *The Laundress (circa 1893)*
119 AUGUSTE PERRET *Apartment house, rue Franklin, Paris* *(1903)*
120 AUGUSTE PERRET *Garage rue Ponthieu, Paris (1905)*

119

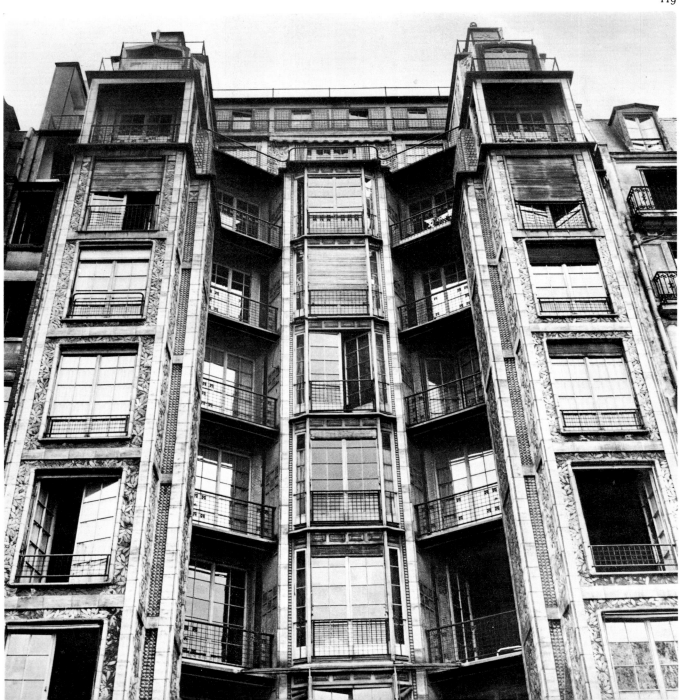

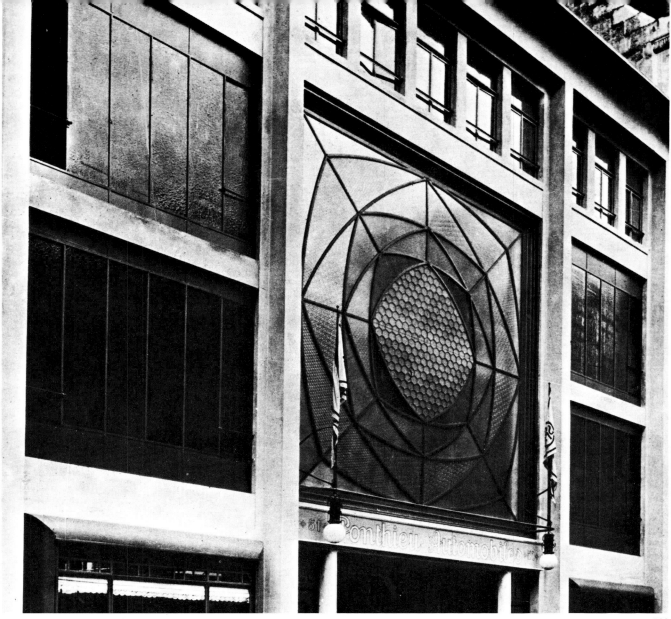

rose window. The thin projecting ledge that runs along the top like a hem is identical to that of Endell's *Elvira Studio* (1897–98, plate 158) and to Mackintosh's north wall of the Glasgow School of Art (1897–99, plate 229).

Perret's architecture is an example of the geometrical, rectilinear late Art Nouveau which had not as yet universally asserted itself. We find the wavy and linear as well as the wavy and flat Art Nouveau as late as 1909, and even up to 1914, in the stage designs of Léon Bakst as well as in the field of Parisian *haute couture*. Bakst's stage sets (plate 121) usually consisted of compactly built-up horizonless landscapes, and in spite of clearly belonging to Art Nouveau's late phase they also reveal characteristics of High Art Nouveau such as can be found nowhere else. In High Art Nouveau, painting landscapes as themes was largely neglected except by Gauguin and his friends of the Pont-Aven school.

Other late influences of High Art Nouveau may be found in Georges Lepape's watercolor renderings of dress designs by Paul Poiret, which were printed in the Paris *Gazette du Bon Ton*. Even Edward Steichen's photographs reveal how greatly the continuous flow of lines, the totally enclosed contour, the homogeneous two-dimensional body, and the refusal to concentrate on any minor detail affected even these fields of fashion and applied art.

In this style that remains grand even in its simplified form, the culminating phase of Art Nouveau lives on so that in the creations of fashion—which are likewise works of decorative and applied art—the innermost quality of the uninterrupted form is embodied. Photographic portraits of around 1900, especially those of the actress Réjane or of Liane de Pougy, a leading *cocotte* (both of them authentic representatives of the latest in fashion), show that dresses were then composed of numerous small pieces—panels, appliqué, and beadwork. In reality, their figures were still far from being those of the simplified sweeping outlines which Lautrec and Bonnard produced on screens, posters, and canvas. Proust was thinking of this lack of homogeneity in fashion when

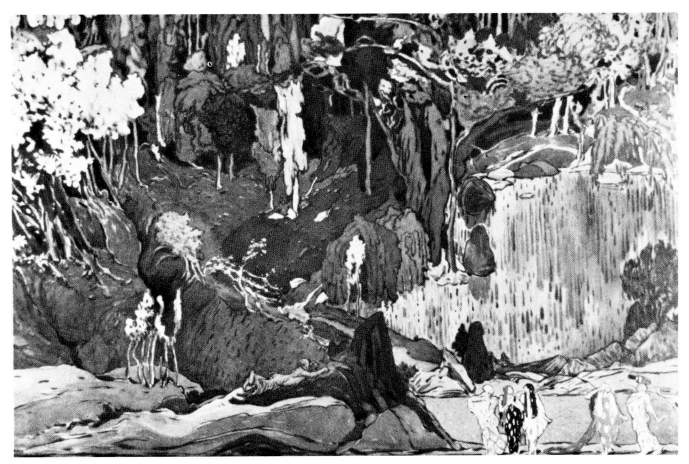

he wrote about Odette as she appeared in the nineties: ". . . while as for her figure, and she was admirably built, it was impossible to make out its continuity (on account of the fashion then prevailing, and in spite of her being one of the best-dressed women in Paris), for the corset, jetting forward in an arch, as though over an imaginary stomach, and ending in a sharp point, beneath which bulged out the balloon of her double skirts, gave a woman, that year, the appearance of being composed of different sections badly fitted together; to such an extent did the frills, flounces, the inner bodice follow, in complete independence, controlled only by the fancy of their designer or the rigidity of their material, the line which led them to the knots of ribbon, falls of lace, fringes of vertically hanging jet, or carried them along the bust, but nowhere attached themselves to the living creature. . . ."[27] Only after 1900 did Odette appear in the long flowing robes which were not taken in at the waist. This proves, in fact, that short-lived fashion often lags far behind art in matters of style.

The love of the heterogeneous and of interrupted forms, which belong to historicism, lives on in the photographic portraits of 1900. Not before Edward Steichen (1879–1973) does one see what might be qualified as Art Nou-

veau photography. Steichen's famous 1902 portrait of Rodin (plate 122) illustrates most strikingly the way in which the human figure and its environment were disembodied and immersed in a spectral and nebulous atmosphere. This photograph is symbolical and neo-Romantic as well as neo-Manneristic. Reduced to a mere silhouette, the sculptor is seated like a demiurge opposite his *Thinker*. Rodin's *Victor Hugo* emerges from the darkness like a flame, as if materialized by spiritualism. The confrontation of the sculptor and his creations is effected in a way unknown to nature and takes place in some imaginary two-dimensional space. The flowing outlines, the closed forms, the flaring, ghost-like substance, the contrasts and the interplay of light and shadows characteristic of Art Nouveau, are achieved here in the media of photography and for the purposes of photography.

LONDON

English Art Nouveau of the last decade of the nineteenth century bears the characteristics of the traditional English gentleman, suggesting great reserve and equa-

nimity, and addicted to understatement. Exaggerated proportions were accepted almost as a matter of course and even the sensational and lascivious element in Beardsley's drawings, since it was expressed in symbols, never overstepped the limits of decency. In the tranquillity of London's Art Nouveau, more delicate melodies became audible too, and the coolness of this style never excluded recourse to a strongly manneristic imagination. Urban functionalism and the comfort of country houses still allowed enough scope for Romanticism which went far beyond mere illustration, though the "soul" of which this Romanticism is by no means deprived was never deliberately exposed. Even the typical element of Art Nouveau remained a mere suggestion of what had been developed and made more apparent on the Continent but still seemed rather frightening in England.

London Art Nouveau owed its reserve to the long years of preparation supplied by the aesthetes and to the continuity of a natural development in which for more than half a century everything had grown from its own roots

or sprung from affinities with an appropriate style; as in this case, Japanese art. On the Continent, the beginnings of the style remained for a much longer period, suppressed by the overpowering influence of historicism. The latter's ideal of form—the open form, picturesque effects, pomp and circumstance in complicated plastic forms—therefore contaminated Continental Art Nouveau and, above all, its French version. The result of this lengthy delay was that when Art Nouveau finally appeared on the Continent, it blossomed suddenly with a decided tendency toward exaggeration. London's traditional wealth of trends which prepared the way for Art Nouveau not only allowed a reserved attitude to it but also, in the nineties, made it possible to modify and discard many of its elements. England had by then

121 LÉON BAKST *Stage-setting for "L'Après-midi d'un faune"* (1912)
122 EDWARDSTEICHEN *Rodin, Victor Hugo, and "The Thinker"* (1902)

122

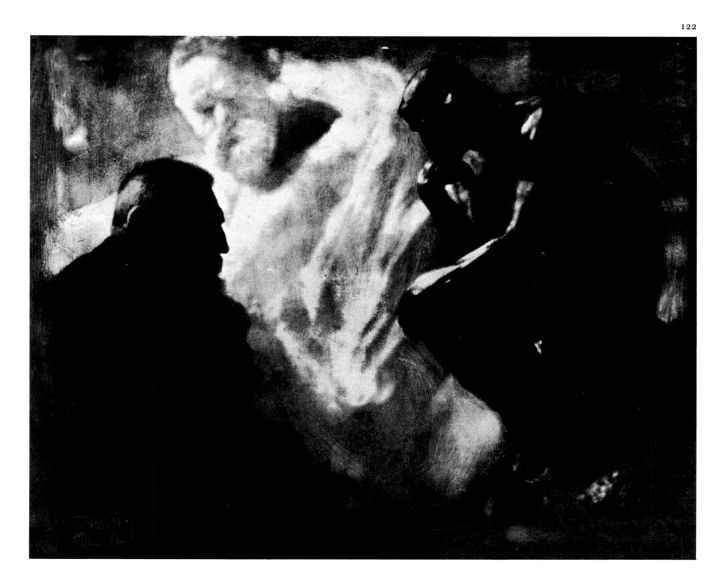

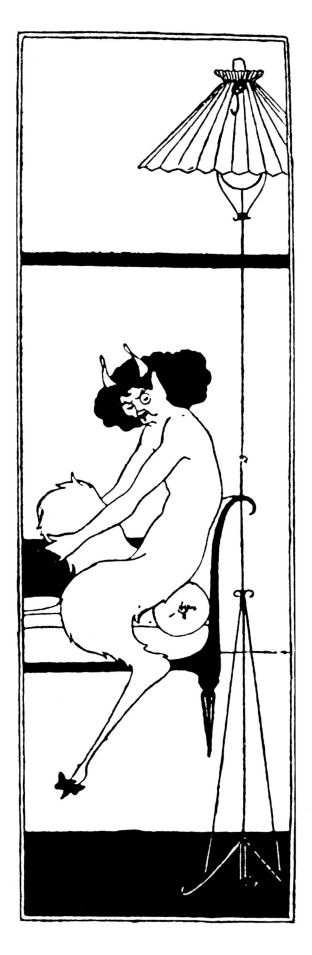

reached the second decade of its own High Art Nouveau, the first, during the eighties, having been characterized by the works of Mackmurdo, by Sumner's *Undine* and the fiery visions of Ricketts. Thus, the flickering movement of Mackmurdo's works (plate 33) has almost vanished from the more tranquil forms of his pupil Voysey (colorplate V); and even Charles Ricketts withdrew more and more into a world of almost classically serene forms, while Beardsley soon discarded Art Nouveau lettering in order to use a more classical typeface. Nothing could be more remote from English High Art Nouveau than the fashionable elegance of Guimard's Métro entrance gates (in spite of the roguish joy that Wilde would have derived from them); nor could anything be more alien to it than the convulsive fits and starts of Van Gogh's painting or of Munch's wild Expressionism.

It is not surprising that after Mackmurdo there was no longer, with the exception of Beardsley, any real representative of London Art Nouveau. If, by Art Nouveau, one understands nothing but Horta's curved iron structures and glass roofs, Gaudí's highly plastic architecture, and the muscular dynamism of Van de Velde's furniture, the above statement is indeed justified. These spatial developments of Continental Art Nouveau were almost entirely unknown in England, where there was no trace of the Rococo elements which influenced the Continental style while also exposing it to the risk of contamination from historicism. But the creations of Gaudí, Horta, and Van de Velde remained styles that were both personal and nationally conditioned, expressing the utmost exaggeration of its possibilities (despite the fact that the two latter-named artists served to impart a character to the style, the influences of which traveled far beyond the borders of their native Belgium). However, none of the three above-mentioned men can be accused of imposing universal or binding criteria.

Indubitably, even mature London Art Nouveau retained the features of its early phases: bodies and spatial forms kept tending toward the rectilinear, frequently adopting the bare and box-like forms of a style which in Vienna and Glasgow later crystallized as late Art Nouveau, but which was inherent to London from the very first. Curves remained within the confines of two dimensions, and, except for Gilbert's sculptures, when they appear in the round, remain limited either to small objects (mostly silverware) or to architectural details. Obviously, English Art Nouveau still existed in the last decade of the nineteenth century and continued for some years after 1900, when it achieved a full-blown quality all its own. At most, one could ask if it was still High Art Nouveau according to Continental standards—but could Beardsley's art be considered anything but an example of this, and could it have been possible anywhere but in the London of the mid-nineties?

123 AUBREY BEARDSLEY *Caricature of James McNeill Whistler* (1893)

"Some flaws, if skillfully set by the jeweler,
can shine even more brightly than the gem
of virtue."
La Rochefoucauld, *Réflexions ou Sentences et
Maximes morales*

Aubrey Vincent Beardsley (1872–98) deliberately chose
to be the buffoon and harlequin of his age. He knew he
was destined to die of consumption and hankered after
immediate success. In his art as in his life, he masked his
efforts and hard work behind the pose of the dandy,
seeking and achieving success through scandal. Up to
his death at the age of twenty-six, he remained a child
prodigy, first in the field of music—the sad music of Cho-
pin and Wagner's sensual art belonged to the few things
he took seriously—then in the fields of both draftsman-
ship and literature.

Beardsley was born in Brighton and the bizarre char-
acter of the Brighton Pavilion may have influenced his
conception of art throughout his life. In London, where
for a while he worked as a draftsman in an architect's
office, he soon entered the circle of friends in which (from
Rossetti and his followers onward) almost all the well-
known artists of English Art Nouveau found themselves
united. Aymer Vallance, the biographer of William
Morris, was one of Beardsley's first friends. The aging
Morris himself had little to say to him and was soon an-
noyed by the frivolity of the designs that Beardsley made
for Malory's *Morte d'Arthur*. But from Sir Edward and
Lady Georgiana Burne-Jones, Beardsley met with much
kindness and encouragement; it was in their house, too,
that he became acquainted with the Wildes. Later, it was
Whistler—at first somewhat distant because he may have
felt parodied (plate 123)—who found words of appreci-
ation that brought tears to Beardsley's eyes. On the
whole, Beardsley belonged to the group of dandies who,
like Whistler and Wilde, kept in close contact with
Paris; the Symbolist poets John Gray and Ernest Dow-
son were also of this group, as well as the painter Charles
Conder, who painted silk coverings for fans, screens, and
the walls of complete boudoirs for Bing. As "*un jeune
Anglais qui fait des choses étonnantes*," Beardsley, who as
yet had little to show, was praised in Paris as early as
1892 even by the President of the Salon des Beaux Arts—
no less a man than Puvis de Chavannes. It seems more
natural that he was later also admired by Lautrec, to
whom Beardsley sent a copy of his *Book of Fifty Drawings*
and in whose studio he tried the effects of hashish. It is
scarcely surprising that one whose art was so much in-
volved with "black magic" should have had a human
skeleton seated beside him when he played the piano.
Nature, natural behavior, or anything like the "simple
life" were notions as alien to Beardsley as to Wilde. On
the other hand, he never missed a "Wagner night" at
Covent Garden and, for the rest, lived in an artificial
world of the ballet and fashionable drawing rooms, of
gambling casinos and hotel lounges.

Burne-Jones and Morris, Japan and Whistler's partic-
ular "Japanism" provided the foundations of Beards-
ley's work. In addition to this, there soon appeared a
sensitive outline, a sharp and characteristic stroke of
penmanship, the tautness of the outer and inner con-
tours of Greek vase painting of the age of Douris as well
as the very expressive silhouettes of Toulouse-Lautrec.
These heterogeneous elements are very soon transformed
by Beardsley into something entirely individual and new,
filled with an explosive force and an expression of un-
erring artistic taste. Indeed, the character of Beardsley's
art was so strong that he was later able to absorb fully
the influences of French Rococo (in his illustrations for
Pope's *Rape of the Lock*), Claude Lorrain (in the bindings
for *The Savoy*), and Mantegna and the Italian Renais-
sance (in the initial letters for Ben Jonson's *Volpone*)—
yet none of these very powerful influences submerged
his own style.

With the exception of a single oil painting (plate 124)
and a few colored drawings (colorplate XIX), Beards-
ley's output was confined to pure black-and-white
drawings. No preliminary sketches were ever made: all
changes were made with pencil on the same sheet, and
were erased once the final version had been decided and
drawn in with India ink. Produced after endless en-
deavor, feverish abandon, and unlimited self-infatuation,
these creations were almost exclusively conceived for
mechanical reproduction by means of the then new
method of line engraving, the demands of which were
fully met by the linear character of Beardsley's work. His
drawings were done on a large scale with a view to their
subsequent reduction, which conferred on them the ap-
pearance of etchings, and were also of great technical
perfection. Apart from a number of ornamental designs
(plate 166) and a few posters (plate 125), Beardsley
chiefly produced illustrative works. Stimulated by Rick-
etts, he moreover designed bookbindings which may be
counted among the most beautiful of his time in the whole
field of book decoration in general (plates 126, 127).

The highly ornamental character of Beardsley's work
is due not only to the network of fantastic ornament
woven around his figures but, above all, to the orna-
mental structure which he stresses in the picture itself.
Beardsley lays bare the ornamental elements of actual
representation: asymmetrical ornaments that seem to
consist of coldly precise nerve fibers; forms in hectic
motion that, despite all their unrest, appear rigid and
immovable, with Baudelairean beauty that resents any-
thing disturbing their outline. Intellectual art of this
kind expresses neither warmth nor sentiment and is en-
dowed with elegance and an infernal and disturbing grace.

Beardsley allows himself such liberties with his texts
that these sometimes lead to parody and anachronisms.
In the frontispiece of *Salome*, he imparts Oscar Wilde's
features to the woman in the moon, and he dresses his
Semitic princess of the first century B.C. either in Ja-
panese kimonos (plate 128) or in the low-cut evening
dresses of Parisian *haute couture* of his own era. In a compart-
ment of Salome's dressing table, an Anglo-Japanese

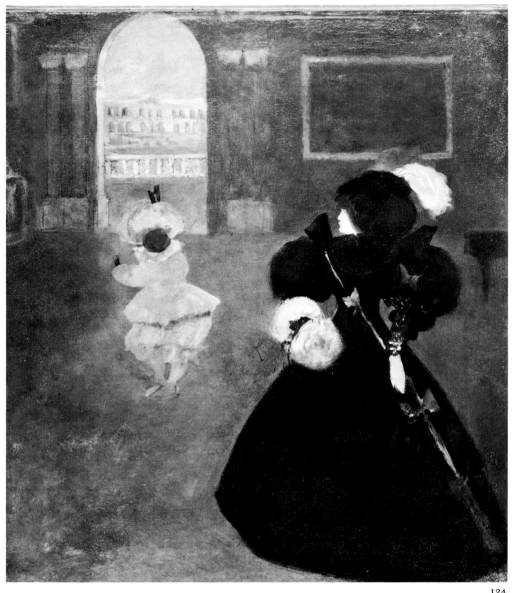

124

piece of furniture in the style of Godwin (plate 129), Beardsley places books on which can be seen the names of the Marquis de Sade, Choderlos de Laclos, and Zola; whereas Wilde had conceived his "dream-princess" as "romantic and mystical" and hinted at a court which, however fantastic, suggested that of the Tetrarch in Jerusalem, suiting his poetic diction to the metaphorical and allegorical style of the *Song of Songs*.

Author and illustrator, in spite of all such individual differences of intellectual approach, agree in the exalted, hysterical, highly strung atmosphere and in the sophisticated abundance of metaphors and details: "How pale the Princess is! Never have I seen her so pale. She is like the shadow of a white rose in a mirror of silver." In the decorative splendor of the green and gold peacockfeather binding for *Salome* (plate 127), Beardsley has summarized the climate of the whole tragedy: a luxuriance that pervades everything, a vegetative and abstract

world of forms in which disaster lurks and fascinates us hypnotically out of sightless eyes. A design of this kind can be understood as a visual parallel to Wilde's poetic metaphors, for instance that of "scarlet sin."

Beardsley is a master of linear Art Nouveau. His line is strongly suggestive of concrete subject matter but at the same time never allows us to forget its abstract geometry. If Beardsley relies on outline, he also uses its complement: the homogeneous two-dimensional body. With

124 AUBREY BEARDSLEY *Caprice* (1894)
125 AUBREY BEARDSLEY *Poster for a book publisher* (detail) (*circa* 1895)
126 AUBREY BEARDSLEY *Binding for Ernest Dowson's "Verses"* (1896)
127 AUBREY BEARDSLEY *Binding for Oscar Wilde's "Salome"* (1894)

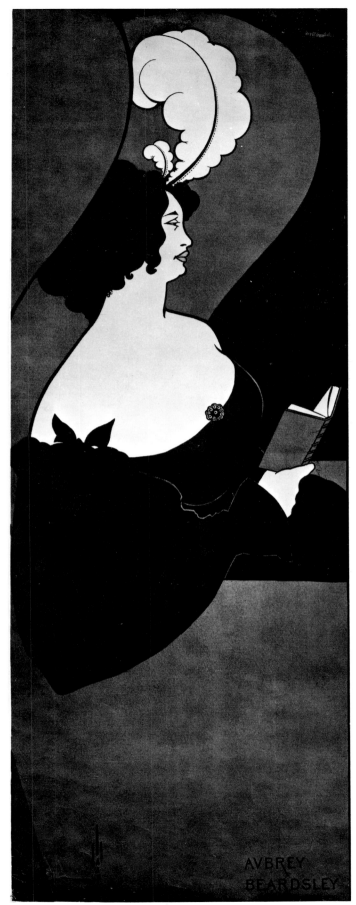

AVBREY
BEARDSLEY

125

126

127

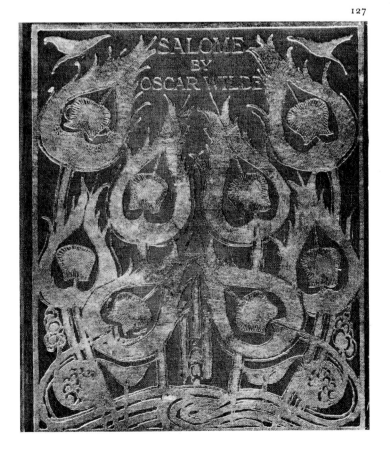

121

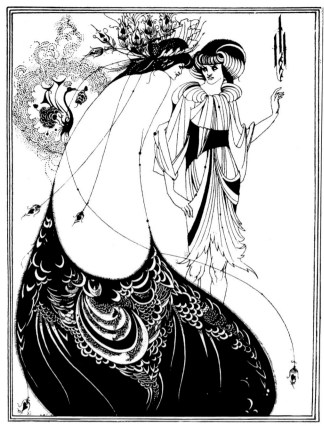

128

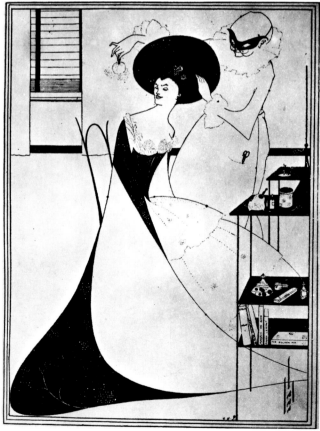

129

his lines he creates hard contours that may seem splintered or widely free in their diverging curves. He was fully conscious of the significance of his line as early as 1891, when he stated that the artists of his own day understood very little of the importance of the contour. He felt that the strength of the old masters lay in their use of outlines and linear relationships, and that the modern artist's weakness was his reliance on color harmonies and relationships rather than linear harmonies and relationships. Blake had already demanded concise and determined lines: "the more distinct, sharp, and wiry the bounding line, the more perfect the work of art." As everywhere in Art Nouveau, Beardsley too was opposed to pictorial Impressionist art. His lines have the sharpness of a draftsman's blueprints, and the straight lines which he sometimes inserted as architectonic elements, or as a stable counterpoise to his unstable curves, were actually drawn with a ruler. Moreover, he worked with dotted lines, with sharply defined patches filled in with black, and with playful alternations of black and white spaces, a method that he borrowed from Whistler.

Beardsley was content to rely on a minimum of means and limited himself to an exclusively two-dimensional art that remains oblivious of space and gravity, of nature and anatomy, of sculptural effects, and of light and shadow. It is a world of the surface, of a surface that appears ironically immaculate but does not lack depth. On the contrary, magically saturated with mystery and danger, it reveals that it springs from subconscious regions lying below our daylight awareness. If Beardsley lived in rooms decorated with black wallpaper and black furniture, and worked even by day with drawn curtains and lighted candles, this was not only because he hated what was normal and therefore shut himself off from the light of day. He also insisted on this artificial night because it stimulated the instincts for the research on which psychoanalysis was later founded. Julius Meier-Graefe, the German discoverer of many a genius of his generation, describes his visit to Beardsley as follows: "Beardsley owned the most beautiful Japanese woodcuts one could see in London, all of them of the most detailed eroticism. They were hanging in simple frames on delicately shaded wallpaper—all of them indecent, the wildest visions of Utamaro. Seen from a distance, however, they appeared very dainty, clear, and harmless." Beardsley was also stimulated by the designs on Attic vases in the British Museum, and he was an outstanding connoisseur of the erotica of world literature. But it is more important that, by nature, "he had an intuitive knowledge of evil and secret things that reached back beyond the memory of a single generation. He enjoyed frightening people with this knowledge"[28] and, like Baudelaire, "cultivated the magic skill of transforming what might disgust us into something fascinatingly beautiful."[29] The same might also be said of Beardsley's only written work, the romantic short narrative, *Under the Hill*, which transposes the legend of Venus and Tannhäuser, made famous by Wagner's music, into an erotic grotesque. Certain pas-

sages of this prose poem make us think of an excerpt from Krafft-Ebing's *Psychopathia Sexualis*, which belongs to the same age, and which Beardsley might well have disguised here as an elegant fairy tale.

More than 300 illustrations, marginal drawings, and initial letters for Thomas Malory's *Morte d'Arthur* (plates 130, 166) kept Beardsley busy in 1891 and 1892, and constitute his first important work. His Pre-Raphaelitic style immediately had a slight quality of caricature and, with the addition of Japanese elements due to the obvious influence of Burne-Jones, became increasingly a parodistic style. From the borders that frame some designs by William Morris, Beardsley extracted the Art Nouveau element which in his hands assumed the highly decorative qualities of Art Nouveau. When, in 1893, the publishers of *The Studio* wished their first number to create a sensation, they introduced Beardsley to their readers; from that time he never stopped being the target of the press in London, New York, and Chicago, and he soon became Wilde's rival as the cynosure of the critics. In 1894, Beardsley achieved his peak in *Salome*. Nothing of the kind had ever yet been seen and his irritated critics, disturbed by the mystical quality of Beardsley's genius, concentrated their attention on the anatomical weaknesses and the obviously perverse features of the illustrations in order to condemn him as a leader in the decadent movement in art and literature. In April, 1894, the first issue of *The Yellow Book* appeared; Beardsley filled this new quarterly's bound issues mainly with his own drawings and provided shocking cover designs for its various issues. When, on April 5, 1895, Oscar Wilde was arrested, Beardsley's activities on *The Yellow Book* came to an end, and his drawings were withdrawn from the press a few days before the appearance of the new issue. Wilde's trial (which Ricketts declared to have done irreparable harm to English art) not only provoked a migration from London's fashionable districts to the French coast, but also acted as a warning: the limits of what the critics and the public could accept as a provocation had been reached. It almost marked the end of hedonistic aestheticism, the manneristic, symbolistic, and romantic component of Art Nouveau. But, after Wilde had served as a scapegoat and indignation had died down, his plays continued to be performed before full houses—with the suppression of the author's name. A new Beardsley periodical then appeared, more brilliant than ever; *The Savoy*, started in 1896, died with Beardsley in 1898. The very title of this voluminous artistic and literary periodical suggested the Savoy Hotel, which was already synonymous with metropolitan elegance. In 1897, Beardsley

130

128 AUBREY BEARDSLEY *"The Peacock Skirt" from Oscar Wilde's "Salome"* (1894)

129 AUBREY BEARDSLEY *"The Toilet of Salome" from Oscar Wilde's "Salome"* (1894)

130 AUBREY BEARDSLEY *Initial from Sir Thomas Malory's "Le Morte d'Arthur"* (1893)

still turned out a few wonderful drawings, in a new style reminiscent of aquatints, the most beautiful of which was a bookplate for Olive Custance, the wife of Lord Alfred Douglas, which Beardsley created just before he died on the French Riviera. In the last of his letters "in which one can see a human being die,"[30] he begged his publishers to destroy his illustrations for *Lysistrata* and all of his other lascivious drawings, a desire which was fortunately never fulfilled.

"His influence was far-reaching: it spread from the art of book illustration to literature and even to the style of living."[31] It extended from Will Bradley in Chicago (plate 215), who left a lasting mark in the field of American books and posters, to Léon Bakst in St. Petersburg. In Germany, Marcus Behmer, Franz von Bayros, and Alastair gratefully acknowledged Beardsley's stimulus. Without him, Thomas Theodor Heine's style would not be imaginable, any more than the styles of Otto Eckmann or Heinrich Vogeler-Worpswede, and it has been proved that even Paul Klee was initially influenced by Beardsley. In Glasgow, Mackintosh and the Macdonald sisters were known to be Beardsley's followers. It is less easy to obtain evidence of the deep impression he made in Vienna, though Fritz Wärndorfer

(whose famous music room was decorated by Mackintosh, and who owned sculptures by Minne) assembled a great number of Beardsley's drawings and autographs and translated some of his letters into German. In the poems that served as the text for Arnold Schönberg's *Pierrot Lunaire*, in the manner it was performed (the reciting lady standing before a Japanese screen), but most of all in its very music, we hear an echo of the hysterical Beardsley atmosphere. In Russia, extensive Beardsley monographs were published, and as late as 1914 a play was staged in Moscow entirely in the Beardsley manner, the sets, costumes, and even the masks of the actors being in Beardsley's black and white.

Apart from Lautrec, Paris at first showed little interest in Beardsley, whose drawings were nevertheless shown at the World's Fair of 1900. But it was only in a particular domain of the final phase of Art Nouveau, and subsequently in the styles of the couturier Paul Poiret and the sophisticated designers around him, as well as in the *Gazette du Bon Ton* (1915–26), that Beardsley found many Parisian followers.

Charles Ricketts

The art of Charles Ricketts (1866–1933) reveals the same refinement and reserve, the same disconcertingly manneristic charm, though the form and the mood may differ from Beardsley's. In 1889, the periodical *The Dial* appeared, bringing him to the attention of the public. It was mainly decorated and illustrated by him (plate 131), and also published some of his fairy tales. The illustrations, endpapers, and binding for Wilde's

131

A House of Pomegranates followed in 1891 (plates 132, 133, and 135). Later, Ricketts also turned toward antique themes, such as Hero and Leander, Amor and Psyche: *Nimphidia and the Muses' Elizium* (plate 134) was set in an Arcadian and idyllic world. Rossetti was a powerful example to Ricketts, but Burne-Jones, Whistler's Japanese style, and Japan itself acted on him as stimuli as they also had acted on Beardsley. Like Beardsley, Ricketts learned much from the Greek vase painters, as had Walter Crane before them (this is especially evident in Crane's *Echoes of Hellas* and even in *Baby's Own Aesop*).

Among other things, Ricketts decorated most of Wilde's books. The binding for *A House of Pomegranates* (plate 135) of 1891 combines a fairy-tale atmosphere with great elegance and a rare quality of form. With the linear symmetry of a carpet design, the strange boughs of the pomegranate tree reach out into the corners of the binding. The crocus blossoms appear in uniform rows like a repeated wallpaper pattern, yet with interesting variations in their ornamental arrangement. The themes of the peacock and the fountain help to establish a balance between abstraction and illustration. But the images, intentionally transposed as symbols, oblige one to proceed from optical contemplation to the deciphering of the signs. This was what Wilde's critics were unable to do; they were scandalized by this bookbinding design in which they could find no sense, or could see at best a top hat turned upside down.

The style of the lettering follows that of Blake or of Rossetti (who had also borrowed from Blake); in their curves and premeditated irregularity, these characters seem to be little ornamental creatures. Quite in the sense of Blake and with great imagination, letters, image, and ornament are alternatively assimilated to each other in a manner that served as a criterion both for Blake's book decorations and for Art Nouveau. In 1889, Wilde was still complaining: "At present, there is a discord between our pictorial illustrations and our unpictorial type. The former are too essentially imitative in character and often disturb the page instead of decorating it." Wilde's *House of Pomegranates* was the first book that Ricketts decorated. Owing to the cover and the endpapers, the illustrations, the asymmetrical construction of the page in Whistler's style, and, last but not least, the harmony of design and text, Ricketts created a book that may be considered as one of the most outstanding in this field of Art Nouveau.

Ricketts distinguishes himself from Beardsley by using landscape elements and forms borrowed from nature which, it is true, appear as ideas conceived by Darwin or Bergson and presented here in a kind of symbolical disguise. Under Ygdrasil, the universal tree (plate 136), the "wheel of the flame of life" whirls as its flames leap up to the figure of man who ecstatically reaches up into the universe. Fishes and birds, bees and frogs—all inhabit the boughs of the tree of life. But what most surprises us is perhaps a landscape represented in *The*

131 CHARLES RICKETTS *Vignette from "The Dial" (1889)*
132 CHARLES RICKETTS *Vignette from Oscar Wilde's "A House of Pomegranates" (1891)*
133 CHARLES RICKETTS *Illustration from Oscar Wilde's "A House of Pomegranates" (1891)*
134 CHARLES RICKETTS *Title page for Michael Drayton's "Nimphidia and the Muses' Elizium" (1896)*

134

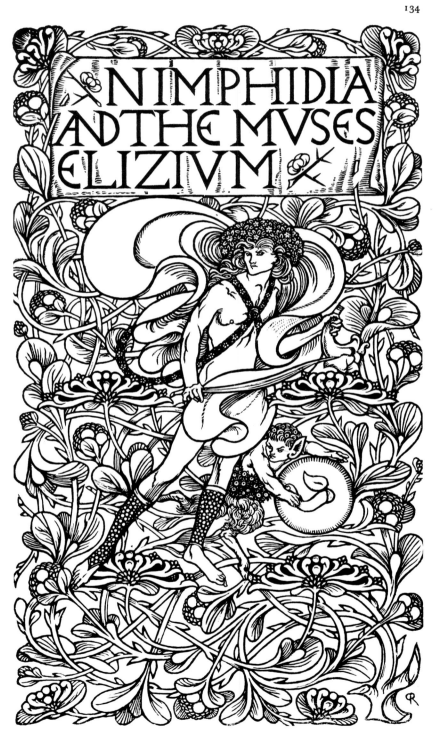

132

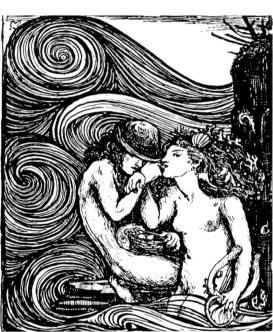

133

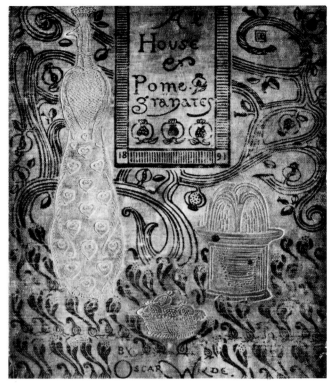

135

Sphinx (plate 137), a poem by Wilde for which Ricketts designed a decorated book. Cliffs formed of jagged and sharp-edged stone slabs surround a circular lake with a flat island in its center. On the island, there are three trees in which vague reminiscences of nature are crystallized into ornaments and symbols. Apart from a

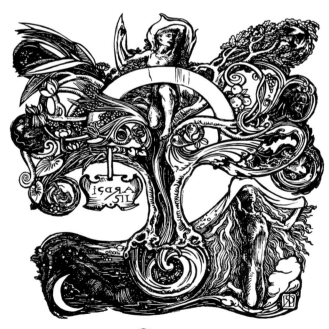

136

total renunciation of all natural objects and forms, one could scarcely imagine anything more remote from nature. Later, it was said that this book might well have been decorated by a Cretan artist of the Minoan period, though this civilization was still unknown in 1893.

Laurence Housman (plate 138) and Thomas Sturge-Moore were both endowed with dual gifts, as illustrators and poets or writers. Like the designs of Ricketts or Beardsley, their drawings were conceived as applied or decorative book art. They likewise began more or less from the same starting point, the Pre-Raphaelitism of Rossetti and Burne-Jones and Whistler's Japanese style; and of course they both knew Blake. The expression of the personality of each artist varied within the limits of this synthesis, but they both preferred to turn away from everyday life and live in a fairy-tale world, which did not preclude elegance in their work. But this spectral weightless world of fable, iridescent and slightly decadent, with its idyllic groves filled with amorous nymphs, muses, oreads, undines, and sylphs, youth-like maidens or maiden-like youths, this dreamworld of the Sphinx, of Salome, of Narcissus, of peacocks and lilies, all these creatures of a *paradis artificiel,* irrevocably began to fade and wither after Wilde's trial. Toward the turn of the century, English posters and illustrated books thus became more realistic, more ''adult,'' and reasonably normal. Figures from contemporary daily life, newspaper vendors, soldiers, even Queen Victoria, take the place of disconcerting creatures born of the imagination; men are true men, women are true women, all is again as it should be.

The Beggarstaff Brothers, a working community founded by William Nicholson (1869–1949) and James Pryde (1872–1949), distinguished itself in the domain of the poster (plate 139), and Edward Gordon Craig, who later reformed stage design, in that of the original woodcut (plate 140). Line engraving is momentarily discarded, the linear style of Beardsley and Ricketts is abandoned in favor of two-dimensional bodies, broader and more ''plastic'' as the outlines assume volume. French influences of Lautrec and Vallotton (the Beggarstaffs had studied in Paris) are visible now that figurative invention is no longer conceived from the start in a two-dimensional plane but begins from the optic appearance of reality, with foreshortenings, plasticity of the forms, and effects of light and shade. Craig's subsequent stage designs, in which he works exclusively with compact, bare, cubic blocks and their negative complement, the cubic hollow, clearly belong to late Art Nouveau. In their geometrical abstraction, they surpass the creations of Glasgow and Vienna.

135 CHARLES RICKETTS *Binding for Oscar Wilde's "A House of Pomegranates"* (1891)
136 CHARLES RICKETTS *Bookplate* (1892)
137 CHARLES RICKETTS *Illustration for Oscar Wilde's "The Sphinx"* (1894)

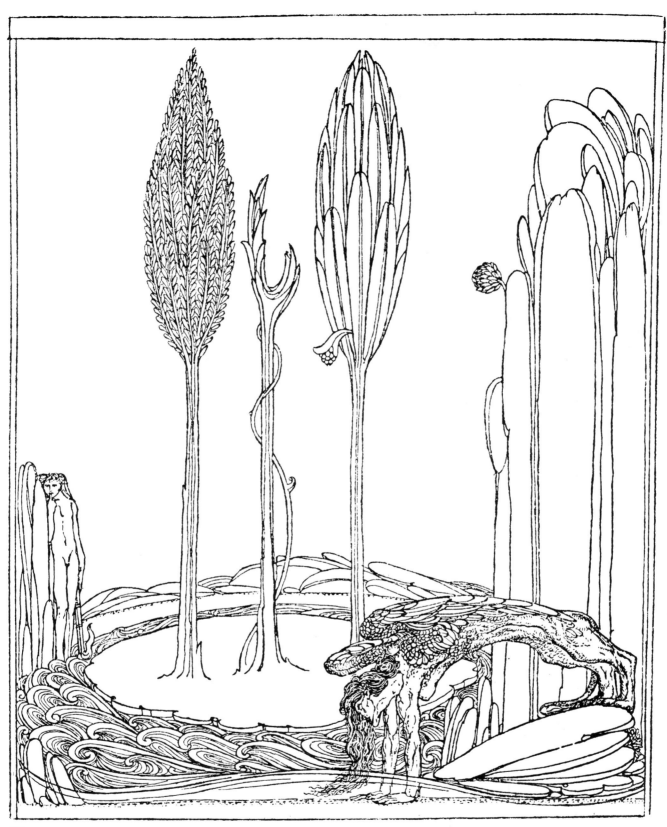

137

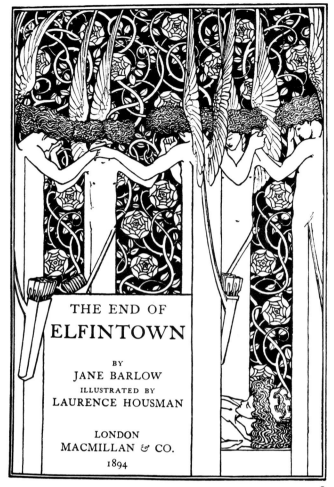

138

and Loos. In addition, we have in Voysey and Ashbee a typically English conception of structure. The contrast between supports and beams, the plastic values of the building, the volume of a wall, these they scarcely stress; for that matter, English architects in general tend similarly to conceive a building in terms of thin upright surfaces which are created solely by the proportions and the somewhat graphic lineaments of the windows.

Charles Annesley Voysey (1857–1941) was influenced by Mackmurdo, as is obvious in his surfaces, his fabrics, and his wallpapers. In his furniture, rooms, and houses, he borrows the forms of the older master. However, for

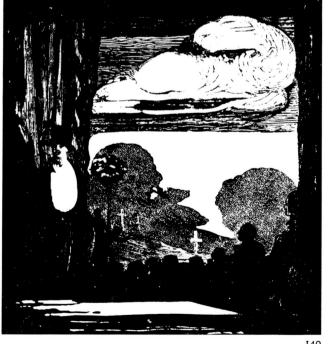

139

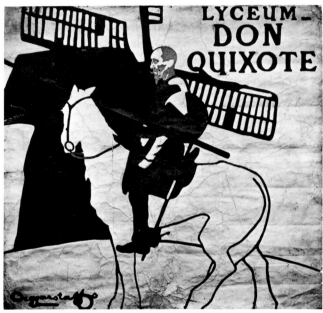

140

Charles Annesley Voysey

In English architecture, examples of extreme late Art Nouveau are as rare as buildings in the curved style of High Art Nouveau. Instead, architects like Voysey and Ashbee developed the Arts and Crafts architecture of Philip Webb and Norman Shaw (plate 43) in more modern terms. Webb and Shaw diverged from the styles of true historicism in that their houses followed the tradition of their native land and did not imitate Italian palaces, Greek temples, or Gothic town halls. Besides, they adapted traditional forms to new needs and possibilities, which led them to a moderate purism and an almost geometrical expression of form. Voysey and Ashbee followed them in this trend, which they simplified until they found a basic form, thus achieving a distillate, the few and constant elements of which they used creatively in new combinations. The thread of tradition wore thin without altogether breaking; but this did not allow them the freedom of originality which Mackintosh attained though he proceeded from the same starting point.

In their almost affected purism and in their lack of all accessories, Voysey's and Ashbee's buildings scarcely fall short of the purist examples of late or final Art Nou-

Voysey as an architect, Japanese influences were perhaps even more important, though they are scarcely recognizable as such in his work. One of his most interesting works, the tower-like house in Bedford Park that he finished in 1891, is an exception (plate 141). The light roof with its low gradient, the concave curved roofing of the oriels, the thin metal supports that seem to raise the roof over the body of the building, the unusually small windows, and the one stressed bull's-eye window are not outright Japanese forms; but the graphic, abstractly ornamental, and asymmetrical character of the surfaces, the contrast in black and white between the apertures and the whitewashed walls, not to mention the frieze-like disposition of various groups of windows under thin horizontal ledges, all clearly reveal the relationship to Japanese architecture, easily recalling Japanese teahouses and small temples, as for example Voysey's similar but lower and longer country houses (plate 142), which are a particular national achievement of English art.

Both within and without his houses, Voysey discards ornamental detail. His only decorative effects are produced by the essential elements of the rooms; while their

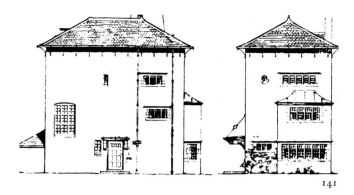

141

functionality is stressed, their proportions are eccentric. The fireplace in the hall of the house called *The Orchard* (plate 143) is purposely heightened, but the hearth is disproportionately small; the door next to it seems unusually low, and the hinges and doorknob are placed on its outer edges; the staircase which reaches right up to the ceiling suggests a well, a motif that was later often adopted, particularly in Vienna and Glasgow. However cozy and founded on respect for tradition and culture such rooms may seem, their asymmetry, their accentuated bareness and luminosity, nevertheless strike a slightly extravagant or disturbing note.

In his metal vessels, Voysey comes closer to Continental Art Nouveau, even more than in his designs for textiles. As early as 1883, he began working on this kind of design under the supervision of his master, Mackmurdo. His designs for fabrics and wallpapers (plates 144, 145, and colorplate V) are all so fresh, with their flowers, birds, and shrubs suggesting spring, that they survived Art Nouveau and remained popular for several decades.

138 LAURENCE HOUSMAN *Title page for Jane Barlow's "The End of Elfintown"* (1894)
139 BEGGARSTAFF BROTHERS (WILLIAM NICHOLSON and JAMES PRIDE) *Poster for "Don Quixote"* (1895)
140 EDWARD GORDON CRAIG *Illustration for Hugo von Hofmannsthal's "Der weisse Fächer"* (1907)
141 CHARLES ANNESLEY VOYSEY *Elevations for a house in Bedford Park, near London* (1888–91)
142 CHARLES ANNESLEY VOYSEY *Broadleys residence, Lake Windemere, Westmorland* (1898)

142

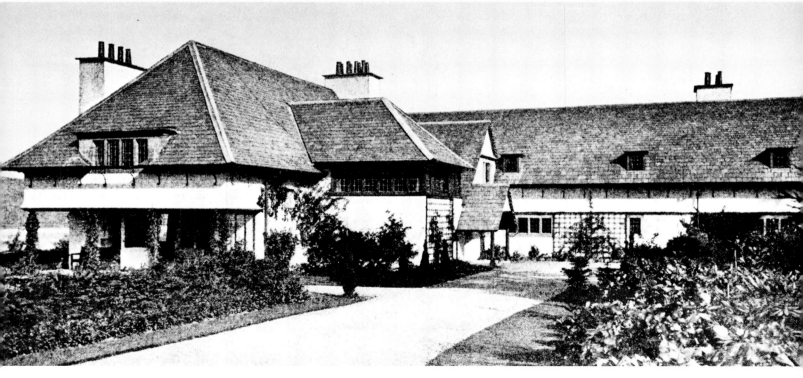

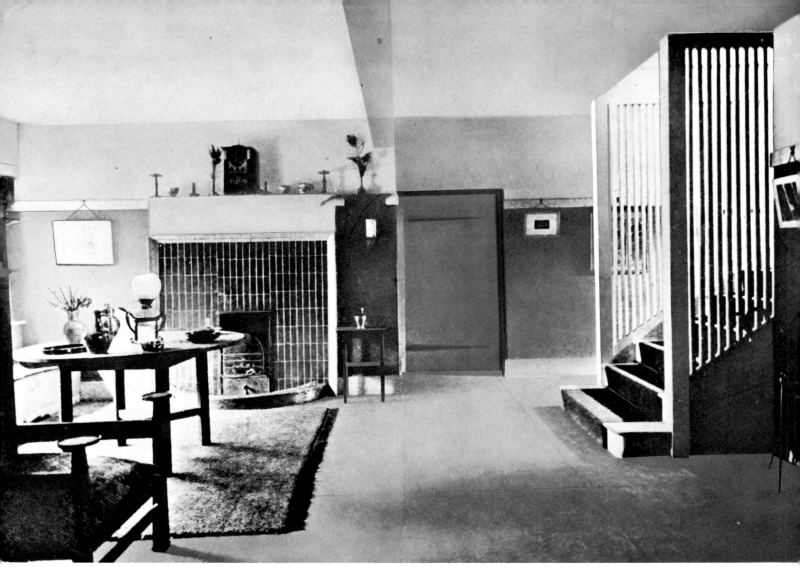

143

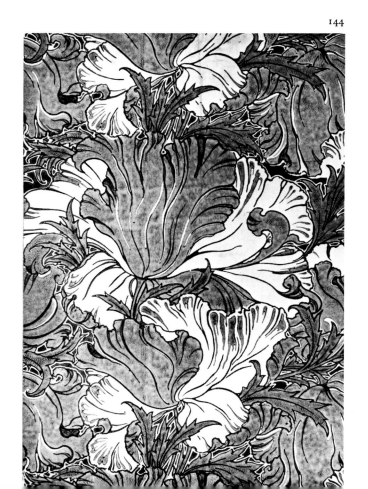

144

145

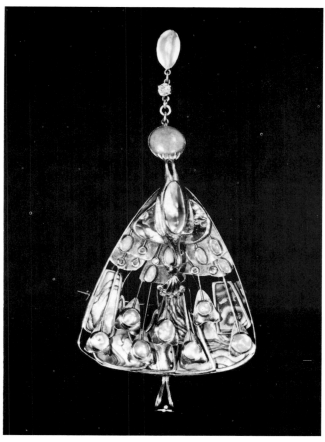

146

the façade (which may have been imposed by the proportions of the ground plan) was consciously stressed, especially in the exaggeratedly pointed gable which contains a wheel-shaped window in a somewhat Classic style and is terminated asymmetrically at different levels, as well as in the overlong windows, the upper row of which seems to hang from the cornice, in the relationship of the floors to one another, in the division of the façade into a light color above and dark below. All this is original, strange, and composed with great feeling. In spite of obvious affinities with Voysey's house in Bedford Park and with Norman Shaw's *Old Swan House* (plate 43) which cannot be overlooked, Ashbee's work can never be mistaken for that of any other architect.

Charles Harrison Townsend

Charles Harrison Townsend (1852–1928) was the only one of the London architects to adorn his buildings with ornaments and, moreover, with sculptured ornaments. Townsend also followed Continental developments more closely than his colleagues. The façade of the Whitechapel Art Gallery, built in 1897 (plate 150), in which relief is stressed, was conceived by him as a symmetrical whole, but its details are asymmetrical and its naturalistic relief of foliage is disposed in a geometrical, non-naturalistic manner. Much more than Voysey or Ashbee, Townsend's ornamentation is borrowed from historistic medieval examples and presented in the Pre-Raphaelitic

147

Charles Robert Ashbee

The architect and designer Charles Robert Ashbee (1863–1924) developed in his handicraft work a curved and swinging style of Art Nouveau. This can be seen in his silver jewelry, often gold-plated (plate 146), and above all in his silverware, in which he follows England's famous century-old tradition (plate 147). Though less known, Ashbee is to be counted among the most important English architects of his period. His art also derived quite naturally from that of Webb and Norman Shaw, but he remains the architect who was best able to transpose most consistently England's traditional country-house style into a style suited to London's multiple dwellings.

Like Voysey's houses, and related to them in form, Ashbee's London house in Cheyne Walk, dated 1903 (plate 148), substitutes mannerism and artificial shapes for movement and swinging lines. The narrowness of

143 CHARLES ANNESLEY VOYSEY *Living room in the artist's home, "The Orchard," Chorley Wood, Buckinghamshire* (1900)
144 CHARLES ANNESLEY VOYSEY *"Tokyo" wallpaper* (1893)
145 CHARLES ANNESLEY VOYSEY *"Cereus" wallpaper* (1886)
146 CHARLES ROBERT ASHBEE *Pendant* (circa 1900)
147 CHARLES ROBERT ASHBEE *Mustard pot and spoon* (circa 1900)

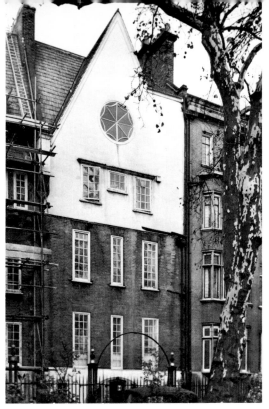

148 CHARLES ROBERT ASHBEE *38 Cheyne Walk, London* (1903)
149 CHARLES HARRISON TOWNSEND *St. Mary the Virgin, Great Warley, Essex* (1904)
150 CHARLES HARRISON TOWNSEND *Whitechapel Art Gallery, London* (1897)

148

149

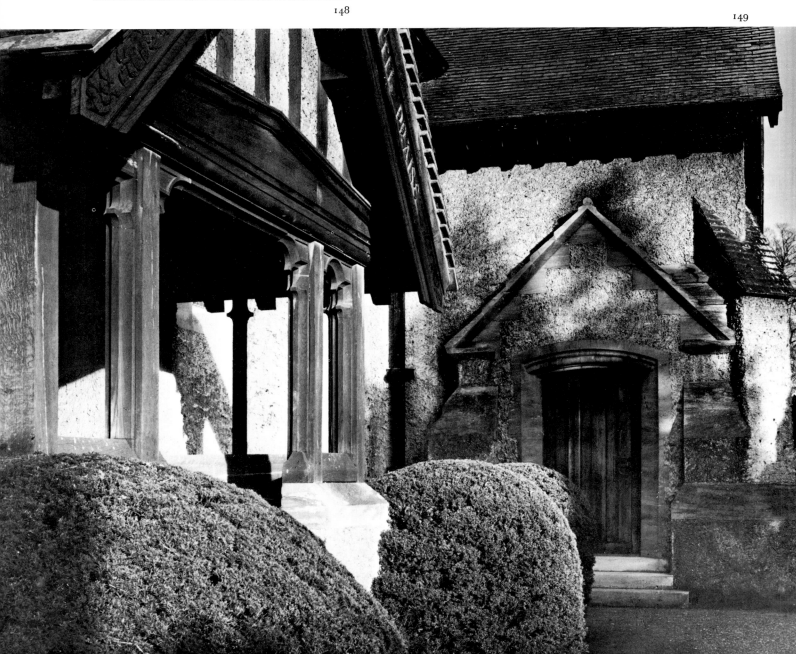

fashion. Townsend also built the church at Great Warley, Essex (plate 149). Simplified and synthesized in form, it reminds one of medieval English village churches; its interior offers us England's most complete example extant of a unified Art Nouveau ensemble, though the style expresses itself again in decoration and furnishings rather than in pure architecture. The predominating color note is the gray of the hewn stone which, together with the walnut brown of the pews, forms the basic harmony. But the vaulting is traversed by ribbons made of aluminum; plates of aluminum decorated with embossed lilies are inserted into the walls, and above the light-green marble balustrade and an altar in dark-green marble, the whole vaulting of the apse is covered with sheets of aluminum. Bunches of grapes in the style of William Morris stand out in brilliant red and Heywood Sumner's windows display angels in red robes standing against green foliage. The whole interior was designed by Sir William Reynolds-Stephens (plate 151) in close harmony with the plan devised by the donors; all the decorative designs were meant to divert attention from death and evoke the idea of resurrection. When, in 1904, the church was handed over to the community, a leaflet was distributed to explain the symbolical plan; it makes special mention of the "floral forms," which are freely used everywhere as emblems of growth in earthly life, but even more as symbols of the glorious hope culminating every year at Eastertide when plants awake to new life. The organic power of self-renewal is thus used everywhere throughout the church as a Christian symbol of resurrection. Reaching far beyond traditional church symbolism, the botanical style of Art Nouveau is here considered suitable for ecclesiastical ritual.

In the ironwork dividing the main aisle from the neighboring areas, the pillars are represented by blossoming trees; there is a hint of the swelling "Belgian" line in the crowning foliage, but the delicate openwork relief nevertheless remains a two-dimensional surface. The altar railing is conceived in the same flat way and composed of lines that recall Voysey and Mackintosh.

Great Warley stands between High and late Art Nouveau, even though it is closer to the latter. The square form of the pillars, the stereometric form of the baptismal font and the lectern, the squares and rectangles of inlaid marble and glazed enamel are all features which are already characteristic of a later period. They show, however, certain signs of High Art Nouveau.

The common genetic origin of High and late Art Nouveau resulting from the early Pre-Raphaelite period can be more clearly seen in Great Warley than anywhere else. To this must be added certain features of Byzantine art which played a part in the ecclesiastic architecture of 1900. The richness of the materials endows the little church with a particularly Byzantine feeling, though the veined and multicolored marbles and the sensitive contrasting harmony of brass, copper, and steel produce no ostentatious pomp.

GERMANY, SCANDINAVIA, AND SWITZERLAND

German *Jugendstil* is characterized by both floral and abstract trends, and the opposition between them found expression in violent disputes. The battle cries of both parties do in fact conceal profound divergencies which conferred on each of these types of *Jugendstil* a clearly contrasting character. Of course, this creative tension between two poles lasted only a short while. Looking back, it is now clear that these two trends were in essence phases that succeeded and replaced each other. The more important achievements before 1900 were mainly of a floral character, and those after 1900 almost exclusively abstract. In the two or three years preceding the end of the century, there was, as it were, a classical period during which the two currents were able to intermingle.

Floral *Jugendstil* is mainly to be found in the decoration and ornamentation of small objects in the applied arts. Function, functional form, and functional symbolism played scarcely any part as yet, according to a formula which is now so offensive to modern ears: "Beautiful and, if need be, useful as well." The form of floral *Jugendstil* is light, delicate, sensitively shaped, often buoyant or spindly, sometimes confused. The structure is linear but rather detailed in its small parts, with little

150

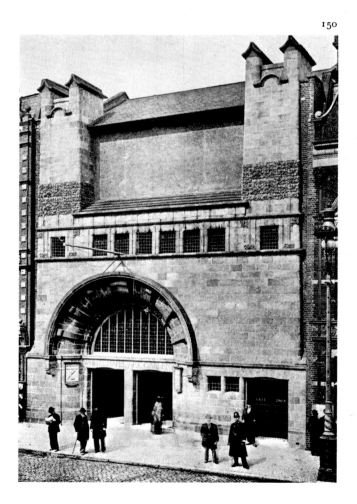

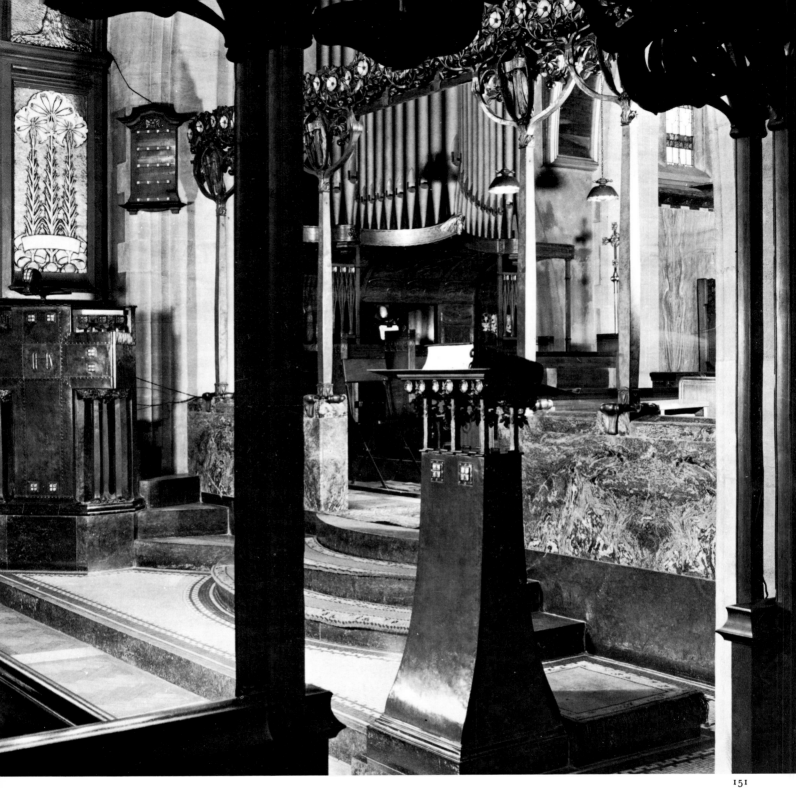

broken lines of a distinctly graphic nature which creates the possibility of a comparatively open form. The complementary relation between the forms is not yet systematically carried out. The atmosphere is spring-like and extends from the fairy tale to the purely fantastic. There are romanticism and symbolism, not in the Western

151 WILLIAM REYNOLDS-STEPHENS *Detail of the interior of St. Mary the Virgin, Great Warley, Essex* (1904)

sense of worldly elegance, but in that of an ardently pursued approach to nature. The conception of floral *Jugendstil* also contains that of the object represented: not only flowers and plants, but also the animal world, swans and other birds, even lowly mammals and other creatures are used as themes. In spite of this, when Thomas Theodor Heine drew a dachshund vignette, this merely represented a parody of the languid aspects of *Jugendstil*. Unlike French developments, German

Jugendstil aims at increasing abstraction and deformation of patterns derived from nature, seeking to achieve a metamorphosis which would result in the creation of an indefinable, organic, and elementary mixture of forms.

For a long time, German artists remained true to the two-dimensional (like their English counterparts) but were in opposition to Art Nouveau in the Latin countries. Rocaille, which had been so decisive in achieving the three-dimensional, was almost nonexistent in *Jugendstil*, although Rococo in Germany had assumed an extremely spatial and sculptural quality. The early phase of *Jugendstil* is almost entirely rooted in English floral Art Nouveau. There may also have been an influence coming from Belgium, as for instance from Van Rysselberghe or from Khnopff's and Doudelet's illustrations which had been published in Germany in *Pan*. There is no trace of any influence from Holland, not even from Toorop; as for Paris and Nancy, the style appeared there at the same time as in Germany, if not a little later. Nor, in the years that followed, had the German artists any particular connection with French Art Nouveau.

The later, abstract phase of *Jugendstil* was largely inspired by Henry van de Velde. Ornament and decoration turn entirely away from examples found in nature. What remains is dynamic movement stripped of all concrete form; this served as a leitmotiv for Van de Velde and the entire school of abstract *Jugendstil* until (in its late phase and mostly influenced by Vienna) the style stiffened here as elsewhere into geometrically static form. In the *Jugendstil* of the abstract phase, the structural and tectonic element prevails over the ornament, so that all that remains is body and space; in the floral phase that preceded it, *Jugendstil* had remained confined to the two-dimensional. Ethical tendencies, the need for a significant reform—the word "reform" is applied to everything from "reform house" to "reform dress"— find their advocates. The demands for honesty and good workmanship that had been expressed by Ruskin and Morris was largely echoed in the ideas of the *Deutsche Werkbund*, founded in 1907.

Preliminary Stages in Germany

Preliminary stages of *Jugendstil*, whether floral or abstract, are rarely to be found in Germany and very seldom have they any causal relationship with German Art Nouveau. The paintings of Hans von Marées (1837–87) were in every respect painterly. But the flowing relationship between the forms in a picture such as *Ganymede* (plate 152), the simplified outlines, the transformation of the objects into two-dimensional bodies with scarcely any shading, the sometimes clearly distinguishable complementary forms, the grandiose conception of the picture as a whole, the unstable center in the asymmetrical equilibrium of the contrasts of light and dark, the ornamental quality of the entire painting, and lastly the outer border which encloses the scene represented by the picture, all these features are already close to the

Jugendstil of a few years later. Whether Marées knew how Japanese painters compose their pictures is a moot point. There is, however, no doubt that the work of Marées belongs to the neo-Mannerist phase of nineteenth-century post-Romanticism by which Art Nouveau and *Jugendstil* were largely influenced. The themes and forms, the highly unstable conception, the hints of *figura serpentinata*, the slightly neurotic atmosphere full of yearning and resignation, are indeed reminiscent of Pontormo or Parmigianino. But the art of Marées contributed no more to the formation of *Jugendstil* than had Philipp Otto Runge's proto-Art Nouveau. After having been entirely ignored for many decades, Runge's paintings were, thanks to the new ideal of art and beauty, rediscovered in Hamburg in 1906 by Alfred Lichtwark, the director of the Hamburg Museum, whose mind was receptive to other novel approaches to art.

Max Klinger (1857–1920) was the only artist in Germany to have achieved a style that clearly heralded *Jugendstil*. After 1875, his designs showed great powers of invention. They were mostly applied to frames and borders (plate 153), which may be considered as belonging to an independent early stage of *Jugendstil*. The drawings themselves contain a considerable element of *Jugendstil*—even if it is not openly revealed; one can feel it in the asymmetrical, ornamental composition of forms foreign to nature, pointing to examples in Japanese art in the contrasting empty areas and others that are crowded with small, detailed forms, as well as in the representation of numerous objects. To be sure, this component loses significance compared to the baroque invention of his work; the irregular, extremely open, and heterogeneous forms and the frequently stressed naturalism.

Klinger's proximity to *Jugendstil* becomes most clearly evident in the books he decorated. His illustrations for the ancient myth of *Amor and Psyche* (1880) are the first and only important work of art in this field between the works of Adolf von Menzel and those of German *Jugendstil*. A profusion of *Jugendstil* elements are to be found here, not so much in the illustrations themselves as in the borders. This is undoubtedly early *Jugendstil*, but the forms are still too graceful, too disintegrated, the whiplash line is not yet revealed, nor the typically *Jugendstil* two-dimensional bodies, and Klinger's objects are still seen from a distance rather than at close range. But the swinging curves already show the genuine rhythm of *Jugendstil*.

The Munich Group

Romantic *Jugendstil* stylizing forms of nature first began in Munich, which remained the permanent center of the floral style, as well as the German art center where inspirations and ideas originated. Although it was soon to be superseded by Berlin, artists of every trend assembled there. The movement began in 1894, with the Munich exhibition of embroideries by the sculptor and

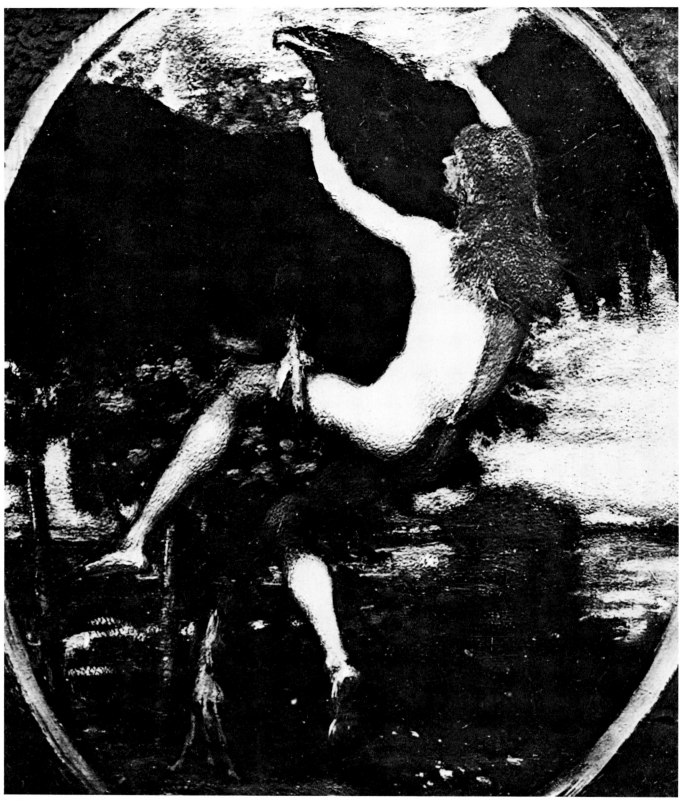

152

152 HANS VON MARÉES *The Abduction of Ganymede* (1887)
153 MAX KLINGER *Page border from Apuleius' "Amor and Psyche"*
 (1880)
154 HERMANN OBRIST *"Cyclamen" wall hanging/"The Whip-
 lash"* (1895)

naturalist Hermann Obrist (1863–1927), which contained "a certain mysterious, primary charm," as Friedrich Ahlers-Hestermann says in his fine book on the "turn of the style," *Stilwende*. Obrist was the son of an aristocratic Scottish lady and a Swiss doctor. He had first studied medicine, the natural sciences—botany, chemistry, and geology—and from childhood had studied plants and animals with the liveliest interest, "exploring the phenomena and forces of Nature."[32] In 1886, a prophetic daydream showed him the way to art: "A complete city appeared in the air, the architecture of which surpassed everything and was unlike anything" he had ever seen. "In this city all was in motion; the streets shifted, displaying squares and fabulous fountains; the houses opened up, showing inconceivably beautiful rooms and enigmatic objects."[33]

In 1888, Obrist began to study ceramics in Karlsruhe;

he soon turned away from the traditional, academic style and went to a rural pottery works in Thuringia. In 1890, he subsequently moved to Paris and became a sculptor. In Florence, in 1892, he founded a workshop for embroidery which was transferred to Munich in 1894. He had discarded the conventional manner of representing figures in the round and devoted himself to designing ornamental forms, at first limited to the two-dimensional plane. These "organic embroideries" were carried out by Berthe Ruchet. "Often, no single stitch is like any other; an inextricable flickering maze of different stitches invades the ornamental forms, as if animated by a pulse beat or enlivened by organic forces and rhythms like the cells of a living body."[34]

The following has been said of Obrist's famous tapestry of golden-yellow embroidery on pale turquoise-colored rep, the *Whiplash* of 1895 (plate 154): "Its

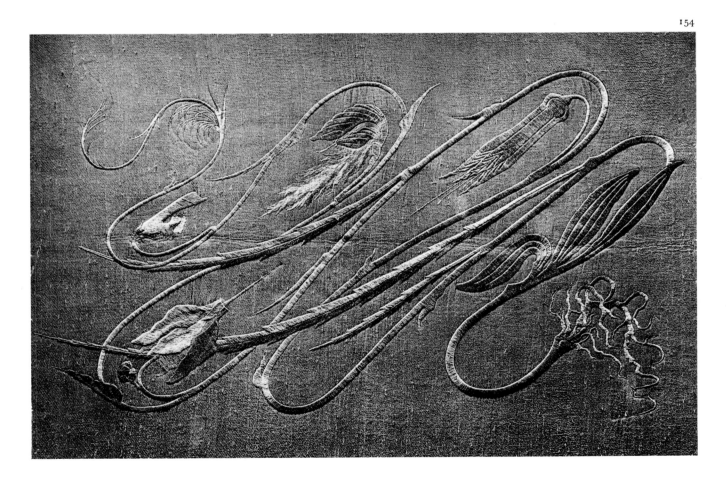

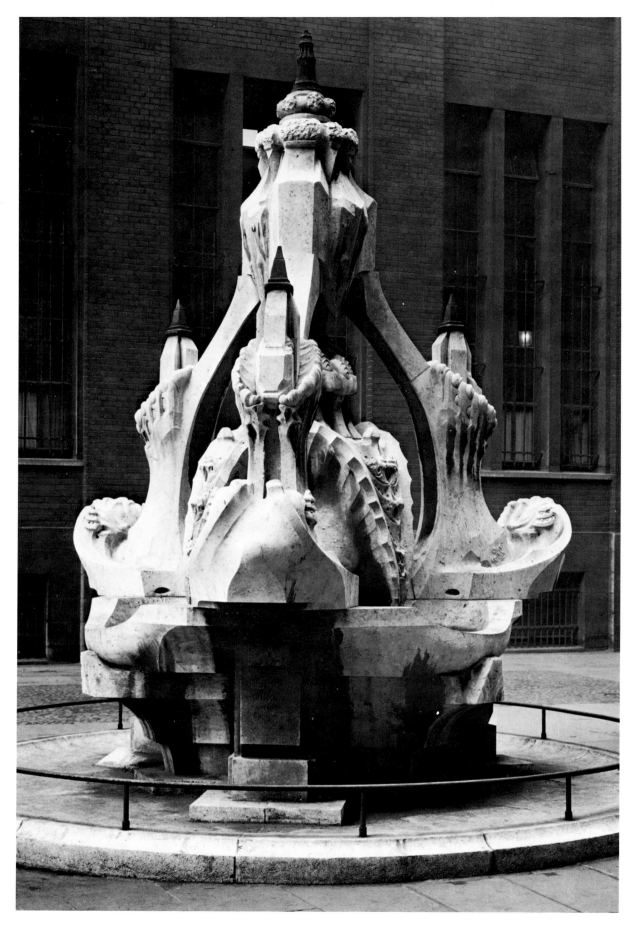

138

frantic movement reminds us of the sudden violent curves occasioned by the crack of a whip: now appearing as a forceful outburst of the elements of nature, a stroke of lightning; now, as the defiant signature of a great man, a conqueror.''[35] Here, calligraphy blends with elementary forces in powerful tension—the form of the cyclamen is interpreted as the *pars pro toto* of created nature, the delicate branching of the roots, the sap-conducting stems, the stiff tips of the buds, the stamens and pistils all representing both the existence and the growth of a plant. On the borderline dividing the symbol and the ornament between abstract dynamism and the representation of a distinctive organism, there arises the visual metaphor of palpitating and struggling life itself. Owing to its content and its decorative quality and elegance, the *Whiplash* belongs to the small number of masterpieces of German *Jugendstil*.

In the beginning, Obrist was doubtlessly helped by Japanese models, even though it has rightly been stressed how greatly his works differ from Japanese art; after all, floral and flat Art Nouveau had already existed for many years in London. In 1887, *The Hobby Horse* published photographs of an exhibition hall of the Century Guild. In addition to Mackmurdo's screen (plate 54) in the silk-embroidered flaming flowers of which one senses the organic life so eloquently described by *Pan*, the photograph also displays a carpet with diagonally disposed spirals that reveal affinities with Obrist's embroidered tapestry. A widely traveled cosmopolitan artist who was half British himself, Obrist may well have been acquainted with works of this kind.

Once Obrist had developed a personal style, he turned from two-dimensional works to sculpture. Whatever Obrist models, chisels, and constructs is ornamental. Unlike Horta, who developed from linear English wallpapers with a floral pattern strictly ''linear'' bodies such as metal supports or floral electric lighting fixtures, Obrist turned from his weightless, feathery embroideries to massive and powerfully plastic volumes. His big ornamental jars, chiseled or sculpted, his tombstones and fountains, all seem to have sprung from an ambiguous substance which shifts from stony rigidity to the doughy clay from which ceramics are made. According to Obrist, figures in the round should yield ''pleasurable sensations, imparted by touch and the joys of touching,'' and thus give rise to a wide range of perceptions, ''the sensation of what is smooth, rough, hard, soft, elastic, stiff, supple, of what is swelling or flat, smooth or sharp-edged.'' Questions of creative means and their powers of expression, such as the problem of abstract form, were already considered, but still related to abstraction and nature. Actually, nowhere in his work did Obrist restrict himself to reproducing and magnifying minute botanical forms; instead, he condensed these into fantastic creations of great structural force. His fountain

for Krupp von Bohlen in Essen (plate 155), conceived in the nineties, reminds one not only of the gaping jaws of imaginary sea creatures, but of the filigree crown of a monstrous iris. He also included in his artistic conception of this piece the rapid element of water, swirling around the raggedly horned buttresses and the knobbed calices. The body and the empty spaces, the interior and the exterior contours, are all complementary. The round core is split and half curved toward the exterior where, as a sort of cage, it spans and surrounds an interior form that appears as soft as flesh.

The figure of man is banished from all this. Even proportions and structure are no longer related to anthropomorphic forms; in the place of articulations or joints, we have a kind of viscous gliding, out of which erupt bulges and volutes. ''To be sure, the human figure permits wonderful sculptural possibilities. But merely compare it to the Tortoise Fountain in Rome whose basins are among the most luxuriously plastic in the world. But what connection has the relief on the rim of these basins with the human nude? What could be more plastic than a small, old, round, and much-thumbed Japanese ivory box, and what could have a more plastic, massive, and titanic effect than the Tyrolian Dolomites . . .? No: the human nude is not the beginning and the end of sculptural form.''[36]

In August, 1898, the popular review, *Die Jugend*, jocularly emitted an ironic prophecy: ''The time will come when, in public squares, monuments will be erected representing neither men nor animals, but imaginary shapes which will fill the heart of man with exuberant enthusiasm and inconceivable enchantment.'' In reality, this time had already arrived: in the same year, 1898, Obrist created an entirely abstract work, the plaster model for a *Monument to the Pillar* (plate 156). Out of a ''natural'' rock rises the immaculately smooth shaft of a column, its capital representing, in a labyrinthine cluster of stereometric forms, the transition from the cross section of the pillar's shaft to the covering square slab.

But there are fundamental differences between such works by Obrist and genuinely modern Cubist or Constructivist sculptures. The actual pillar is the theme of this work, even though the choice may seem unusual; such a theme is symbolic, a parable, so to speak, of the transformation of chaotic matter into such as has been shaped by the mind. The beginning of the pillar winds up in serpentine twists out of the pedestal made of raw, unhewn rock, and transcends this material base. The ''capital'' is transposed into a stereometric movement which embodies the crystalline nature of the stone. The classically conventional abacus, the covering slab, integrates all the above-mentioned features into the given form of the pillar, the abbreviation of the architectonic element, and terminates the procedure as a period ends a sentence. This astonishing work thus stands midway between historicism and modern art and, as early as 1898, embodied the style of geometric late Art Nouveau, and it is the only known example in the field of abstract

155 **HERMANN OBRIST** *Fountain for the Krupp von Bohlen residence, Essen* (1913)

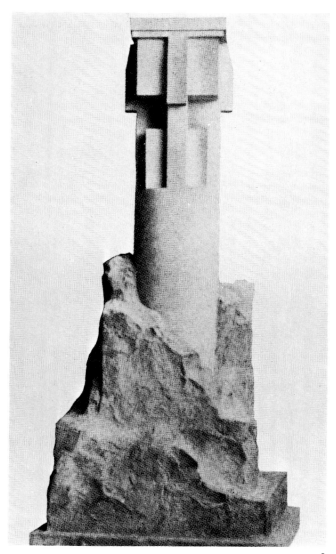

156

essence, Obrist transposed the drama of content into the drama of form. The peak projecting diagonally into space becomes a cry expressed in stone; in a way, it corresponds in sculpture to the painting by Munch entitled *The Cry* (colorplate II). Here, the expressive element of *Jugendstil* begins to turn away from the objective theme and to point toward Expressionism, just as the dynamic element of *Jugendstil* pointed toward Futurism. Curjel has quite rightly compared this piece of sculpture to Boccioni's Futurist *Muscoli in velocità* (1911), and even more surprisingly to Tatlin's Constructivist design for a *Monument of the Third International* (1920).

The relationship between Obrist and August Endell (1871–1925) was almost that of master and pupil. Born in Berlin, Endell had first studied philosophy and later returned to his native city after having spent a few decisive years in Munich in the Riemerschmid and Obrist circle. The chief work of his Munich period was the redecoration of the façade of the *Elvira Photographic Studio*. The world of Endell's forms is quite as subtle as Obrist's, but more exuberant and unruly, suggesting at the same time some grotesque features. The fanciful ornamentation of the *Elvira Studio* is no more floral than abstract, but it is organically alive and formed of a substance which possesses all kinds of biological possibilities, although presented almost in confusion. From an undefinable cellular mass, sharp antennae emerge from beneath a gigantic protruding thorn which terminates on the left in a sort of comet's tail. Beneath it, in the opposite direction, emerges a sharply ragged form like a bat's wing, its ramifications reminding one of the

sculpture in the round. It is also the only example of an artistic anticipation in Obrist's work; generally, he preferred to work in a more emotional idiom in which he nevertheless continued to conquer for *Jugendstil* the domains of monumental art, an area which he was the first of his school to explore.

In 1902, the *Design for a Monument* (plate 157) was created. At first sight, it was again an abstract form: as sculpturally daring as Rodin, Obrist here abandoned the urge for erect anthropomorphism and went beyond the static, structural norm of the vertical axis in the case of a monument which actually never went beyond the plaster model. The form seems to dart like an arrow into space, a monument of the diagonal, encircled by an orbital spiral. Only on a second look does one realize that at the very top an angel with ragged wingtips is lifting an upward-striving figure veiled in clouds toward the summit. This "sculptural study of movement"[37] is not nonobjective in the modern sense of the word, but is the embodiment of its own symbolical content. Yet, in

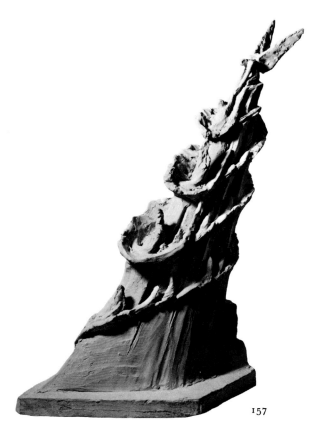

157

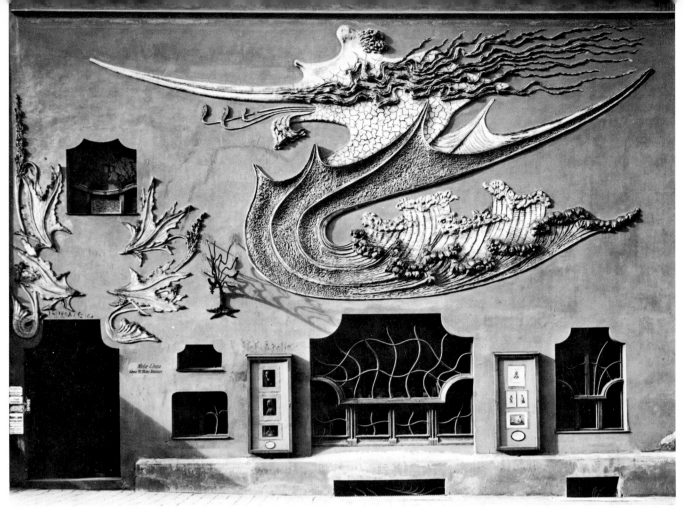

foamy waves of the sea. The whole shape has the swerve
of a question mark and the vigor of an exclamation point;
it is life, aggressive in itself, without sense or aim,
eternally quivering and pliantly eluding all attack, a
creation of magnificent decorative effect, a significant
form unparalleled in the whole of Art Nouveau (plates
158, 159). These forms are varied and repeated in the
relief of leaves above the door, in the window grilles, and
in the interior staircase.

The ornamentation of the *Elvira Studio* is carried out
in relief which gives the appearance of looking as though
one of Obrist's embroideries had been enlarged to
enormous size and spread over the façade of the entire
building. The façade is entirely flat except for the base
at the foundation and the top ledge which proceeds to
curve outward forming a gentle overhang. The window
apertures are cut into the walls without any ledges or
molded curves, and except for the wave-like wooden
grilles of the central window, the windows and the
thicker portions of their inner frames are quite different

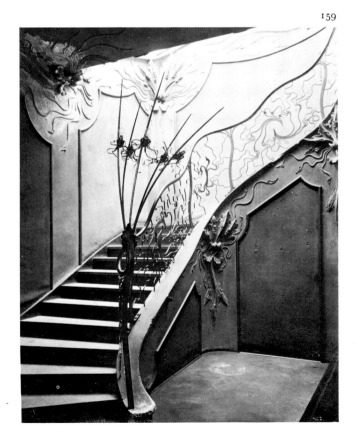

156 HERMANN OBRIST *Monument to the Pillar* (1898)
157 HERMANN OBRIST *Design for a Monument* (1902)
158 AUGUST ENDELL *Façade of the Elvira Photographic Studio,
Munich* (1897–98)
159 AUGUST ENDELL *Staircase in the Elvira Photographic Studio,
Munich* (1897–98)

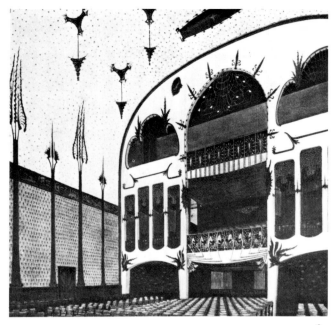

160

in style from the ornamentation of the façade. The silhouettes of the window apertures are geometrically defined, consisting of right angles at the bottom with convex quarter-circles at the top corners looking like looped-back curtains—the entire effect somewhat anticipating late Art Nouveau. Similar forms are repeated in the surprising designs which Endell published in 1898 and which Nikolaus Pevsner reprinted fifty years later. They are studies of the proportions of entirely flat façades in which Endell tests the emotional impact of over-narrow and overbroad façades and window apertures. In Endell's *Buntes Theater* in Berlin of 1901 (plate 160), the forms are more detailed than in the *Elvira Studio*. The vaulted ceiling of the auditorium looks as though living cells had grown together, a theme also employed by Gaudí in the *Casa Batlló*. From this sky, starred with small protoplasmic dots, hang lamps that are as pointed and coral-like as the trees decorating the side walls. Around the upper part of the walls runs a frieze with all sorts of submarine creatures such as sea dragons, sea serpents, sea horses, and aquatic insects. Over the curved proscenium arch and the balcony and box railings, metal spider webs are stretched; above the stage is suspended a gruesome monster of mixed origin, part squid, part jellyfish, and part stingray, while the curtain is decorated with ornaments suggesting butterfly cocoons, caterpillars, and seed pods—such an ensemble can scarcely be qualified as architecture. Endell decorated the *Buntes Theater* for Ernst von Wolzogen and his artistic *Uberbrettl* cabaret revue. "Since not much money was to be spent, a dreary old dance hall in the distant Köpenickerstrasse was redecorated. Endell shot off the whole fireworks in his decorations which were full of spikes, restlessly sparkling, flickering in little flames; the rows of seats were of different colors, indicating the different prices; even the usherettes, dressed in green and mauve,

wore aprons which ended in points above and below, giving the arriving audience the impression that the little theater itself was the first number of the program. As a piece of brilliant grotesque, it was the highest achievement of *Jugendstil*. Had it been achieved with less wit, it might have turned into the most shocking tinsel amusement park decoration."[38]

Like all other significant German *Jugendstil* artists, Endell was very versatile; he designed furniture, carpets, fabrics, and jewelry. In the big department stores and other buildings which he built later in Berlin and Breslau, the ornamentation was greatly reduced without, however, being entirely suppressed. The swing which had mostly been applied to the surface was now extended to space and to the body of the building itself; however, these buildings fell short of the originality of his first works.

Otto Eckmann (1865–1902) was considered in Germany the undisputed master of floral *Jugendstil*. As in Obrist's case, Eckmann's beginnings date back to the decisive year 1894. A native of Hamburg, he used to sell his pictures by auction, considering them his "artistic legacy," before subsequently turning to the designing of furniture, lamps, and articles of common usage. But his best work was achieved in two-dimensional art, in ornamentation and often half-illustrative decorations for books and periodicals such as *Die Jugend* and *Pan*. *Die Jugend* was started in Munich in 1896 and was decidedly popular in its editorial policy, being somewhat uncritical in its choice of contributors, its presentation rarely reaching a very high level. Eckmann therefore submitted his finest works to *Pan*, not to *Die Jugend*. As early as 1895, Berlin was in competition with Munich, and with the publication of *Pan* it became the second German art center. The spiritual father of this unprecedented periodical was Julius Meier-Graefe. *Pan* was a luxuriously produced publication, large in format, printed to perfection on exquisite paper, and very exclusive in tone. Its policy was one of open-mindedness and generosity, and it welcomed contributors from all over Europe, taking in its stride diversified talents ranging from Nietzsche to Toulouse-Lautrec, from Khnopff to the poet Scheerbart, Van de Velde to Hofmannsthal (who wrote under the nom de plume of Loris), from Seurat and Signac to Klinger, Böcklin, or Liebermann, and from Beardsley to Minne. It was *Pan* that published the first and probably the finest vignettes and decorative borders by Otto Eckmann, Thomas Theodor Heine, and Emil Rudolf Weiss; works by such writers as Fontane, Schlaf, Dehmel, and Bierbaum were also published there, and museum directors such as Bode, Brinckmann, and Lichtwark were among its other contributors.

Some of Eckmann's finest works created for *Pan* were

160 AUGUST ENDELL *Buntes Theater, Berlin* (1901)
161 OTTO ECKMANN *Fighting Swans* (circa 1900)
162 OTTO ECKMANN *Sketch for a decorative design* (1897)

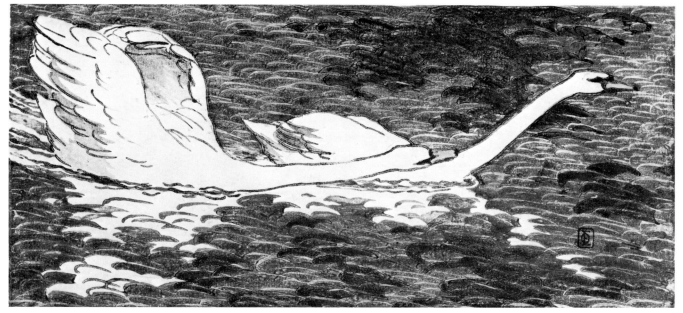

synthesized and simplified floral vignettes (plate 165), consisting of lines of such uniform width that they may be considered as linear two-dimensional bodies that sink into the white paper like inlaid work. In Eckmann's other creations his style is not always distilled as it is here to the point where it yields its finest essence, but his form is never heavy, never without grace. Despite his affinity with Obrist, Eckmann's work refrains from appearing as hard or as pointed; it has a less interrupted flow of form and a softer movement. Nor do Obrist's and Endell's symbioses of organic hybrid forms occur to any appreciable extent in the work of Eckmann, who is mainly preoccupied with floral themes, using blossoms possessing swinging leaves and antenna-like stamens, above all with lilies, irises, and other long-stemmed flowers; or else, with those swans which have now become almost the symbol of his art, with their gracefully curved necks and proud bearing. He represented them more figuratively, as in a colored woodcut (plate 161), or

more ornamentally abstracted, as in his frieze of swans (plate 162), where they are reduced to swinging, powerful lines, almost reaching the abstraction of calligraphic symbols.

In 1897, he also designed some architectonic supports (plate 163) which might be said to suggest plants. Not only is every descriptive impulse lacking in their form, but the basic theme of a supple, upward surging movement has also been diverted from the representation of any concrete vegetal pattern. Only four years later, in 1901, did Van de Velde create anything similar, in the supports of the Folkwang Museum (now the Karl-Ernst-Osthaus Museum) in Hagen. This is all the more worthy of attention because Eckmann, in the polemical writings of Van de Velde, is named as the principal representative of "sentimentality as expressed in ornamentation." Actually, although Eckmann continued to produce floral designs, and in spite of many a sentimental blunder, he had been the first in Germany to achieve an

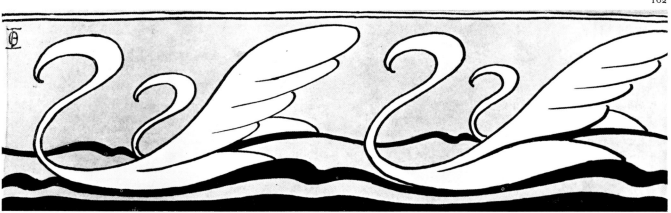

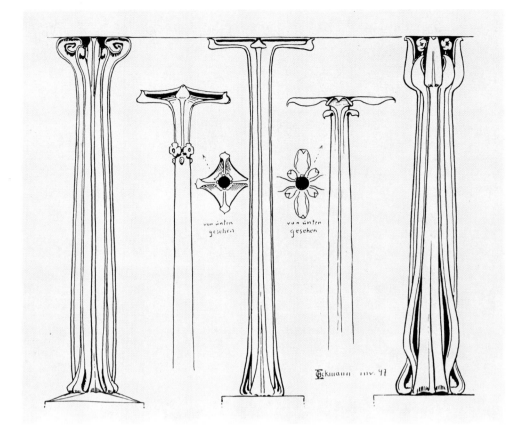

163

163 OTTO ECKMANN *Sketches for supports* (1897)
164 OTTO ECKMANN *Capital letter (circa* 1900)
165 OTTO ECKMANN *Margin design from "Pan"* (1896)
166 AUBREY BEARDSLEY *Margin design from Sir Thomas Mal-ory's "Le Morte d'Arthur"* (1893)

164

165

166

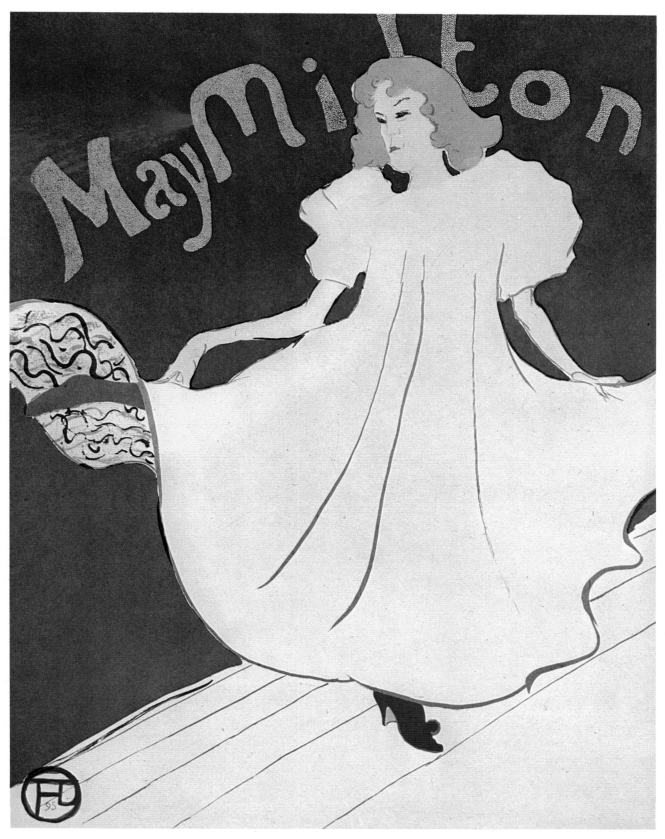

XVI HENRI DE TOULOUSE-LAUTREC *May Milton* (1895)

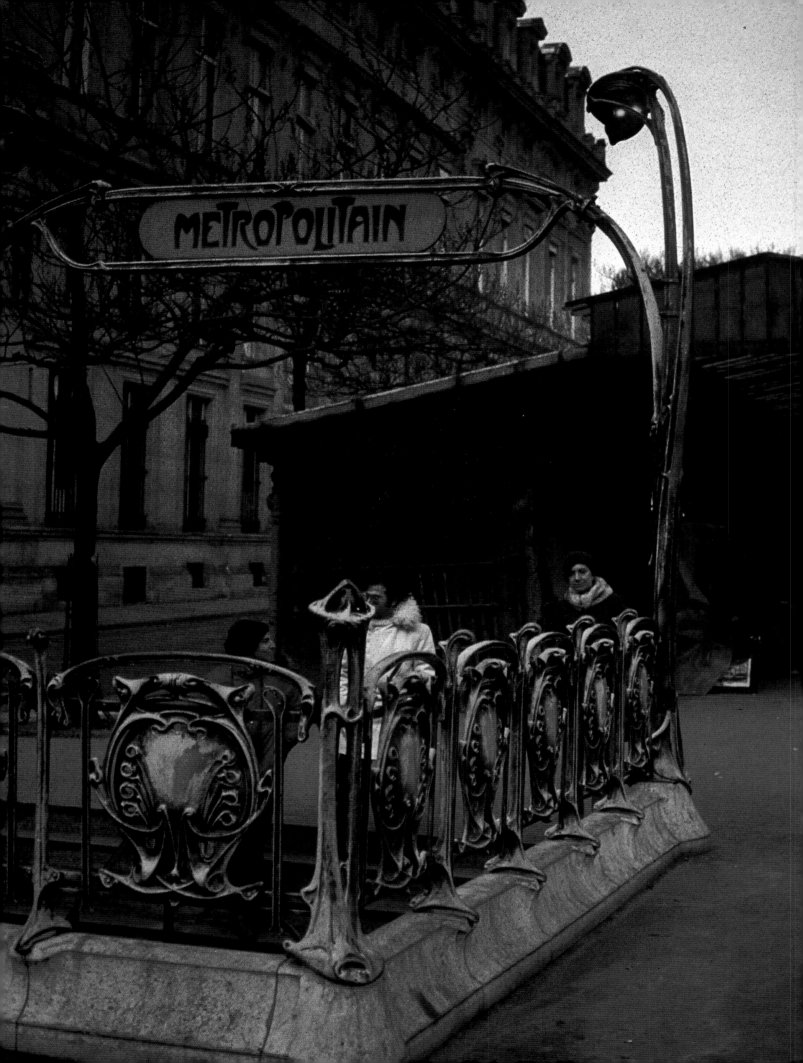

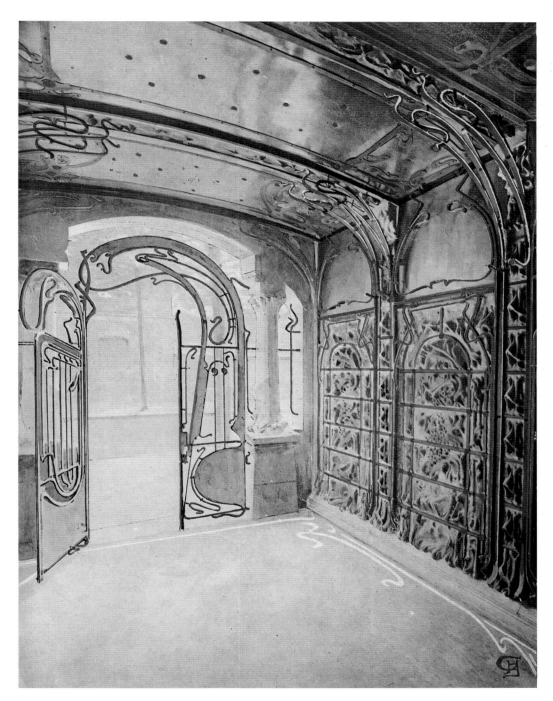

XVIII HECTOR GUIMARD *Castel Béranger, Paris* (1894–98)

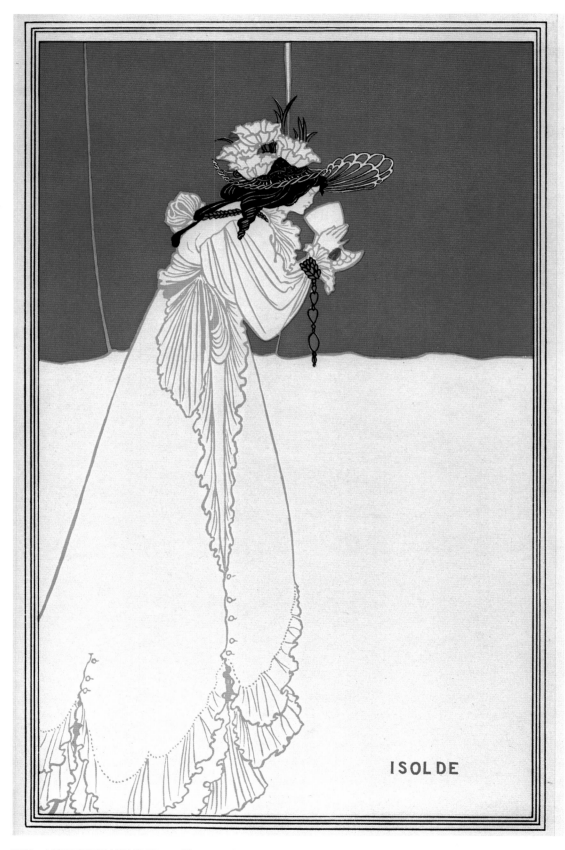

ISOLDE

XIX AUBREY BEARDSLEY *Isolde (circa 1895)*

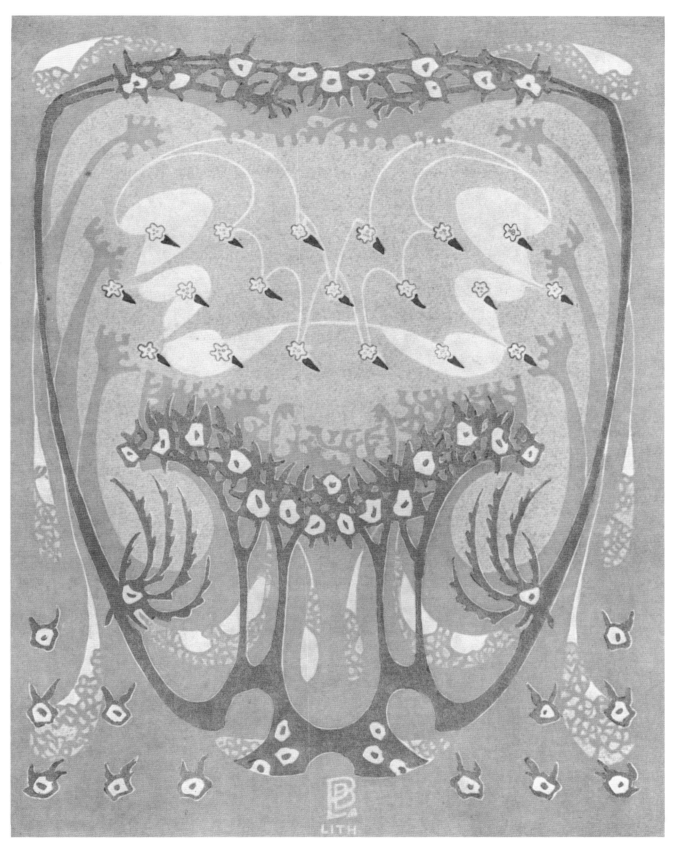

XX BERNHARD PANKOK *Endpaper for the official catalogue of the
exhibit of the German Empire at the International Exhibition in Paris* (1900)

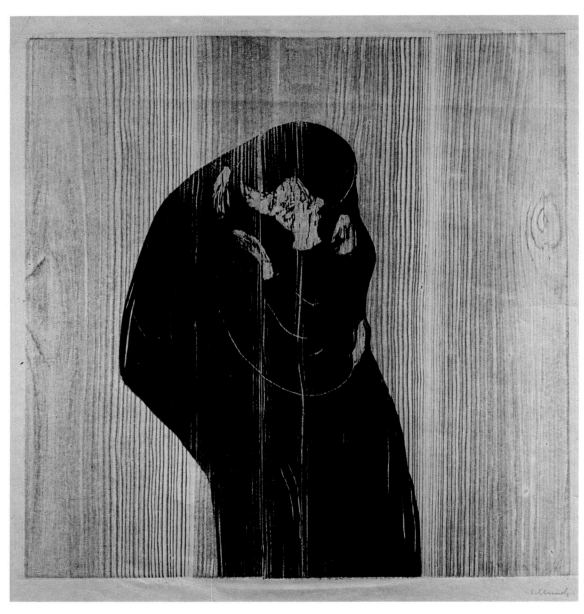

XXI EDVARD MUNCH *The Kiss* (1902)

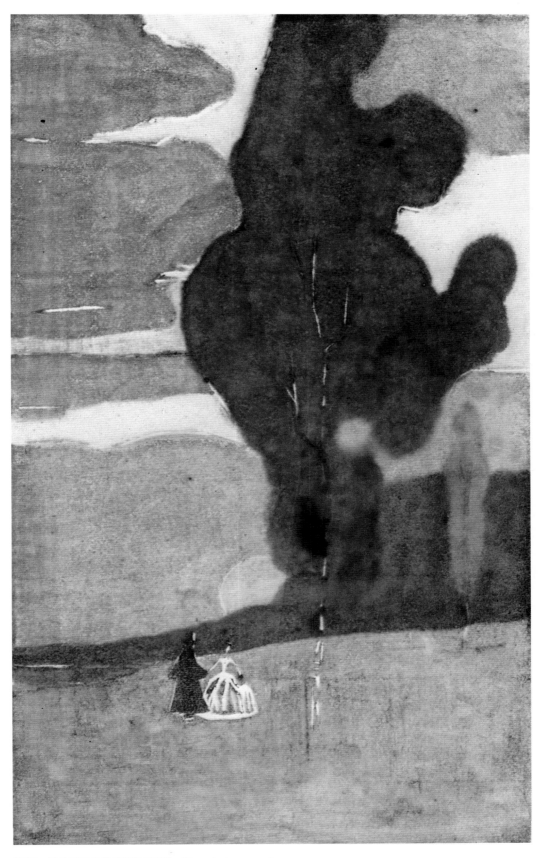

XXII WASSILY KANDINSKY *Moonrise* (1902–03)

XXIII ANTONI GAUDÍ *Façade of the Church of
the Sagrada Familia, Barcelona* (1883–1926) ▶

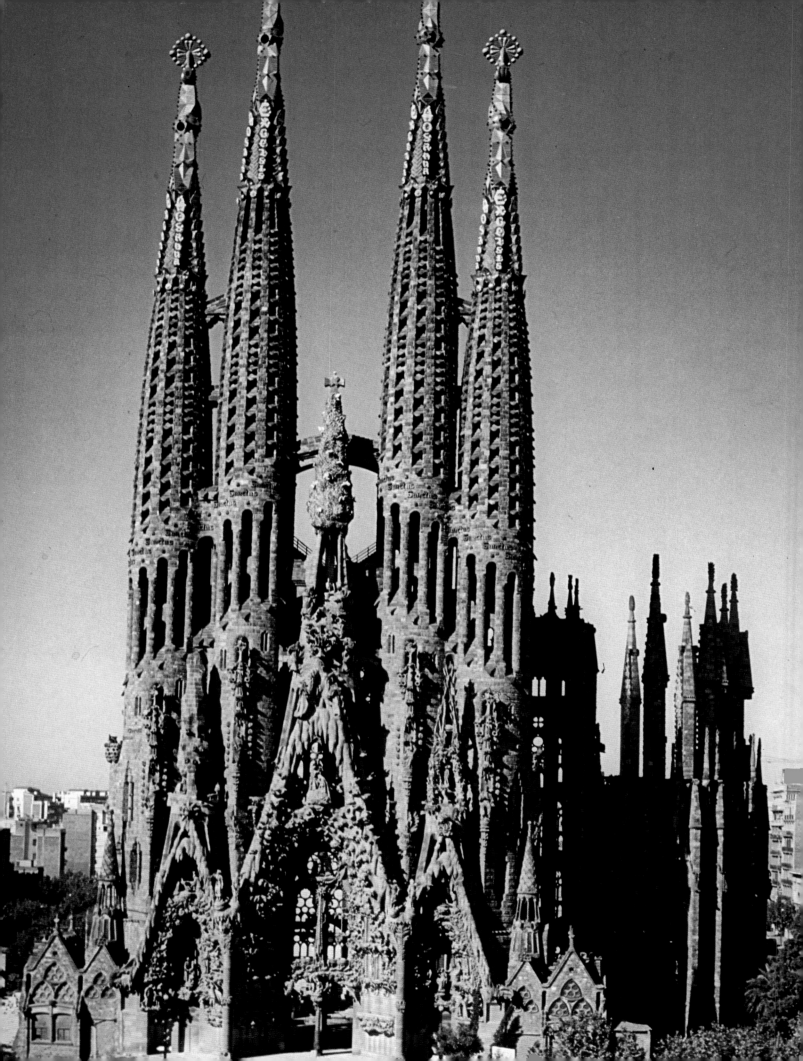

abstract dynamism equal to that of the ''Belgian'' line. His lettering, the Eckmann type, is also abstract and dynamic (plate 164); it may now be considered his main achievement, and its final form was created in 1899. True, he may have seen similar initials published by Van de Velde in 1896 in the periodical, *Van Nu en Straks*.

More clearly than in the case of Obrist and Endell, one recognizes in Eckmann's work the part played by Japan in the final form of *Jugendstil*. As a native of Hamburg, Eckmann in early youth had seen examples of Japanese applied arts in that city's Museum of Arts and Crafts, ''whose enlightened founder and curator, Justus Brinckmann, had been the first in Germany to acquire products of Japanese art, not the usual sumptuous man-high vases, but ornamental sword guards, small objects in lacquer and jade, and colored woodcuts''[39]—in fact, objects which in Japanese art come closest to Art Nouveau. Eckmann and his contemporaries were very conscious of the inspiration they were deriving from Japan; they also were aware that the English had preceded them in adapting and assimilating Japanese elements. It is moreover in Eckmann's work that one sometimes comes across examples of a direct relationship between German *Jugendstil* and English Art Nouveau.

Eckmann's 1895 decorations for a poem in *Pan* (plate 165) display in theme and style a very strong affinity with Beardsley's decorative borders for Malory's *Morte d'Arthur* (plate 166). If, in Beardsley, the still undecided symbolical content of the very expressive flowers had already surpassed that of Morris (who was more noncommittal in his decoration), Eckmann's broken tulip stem has a very strongly defined meaning: it is the symbol of the premature death of the girl who was the protagonist of the poem. Eckmann takes his point of departure from the studies of natural floral growth, but when he transmutes actual botanical forms into ornamentation his prototype is the perfected stylization of the English artists. Having learned much from Beardsley (and nature did not exist for Beardsley, who followed in the footsteps of Morris, Burne-Jones, and Whistler), Eckmann in turn attained a highly individual and specifically German style.

Peter Behrens (1868–1940) was another of the more important Munich artists to draw inspiration from Japanese objects. The founder of the *Vereinigten Werkstätten* (United Workshops) in 1897, Behrens, like Eckmann, had also started his career as a painter and designer, then turned to the applied arts, where he chiefly designed carpets and furniture, and at last arrived at architecture, a field in which his work carried him far beyond *Jugendstil* into the realms of what can be called the modern art of building. His earliest works in *Jugendstil* are ornamental drawings like the delicate sketch of butterflies alighting on lily pads framed by rushes (plate 167), and in this design his affinity with Japanese art is obvious. But unlike the other Munich artists working in the early floral phase of *Jugendstil*, Behrens, from the outset, continued to produce work that was more inte-

grated, somewhat heavier, hesitant, and viscous in conception, instead of being spikey and vigorous. In the above-cited butterfly design, the lily pads and the faintly indicated paths of the fluttering butterflies already reveal his inclination toward the oval form, while the rushes indicate his predilection for broad, ribbon-like, two-dimensional bodies. The forms are surrounded by contours in contrasting colors, a feature which vanished as soon as Behrens was subjected to the influence of the ''Belgian'' line and shifted to the abstract.

The color lithograph, *The Brook* (plate 168), shows a highly abstract stream in the flat Japanese style flowing between tree trunks and framed by large leaves. If, at this point, pictorial description has been already replaced by a highly symbolic representation of idyllic nature, the two lateral panels of the triptych repeat the flow of the water in an entirely ornamental and symbolic manner. Far removed from any conventional representation of nature, Behrens' art distills, so to speak, the essence of German Romantic art in rendering landscape and nature, making it pleasantly unfamiliar and adding an exotic element as a piquant note.

On the other hand, the style of Bernhard Pankok (1872–1943) belongs to that of Obrist's and Endell's circle. Born in Münster, Pankok lived in Munich after 1892 and, in 1897, was one of the founders of the *Vereinigten Werkstätten*. His career also began as a sculptor and a designer of surface ornament, before he went on to the applied arts and finally to architecture. His furniture and interiors as well as his surface-decorations represent an individual variation of Obrist's and Endell's forms. His knotty and antler-like forms are far removed from nature, irregular and gnarled after Dürer's fashion, and almost grim. As quasi-organic growths, they reveal a certain affinity with Hector Guimard's furniture (plate 114). But elegance and a narrow linear construction are lacking; everything in Pankok's work is much heavier, knottier, specifically middle-class and cozy, creating an atmosphere like that of Grimm's fairy tales. One of Pankok's most beautiful interiors, the alcove-like living room with an entrance through a vast curved doorway (plate 169), was designed for the Paris Exhibition of 1900 and shown again two years later in Turin. This room proves anew how German *Jugendstil* succeeded in conceiving and carrying out interior decoration in terms of an integral work of art.

Actually, the style of Van de Velde had already influenced this interior. Pankok's ensemble thus shows signs of his awareness of the ''Yachting Style,'' except that the room is not reminiscent of the cabin of a streamlined motorboat, but rather of the stateroom of a large Hanseatic liner.

In his graphic work, Pankok combined naturalistic verisimilitude with ornament, particularly in his large border designs for *Pan*, best exemplified by those for the *Phantasus* poems by Arno Holz, who merits a place of honor close to the younger Rilke and Stefan George in German *Jugendstil* poetry. Pankok's best design is prob-

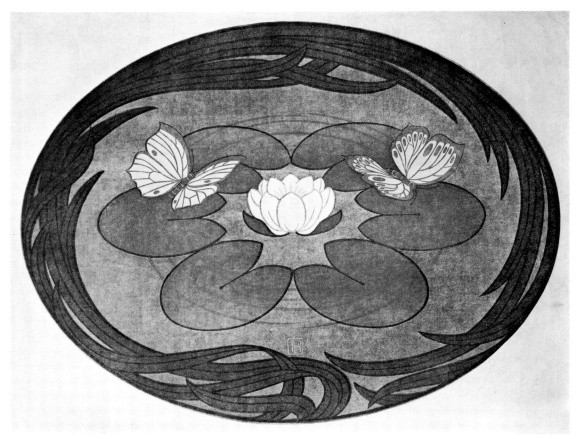

167

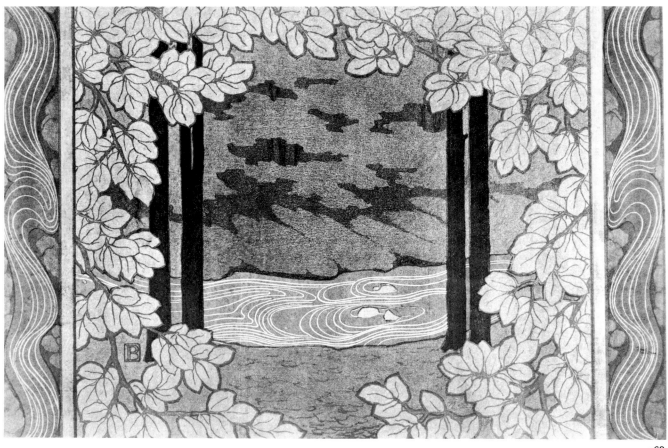

168

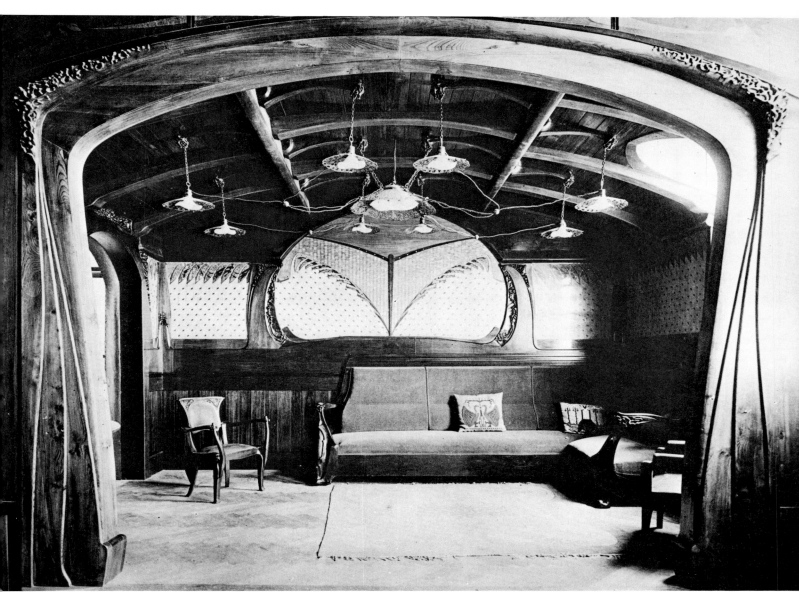

ably the color lithograph for the frontispiece in the official catalogue of the German section for the Paris International Exhibition of 1900 (colorplate XX). This is a poetic and decorative creation in which, however powerfully abstracted, a fairy-tale spring unfolds, wells up, foams forth, and flares up like fireworks: a new symbol for the metamorphosis of nature's forces as joyously exemplified in flowers. In style, this design is halfway between Obrist's embroideries and the line drawings of Van de Velde; here again—but none the less as late as 1900—we find a floral style that had become almost abstract.

Richard Riemerschmid (1868–1957), the only one of the Munich group to have been born there, was the first to follow this trend and the one who carried it to its farthest point. He too began as a painter, but as early as 1896 he designed and built his own house in Pasing, near

Munich. His field was just as universal, ranging from architecture to fabric design, glassware, and silver flatware. But he was most of all important as a furniture designer. One of his chairs (plate 170), though it obviously belongs within *Jugendstil*, is so ageless and so convincingly right that in the United States the furniture firm of Dunbar is currently producing it again, with only the slightest modification. It is devoid of ornament, having itself become a plastic ornamental form in space. The chair's supple supporting and connecting wooden

167 PETER BEHRENS *Butterflies on Water Lilies* (between 1896 and 1897)
168 PETER BEHRENS *The Brook* (before 1901)
169 BERNHARD PANKOK *Living room designed for the International Exhibition, Paris* (1900)

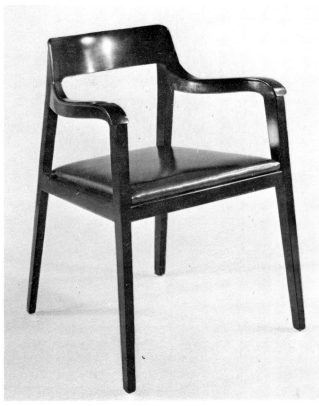

170

frame seems alive, but not really "organic" or even at all "floral." It is the very manifestation of vital forces, translated here into terms of ornament and symbol. No wonder then that Van de Velde, who was faithful to the tradition of William Morris and Arts and Crafts in advocating integrity and skilled workmanship, found these combined in Riemerschmid and said that "each of his works is a good deed."

For all his modernism (not only in the *Jugendstil* sense), Riemerschmid was primarily inspired by folklore and regional tradition. In his small easy chair of about 1900 (plate 171), he combined sturdy rural craftsmanship and urban elegance. Constructed of flat boards but still organic and plastic, a bit clumsy but almost toy-like, compact as a block but interrupted in its design within this context, it is purposeful but manifestly exaggerated, simple and labyrinthine, rustic and elegant. This piece of furniture offers indeed a dialectical synthesis of the essential qualities of *Jugendstil* and, at the same time, a convincing link between curved High *Jugendstil* and geometrical late Art Nouveau.

German ceramics of this period aimed just as consciously at rustic effects. The most important masters of pottery were Max Laeuger (1864–1952) and Johann Julius Scharvogel (1854–1938). Scharvogel's beautiful vase (plate 172) has two handles like an amphora, which give it an almost circular outline. The vessel has a swelling plasticity, without any hint of nature's forms, deriving its life only from the movement of its shape modeled in clay and from the mottled, down-flowing glaze. It is, of course, inspired by Chinese models, but in such a vase the sophistication of the Far East has regained the spontaneity of pure craftsmanship.

Scandinavia

This mixture of craftsmanship and popular art is also present in the armchairs and straight chairs which the Finnish artist Akseli Gallén-Kallela (1865–1931) constructed of birchwood and upholstered in a very beautiful wool material with fir-tree patterns appliquéd in green and blue (plate 173). These designs appear somewhat alien to all the other trends current at that time, and stress a middle-class and even rustic note, renewing the Biedermeier tradition. Akseli Gallén was most famous for his murals and illustrations. In the very first number of *Pan*, he already illustrated (or rather symbolized) Nietzsche's *Königslied*.

Apart from Royal Copenhagen porcelain, Scandinavia distinguished itself mainly in this period through its woven tapestries, chiefly Gerhard Munthe's *Daughters of the Northern Light* and Frida Hansen's *Milky Way*. Again it was *Pan* that, at an early date, encouraged these endeavors which are related to Gallén's style. A Swedish example, so far unknown, is an endpaper by Ivar Arosenius (plate 174), which stands midway between High and late *Jugendstil*. Abstraction and lightness are present in it to the same extent, while ambiguity of form that is

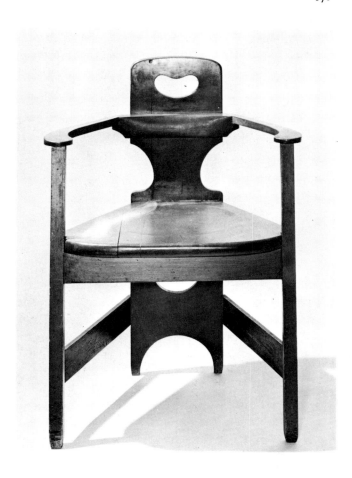

171

at the same time organic and geometric is represented in pleasing repetitions. The snail-like coils of hair on either side of each of the little heads recall actual snail shells, and the openly revealed breasts are also seen to be reversed hearts. The circular faces match the small circles in the rows of beading, and the flat spirals of the coils of hair are matched by the twined ribbon-like strips that alternate with the rows of heads and beading. The harmonious proportions of the uniformly sized circular heads, the rows of beading and the breasts, the thinly outlined forms and faint colors, all contribute to give the design an evenly distributed density. Artlessness and subtlety are skillfully counterbalanced, and together with its cheery quality (as rare in *Jugendstil* as it is in Art Nouveau) combine to assure this small-scale masterpiece a place of its own.

In the work of the Norwegian painter Edvard Munch (1863–1944), Scandinavia achieved great art in the truest sense of the term (plate 175 and colorplates II, XXI). Although Munch borrows from Gauguin (whose paintings, together with Van Gogh's, he had seen during his 1898 sojourn in Paris) the essential elements of form that belong to his unmistakably personal style, the nature of his art is so obviously "Germanic" that it can be best understood in the context of German *Jugendstil*.

During the eighties Munch joined the bohemian group of artists working in Christiana (present-day Oslo); this group's outlook combined both libertinism and criticism of middle-class society, and this viewpoint influenced the themes of the great works he was soon to produce. In 1892, Munch held an exhibition in Berlin at the invitation of the Berlin Artist's Union. This exhibition provoked such a scandal that it had to be closed a few days after the opening; this closing resulted in the founding of the group known as the *Berliner Sezession*.

During his Berlin years Munch lived in those circles of the Berlin *bohême* that were frequented by such writers as Arno Holz, Richard Dehmel, Otto Bierbaum, and August Strindberg, and by the art critic and founder of *Pan*, Julius Meier-Graefe. At that time he also made the acquaintance of some of the great German collectors, including Count Harry Kessler, Eberhard von Bodenhausen, and Walter Rathenau. Berlin also provided Munch with his first literary supporters: in 1894, Stanislas Przybyszewsky published an anthology of writings, *The Works of Edvard Munch*. This collection contained articles by many of the men who moved in the perceptive group of artists that founded the *Genossenschaft Pan* (Pan Society) that same year, and the following year launched *Pan*, German *Jugendstil's* most brilliant and articulate periodical. Active literary support was also provided by August

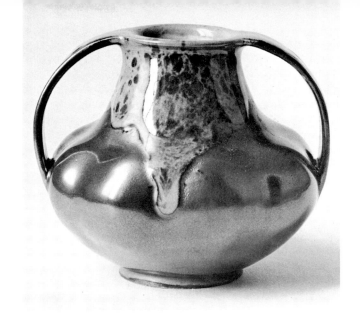

172

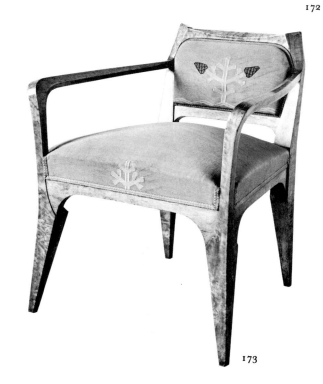

173

174

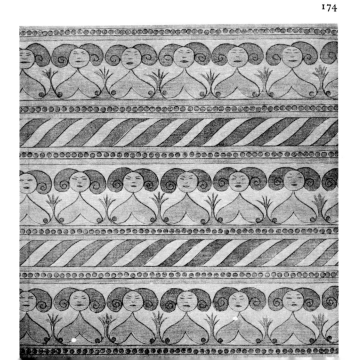

170 RICHARD RIEMERSCHMID *Armchair* (1899)
171 RICHARD RIEMERSCHMID *Armchair* (before 1900)
172 JOHANN JULIUS SCHARVOGEL *Vase* (circa 1900)
173 AKSELI GALLÉN-KALLELA *Armchair* (circa 1900)
174 IVAR AROSENIUS *Endpapers for "Tjugonio Bilder i Färg"*
 (1909)

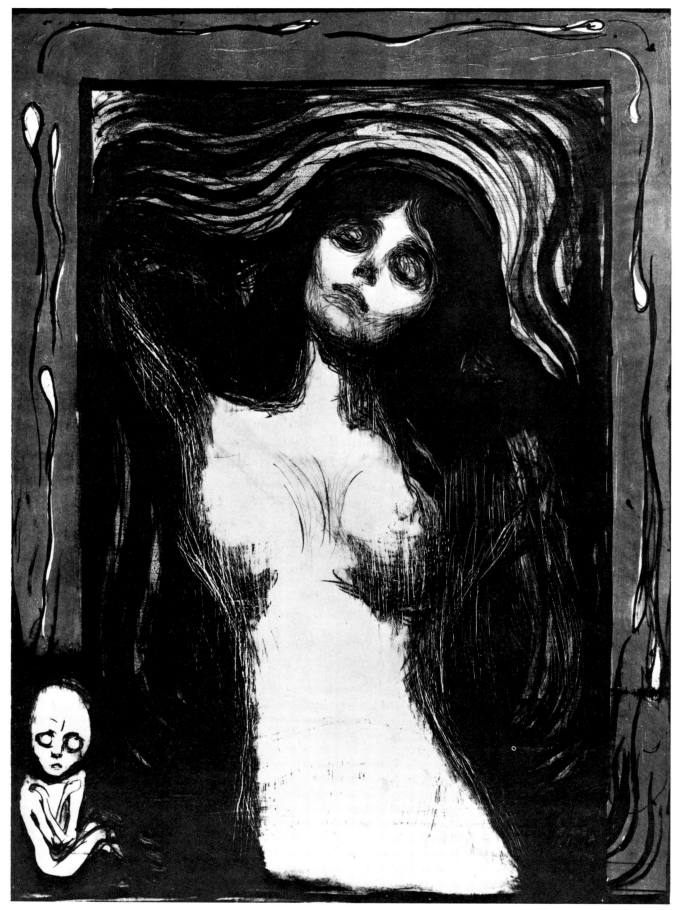

175

Strindberg, who in 1896 reviewed an exhibition of Munch's works held at Bing's gallery in Paris. Strindberg's critique appeared in the *Revue Blanche*, the most important publication of the *Nabi* group.

Between 1890 and 1900, Munch's paintings bear such titles as *Jealousy*, *The Kiss* (colorplate XXI), *Puberty*, *The Cry* (colorplate II), *After the Fall of Man*, *Anguish*, *Flower of Sorrow*, *In the Masculine Brain*, *Attraction*, *Detachment*, and *Fertility*. Though his power carried him beyond the limits of the movement, Munch shared with the whole of Art Nouveau an inclination toward the Symbolist movement, and also toward hysteria, hypersensitivity, and a fascination with eroticism. He lacked the elegance, the fashionable playfulness, and the aloofness of the dandy: "The animal breaks out in Munch as a full expression of his unbroken being."[40]

For Munch, the outline was an essential device of creation, frequently circumscribed in flowing lines of color. After 1894, he also used such graphic media as etching, lithography, and the woodcut; he was equally great as a painter and as a draftsman. In those of Munch's works which were typically *Jugendstil*, the lines are so fluid, soft, and undulating that compared with them Gauguin's harmonious outlines seem almost hard, rigid and reminiscent of woodcuts. In spite of their animal but helplessly revealed vitality, Munch's forms are capable of the most delicate curves, shapes that may be large and synthesized, even clumsy, but with an expressive and evocative quality which makes us feel with almost frightening intensity the demonic power of the elementary side of nature and of the sexual nature of man. Colors play an important role and courageously include black; Munch's reds may appear bloody and poisonous; his colors are often crude and stabbing, but they never allow us to forget the great painter in Munch, in spite of all his overobvious display of psychology. Munch shares with Art Nouveau its great decorative quality; but his anger, his torment, his greed are never constrained by calligraphic effects.

Ferdinand Hodler and Ludwig von Hofmann

The inclination of many German and, in particular, Scandinavian artists of *Jugendstil* tended toward the bucolic and a world of unbroken local tradition; similarly, other German artists were attracted to the world of the child and youth. Both trends reveal the nostalgia of that age for the sources of unspent and intact forces; both fight against historicism. The longing for youth in art and life can be felt everywhere, but most clearly in English early and High Art Nouveau as well as in late *Jugendstil*, wherever the convulsive excitement of Continental High Art Nouveau does not predominate. This nostalgic longing fills Kate Greenaway's and Walter

Crane's children's books; while interiors, above all those by Voysey, look like nurseries. It is precisely the oft-used "innocent" white color employed in furniture and rooms that recalls nurseries suggestive of an almost clinical hygiene. We meet this tendency, inspired by Voysey and later by Glasgow, in the work of the Viennese architects Hoffmann and Olbrich. The *Playhouse for the Princesses* that Olbrich built in 1901 at Schloss Wolfsgarten bei Langen, near Darmstadt (plate 176), is, in accordance with its actual function, a sort of house for dolls and children's games. In general, Van de Velde's more "adult" creations do not reveal this feature except once; in 1903 it is present in Count Harry Kessler's handsome dining room in Weimar (plate 181). The white lacquered furniture and panels and a childlike, naive mural painting by Maurice Denis all seem to be intended for a young girl's room.

Features of this kind also appear in the paintings of the Swiss-German artist, Ferdinand Hodler (1853–1918). In its conception and execution his work *Spring* (plate 177) shows a freshness and youthfulness and a desire for a youthful art and a youthful style. Such paintings are entirely devoid of the complicated, half-artificial childhood element that Hofmannsthal detected in the English style; they are free from decadence or a coy toying with the child-like. Eros awakens in the souls and in the undeveloped bodies of the girl and the adolescent boy; in the fascinated gaze of the latter there is something resembling surprise, something also like fright in the gesture of the girl who, with eyes closed, is listening to an inner voice. In its form as well, Hodler's painting is closely related to *Jugendstil*, in spite of its powerful plastic quality and the heaviness of its far-from-ethereal figures, in spite of comparatively realistic representation and the firm structure of the work. With his often symmetrical and slim figures developed parallel to each other, and with the parallelisms of his details, Hodler achieves a

176

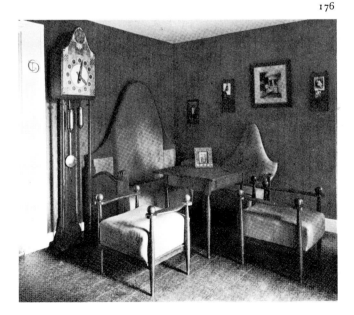

175 EDVARD MUNCH *Madonna* (1895)
176 JOSEPH MARIA OLBRICH *Room in the Playhouse of the Princesses, Schloss Wolfsgarten, near Langen* (1902)

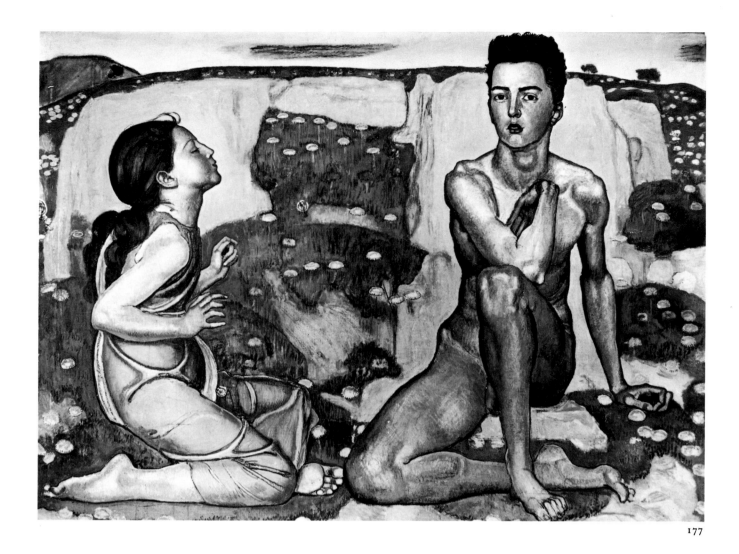

clear, ornamental composition that confers decorative and expressive effects, symbolism and monumentality, on paintings bearing pretentious names: *Eurythmics, The Chosen, Spring, Day,* and *Night*. Hodler's art is perhaps the best example of a monumentality rare in painting that is not necessarily inherent in the style. The simplified and almost ornamental outlines make the plastic figures strictly and inevitably fuse with the surface of the picture. Hodler's manner of painting suggests no painterly quality; his treatment of color is dry and devoid of surface brilliance, as in fresco technique, to which his art is also close in spirit. Within the contours, the colors are relatively homogeneous, with scarcely any effect of light or shade and no cross-hatching. A fruitful relationship exists between the powerfully fascinating figures that transcend themselves like symbols in their impressive plastic qualities and the entirely flat background, which has practically no spatial depth. The horizon line is frequently drawn quite high, so that the highly stylized landscape background (usually consisting of flowery meadows) lies like a kind of wallpaper behind the figures, but in such a way as to include them in its carpet-like pattern and structure. The large, round flowers which

Hodler likes to scatter through his meadows in decoratively irregular groups are individually seen in perspective, causing the round form of the flower to be flattened into an oval. In the relationship between foreground and background, or horizon, this perspective remains almost without effect: up to the middle ground, and even as far as the background, the flowers are all of nearly the same size and thereby greatly contribute to the decorative effect of the pictorial surface.

The flower backgrounds were no doubt inspired by Japanese art but have been transformed into something quite individual. In the same way, Hodler's relationship to French painting is evident, particularly to the equally fresco-like works of Puvis de Chavannes, but this relationship has in no way made Hodler's work derivative of French painting.

The atmosphere pervading the paintings of Ludwig von Hofmann (1861–1945) is equally vernal, although his work is slightly less Art Nouveau in style than that of Hodler. But, unlike the latter, Hofmann also illustrated and decorated books in a typically *Jugendstil* manner.

Ludwig von Hofmann was inspired by the works of Puvis de Chavannes—and it is perhaps interesting to

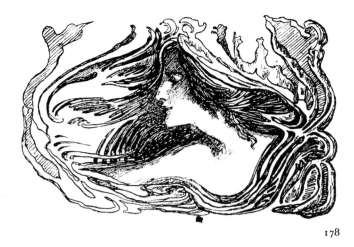

note that Hofmann was the teacher of the young Hans Arp—though he softened Puvis' severe and rather stiff forms and transposed the quiet immobility of the French painter's idealized Arcadian figures into something possessing a dance-like movement.

After studies in Paris in 1889, Hofmann went to Berlin where he became friendly with the painters, Klinger, Leistikow, and Liebermann. From the beginnings of the nineties his art developed along lines suggested to him by that of Hans von Marées, an earlier painter in whose work Hofmann sensed elements that anticipated *Jugendstil*. But, unlike the predominantly dark and heavy splendor of the palette of Hans von Marées, the sweetness of watercolor tints prevails in the paintings of Ludwig von Hofmann.

Hofmann comes closest to real *Jugendstil* in his lithographs (plate 178), which are at the same time illustrations and arabesques, idyllic scenes and symbolic borders: *Pan* reproduced many of them. In 1903, Hofmann was appointed to the art school in Weimar, a city which, thanks to Count Kessler and Henry van de Velde, had become a small but important center of art immediately after 1900. Hugo von Hofmannsthal has expressed essential thoughts about Hofmann in his book, *Prologue to Ludwig von Hofmann's Dances*: "These drawings are beautifully assembled, like an album of Mozart sonatas. Their unity is born of the bliss their rhythm communicates, which the soul eagerly accepts through the eye and ear. His figures express nothing but their nudity. Rhythmically, they fill space; the imagination can play with them through page after page and is softly rocked by them, as on a blissful sequence of tones. A neck gently curved backwards; a woman's arm raised so straight that the hollow of the armpit becomes flat; nude, slender-limbed forms riding faun-like on naked shoulders; crouching on the ground, animal-like, hand on heel; feminine bodies strained against the body of a bull; a dance of maidens, bare to the waist. But, despite all their voluptuousness,

177 FERDINAND HODLER *Spring* (1901)
178 LUDWIG VON HOFMANN *Vignette from "Pan"* (1897)

these pictures are empty of lushness so that they are vernally at one with the world of the young trees which rise into the pure sky from the hills of spring, at one with the contours of the isles which emerge yonder from lyre-shaped Southern bays into the fragrance of the morning.

Mature and Late Jugendstil

The work of Eckmann, Behrens, and Riemerschmid had already prepared the way toward an abstract and constructive phase of *Jugendstil*. To the decorative designs which he had published in 1897 under the title *New Forms*, Eckmann had then added a few with abstract curvy lines, somewhat after the spirit of the "Belgian" line. His ornamental capitals and typographical ornaments for the Rudhard type foundry (plate 164) are firmly constructed in spite of their soft curves, and never make use of any purely decorative accessories. The letters are perfectly clear and legible and their general aspect is harmonious. They are completely abstract; letters transformed into ornament, yet these printed letters retain the character of flowing penmanship, as though written with a soft, thick brush. Freely designed, they were naturally more in accordance with *Jugendstil* than the more architectural *Antiqua* typeface, even though the lettering of *Jugendstil* is based on the latter and though only accessory elements were borrowed from Gothic characters.

According to the nature of his talent, Peter Behrens tended toward a serious, heavy, constructive form, as is shown in the fine drawing, *The Brook* (plate 168), as well as in the book decorations and lettering designs that he began to produce in 1898. In his first architectural work, the house he built for himself on the Mathildenhöhe in Darmstadt, Behrens used abstract *Jugendstil* for the first time. Every "promise" contained in his lettering, his ornaments, and his drawings already seems to be fulfilled in the most personal manner in the rooms of this house, particularly in the very unified library (plate 179) which may be counted among the best examples of *Jugendstil* interior design, and also in certain details, such as the magnificent door of dark-green lacquered wood with the linear design of its fittings (plate 180). At the same time, however, we cannot overlook the fact that a new stimulus had operated from without: Van de Velde and his "Belgian" line. We can detect here the influence of the Belgian master whose work (through his contribution to the development of the style) had made him one of the main figures of *Jugendstil*, not only in the comparative weightiness of his forms, which corresponded to the ideas of Behrens concerning form, or in his conception of space, but also essentially in the "Yachting Style" flavor that permeates the Behrens library.

The rooms which Van de Velde exhibited in Bing's gallery in Paris in 1895–96 met with unfavorable criticism. He showed the same rooms in Dresden in 1897, with the addition of a newly created "relaxation-room"; there, in general, he was successful. These rooms launched

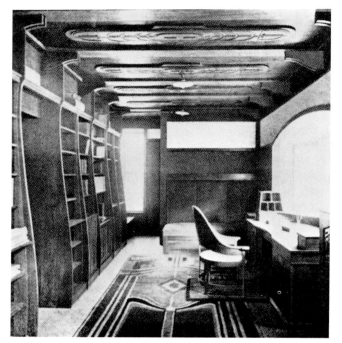

179

Van de Velde in Germany, and in 1899 he began to work in Berlin where he at first decorated store interiors. But Van de Velde's most important work of these years was the interior of the Folkwang Museum in Hagen, completed in 1902. In the main hall, the cylindrical fountain is dominated by Minne's five sculptured youths with their tensely angular movement (plate 85). Not only the severe banisters of the staircase, but also the side rooms and the small music room (plate 80) are worth mentioning. The unity of these rooms is achieved without the aid of additional ornaments, whether painted, woven, or carved. Here the "Belgian" line appears in wide, calm curves.

Even elements of late Art Nouveau can be felt in Van de Velde's work, expressing themselves in the interiors he designed for Count Kessler in Weimar in 1902–03 (plate 181) in his noblest and—rare for Van de Velde—most elegant manner. The interior architect, decorator, and designer in him is subordinated here in order to serve the purposes of the work of art. The convulsions of Belgian High Art Nouveau are abandoned in favor of delicate curves, with a suggestion of Biedermeier modesty and neatness.

These rooms are expressly decorated as a setting for Count Kessler's eclectic collection of works of art, of old masters as well as of such moderns as Maillol, Bonnard, and Maurice Denis; and no conspicuous decoration was

to diminish their effect. One is tempted to say that Van de Velde, who was not entirely free from dictatorial tendencies, has surpassed himself here through self-effacement.

Among Van de Velde's works in the field of the applied arts, his set of silver flatware from about 1912, in which beauty and simplicity are perfectly combined (plate 182), is particularly noteworthy. Knives, forks, and spoons revert to fundamental forms; here form attains the highest functional value and, from the point of view of the artisan, is most appropriate to the method of production. This tableware, which even today might win the highest award for good functional form, is one of the rare works of Van de Velde (and of *Jugendstil* in general) that achieved a timeless style, the aim pursued by *Jugendstil* with so much ardor.

Far less unostentatious were the sumptuous rooms for the Dresden Exhibition of 1906, the central hall in particular. Here, after some years of working in a simple, distinctly geometric style that was in keeping with his

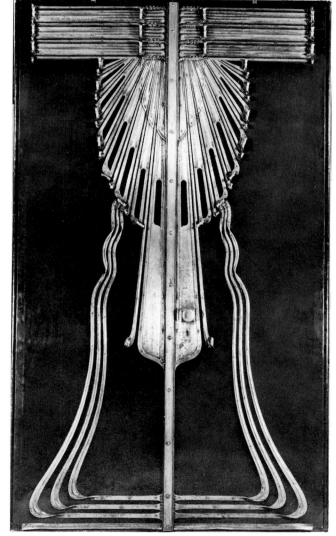

179 PETER BEHRENS *Library in the Behrens residence, Mathildenhöhe, Darmstadt (1901)*

180 PETER BEHRENS *Door in the Behrens residence, Darmstadt (1901)*

181 HENRY VAN DE VELDE *Dining room in the residence of Count Harry Kessler, Weimar (1902–03)*

180

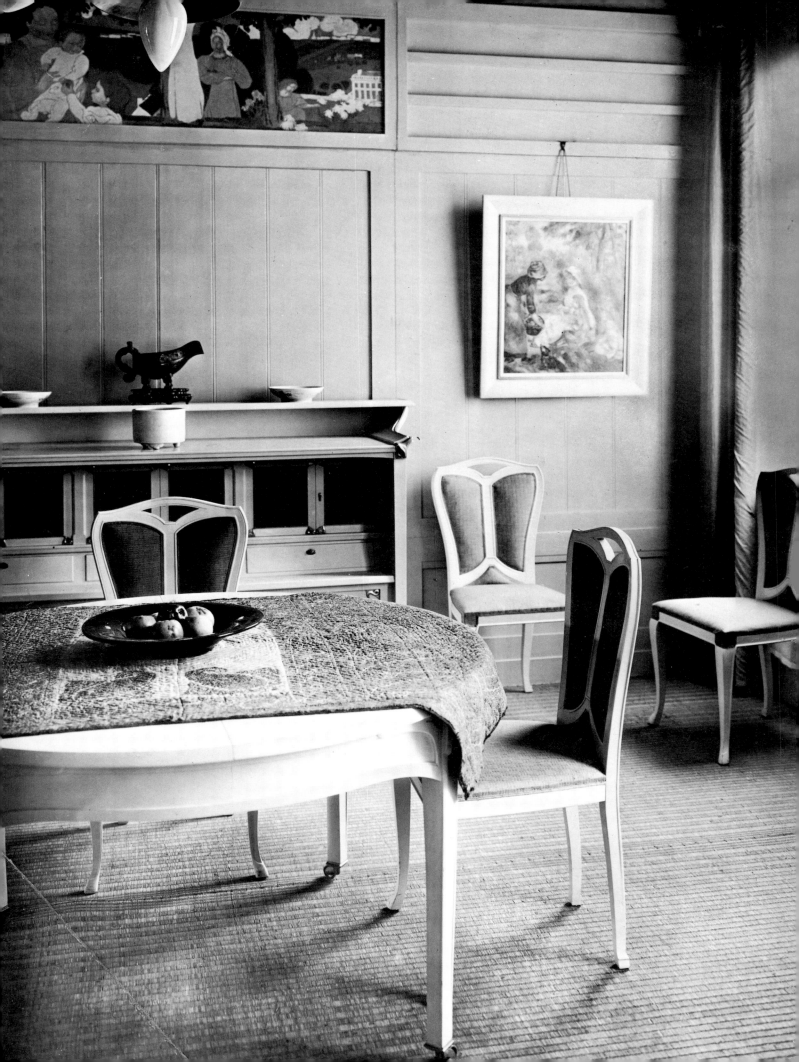

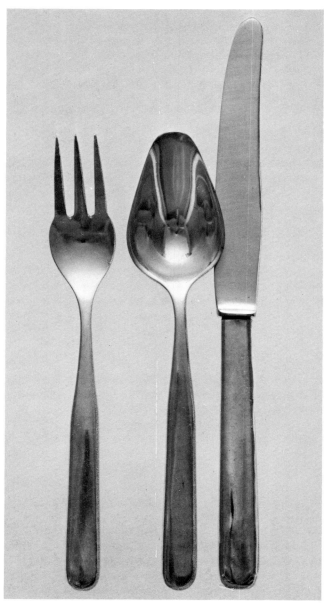

spite of the quality of its form this building, which was designed only five years after Behrens' AEG turbine plant and three years after the Gropius Fagus Factory, might almost be considered a romantic echo of *Jugendstil*.

Most of Van de Velde's other works also show this synthetic quality. The curved rhythm of High *Jugendstil*, which is often expressed in a very noble and simplified compactness of form, prevails in his ornaments and bookbindings, his furniture, jewelry, and hand-wrought silverware, in his candelabra and tea services (plates 184, 185, 186, and colorplates X, XI). The noble distinction of Count Kessler's diningroom ensemble or the distinctive shapes of the silverware already pointing toward future styles was seldom again achieved by Van de Velde, but many of his other creations may be considered as prototypes of Art Nouveau: for instance, his masterpiece of a "linear" Art Nouveau, the candelabra of about 1902; or his main example of a three-dimensional Art Nouveau, the silver tea service of 1905–06; or his ideal form of an Art Nouveau armchair, for which Georges Lemmen designed the upholstery fabric.

From Jugendstil *to Modern Trends*

The immediate transition from High and then late *Jugendstil* to modern architecture is clearly seen in the work of Peter Behrens. Soon after 1900, leading personalities among German architects and designers adopted a new Biedermeier style: the poet, Rudolf Alexander Schröder, for instance, in the rooms he decorated in 1901 for Alfred Walter Heymel in Munich, the founder of the famous *Insel* books and publishing house; or Bruno Paul (1874–1954) in the rooms he designed for the *Deutsche Werkbund*, founded in 1907; or Joseph Olbrich in 1901 in his own house in Darmstadt. For more important buildings, Behrens developed a kind of neo-Classicism, from which he soon progressed to a more functional style. The factories which he built in 1909 and 1911 in Berlin for the *Allgemeine Elektrizitäts-Gesellschaft* (AEG), a huge electrical and engineering industrial concern, deserve particular mention here. But just as Perret's house in Paris on the Rue Franklin (plate 119) and his garage on the Rue Ponthieu (plate 120) stand between late Art Nouveau and modern architecture, so do the above-mentioned Berlin buildings by Behrens reveal a link with the *Jugendstil* past. The Berlin AEG turbine factory (plate 187), for instance, is constructed entirely as a rectilinear skeleton of glass and steel. To illustrate the principle of an "architecture that speaks for itself," it has powerful corner pillars, whose tapering reminds us of Egyptian forms; besides, an exaggeratedly heavy-looking gable lies across the body of the building, which thus acquires, as a whole, a certain grandeur, since its weight—now quite static—seems to symbolize energy. But all this is scarcely in accord with pure functionalism. Mies van der Rohe then followed Behrens in his Classicist phase, and both Gropius and Le Corbusier worked for a while in his office:

time, Van de Velde reverted to a curved and linear style which he now greatly simplified, thereby alienating himself more and more from the actual trends of the future. One of his chief architectural works, which at the same time proved how long he remained faithful to a curved *Jugendstil*, is the *Werkbundtheater*, built for the 1914 Cologne Exhibition (plate 183). Had it been built ten years earlier, we might consider it as a main achievement of *Jugendstil* and Art Nouveau architecture. In spite of the extreme compactness of the bulk of the building, which seems to have been molded out of some liquid matter, its main body as well as its separate parts are rhythmically arranged. Contrasting directions and forms blend in a synthesis which comprises the geometric, the organic, the functional, and the ornamental elements. In

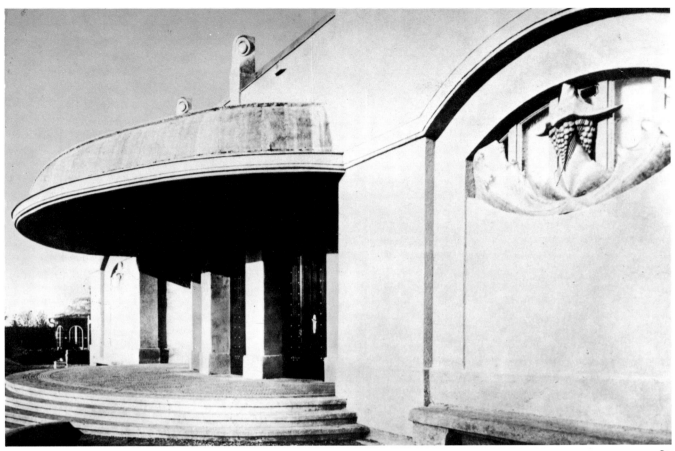

Europe's three leading architects thus reveal an affinity with Behrens.

In the field of painting, Munich *Jugendstil* offered the most fertile ground for the growth of modern art. Its *Blaue Reiter* group, in their Romantic tendencies, were not so very far removed from the Romantic element inherent in German *Jugendstil*, nor adverse to the efforts to revert to popular art. It is known that among the *Blaue Reiter* artists, Paul Klee had studied the works of Beardsley and Blake. Franz Marc's paintings are largely composed of swinging curves, two-dimensional bodies, and rhythmic relationships. In this respect, the early works of Wassily Kandinsky (1896–1944) offer perhaps the most interesting examples of such a transition. His watercolors and colored woodcuts, with their somewhat romantic and withdrawn moods, are not only related to *Jugendstil* but also satisfy most of its criteria of form (colorplate XXII). Flat areas and surface-bodies that condition each other with swinging and gliding outlines and remain entirely homogeneous in color (though with somewhat painterly patches in certain areas) reveal a

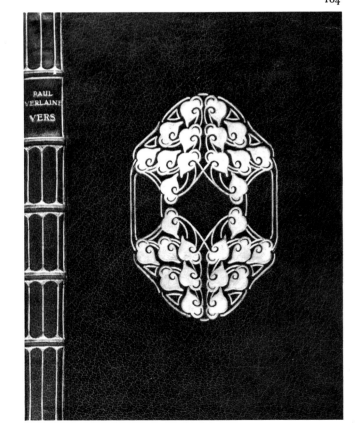

182 HENRY VAN DE VELDE *Knife, fork, and spoon (circa 1912)*
183 HENRY VAN DE VELDE *Entrance to the Werkbundtheater, Cologne (1914)*
184 HENRY VAN DE VELDE *Binding for "Vers" by Verlaine (1910)*

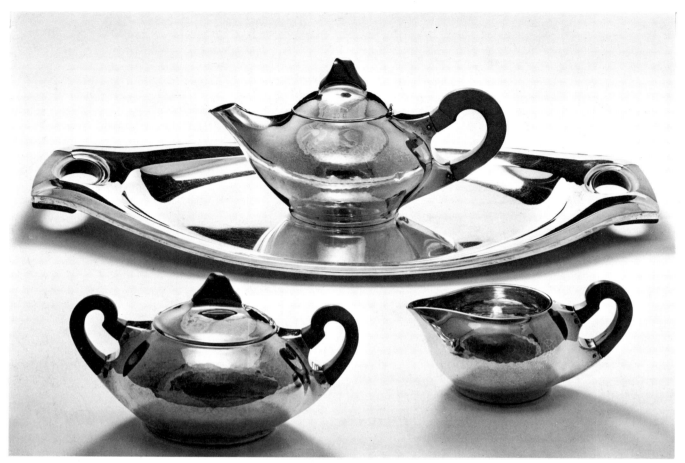

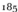

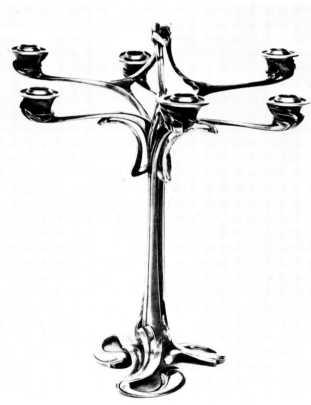

powerful stylization in their forms which seem to be laid into the surface rhythmically, almost as if they were inlaid. The early woodcuts might even be classified as examples of Art Nouveau "volume effects," being composed only of broadly formed, two-dimensional bodies; but they still reveal convulsive movement in the swing of the curves and in their self-sufficient (or narcissistic) calligraphy. Later works, such as Kandinsky's cover design for the *Blaue Reiter* catalogue of 1911 and some of his early abstract compositions are closer to *Jugendstil* in this respect.

BARCELONA

In Spain, Art Nouveau flourished chiefly in Barcelona, the rich capital city of Catalonia. Barcelona's greatest master of Art Nouveau was Antoni Gaudí i Cornet (1852–1926), who was also the outstanding genius of the entire international Art Nouveau movement. Starting with historicism and passing through the various phases of early, High, and late Art Nouveau, Gaudí's style of building, often anticipatory, underwent all the transformations caused by contemporary developments but remains so original that it develops every aspect of style to its utmost possibilities.

186

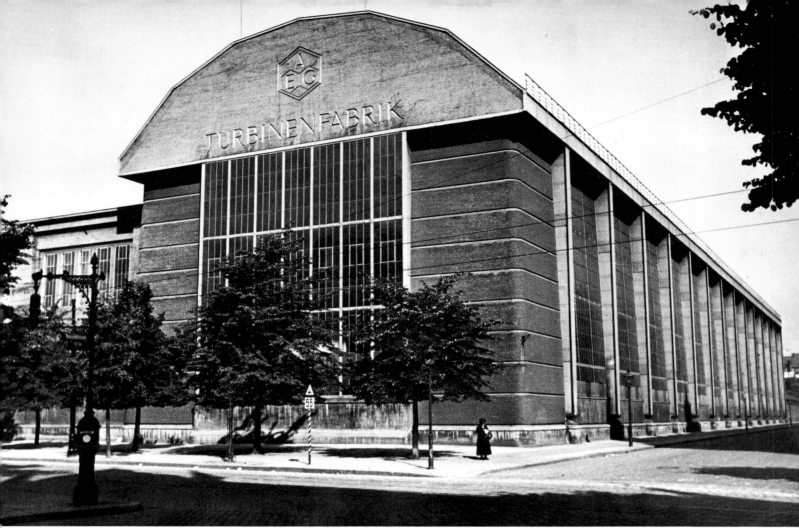

Antoni Gaudí's Early Works

The son of an ironworker, Gaudí was born in Reus. As a boy he practiced his father's craft, a craft which for centuries the Spaniards have developed with outstanding ability. This early training is evident in many of Gaudí's mature works, where the inexhaustible inventiveness of form and the admirable technique of the ironwork play such an important and integral part. Even his architecture grew under his hands as though it were a piece from a smithy's forge, so that the completed work is often quite different from the original plan.

Gaudí's studies of architecture were influenced by the theories of Viollet-le-Duc, and from his youth Gaudí was also familiar with the writings of Walter Pater and John Ruskin, and probably with illustrations in the early English Art Nouveau style. He was one of the first in Spain to admire Wagner. As a young man, he lived the life of a dandy and constructed palaces, villas, and architectural "follies" for patrons to whom money was no object. During the last decades of his long life, he retired like a hermit in order to devote himself exclusively

185 HENRY VAN DE VELDE *Tea service* (1905–06)
186 HENRY VAN DE VELDE *Candelabra (circa* 1902)
187 PETER BEHRENS *AEG Turbine factory, Berlin* (1908–09)

to the almost superhuman task of building the *Church of the Sagrada Familia* (plate 205 and colorplates XXIII, XXIV). Gaudí had always been deeply religious; he felt increasingly that a mystic symbolism inhabits the forms of architecture. His death through a street accident was considered a national misfortune; the people of Barcelona, who had loved both him and his art, accompanied the funeral procession for miles.

Gaudí's conception of a building as an integrated whole, his love of rich decoration and decorative as well as symbolic elements in his constructions, and finally, the forms he created and which drew elements from every domain of plant life and animal life (here too, in the figurative sense, he was eminently "catholic"), made him an artist who, through an idiom of unconventional and individualistic form, achieved the inner intentions of Art Nouveau in the most grandiose manner.

In 1877, as assistant to the architect José Fontseré, Gaudí began working on the great waterfall in Barcelona's *Parque Ciudadela*, a construction that was strongly inspired by Espérandieu's *Palais Longchamps* in Marseilles. In the sculptured ornaments on which Gaudí also worked, one can detect features of Art Nouveau in spite of an otherwise historistic style partly dependent on Mannerism. This affinity with Art Nouveau is even more clearly felt in furniture which Gaudí designed for his

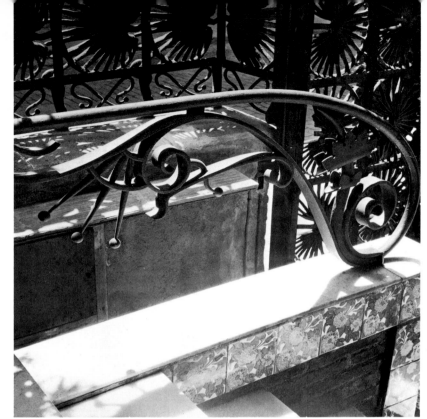

188

189

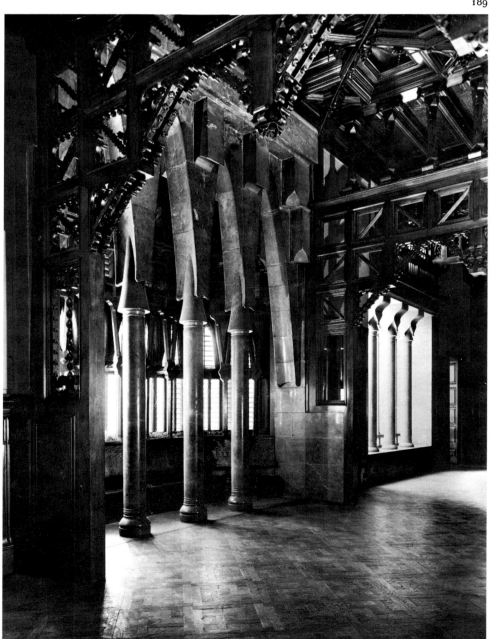

first important work, *Casa Vicena* (1878–80). This is a small but sumptuous villa-like house, built in what was then a suburb of Barcelona, and conceived as a fanciful variation in the Spanish-Moorish *Mudéjar* style. But the small chimney-towers, the precursors of Gaudí's later and more grandiose sculptured chimneys, already strike one as inventive and entirely original, while the iron-work railings express Art Nouveau ideas even earlier than Mackmurdo's earliest creations. The garden railings, for instance, are the most vigorous achievements in this field of flamboyant extravagance (plate 188). Above a skeleton consisting of square areas marked off by horizontal and vertical bars, and surrounded by circular forms, star-shaped palm fronds are juxtaposed and superimposed in endless repetition. At each jointure of the squares, plump lotus buds push forward. Here, as in the wide curves of the terrace railings, the new style—as was the case in all other countries—expresses itself first in terms of line and two-dimensional area.

Considering the originality of such a building, it would be idle to seek English influences there. Still, we have proof that Gaudí knew English works of this kind at least in theory, and that his patron, Count Güell, was a decided Anglophile. English examples of form were of importance to Gaudí, and his biographer, Ràfols, states that the *Casa Vicena* contained mural decorations and draperies which were inspired by illustrations contained in an English periodical found among Gaudí's private papers after his death.

Gaudí's first masterpiece is the palatial building he designed and built between 1885 and 1889, near the old so-called "Gothic" quarter of downtown Barcelona, for the shipowner and industrialist, Don Eusebio Güell. The original design for the façade reveals certain stylistic and decorative reminiscences of early Venetian palazzos, but there is no sign of these features in the completed façade. The interior, however, is largely influenced by such Gothic and Venetian styles which are blended with Moorish influences. Whether in the interior decoration or in the final version of the double portals of the façade, we nevertheless find no pointed Gothic ogives or Moorish arches; instead, a creative development of both—Gaudí's own parabolic arches, forms which seem irregular but are mathematically conceived and, in the arrangement of the colonnades leading toward the loggia (plate 189), display a refined elegance. The capitals and the abutments blend in an entirely new element of construction and, in contrast to all historical and traditional examples, taper upward to form cone-shaped arches. As if formed out of a ductile substance, these conic forms glidingly cut into the stalactite-like, downward-hanging spandrels. Nowhere but in Art Nouveau were such forms possible

and, in fact, nowhere can they be found except in Gaudí's work.

The interior is the most interesting feature of *Palau Güell*. In the ground plan as well as in the vertical construction, different space units intermingle to give the whole a magnificently labyrinthine aspect: a unit comprising sections of entirely open or half-open rooms, openwork walls, balustrades, railings, and columns, all of which (in quite different, and above all, far heavier forms) anticipate Mackintosh's open-walled rooms (plate 232). This series of rooms culminates in the central domed hall which reaches up to the topmost floor and receives its light from a lantern-like cupola window (plate 190). The actual cupola rises like an airy tent above parabolic arches. The impression of a very thin-skinned wall is confirmed by the hexagonal tiles which honeycomb the inner surface of the cupola; through the circular apertures, daylight or, at night, electric light, illuminates the dome in a very subtle manner. Gaudí's creation is no doubt the most original new version of this old theme since Borromini's and Guarini's cupolas and, at the same time, disconcertingly recalls prehistoric architecture: the interior of similar cone-shaped constructions of the Stone and Bronze ages.

A great wealth of materials and forms is combined in the *Palau Güell* in amazingly daring structural inventions. In this respect, Gaudí belongs entirely to the 1880 period. Pillars and slabs of marble, costly woods even more expensively worked, and a great profusion of hand-wrought ironwork, all combine to give the rooms a splendor that is anything but suggestive of mere comfort. Almost ten years before Horta had incorporated structural details as part of his architectural ornamentation, Gaudí freely revealed the iron supports of the hall ceilings on the ground floor and also those above the curve of the staircase leading from the mezzanine to the main floor. Furthermore, the marble slabs in the reception rooms are sometimes secured to the walls by visible iron supports. Here, as with Horta, elements of modern functional construction achieve a hitherto unknown unity with those of opulent decoration. In this composite structural work of art (where only painting has not been included), one is again impressed mainly by the iron-work, especially the vehement, serpentine curves of the grilles on the upper part of the parabolic arches of the portals. Of even greater interest are certainly the far smaller wrought-iron ornaments in the interior of the master bedroom, which playfully surround the capitals and the abutments of an open arch with a design (plate 191) of incredible inventive and imaginative power; although more mature, such forms recall the stone ornamentation of Furness (plate 210), and Sullivan's early designs (plate 209).

The furniture designed by Gaudí for the luxurious *Palau Güell* includes a dressing table and a *chaise-longue* (plates 192, 193) which are particularly remarkable. In the continuous curve of the latter, reaching compactly out into space, High Art Nouveau can already be dis-

188 ANTONI GAUDÍ *Banister and garden railing of the Casa Vicena, Barcelona* (1878–80)
189 ANTONI GAUDÍ *Drawing room of the Palau Güell, Barcelona* (1885–89)

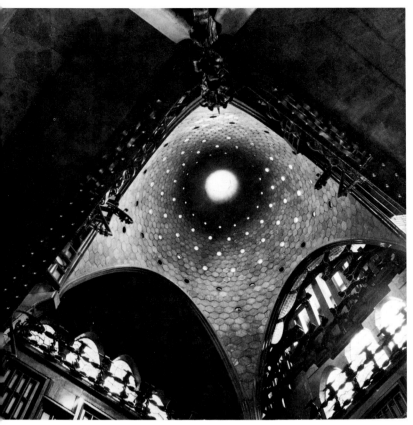

190

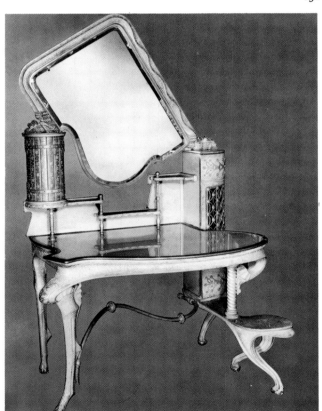

192

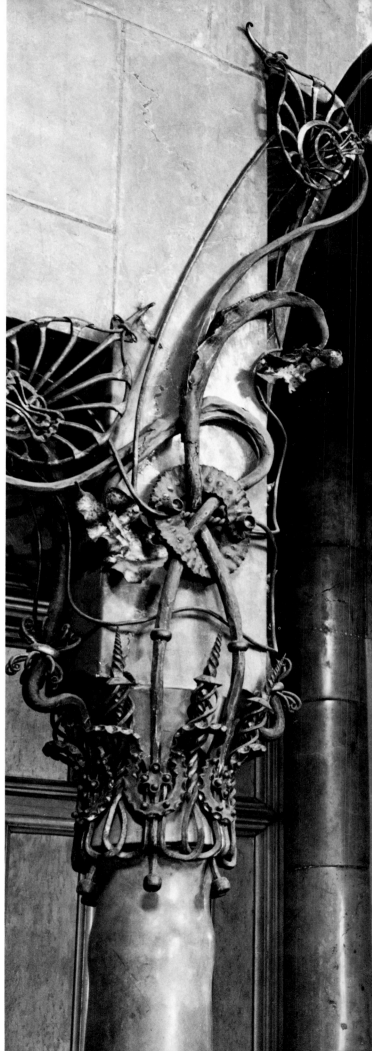

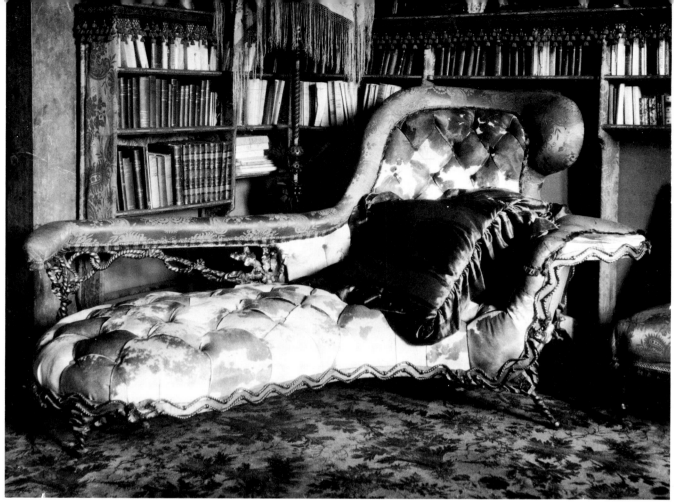

cerned, although the profusion of detail in the forms, especially in the dressing table, is still very heterogeneous. These two pieces of furniture are indeed excessively elaborate, and lack the simplifying element and the dynamic tension of Van de Velde's creations. They are showpieces of the *grand bourgeois'* ''conspicuous waste'' of the eighties; on the other hand, they show that the conglomerates of the studio-style already carried within themselves some indications of the Art Nouveau tendency toward synthesis. One might almost say the same about the Tiffany rooms in New York, which are equally opulent but less original.

The furniture, particularly the chairs, which Gaudí designed for the *Casa Calvet* in Barcelona between 1898 and 1904, is much simpler (plate 194). Here, the suggestion of copying earlier styles is no longer noticeable. Instead, an element of purity of style and of independence (in spite of their peculiarity) makes these pieces legitimate examples of High Art Nouveau. Not only do they perfectly achieve the fusion between the structural and

the decorative, but, coiled like snails and dynamic as springs, they give the impression of vegetal and organic growth.

These qualities are developed on a gigantic scale in the chief works of Gaudí's High Art Nouveau. The vaulted roofs of the porter's lodge in the Park Güell (plate 2) swell like an enormous colored and shimmering Portuguese man-of-war; the scaly, tiled roof of the *Casa Batlló* (plate 195) is humped like the back of a dinosaur. The outline of the parapet of Park Güell seems like the petrified curved line of a wave which the receding sea might have left imprinted upon the sands of a shore (plate 13).

Lluís Domènech y Montaner

During the time Gaudí was creating these works, he was undoubtedly acquainted with the Art Nouveau of northwestern Europe, for during those years Barcelona was the most cosmopolitan city in Spain, a city eager for novelty and closely in touch with the latest European trends. Even apart from Gaudí's personal style, the *Stile Modernista* design of upper-class apartment houses was more popular in Barcelona than in any other city. Symbolistic and Art Nouveau periodicals appeared, among them a counterpart of Germany's *Die Jugend*, the Catalan *Ioventut*. Catalan Art Nouveau concentrated

190 ANTONI GAUDÍ *Domed ceiling of the music room in the Palau Güell, Barcelona* (1885–89)

191 ANTONI GAUDÍ *Ornamental detail in a bedroom of the Palau Güell* (1885–89)

192 ANTONI GAUDÍ *Dressing table* (1885–89)

193 ANTONI GAUDÍ *Chaise longue* (1885–89)

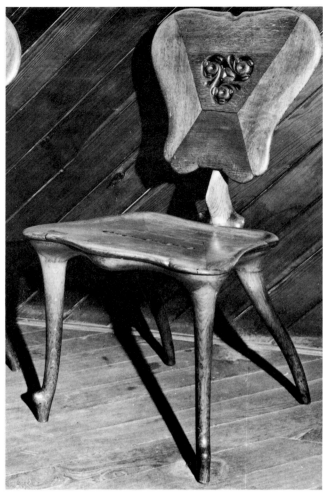

194

mainly on architecture and pictorial art, and the applied arts and textiles were somewhat neglected. The fine binding designed as early as 1899 by the poet Riquer for a volume of his poems, *Crisantemes* (plate 196), deserves our attention if only because it shows that Japanese style also came to Barcelona as an element already legitimately adopted by Art Nouveau.

The different styles which mingle in the *Palau de la Musica Catalana* (Hall of Catalan Music) are as heterogeneous as the inspirations that marked Gaudí's early works. This building (plates 197, 198) was built in Barcelona between 1906 and 1908 by Lluís Domènech y Montaner (1850–1923), and is the most brilliant and artistically important example of a "hybrid" Art Nouveau adulterated by historicism to be found anywhere in Europe. Particularly during the years following 1900, when it became very popular, Art Nouveau did not always progress from its curvy and organic High phase to the cubic and geometric late phase, but sometimes experienced a revival of what was characteristic of late historicism: a tendency toward the conglomerate, or the synthesis of heterogeneous elements. Such a blend of Art Nouveau with remote historical styles is not inevitably

inferior, but may sometimes lead to remarkable results which seduce us through their sheer fantasy and magnificence, such as D'Aronco's building for the Turin Exposition (plate 199), or Domènech y Montaner's *Palau de la Musica Catalana*.

With virtuoso ease and a barbaric strength much like Gaudí's, Domènech y Montaner unites Romantic, Gothic, and Venetian styles. The magnificent raw brick walls are decorated with many-colored mosaics and ceramics worked in relief. Above these walls rises a dome and turret whose style is easier to feel than to define: certainly Byzantine influences (somewhat neglected by true historicism) play a strong part in their overall conception, just as in the Sacre Coeur in Paris and Tiffany's 1893 chapel for Chicago. In Domènech y Montaner's building, the Byzantine element is vaguely reminiscent of Saint Mark's in Venice, and even more of Russian churches. The cupola of the tower is carried by supports that resemble spears from which are suspended shields, bringing to mind the sword-flourishing Tartar hordes of Genghis Khan. By transposing the studio-style into architecture the result becomes phantasmagorical: Art Nouveau's predeliction for the fairy-tale world now reaches out as to the *Arabian Nights*. Japan and its art and, perhaps at the same time, also its subtle ability to choose and simplify lose their hold and are superseded by the Orient. After 1900, there is moreover a reaction against the decadent and morbid quality of Art Nouveau; instead, we can detect an enjoyment of sheer brutality which no longer seeks the vital element in primary forms of life, in delicate seaweeds or in the stamens of flowers, but rather in the art of the South Seas or of Africa. The cult of brutality in the early phase of modern art, in Fauvism, Cubism, and *béton brut* architecture, finds a parallel in the exuberance of Gaudí's and Domènech y Montaner's buildings. The Diaghilev ballet was increasingly successful after 1909 because it came at exactly the right moment and was animated by the same brutal vitality, rigorous discipline, and luxuriant sensuality; besides, its productions were at first nearly always based upon Oriental or barbaric themes. In his designing of the chandelier for the middle of the ceiling, Montaner created a hybrid object which had never existed before. It consists of a skylight which provides lighting both by day and by night and swells downward into the hall like a huge jellyfish hanging upside down. Skylight and chandelier have become one.

Gaudí's Late Works

If Domènech y Montaner combined heterogeneous elements in his work, Gaudí achieved genuine synthesis in his Park Güell (1900–14), a creation that is as

194 ANTONI GAUDÍ *Chair from the Casa Calvet, Barcelona* (1898–1904)
195 ANTONI GAUDÍ *Detail of the roof of the Casa Batlló, Barcelona* (1905–07)

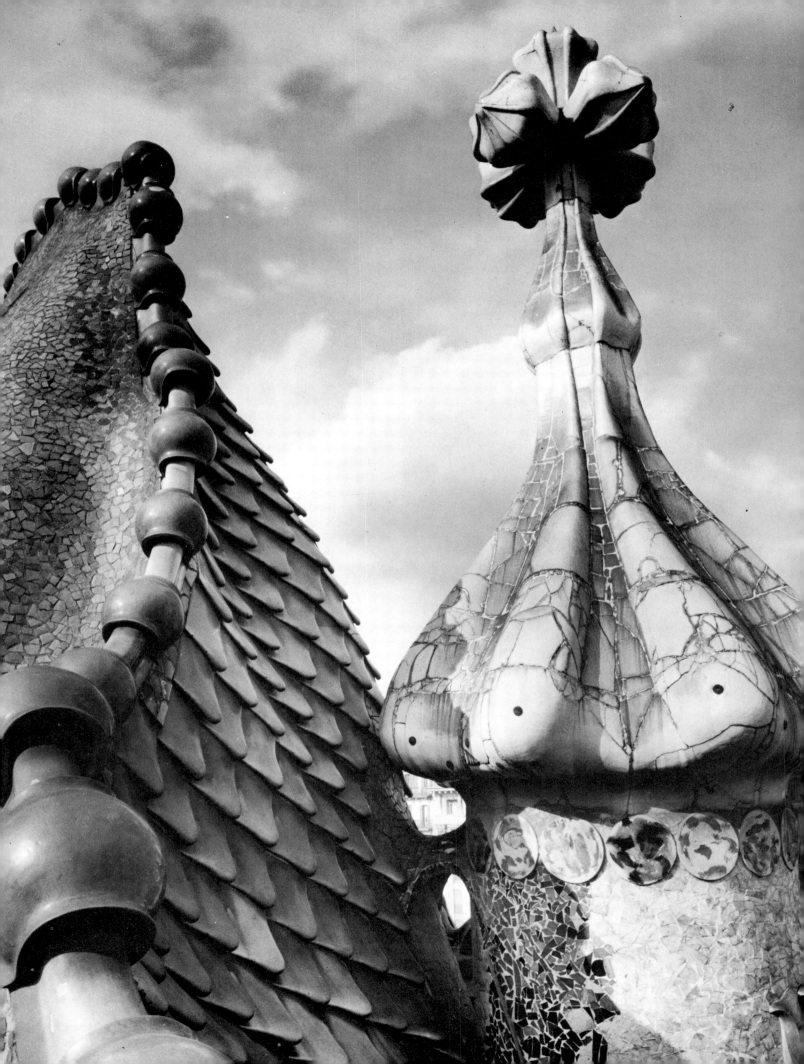

grandiose as it is bizarre and unique for its time (color-plate XXVII). By integrating organic matter with the forms of art and transposing nature into ornament, he nevertheless fulfilled the aims of Art Nouveau. The center of this ensemble of garden and architecture is the great terrace which rises above a peristyle of slightly inclined Ionic columns. The parapet (which also doubles as a continuous bench) winds around the edge of the terrace in wide, irregular curves (plate 13). It is set with myriad fragments of ceramic tiles in various shapes, sizes, and colors, all crowded together to form variegated patterns of infinite variety. Scintillating like the colored scales of a petrified sea serpent which seems to have lain there from time immemorial, this parapet is one of the most incredible creations of Art Nouveau.

The same combination of the reptilian and submarine may also be found on the roof of Gaudí's *Casa Batlló* (plate 195): in the soft yet powerful form of the dome crowning the small turret and capped by a type of Gothic cruciform plant shape, as well as in the undulating ridge of the roof to its right. One half of this roof is covered by small bits of irregularly broken marble, giving it the appearance of chain mail; the other half is sheathed with scale-like shingles which lend it a rather saurian quality; while the dividing ridge seems somewhat like the vertebrae of a gigantic sea monster or dinosaur. The *Casa Batlló* is an apartment house situated on the Paseo de Gracia, a fashionable Barcelona thoroughfare. The main structure of the building was already in existence before Gaudí transformed it between 1905 and 1907.

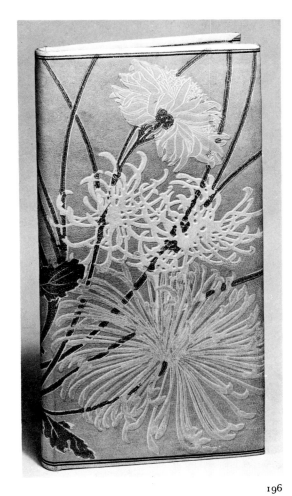

196

197

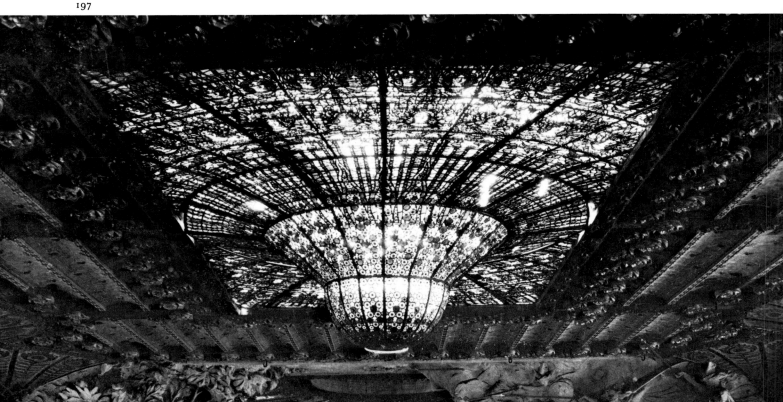

174

The front of the second story is enlivened and opened up by loggia-like galleries which suggest movement. Nevertheless, the separate forms, as well as the entire ensemble remain continuous and closely related, never achieving the open Baroque form, with which this façade is often compared. The supports of the loggia appear to be constructed of bones, while above them the surface of the façade is covered with a mosaic consisting of colored-glass tesserae whose delicately changing hues lend it the quality of neo-Impressionist pointillism (plate 201). At the back of the house, the façade is more unified; it is pierced by windows and wrought-iron balconies culminating at the top in a ribbon-like undulating parapet decorated with mosaic, above which rises the snaky silhouette of the roof itself (plate 200). The parapet of the top balcony and the wall above it are covered by mosaic flowers which also climb up the sides of the building. These flowers are similar to the rosettes of Viennese late Art Nouveau.

A few hundred yards farther down from the *Casa Batlló*, and on the same sumptuous street, stands the *Casa Milá* (plate 206). This building looks something

196 ALEXANDRE DE RIQUER *Binding for "Crisantemes"* (1899)
197 LLUÍS DOMENÈCH Y MONTANER *Chandelier in the auditorium of the Palau de la Musica Catalana, Barcelona* (1906–08)
198 LLUÍS DOMENÈCH Y MONTANER *Palau de la Musica Catalana, Barcelona* (1906–08)
199 RAIMONDO D'ARONCO *Pavilion for the International Exhibition of Decorative Art, Turin* (1902)

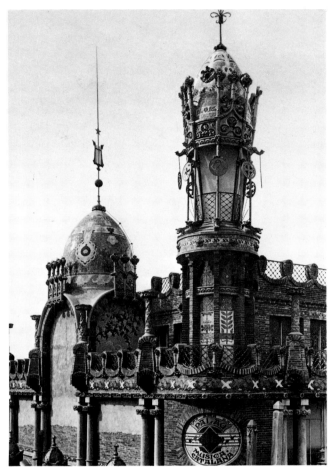

198

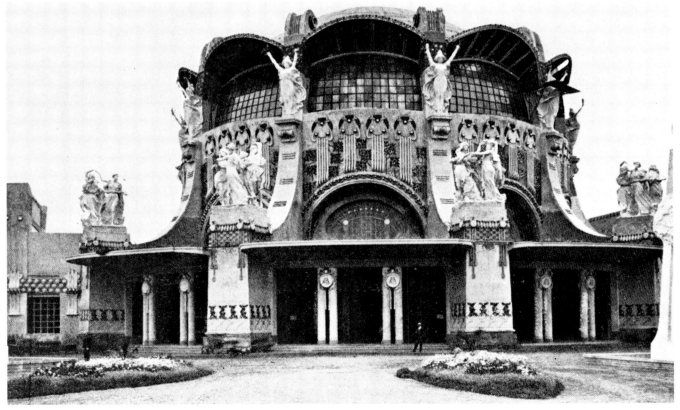

199

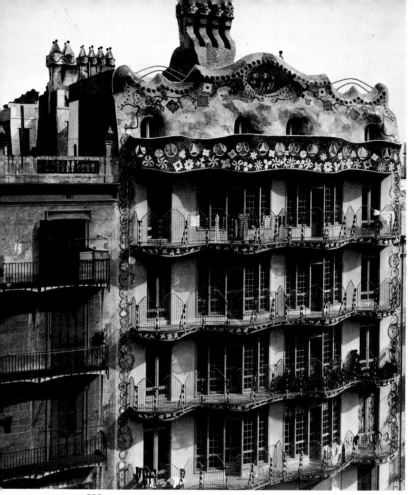

200

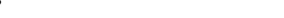

like the walls of a gigantic quarry, and is popularly known as *La Pedrera*. The *Casa Milá* was built between 1905 and 1910, but was never actually completed. It is a stylistic continuation of the *Casa Batlló*, progressing more and more toward a unified synthesis and simplification expressed in larger forms. The nature of the site suggested the building's convex bulges and irregular form. A typical floor plan (plate 202) is composed of curvy, asymmetrical units connected in the manner of a labyrinth. The inner courts are also shaped irregularly: the one to the right being somewhat kidney-shaped, and the one to the left a kind of hemicycle. The interior skeleton is composed of widely spaced steel girders which act as the building's main supports, and thus free the inner walls from their function as props, thereby allowing greater freedom in the distribution of the rooms. No two floors are exactly alike in their layout, but in each apartment (the sizes of the apartments vary considerably) the main rooms are always connected without any dividing partition.

The same movement which animated the floor plans is also found in the vertical projection of the exterior. The columnar supports of the ground floor seem to lurch obliquely both inward and outward, with this movement continuing upward through the subsequent levels; the parapet of the outer edge of the façade beneath the attic level terminates this movement, and rises and falls like

201

202

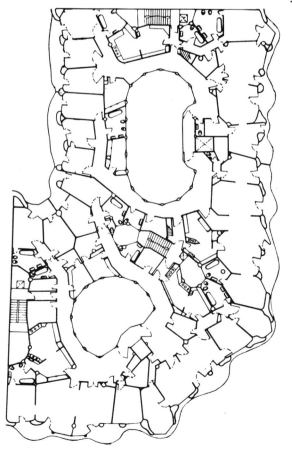

the horizon of hilly ground. On the upper roof, chimneys spiral upward like nightmarish towers, creating a veritable ''mass in movement'' that, however, is not in the least Baroque; despite their many apertures which swallow space, the individual details of these chimneys are compact and self-contained, and therefore un-Baroque. The plastic mass of the entire building and its outer contours are so viscous and fluid in their gliding spatial effects that the total impression is of space flowing away in all directions from the central mass of the building.

The *Casa Milà* has quite correctly been compared with dune formations, and the abstract sculptural decorations of the balcony railings look like frozen sea spume found on a beach after a storm. The decorative theme of organic irregularity is carried out with the utmost consistency. Even the seaweed-like staircase railings (plate 203) and, above all, the fine and totally unique iron and glass portals (plate 204), with their coral-like interstitial parts, remain faithful to this one theme.

The whole development of Gaudí's art can be traced in the grandiose but never completed *Church of the Sagrada Familia* in Barcelona (plate 205 and colorplates XXIII, XXIV). Gaudí worked on this church (certainly the most important ecclesiastic building since the late eighteenth century) from the beginning of the eighties until his death in 1926—in other words during the whole of his life as an architect. The church's first supervisor was

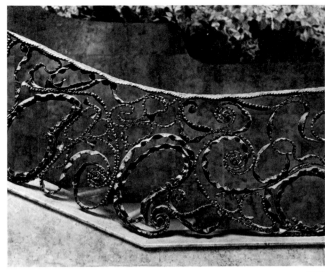

203

200	ANTONI GAUDÍ	*Rear façade of the Casa Batlló, Barcelona* (1905–07)
201	ANTONI GAUDÍ	*Front façade of the Casa Batlló, Barcelona* (1905–07)
202	ANTONI GAUDÍ	*Ground plan for the Casa Milá (1905–10)*
203	ANTONI GAUDÍ	*Banister in the Casa Milá, Barcelona* (1905–10)
204	ANTONI GAUDÍ	*Main entrance of the Casa Milá, Barcelona* (1905–10)
205	ANTONI GAUDÍ	*Model for the Church of the Sagrada Familia, Barcelona* (1925)

204

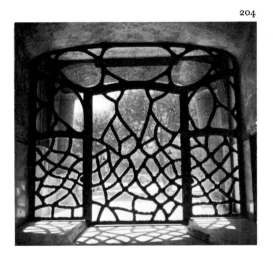

205

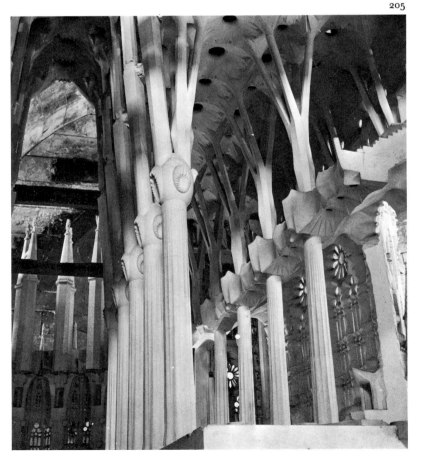

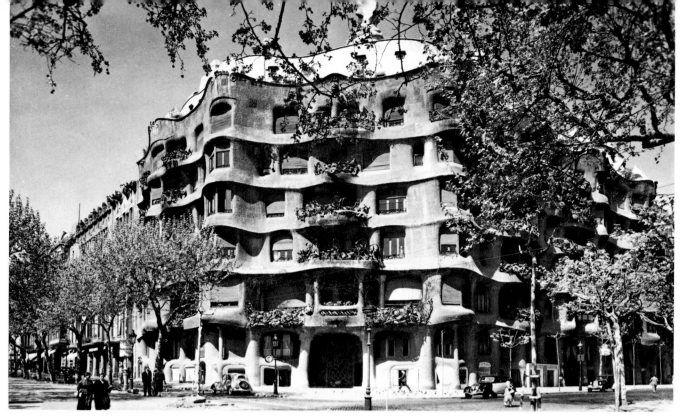

the architect Villar, who in 1882 began building it in the neo-Gothic style. At the end of 1883, Gaudí began to direct the work himself and completed the crypt and the window side of the choir according to Villar's previous plans. From 1891 to 1903, the façade of the transept of the Nativity was erected according to an entirely new plan Gaudí had designed. Here, High Art Nouveau is mingled with Gothic elements, and in the towers (built between 1903 and 1926) Gaudí transcends the style of his previous buildings in order to achieve what might best be qualified as Expressionist architecture. The towers rise like hollow anthills or infinitely elongated bee-hives. In spite of their "cubistically" sharp edges, they seem to be made of organic matter, and are not unlike the arms of an octopus with their honeycomb design of ornaments looking like suckers.

CHICAGO AND NEW YORK

North America's contribution to Art Nouveau was mainly the work of two artists: the architect, Louis Sullivan (1856–1924), and the decorator and glassware designer, Louis Comfort Tiffany (1848–1933). From the outset, they both conceived of Art Nouveau as a surface style, but their final results were dissimilar, just as they

206 ANTONI GAUDÍ *Front façade of the Casa Milá, Barcelona* (1905–10)
207 LOUIS SULLIVAN *Detail of the main entrance of the Guaranty Building, Buffalo, New York* (1894–95)
208 LOUIS SULLIVAN *Main hall in the Auditorium Building, Chicago* (1887–89)

had both distinguished themselves individually from European Art Nouveau. Beginning in the mid-nineties, Tiffany had a decisive influence on the Continental style as a whole, but Sullivan never became known in Europe.

Sullivan and the Chicago School

Before settling in Chicago at the age of twenty-three, Louis Sullivan had become well versed in the historistic architectural styles of his day through two of its more prominent exponents: Emile Vaudremer in Paris and Frank Furness in Philadelphia. Sullivan worked in Vaudremer's *atelier* as part of his studies at the École des Beaux Arts in Paris, and with the very individualistic Furness two years previously.

Sullivan's first works that show the beginnings of his extremely personal style were the Max M. Rothschild houses in Chicago, which he designed in 1880 together with Dankmar Adler. This row of houses was designed in the tradition of Norman Shaw's brick buildings (plate 43). The woodwork of the bay windows was adorned with rosettes in chip-carving and with vertical, highly abstract plant ornaments, like symbolic "trees of life" carved in high relief. Here, Nordic popular art, Gothic style, Celtic interlacings, and Greek palmettes seemed to blend in these strangely rigid forms. The origin of the highly abstract ornaments used here remains obscure, although we nevertheless perceive in them touches of Sullivan's later and more Gothic plant-like and plastic decorations. But it can be assumed that Christopher Dresser's books on ornamentation, if not Owen Jones' *The Grammar of Ornament*, were already as well known in

American schools of art and architecture and in public libraries as in England, and that Sullivan was acquainted with them. An American edition of *The Grammar of Ornament* had appeared in 1880. The similarity with Dresser's ornaments (plate 36) is easily detected in the Rothschild store, even though the plastic quality of Sullivan's details is new. True, even this ornamentation is conditioned by the surface on which it appears, and Sullivan's later architectural decorations (plate 207) are likewise developed in terms of the façade's surfacing: only rarely do they assume rounded, column-like forms. Only later, in the outwardly curving upper cornice of the otherwise entirely rectilinear Guaranty Building (1894–95), do we find a swinging movement in his architecture. Softer, more Gothic, and plant-like ornaments began to appear in 1887–89 in the staircases, the bar, and in the huge auditorium of the Chicago Auditorium Building (plate 208), as well as on the exterior of the Walker Department Store, both built in Chicago during approximately the same time (1888–89). These decorations are evidently a translation in sculptural terms of the ornamental designs which Sullivan had created in 1884–85 (plate 209). In turn, these were

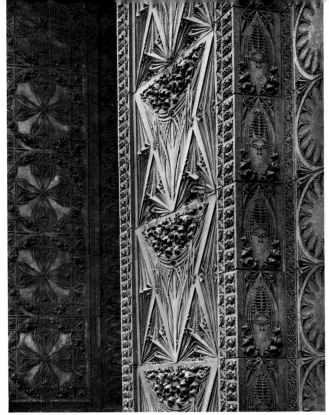

207

208

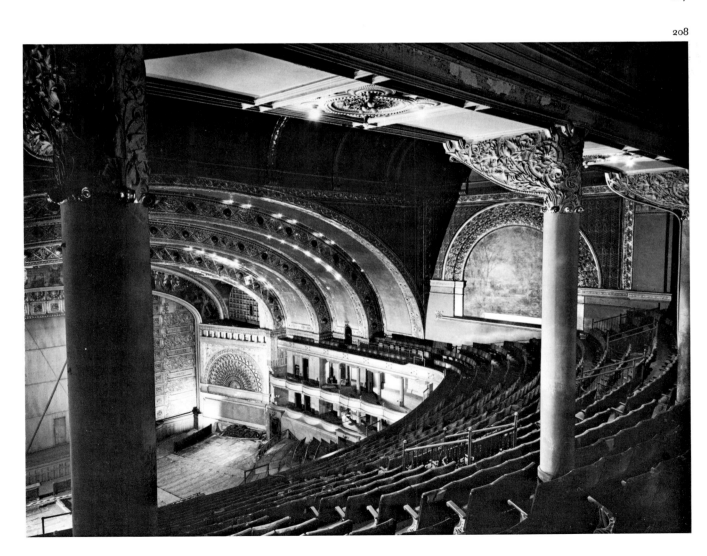

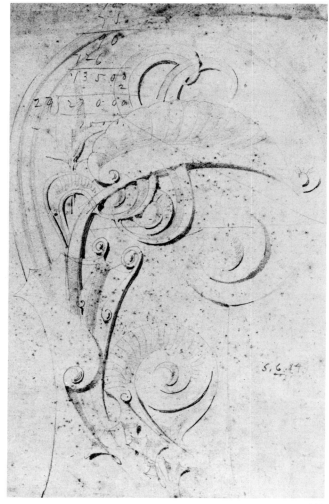

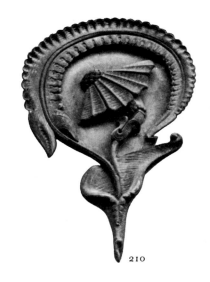

209

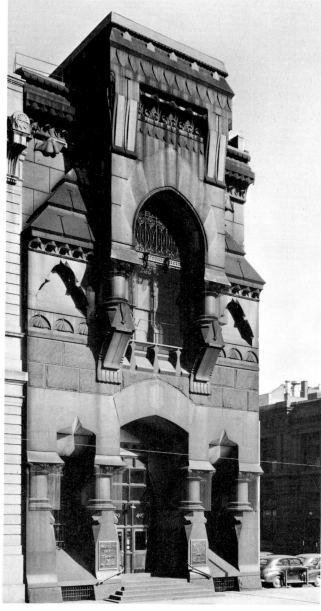

closely related to ornaments with which his first employer, Frank Furness (1839–1912), had adorned the School of Arts in Philadelphia in 1872–76 (plate 210). Furness conceived his buildings in a very imaginative, independent, and strongly articulated neo-Gothic style of somewhat exaggerated proportions (plate 211); his ornaments were clearly derived from the natural plant-like forms of late Gothic. The flamboyant style of late Gothic is transposed here into something fluid and lush, its vegetal forms almost assuming a reptilian aspect.

In the famous department store built for Carson Pirie Scott & Co. in Chicago (1899–1904), we see luxuriant ornaments in relief as well as more reticent surface-ornaments (plates 212, 213). The ground floor and mezzanine of this building are covered with detailed, power-

209 LOUIS SULLIVAN *Sketch for a decorative design* (1884)
210 FRANK FURNESS *Detail of the entrance to the Pennsylvania Academy of the Fine Arts, Philadelphia* (1872–76)
211 FRANK FURNESS *Provident Life & Trust Company, Philadelphia* (1879)
212 LOUIS SULLIVAN *Detail of the façade of the Carson Pirie Scott & Co. Department Store, Chicago* (1899–1904)
213 LOUIS SULLIVAN *Detail of the façade of the Carson Pirie Scott & Co. Department Store, Chicago* (1899–1904)

211

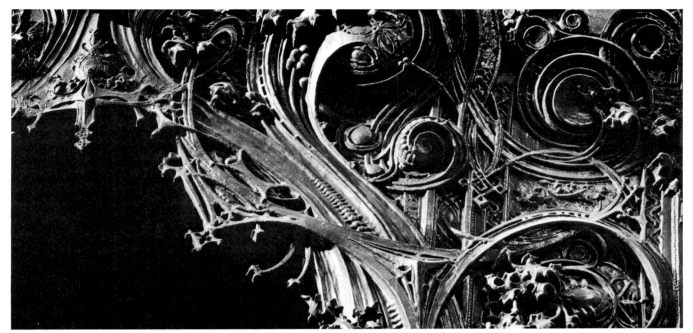

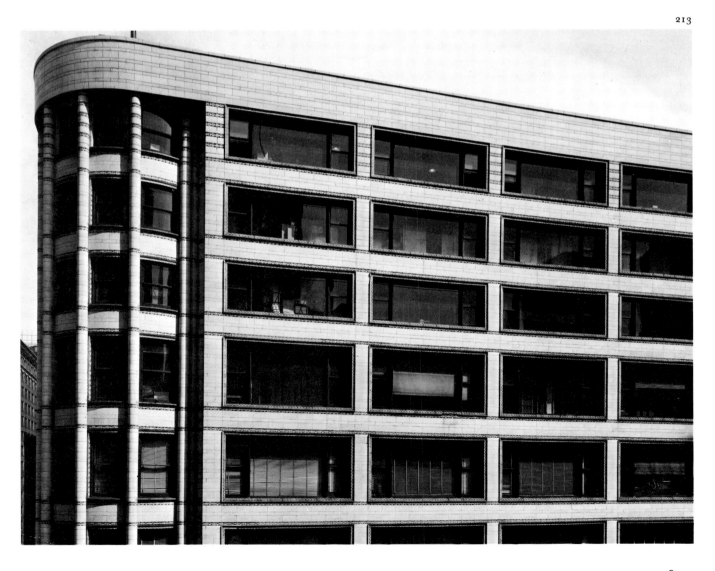

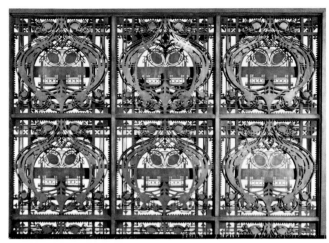

214

fully disrupted metal ornaments: overflowing and thorny acanthus leaves intertwining with smooth spiral ribbons of metal. The upper floors are entirely different: here the façade is covered with a smooth sheath and, from a distance, the windows look like single bands, anticipating the style of the present day. Each of the broad windows is framed and the bands of windows are connected by friezes above and below which show discreet geometric interlacings. In the interior, gate-like wooden partitions are employed as if to filter space (plate 214); their powerfully geometric but very complex and imaginative forms are cut out of thin wood and produce a clear, ornamental effect in spite of the variety of their forms.

Sullivan's buildings themselves, however significant in their architecture, can scarcely be considered as Art Nouveau. His oft-quoted theory that ornament must form an organic whole with the building and give expression to the structure is very loosely applied in actual practice. However much the stone, terracotta, or metal surfaces of his buildings may shift from organic life to the imaginatively geometric (the vegetal ornaments often cover the entire exterior of the building), they are nevertheless very scantily connected with the basic structure. The general form of his buildings would scarcely be changed if their ornamented surfaces were simply peeled off.

It was also in Chicago that the periodical, *The Chap-Book,* was published, whose pages carried drawings by William H. Bradley (1868–1962), designs which so closely resembled Beardsley's (plate 215). The finest and the most personal and independent of these is the almost abstract image of the American dancer, Loïe Fuller (plate 4), who was so successful on the European continent and who, in the medium of dance (that is to say

in real movement), was the very embodiment of High Art Nouveau. She wrapped herself in long, undulating veils which rose in whirls and spirals during her dance, and thus produced an almost abstract rhapsody of movement and light—for lighting indeed played an important part in her performance (Diaghilev said that Loïe Fuller was a greater genius in her lighting effects than in her dancing): she employed moving colored spotlights to illumine her veils, an effect which nobody before her had ever thought of using.

Louis Comfort Tiffany

It is difficult to find a common ground in the entirely different worlds of Sullivan and Tiffany, and much easier to establish a relationship between Loïe Fuller's dances and Tiffany's vases—though less in terms of a certain consistency found in American conceptions of form, than in terms of an extremist American version of High Art Nouveau found in both dancer and designer. Loïe Fuller must have produced the effect of a moving, iridescent, illuminated Tiffany vase, whereas Tiffany's slender, soaring, spiral vases seem to be veiled dancers frozen into glass. However, the common element that strikes one in such different manifestations of art expressed in Tiffany's vases, Loïe Fuller's dancing, and Bradley's posters is their smoothly abstract, clear, and relatively uncomplicated conception of form. Tiffany's forms seem indeed simple when compared to Gallé's glassware, so differentiated in their more subtle, morbid, and almost autumnal moods.

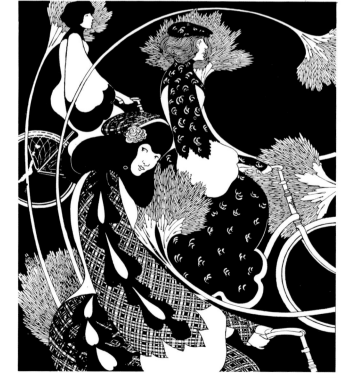

214 LOUIS SULLIVAN *Latticework on the façade of the Carson Pirie Scott & Co. Department Store, Chicago* (1899–1904)
215 WILLIAM H. BRADLEY *Poster for a bicycle company* (n.d.)
216 LOUIS COMFORT TIFFANY *Fireplace in the artist's house on 72nd Street and Madison Avenue, New York* (1883)
217 LOUIS COMFORT TIFFANY *Floor lamp* (before 1900)

215

Louis Comfort Tiffany did not work in his father's famous Fifth Avenue jewelry store. After taking up painting and then going to Paris, he turned to interior decoration. His evolution was thus similar to that of William Morris, Van de Velde, and the majority of the German *Jugendstil* masters. From the very start, however, Tiffany was not concerned with simple structures (in furniture for instance) nor with new forms of expression. As the decorator of the homes of New York millionaires, he created suites of rooms in line with the studio-style, which might have existed in the *Arabian Nights*. Like Gaudí, Tiffany had a preference for the Moorish style, but soon Japan also aroused his interest. In 1880, he decorated a room in the *Bella Apartments* in Japanese style, and this led him to adopt flatness, conciseness, and geometric arrangements in the articulation and decoration of his wall surfaces. The chestnut-leaf motif of Jones now becomes manifested as a two-dimensional surface design, and as openwork relief in the Japanese manner. In spite of an eclectic and conglomerate quality inherent in his groupings of various luxurious pieces of furniture employed throughout Tiffany's interiors, every so often one finds simple Thonet chairs revealing the sleek curves of their construction.

Since his workshops also produced lamps and other glass and metal objects for daily use, Tiffany studied the chemical composition of glass and various effects of metallic vapors as coloring agents for his pieces. He then patented his new invention of iridescent and opalescent glass, calling it *favrile*. At first this glass was used only for decorative "stained-glass" windows. Art Nouveau, with

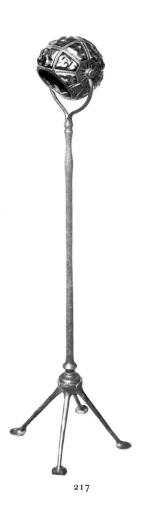

217

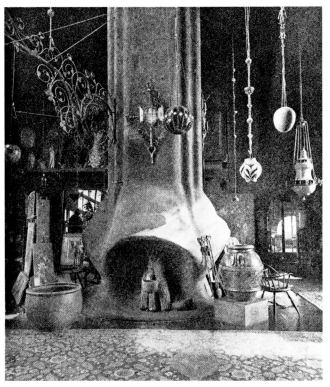

216

Tiffany, simply starts in the decorative use—and thus in the aesthetic appreciation—of movement expressed in solidified glass. Only much later, after 1893, did these beginnings lead him to experiments which resulted in the famous Tiffany vases. Tiffany did not work the glass himself, but his forms were created according to his personal instructions, and are thus expressions of his own conception of form.

Meanwhile, Tiffany continued to design new interiors. In 1884, he decorated a studio and penthouse apartment for himself, in the main room of which there stood a chimneypiece with four fireplaces (plate 216) placed away from the wall. With its smoothly curved forms, it is the first example of plastically conceived American Art Nouveau. Quite unconventional and inspired by no models extant in traditional Western rooms, but possibly inspired by Moorish or Byzantine examples, this room also has lamps of many kinds hanging from the ceiling, suspended by chains or bunches of chains in asymmetrical groups and at different heights. Most of these hanging lamps are spherical in shape; among them hangs an ostrich egg. Tiffany later found other original solutions for lighting fixtures: for instance, an electric lamp created shortly before 1900 is set on a straight bronze stand and carries on its long stem a globe consisting of strips of metal between which is inserted black glass which has a green shimmer when lighted (plate 217).

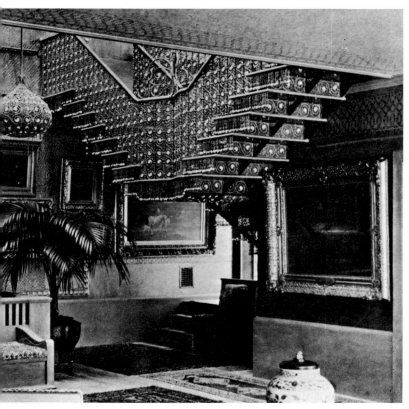

Until glass became his main preoccupation, Tiffany often designed objects to be executed in metal. The banisters of the astounding ''hanging staircase'' in the Havemeyer residence (plate 218) consist of threads of metal juxtaposed in spirals and adorned with a metal fringe. The pointed pendants on the hanging lamps are made of the same filigree work, and the lamps are pierced by unusual apertures which seem to have been achieved by cutting out pieces of metal, a procedure which was later employed in Tiffany's above-mentioned standing lamp.

After 1893, at the height of his career, Tiffany created his vases in *favrile* glass (plates 1, 219, 220, 221, and colorplate XXX). The forms of these vases employ the softly modeled sculpture of his 1884 chimneypiece combined with the shapes occurring in the molten glass of his opalescent stained-glass windows (plate 216). The glass is sometimes opaque, sometimes transparent, but with threads, whirls, or clouds, sometimes with smooth, or else with ingeniously roughened surfaces of a metallic patina; the pieces are incredibly varied in color, and even more so in their grandiosely conceived but precise and evenly flowing forms, so that each of them appears to be different and unique. One senses affinities with Persian flasks, antique Roman glass, and shapes suggestive of Attic amphorae. Their scintillating, corroded surface reminds one of ancient glass that has

218 LOUIS COMFORT TIFFANY *"Hanging Staircase" in the Havemeyer residence, New York (before 1893)*

been buried in the earth for centuries. Tiffany's formal inventiveness of form is particularly striking: in spite of the regular, uninterrupted flow of the contours and of an ornamentation solely due to the haphazard flow of the molten glass, these magnificent individual pieces suggest something bizarre and extravagant which is always convincing and of great taste and distinction. The veined, marbled pattern of the glass takes on a metallic shimmer as it hardens and assumes a resemblance to the peacock-feather design so popular throughout Art Nouveau. A vase in the Metropolitan Museum (plate 221) enchants us as a pure object rather than as an imitation of a pattern found in nature, yet it is no more abstract than the superbly outstretched tail feathers of an actual peacock. Tiffany also shares Art Nouveau's predilection for ''cutout forms''; his patterns go all the way through the glass, as if the vessel had been formed out of a slice cut from a homogeneously structured mass.

The few ceramics that Tiffany created are not so famous as his glass, but they include some very fine pieces. After 1900, Tiffany left the designing of his glass more frequently to his craftsmen and, in general, his creative powers diminished with the decline of High Art Nouveau. Replicas produced almost as a series, and of far poorer quality, appeared with a greater frequency; the only way of satisfying the enormous demand for his wares was to produce the same model over and over again and to employ craftsmen of lesser skill. Until quite recently, Tiffany's workshops turned out lamps, penholders, inkstands, and other articles mostly of doubtful quality. By means of his personal creations, however, and most of all through the glassware he produced between 1893 and 1900 that was responsible for his universal fame (he was clever in displaying it advantageously in exhibitions, and in bestowing particularly fine specimens to museums), Tiffany became one of the most prominent artists of Art Nouveau.

GLASGOW

In the work of the Scottish artist, Charles Rennie Mackintosh (1868–1928), Art Nouveau entered its late phase during the early nineties. This phase found its most important and fruitful expression in Mackintosh's style and in that of a small group of artists who were intimately connected with him. The creations of these Scottish artists bear witness to the close tie between High and late Art Nouveau, both of which spring from the same roots, though the more frequently geometric, rectilinear, and cubic late phase may at first appear to be diametrically opposed to the curved, organic High phase. It is not surprising that in its late phase all reminiscences of historic forms which still appeared in early Art Nouveau should have been discarded and that, in their stead, astounding premonitions of the style of our own twentieth-century art and architecture should begin to appear.

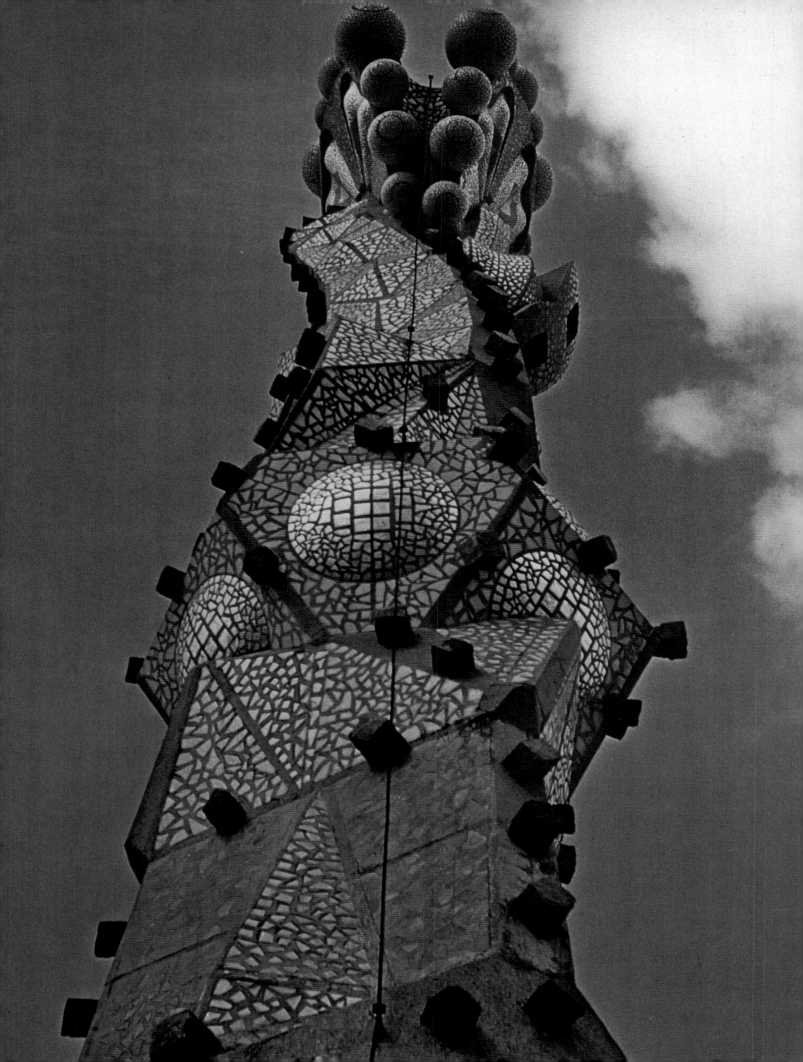

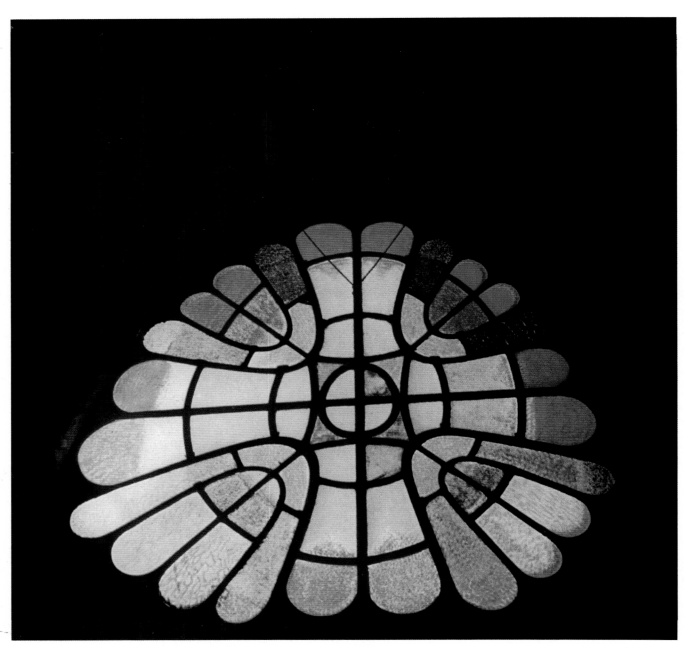

XXV/XXVI ANTONI GAUDÍ *Stained-glass windows in the chapel of the Colonia Güell*
(between 1898 and 1914)

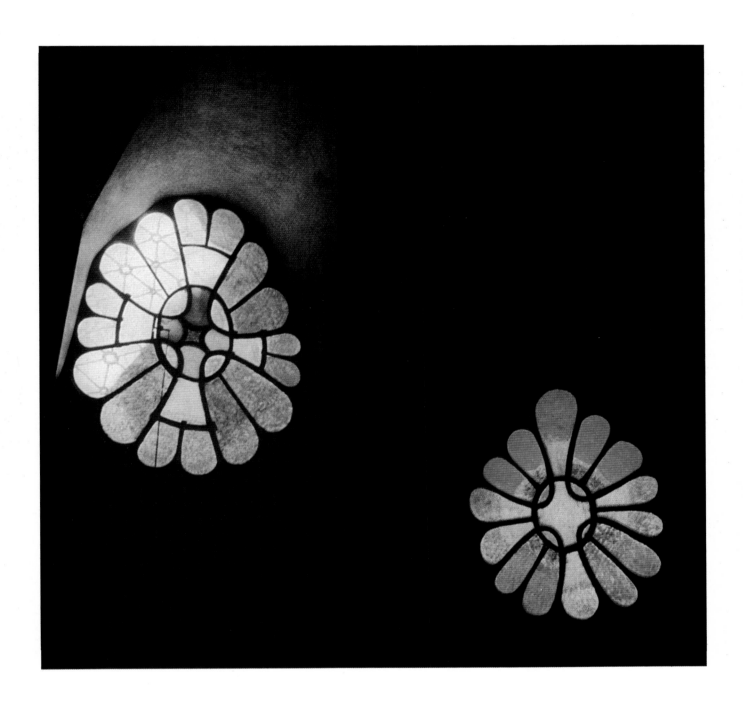

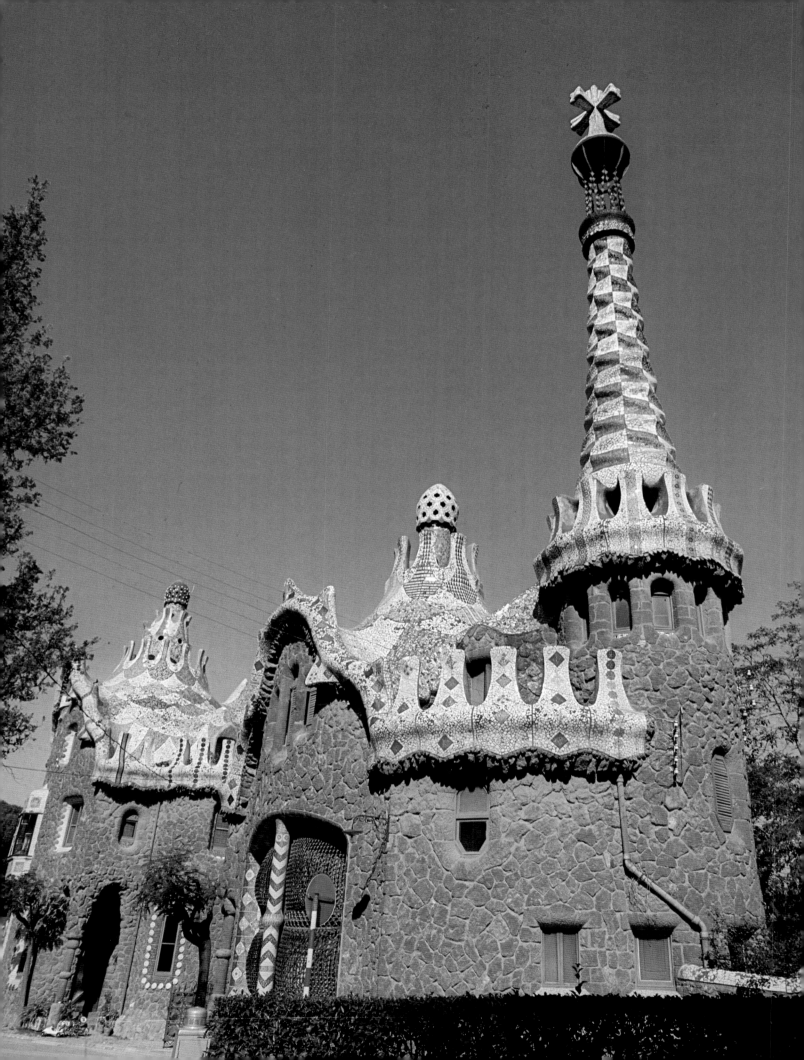

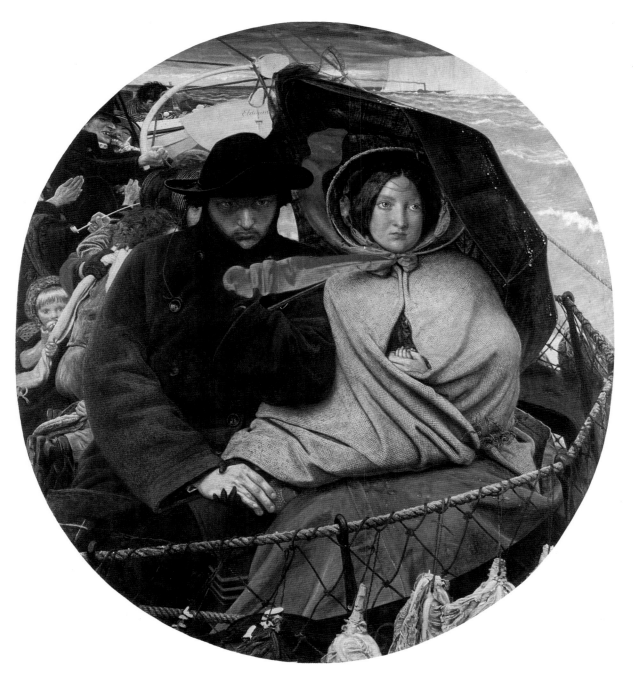

XXVIII FORD MADOX BROWN *The Last of England* (1852–55)

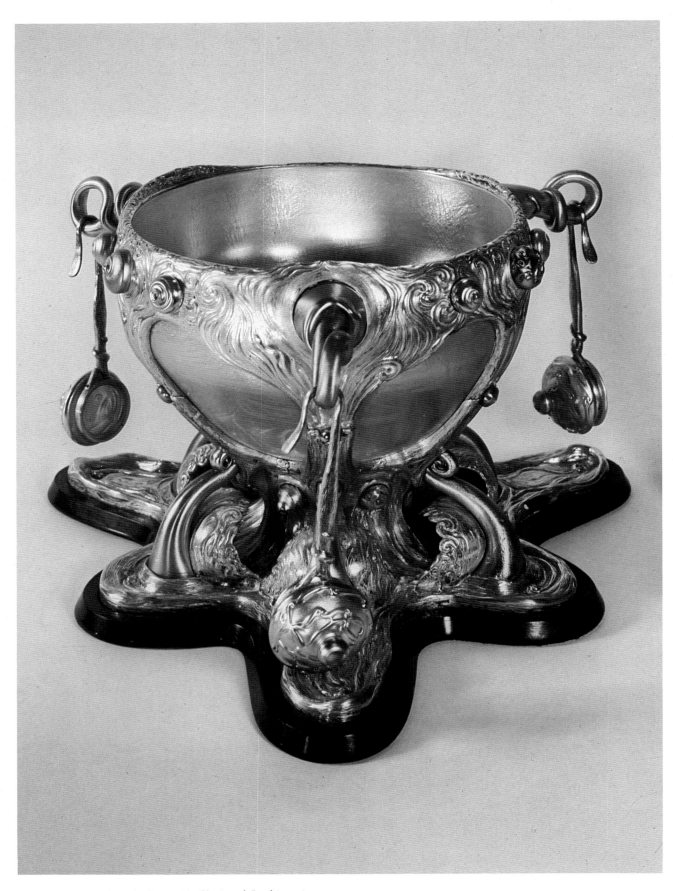

XXIX LOUIS COMFORT TIFFANY *Punch Bowl* (1900)

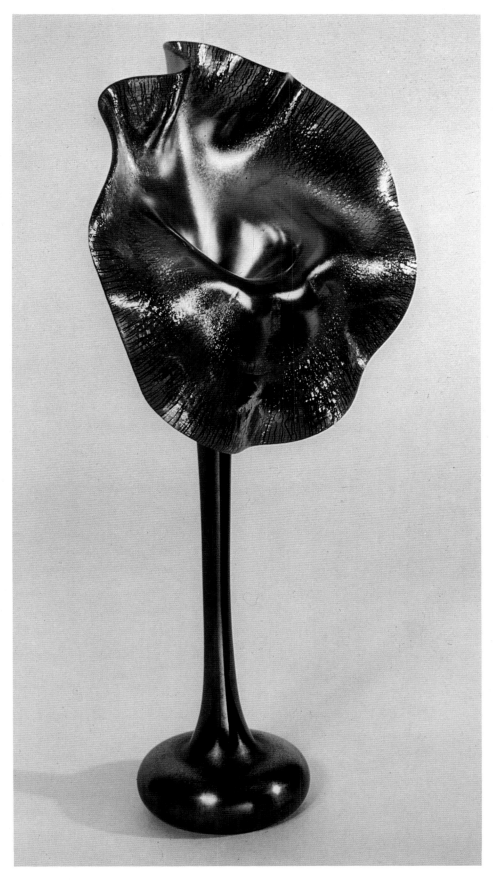

XXX LOUIS COMFORT TIFFANY *Vase (circa* 1900)

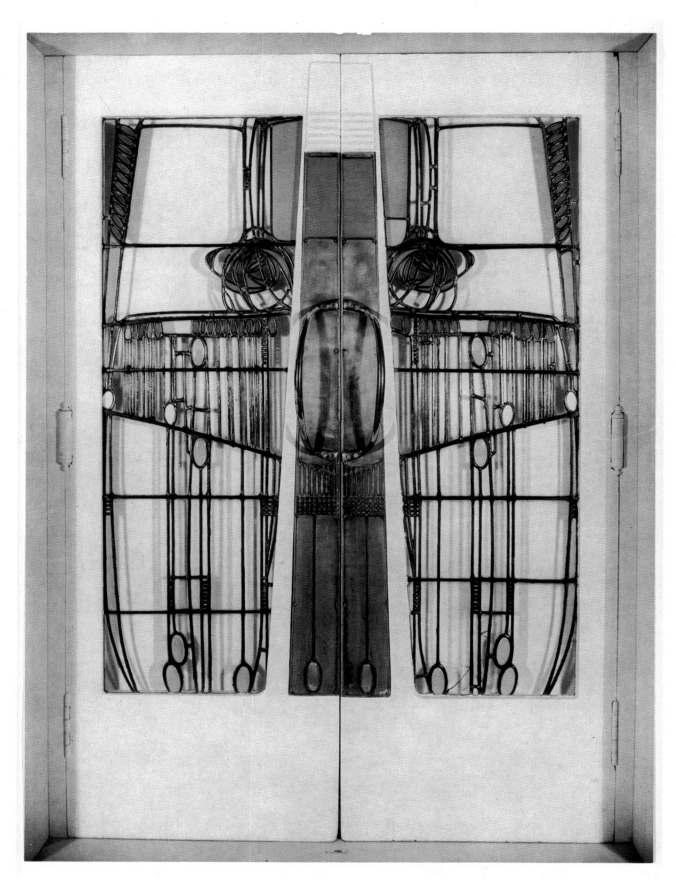

XXXI CHARLES RENNIE MACKINTOSH *Door to the "Room de luxe" of The Willow Tea-Rooms* (1904)

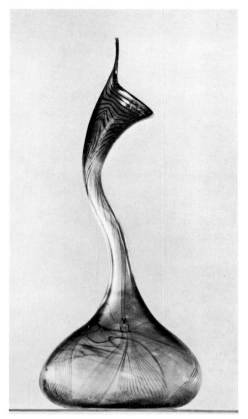

219

220

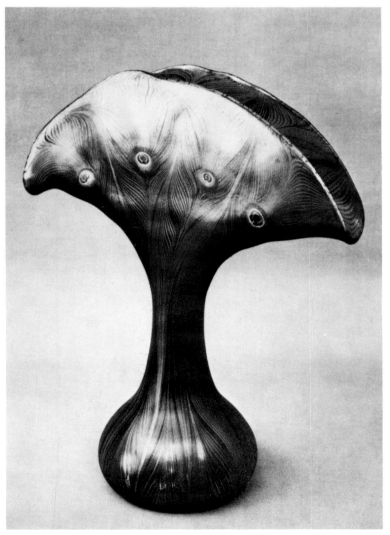

221

219 LOUIS COMFORT TIFFANY *Vase* (before 1900)
220 LOUIS COMFORT TIFFANY *Vase* (*circa* 1900)
221 LOUIS COMFORT TIFFANY *Vase* (before 1896)

Mackintosh developed his style within the surface of his work. Although his buildings and rooms are often almost free of any adornment, surface ornamentation was actually his point of departure. In his monograph on Mackintosh, Thomas Howarth has fully investigated the sources of his style, not only the influence exerted on him by the Pre-Raphaelites and the Japanese school, but also in certain secondary or less direct influences. The early date at which essential and relatively independent features of Mackintosh's style appear is noteworthy. In a photograph of the interior of his studio taken around 1890 (plate 222), we see Japanese woodcuts hanging on the walls together with such reproductions of Burne-Jones paintings as *The Six Days of Creation*. The decorative frieze beneath the ceiling had obviously been painted on a long roll of wrapping paper: in its center, the vertical figure of what appears to be an angel forms a sort of symmetrical axis for other groups which, in turn, are also symmetrical. On the left, below an immense circular moon, two pairs of cats face one another. The stylization of the figures is very powerful: they are conceived as concisely limited, homogeneous, two-dimensional forms with broad spaces between them. With the exception of the purely geometric, circular disk, these two-dimensional bodies are all curvilinear, but without any trace of the heavily flowing or convulsive outlines of High Art Nouveau. In this instance it is rather a matter of wide and flat curves, like oval segments, almost in the style of late Art Nouveau. As to the style of this frieze, no parallel to it can be found in its day, whether in England or elsewhere. Years before Beardsley and Toorop, who are both generally quoted as the probable sources of the style of the Glasgow group, could have had any influence (Beardsley had not yet produced anything at that early date), Mackintosh had demonstrated the originality of his forms. Indeed, from the very start, he was much less dependent on outside influences than has been supposed.

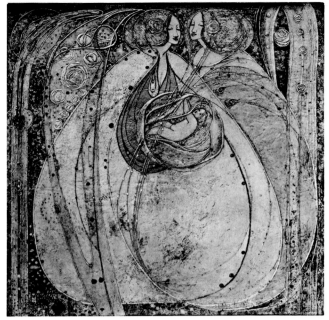

223

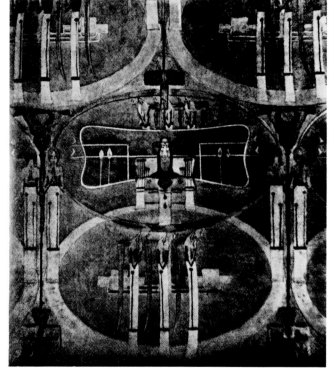

224

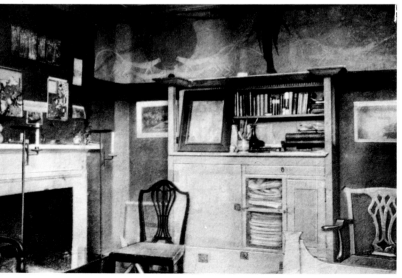

222

222 CHARLES RENNIE MACKINTOSH *The artist's room at Dennistoun, Scotland (circa 1890)*
223 MARGARET MACDONALD-MACKINTOSH *Motherhood (1902)*
224 MARGARET MACDONALD-MACKINTOSH *Crucifixion (1894)*
225 MARGARET MACDONALD-MACKINTOSH and FRANCES MACDONALD *Candle holder (circa 1897)*

The highboy in the photograph is clearly the first piece of furniture made by Mackintosh, almost quadrangular in outline, its lower two-thirds being box-like and fitted with doors, whereas the top is open and contains a shelf. This is a typical example of his earlier work; features of his later furniture, and also of his architecture, are already discernible, but as yet have not assumed a clarity and purity of form. The corners of the lower part terminate in two shaft-like pillars which are covered by widely protruding plinths. This device is frequently found—but at a later period—in works by Voysey, and the common source for both Mackintosh and Voysey was Mackmurdo (plate 40). The lower part of the highboy is already an example of what is called ''broken symmetry,'' the combination of symmetry and asymmetry which was later to be of such importance in Mackintosh's architecture. The bottom drawer takes up the entire width and is provided with three symmetrical metal pulls. The main part of the cupboard is divided into two halves, the left side being covered by a door, while the right is symmetrically subdivided, with only its right half fitted with a door, the open portion on the left containing pigeonholes; above this subdivision there is a shallow drawer. This articulation and spatial divisions of the piece show clear signs of Japanese influences, and what was somewhat primitively attempted here was later carried out very lavishly and in perfectly balanced proportions: above all, in the façade of the Glasgow Art School.

However, what did not derive from Japanese art was the emphasis on symmetry that so markedly distinguished the early ornamental drawings of Mackintosh and the Macdonald sisters (plates 223, 224) from asymmetric High Art Nouveau. In spite of the probable influence exerted by Toorop's painting, *The Three Brides*, reproduced in *The Studio* of 1893, none of the basic features of the figurative graphic work of the early period of the Glasgow school up to about 1896 are derived from historicism. Here, even though no documentation confirms this fact, we find a relationship which was of great importance to the whole of English Art Nouveau: the impact of William Blake's work.

In the early watercolors by the Macdonald sisters, such as Frances Macdonald's *Ill Omen* (1893) and *A Pond* (1894), and *November 5th* by Margaret Macdonald-Mackintosh (she was Mackintosh's wife), the affinity with Blake is easily discerned. Though the Scottish artists translated Blake's ideas into their own individual idiom of form, the basic conception and certain details of their patterns remain so similar that a comparison shows that the analogy cannot be merely coincidental—even though they had simplified the forms, added purely geometric elements, and emptied the theme of its content.

The tangle of powerfully curved bands, lines, and stripes which (without their having any recognizable sense as objects or symbols) enclose the very stylized nude figures was later transformed by Mackintosh into

entirely abstract ornamentation, while the Macdonalds were more inclined to remain faithful to figurative and representational ornament (plates 223, 225). We do not, of course, find Blake's curves and rhythms here, but we do see evidences of his geometric structures, his rigid symmetry, and his arrangements in rows and parallels. The Glasgow artists indeed discovered late Art Nouveau through Blake's work.

Margaret Macdonald-Mackintosh, in her greatly ornamental *Crucifixion* of 1894 (plate 224), borrowed much from Blake's *When the Morning Stars Sang Together* (plate 226): the division of the extremely flat picture into oval and semi-oval sections, filling up the empty spaces with figures, and the blending of representational and abstract elements. She likewise borrowed from Blake's watercolor, *The Procession from Calvary*, the parallel arrangement of the figures which, however, she presented partly in profile as they all bear the load of the outstretched body. The main difference is again the transformation of the picture into a decorative work which has little meaning but remains vaguely symbolical. Blake's vision ''which represents the exterior universe such as the inner eye of poetic imagination sees it'' has given birth to a type of wallpaper pattern which could

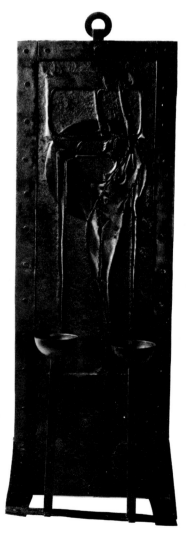

225

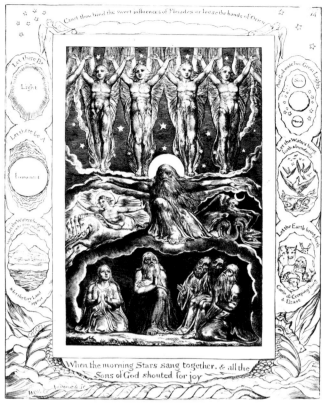

226

placed behind it like a vaguely symbolical halo which corresponds to the most variegated abstract figures or circles and disks in works of Mackintosh and the Macdonald sisters. The motif of the abstract rose, which the Scottish artists often placed in the middle of an either circularly enlarged or vertically elongated figure (plate 228), and Margaret Macdonald-Mackintosh's stylized rose in the center of a work in stucco depicting a small child (plate 223), is anticipated in Ford Madox Brown's painting, where the baby is wrapped in a cloth draped in the form of a rose. However, in his work even the indistinct form to the right of the young mother, the bed curtains loosely hanging from a curved metal rod over the small cradle, has also left its impact on later works, although not as a figurative motif, but as an abstract and ornamental one, in the downflowing strip to the right-hand side of the stuccowork and also in curves on the left, which look like the eyes of needles. The interruptions of lines and forms by means of small rosettes or circles was first conceived by Beardsley in his

be expanded in either direction without much difficulty.

We can also precisely trace the origins of the style of the Glasgow group back to the Pre-Raphaelites of the late eighties and early nineties. The whole world of Art Nouveau artists was naturally subject to Pre-Raphaelite influences, so that no direct contact with Rossetti or Burne-Jones, for instance, would have been necessary. Yet in the Glasgow school we find a concrete link with a specific work of the early phase of Pre-Raphaelitism: an unfinished painting by Ford Madox Brown (plate 227). This picture, *Take Your Son, Sir* (1856–57), was strongly influenced by Rossetti, though it retained a definitely personal note. Here we find the first appearance of those feminine figures which the Scottish artists transformed into expressive ornaments, and we also see here the expression of adoration and self-abandonment in the certainly not beautiful but very characteristic faces and in the position of the woman's body. But let us first of all examine the formal theme: the shape of a woman with an unbroken, pear-shaped contour, her garment swinging from neck to hem, hiding her feet; her small oval face framed by the simplest arrangement of hair. In Brown's painting, the head appears against a mirror

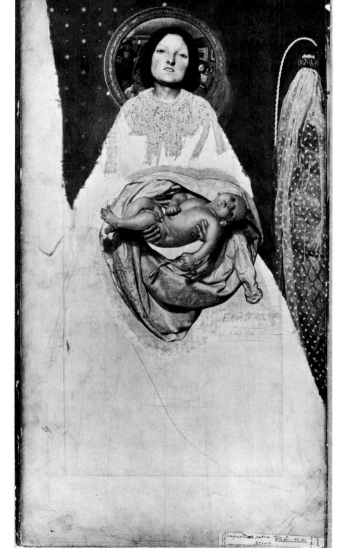

226 WILLIAM BLAKE *When the Morning Stars Sang Together* (1825)
227 FORD MADOX BROWN *Take Your Son, Sir* (1856–57)
228 CHARLES RENNIE MACKINTOSH *Decorative wall hanging* (1902)
229 CHARLES RENNIE MACKINTOSH *Main entrance of the Glasgow School of Art, Glasgow* (1897–99)

227

drawings, whereas the sense of proportion (in spite of its development and exaggeration by the Glasgow artists) already appears in Ford Madox Brown. No doubt, the unfinished state of the picture, in which the blend of abstract and concrete elements, the sleek contours, and the two-dimensional bodies are stressed, may have exerted a particular influence over these subsequent works.

Charles Rennie Mackintosh

In the beginning of his career as an architect, Mackintosh (1868–1928) worked for several years in the office of the architects, Honeyman and Keppie, and on many buildings designed by this firm; in Glasgow's Martyrs' Public School (1895), in particular, characteristic features of his own style have begun to appear. But, according to the standards of his own style, derived from flat ornament and interior decoration, one of his first really important works was the interior decorations for

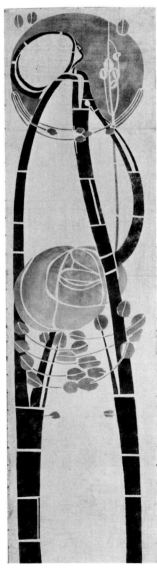

228

229

Miss Cranston's Tea Rooms. In 1897–98, he decorated the first of these restaurants, the famous Buchanan Street Tea Room in Glasgow, having previously published his designs for them in *The Studio*.

In 1897, he was fortunate enough to have his design for the Glasgow School of Art accepted. The main part of the building, the first important work in geometric late Art Nouveau, was finished in 1899 (plates 229, 230). The heavy, block-like building was erected on an unusual site which slopes steeply to the rear, and on its south side is mostly blocked off from the sun. The design represents a complex synthesis: on the one hand, close units as forbidding as fortresses and formed by sharply impinging walls; on the other, labyrinthine interpenetration of powerful plastically conceived units, deep apertures, and incisions. As a unit, however, it produces a homogeneous impression, and only within the context of the general contour do we see the play of receding and protruding forms, now massive, now hollow. On the north façade, with its enormous windows, the static, calm element predominates: and in the symmetry of its broad rectangular form, internal asymmetry—so to speak—predominates. As a characteristic sign of Mackintosh's work, a clear and unconventional functionalism blends with an imagination expressed in plastically conceived spatial and decorative forms.

However, this synthesis of contrasts does not express itself in the Baroque manner—that is, movement does not become the dominant factor. Actually, the overall

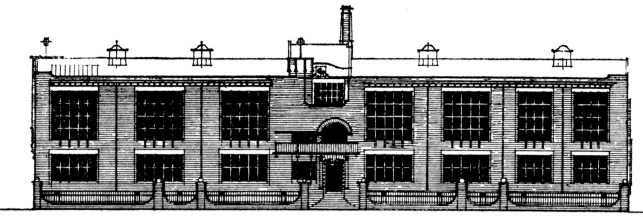

effect in terms of unrelieved tension is closely related to Michelangelo's Mannerism as seen in the Sacristy of San Lorenzo. This tension in Mackintosh's design expresses itself as a disruption of forms minimized with great sensitivity through beautifully balanced proportions giving the impression of passive form. Yet despite this inner reserve and refined simplicity, the innate vitality of the building is clearly evident, and the façade's apparent quality of combined symmetry and asymmetry is an illusion effected by a balance of forms that are both unrelated and disrupted.

The plans of the building demonstrate far better than any photograph how Mackintosh achieved these effects (plate 230). The elevation clearly shows that he has divided the rectangular façade by means of eight shafts, or sections, of masonry which are placed between the window apertures. This arrangement is conceived so that

none of the eight shafts is centrally positioned. In spite of this, the main entrance, which is placed in the fourth shaft, actually falls in the exact center of the façade. However, this fourth shaft does not occupy the entire center section, as this section contains only the asymmetrically placed entrance or portal. As an architectural unit this portal is actually twice as broad to the left of the building's geometrical center as it is to the right, so that one still feels that the fourth shaft is an integral part of the façade's left half. The fourth shaft's eccentric position distinguishes it from the seven others as the former contains narrow, fortress-like window slits, while the others are pierced by very broad windows that open out widely. But these seven other shafts also offer dissimilarities. The two on the right, for instance, are somewhat narrower than the other five, so that the sequence of shafts starting from the left presents the follow-

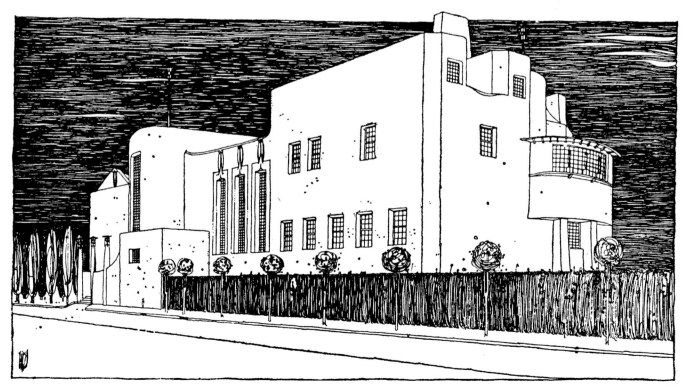

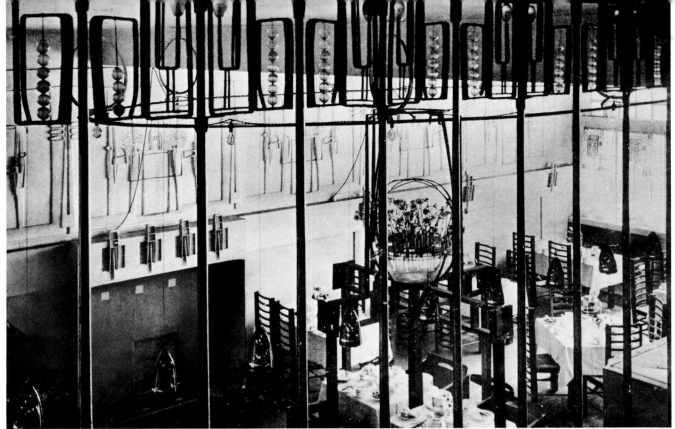

ing: three wide shafts, an irregular fourth, two more wide ones, and ending with two narrow shafts on the right. However, the "disturbed" part of the entrance appears to have two shafts of its own, so that the entire façade might be said to consist of nine shafts, the fifth of which is situated in the exact center of the building. This extremely subtle and almost acrobatic balance of symmetry and asymmetry also extends to the horizontal plane of the building as well as to the vertical. The fourth shaft is three storeys in height and bears an asymmetrically placed chimney, while the other shafts are only two storeys high, and the windows on the ground floor level are horizontal rectangles, while those on the second floor are the same width but are twice as high.

These proportions which have been analyzed in the plan of the building's elevation become even more complex to the eye of the passer-by who perceives them three-dimensionally and in perspective from the street level looking upward. Seen from this angle, the "disturbed" area is distinguishable from the other shafts because its topmost part terminates in a cubic form, somewhat rock-like in profile. All the other shafts, however, are terminated by flat, board-like cornices which project far out from the building, and protect the large windows from the direct rays of the midday sun. The whole conception and theme of the building (which is elaborated far more than

230 CHARLES RENNIE MACKINTOSH *Elevation of the north façade of the Glasgow School of Art* (1896)
231 CHARLES RENNIE MACKINTOSH *Preliminary sketch for the "House for a Lover of the Arts"* (1901)
232 CHARLES RENNIE MACKINTOSH *The Willow Tea-Rooms, Glasgow* (1904)

in any of Voysey's buildings) shows a kinship with Mackmurdo's designs and also recurs in Mackintosh's subsequent country houses as well as in his famous *House for a Lover of the Arts* (plate 231).

The severe, solemn, and almost ascetic quality of the Glasgow Art School's façade also contains an additional subtlety and richness of design: a fine, linear network of iron railings and window-frame decorations surrounds the building like a halo, bringing it into a kind of harmony with the space surrounding the building. As Nikolaus Pevsner stated: ". . . this row of metal lines reveals one of Mackintosh's most important qualities, his intense feeling for spatial values. Our eyes have to pass through the first layer of space, indicated by metal brackets, before arriving at the solid stone front of the building. The same transparency of pure space will be found in all of Mackintosh's principal works." A theme upon which Mackintosh was later to produce variations, especially in his interiors (plates 232, 233 and colorplate XXXI), is here employed on an exterior as a device for reducing space to a linear, abstract network stretched across the three-dimensional volume of the building.

VIENNA

In 1898, Berta Zuckerkandl, a friend of Alma Mahler-Gropius-Werfel, wrote an article for the second issue of the Viennese periodical, *Ver Sacrum*, entitled *Examples of Viennese Bad Taste*, in which she said: "Where has our refinement vanished? The ideal of our present-day cultured society still seems to be the possession of a flat on the Ringstrasse, with, if possible, a private entrance

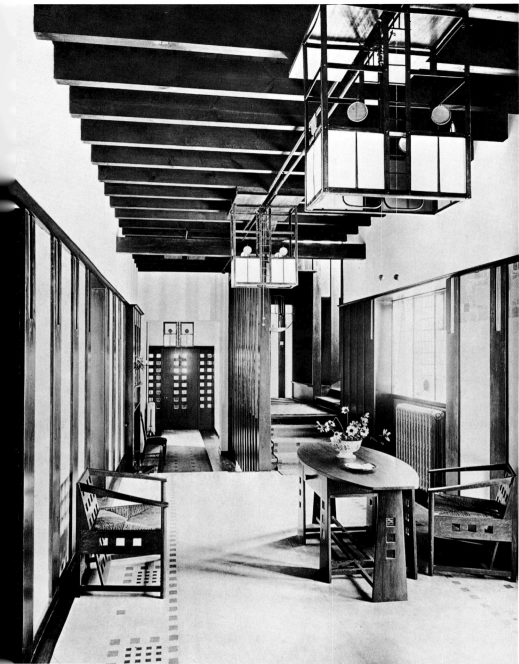

233

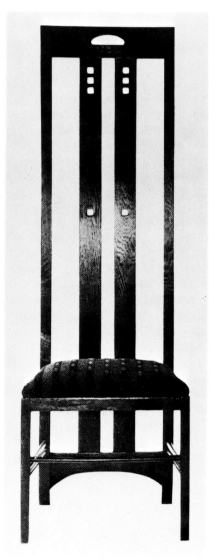

233 CHARLES RENNIE MACKINTOSH *Hallway in Hill House, Helensburgh, near Glasgow* (1902–03)
234 CHARLES RENNIE MACKINTOSH *Chair* (1900)
235 OTTO WAGNER *Detail of the façade of the Mietshaus on the Wienzeile, Vienna* (1898–1900)
236 JOSEPH MARIA OLBRICH *Sketch for the exhibition hall of the "Wiener Sezession"* (1899)

234

leading from the street. In one of these first-floor apartments in a four-storey luxury tenement one lives amidst a perpetual cloud of dust and noise rising from the street. We have no sense of real elegance, especially since the interior of such a flat is as banal as the exterior of the building . . . Our decorators and upholsterers are usually hostile to any artistic taste, being totally unaware of the important role which might be played by such taste in interior decoration. To say the least, they are terribly stubborn and obtuse: for instance, unlike the decorators in Paris and Berlin they do not stock an entire range of decorative art products designed by such artists as Walter Crane, Gerhard Munthe . . . Köpping, Gallé, Obrist, and so many others. Our Viennese decorators take the rooms we entrust to them merely to celebrate within them their own perfectly absurd orgies of brocade, plush, and gilt.''

As may be inferred by the above statement, Vienna was the last of the major European capitals to adopt Art Nouveau. The number of influential artists working there was small, including, among others, the painter and designer Gustav Klimt, and the architects Wagner, Hoffmann, and Olbrich. The latter two, after the manner of other many-sided Art Nouveau artists, not only designed buildings, but also interiors, objects for daily use, furniture, textiles, lettering, and, above all, ornaments, which are very much like those in Klimt's paintings. The architect Adolf Loos was only vaguely connected with this group, though we can detect in his work a tendency toward late Art Nouveau, toward simplification, rectangularity, rectilinearity and *amor vacui*.

In its typical form, Viennese Art Nouveau is, almost without exception, free from any admixture of Rococo and Baroque elements, although it would have been particularly easy in Vienna to revert to the Baroque style. We can detect here no relationship to Horta or Guimard, though in the beginning, we may find now and then Van de Velde's typical curves. Very soon, the boxy shapes of English Arts and Crafts furniture and rectangular or rectilinear architecture appeared in Vienna, with smooth surfaces that suggest the styles of Norman Shaw, Voysey, Ashbee, and Townsend. Other inspirations came mainly from the Scottish artists, Mackintosh and the Macdonald sisters. In addition, there were affinities with Khnopff and Toorop, Minne and Hodler.

After 1901, however, Viennese Art Nouveau inspired some German artists, such as those who participated in the exhibition on the Mathildenhöhe, near Darmstadt, which bore Olbrich's distinctive sign. Italian Art Nouveau also depended on Vienna, as well as on English architecture, as is indicated by its name, *Stile Liberty*, borrowed from the famous London firm. Italian attempts at Art Nouveau were indeed founded mainly on imported ideas and limited to details, without achieving any integrated idiomatic Italian Art Nouveau style.

Vienna's great architect, Otto Wagner (1841–1918), had for many years designed buildings in a historicist style that ranged from the Renaissance to Rococo, with

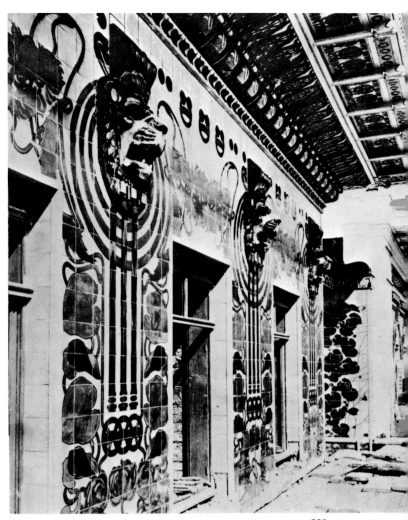

235

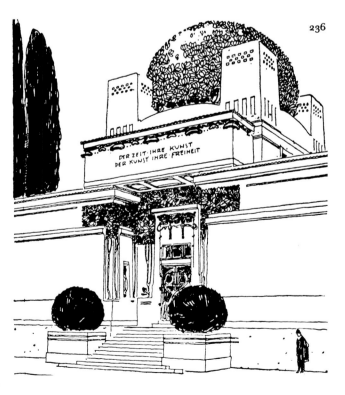

236

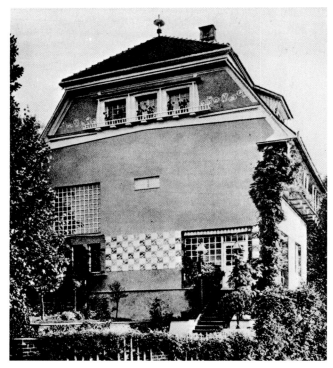

237

finally a touch of Louis XVI. But the simplicity of his box-shaped buildings and the clear fundamental elements on which his architecture is founded began to be increasingly apparent in his work. The most important examples of Wagner's late Art Nouveau style include the façade of his building on the Wienzeile (1898–1900), which is decorated with colored majolica tiles (plate 235), the somewhat Byzantine domed church in Steinhof, near Vienna, the famous central Vienna office of the Administration of Postal Savings Accounts—the last two buildings both date from 1906—and, finally, the charming administrative offices of the River Traffic Authority on the Danube embankment, built in 1913 in the style of his former pupil Obrist.

In 1895, Wagner published his important and widely read book, *Moderne Architektur*. Though Art Nouveau is not often mentioned here, all the important Viennese Art Nouveau architects belonged to his school. Wagner liberated Viennese architecture from the shackles of historicism. "It is not a rebirth of the Renaissance, but only a birth," he wrote. Josef Hoffmann also noted, in this context: "I am particularly interested in the square as such and in the use of black and white as dominant colors, because these clear elements have never appeared in earlier styles."

In Wagner's architecture, the proportions of the cubic and compact block shapes of his entirely flat surfaces or of his discreet geometrical ornaments nevertheless revealed a slight touch of the Empire style or of Classicism; but these elements are no longer visible in the work of his pupils, the architects and designers, Josef Hoffmann (1870–1955) and Joseph Olbrich (1867–1908), and the

designer Koloman Moser (1868–1916). After some initial indecision on their part, the typical and almost geometrical Viennese style first appeared in their drawings for the periodical *Ver Sacrum*. The earliest building conceived in this general context was Olbrich's hall for the exhibitions of the *Wiener Sezession*, built between 1889 and 1899 (plate 236), which looks as though it had been made of compact, sharp-edged, flat-surfaced blocks topped by three-quarters of a sphere. The latter is an openwork dome made of gilt bronze laurel leaves. The tendency to add a relatively incongruous element, such as this dome, appears frequently in Viennese works of this period. In this building, the forms are not only reminiscent of Wagner's earlier Empire style, but also of the *retour d'Égypte* element displayed during the Napoleonic Empire; all the blocks and pylons decrease gradually in volume toward the top. This exhibition hall, conceived in terms of cubes, squares, and spheres, provided the groundwork for Vienna's late Art Nouveau. It had, moreover, borrowed some decisive elements of design from Townsend's Whitechapel Art Gallery (plate 150), where the structure's cubic articulation and the decorative carved foliage ornamenting the façade were both more constrained to the two-dimensional plane because Townsend had merely redesigned the front of an already existing building that was part of a group forming an integrally designed row of houses. A group of houses designed for use as an artists' colony on the Mathildenhöhe near Darmstadt in Germany also bears the imprint of Olbrich's personal style. This entire community was designed by Olbrich (with the exception of one house built by Peter Behrens), and is particularly interesting because it was especially commissioned by Grand Duke Ernst Ludwig of Hessen who had it built for an exhibition called *A Document of German Art*, a title that was subsequently given to the colony itself.

Olbrich's own house in the colony (plate 237) proved

238

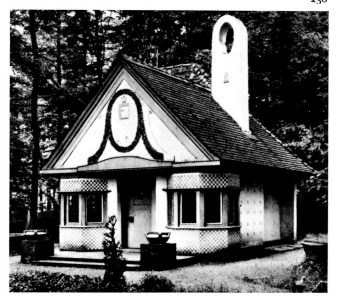

to be particularly felicitous in its design. It is distinguished from the other buildings by its row of tiles which girdle the structure, and by the roof of rustic design (reminiscent of English country houses). Here and there themes borrowed from designs by Webb, Norman Shaw, Voysey, or Baillie Scott can be recognized, but Olbrich has transposed them in an inventively playful mood. A real playhouse was built by Olbrich for the young princesses of Hessen in Wolfsgarten, near Darmstadt (plate 238). It is a good example of the Viennese predilection for the cube and rectangle, transplanted to Germany. Later, in 1907, Olbrich built the *Wedding Tower* (plate 239) on the Mathildenhöhe, a most original piece of work whose independently personal style endowed the city of Darmstadt with a new landmark.

To the left of its entrance the hall of the *Wiener Sezession* bears the words *Ver Sacrum*, which became the title of the whole movement's publication. The periodical's appearance and its almost square format likewise make use of the simplicity of a basic geometric form. As a periodical, it introduced to the public many of the most important artists of its time. Japanese prints were reproduced; Hermann Bahr, Rilke, and Loris (the nom de plume of the young Von Hofmannsthal) contributed articles of great subtlety on art; articles in memory of Burne-Jones or Puvis de Chavannes were printed; photographs in the manner of Art Nouveau by the Viennese Camera Club were reproduced; the new interior decorations of the *Sezession* building, such as those by Klimt for Klinger's *Beethoven*, were shown; and throughout its pages the specific Viennese style of ornament was displayed. This ornamentation, mostly designed by Hoffmann, Olbrich, and Moser, rarely uses the gliding lasso-like line; what one finds there most frequently are rosette-like forms which were multiplied and used in rows, friezes, and frames. After 1900, lines disappear almost entirely, leaving mostly regular squares, circles, dots, and checkerboard patterns. These last were particularly used by the most refined of the Viennese artists, Hoffmann, who was even nicknamed "Checkerboard-Hoffmann." Such rows of squares were used especially on edges and borders in interiors, and on exteriors often around windows which were set in entirely unadorned, whitewashed areas.

Viennese furniture of this period is almost always box-shaped and reveals many affinities with English furniture of the Arts and Crafts movement, but with a new element of charm and eclecticism which was not unknown to the English though it was now developed in Vienna with a more refined and feminine elegance. The Viennese transformed these pieces of furniture into ob-

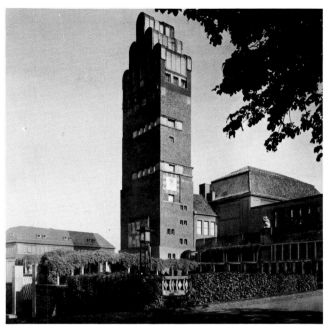

239

jects of luxury by using materials of the highest quality. All this, and indeed the entire style, was still strongly influenced by Japan; and it was mainly through *The Studio* that Japanese and English art became known in Vienna after 1893. The impression that this English periodical made there is illustrated by one of Peter Altenberg's charming stories in which he describes what a great event it was when a new issue of *The Studio* arrived in an art-loving, wealthy household: a kind of silently aesthetic celebration, after which the master of the house had scant hopes of the fulfillment of more profane desires.

The Viennese or *Sezession* style was represented first and foremost in *Ver Sacrum*, but found its last truly creative expression in Hoffmann's *Palais Stoclet*, built in Brussels between 1905 and 1911 (plate 240). This spacious building limits itself almost entirely to rectilinear and rectangular forms and to the relationships between them. However, it gives us no impression of cubic forms; its extremely varied structure seems to be disembodied, as if composed of plates of glass. The different sections of the walls are faced with white marble; these slabs, in turn, are framed by golden friezes, the ornamentation of the entire exterior being limited to these frames. Reminiscences of Olbrich's *Sezession* exhibition building seem to appear at the top of the tower of the *Palais Stoclet*, which displays an element of drama not entirely suitable for a private home. The garden of this building was conceived as part of the general architectural plan, and is an extension of the structure itself (just as certain Art Nouveau paintings frequently are extended into their frames), and its stone pylons, hedges, and small clipped trees all suggest the same architectural style of the building. The dormer windows protruding squarely from the top of the façade are also a noteworthy feature of the

237 JOSEPH MARIA OLBRICH *The Olbrich residence on the Mathildenhöhe, Darmstadt* (1901)
238 JOSEPH MARIA OLBRICH *The Playhouse of the Princesses, Schloss Wolfsgarten, near Langen* (1902)
239 JOSEPH MARIA OLBRICH *Exhibition Hall and Hochzeitsturm, Mathildenhöhe, Darmstadt* (1907)

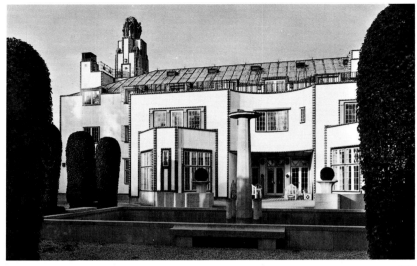

240

241

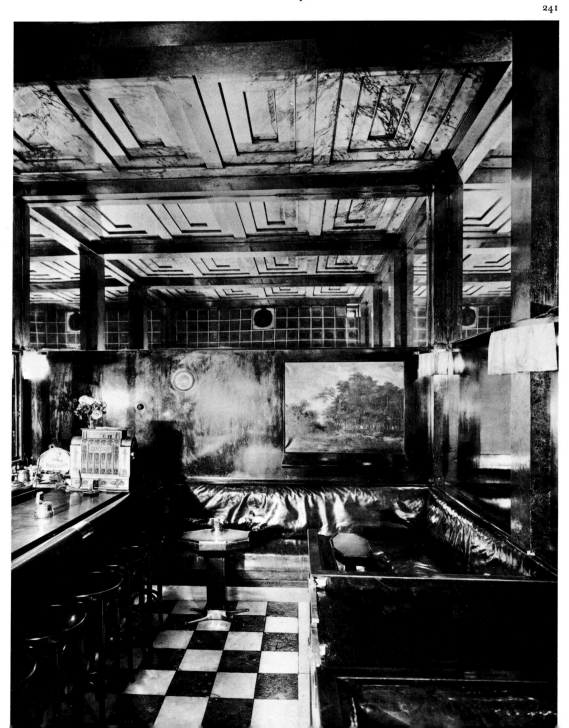

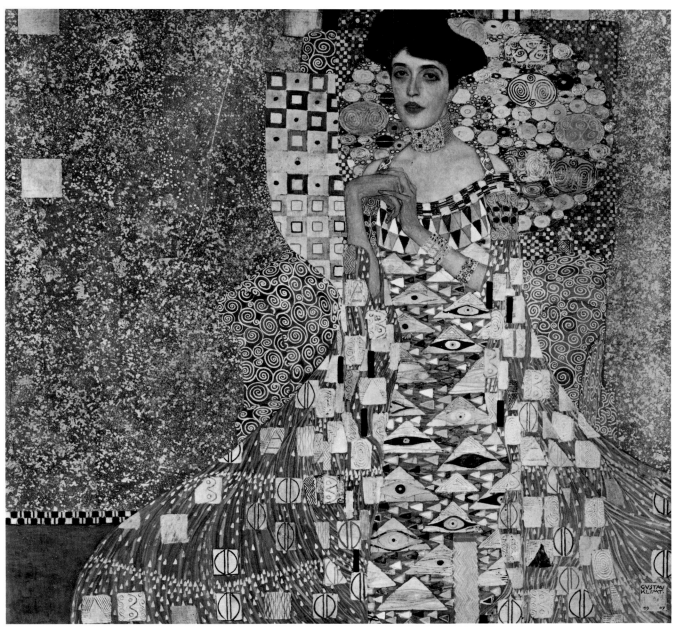

building. These windows bear out Art Nouveau's avoidance of the sculptured cornice (so characteristic of Renaissance and Baroque styles), and are clearly borrowed from England where this architectural style appeared for the first time in Norman Shaw's *Old Swan House* in Chelsea (plate 43), and was later developed by Mackintosh.

Such a building as the *Palais Stoclet* is a perfect example of the bare and unadorned style of late Art Nouveau, where curves appear with less and less frequency, as can be observed in the buildings designed by Mackintosh or Perret. As a disciple of Voysey, the former no doubt exerted a great influence in Vienna: Meier-Graefe and

240 JOSEF HOFFMANN *Palais Stoclet, Brussels* (1905–11)
241 ADOLF LOOS *Kärntner Bar, Vienna* (1907)
242 GUSTAV KLIMT *Portrait of Frau Adele Bloch-Bauer* (1907)

Ahlers-Hestermann both describe the enthusiasm with which Mackintosh's works were received in the Austrian capital, especially on account of his refinement of means, and his curiously evanescent or disembodied charm, so typical of his style. Mackintosh's predilection for white lacquered furniture and dark wood was bound to appeal to the Viennese, who had similar tastes. Fritz Wärndorfer, the Viennese translator and collector of Beardsley, had a large music room decorated by Mackintosh, and an issue of *Ver Sacrum,* with color reproductions, was dedicated to Mackintosh and the Macdonald sisters.

But there are fundamental differences between the styles of Vienna and Glasgow. At first encouraged by English examples, the Viennese style became independent and had developed a character of its own before

the closely related ideas of Mackintosh were known to any appreciable extent among Austrian Art Nouveau enthusiasts.

While Van de Velde fought against the Romantic element in the ornament of floral *Jugendstil* in Germany, in Vienna, where neither the floral trend nor the "Belgian" line were popular, a distaste for any kind of ornament was felt at a very early date. Developing the ideas and tendencies of Wagner, Adolf Loos (1870–1933), soon after 1900, pronounced a veritable anathema on ornament in general. In contrast to most of the theoretical writers on Art Nouveau, he was true to his own principles and very soon attained a smooth and cubic style of architecture and interior design (plate 241) that appears to be related to the slightly exaggerated proportions of late Art Nouveau, but which tends quite independently toward modern architecture.

The most powerful personality among Viennese painters of this period was Gustav Klimt (1862–1918). Highly gifted as a decorator, he may probably be compared with Beardsley in that his works, quite apart from their ornamental element, are charged with an alarming expressiveness which arises from an obscure subconscious domain, an inner world which Sigmund Freud, concurrently (and also in Vienna) had also begun to explore.

To begin with, the formats of Klimt's paintings are unusual: not infrequently, they are rigorously square. Producing an extraordinary effect from a distance, the human figure in his works is transformed into an ever-asymmetrical and pictorial ornament. His people appear to be overgrown with many small ornaments, striking us as strangely unfamiliar beings; actually his ornaments and designs are not derived from any pre-existent sources, however exotic. However, his treatment of eye forms as ornaments was borrowed from ancient Egyptian art. Klimt's world of ornament is founded mainly on geometric forms such as the square, the circle, and the spiral, and within these we find similar or slightly varied forms grouped in an irregular fashion (colorplate XIII). The fact that his colors—especially gold—are sometimes applied so thickly that they achieve relief effects, reinforces the impression of jewel-like splendor in his paintings.

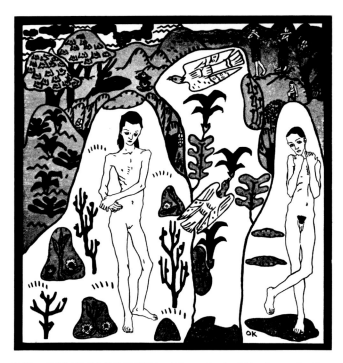

243 OSKAR KOKOSCHKA *Illustration for "Die träumenden Knaben"* (1908)

Klimt's figures are stiffly posed like those in Byzantine icons, but their faces are treated more three-dimensionally and realistically, and rising from the rigid bodies they produce a kind of shock in the viewer (plate 242).

Oskar Kokoschka (born in 1886) emerged as an artist from Klimt's circle before shifting to his own Expressionism. In his book, *Die träumenden Knaben* (plate 243), Kokoschka created a work which, in form, content, text, and illustration, represents one of the most homogeneous and valuable examples of its kind in the declining period of Art Nouveau. With a great flair for folklore, Kokoschka also suggests the same curious impression of the nursery atmosphere as may be found in certain interiors by Hoffmann which, however indirectly, had their source in England.

THE SIGNIFICANCE OF ART NOUVEAU

"All art is at once surface and symbol. Those who go beneath the surface do so at their peril. Those who read the symbol do so at their peril."
Oscar Wilde, *The Picture of Dorian Gray*

Biological Romanticism

During its highest phase, at least, the homogeneity of form and structure in Art Nouveau remained unusually original and idiomatic, with lines, transversal axial curves, and uninterrupted contours dominating. However, asymmetry of form appears nearly everywhere in all phases of Art Nouveau, and signifies life and movement. All the swinging, swirling, throbbing, sprouting, and blossoming is intended to be an unequivocal sign of organic life, of living form. Occasionally, the "life" of the elements manifests itself: leaping flames, rushing wind, and, most of all, flowing, rippling waters. There are hints, too, of natural organic forms: the irregular spots or stripes of the skins of the leopard or zebra; the "eyes" in the feathers of peacocks and the wings of butterflies. Frequently, these natural forms remind us of anatomical preparations preserved in alcohol under glass and, even more frequently, associations arise in our minds suggesting "that strange interregnum inhabited by the lower forms of life—the plantlike animals of the sea bottom," that underwater world which, with its unfamiliar and even repulsive grace and elegance, its "half-sucking, half-suspended way of life," fascinated the artists of this period.[41]

In linear Art Nouveau, skeleton and membrane dominate as a structural principle in both architecture and smaller three-dimensional forms. Powerfully dynamic lines (like veins through which the lifeblood flows) compose the structure and, between them, thin and transparent planes extend like the wings of dragonflies. Rooms, halls, or transparently constructed façades appear to be groves of upward-striving saplings or supporting stems of flowers. On the other hand, three-dimensional Art Nouveau produced vases that look like mollusks, rooms like caverns, and building exteriors that remind us of dunes swept by wind and water. In Gaudí's buildings, there are passages with thin and perforated cellular walls, like the shell of a snail, while the interior construction of his houses is as complicated as a labyrinth. The measurements of the human form are never employed as a module to illustrate proportions and rhythms. Instead of being habitations designed for firmly built, square-shouldered men, these buildings seem to be intended for gliding, floating beings whose bearing and movements would tend to suggest Rossetti's Art Nouveau nymphs, or the graceful motions taught by Isadora Duncan. Considered from a classical point of view, Art Nouveau structure at its peak is nonstructural; seemingly without firmness or solidity, it appears weightless and in a constant state of flux.

The materials employed in the construction of these buildings is of a similar nature, ambiguous in spite of clearly determined and sharply defined forms. The substance seems forever changing and tending toward fusion and metamorphosis. In most cases the substance employed is smooth, almost gelatinous, somehow managing to give the impression of nudity—not so much a substance determined by the actual material used, as an undefined, living substratum. However much Art Nouveau developed form from nature (in opposition to historicism), the material of a Guimard vase, for instance, remains ambiguous, scarcely betraying the fact that it is porcelain. If pieces of furniture are lacquered white (a usual practice during Art Nouveau's main phase), they are so masked with the purposeful intention to conceal the wood, disguising it under a homogeneous mass of white so that one does not recognize the material used for the construction. Only seldom, and principally with Gaudí, does the wall (or the "flesh") of a building wear a kind of armor consisting of mosaic, or ceramic "scales" (plate 195). However, when the wall is so covered it is because it was meant to either scintillate or appear iridescent. Stone is seldom intended to look like stone, or wood like wood. The substance invariably depends on the imposed form, and this form alone determines the outward appearance of the materials used.

The figures on one of Gaudí's architectural pendants (plate 244) thus seem to be corals, set in a tangled swirl of seaweed. Glass, also, may appear to be a veined substance, half plant, half animal, almost as distasteful to the eye as living matter torn from the body of a sea creature, but which, at the same time, is gracefully wrought and presented (plate 245). In his fairy tale, *The Fisherman and His Soul*, Oscar Wilde writes: ". . . and putting forth all his strength, he tugged at the coarse ropes till, like lines of blue enamel round a vase of bronze, the long veins rose up on his arms." Who else might have noted this simile before? Who else could have expressed

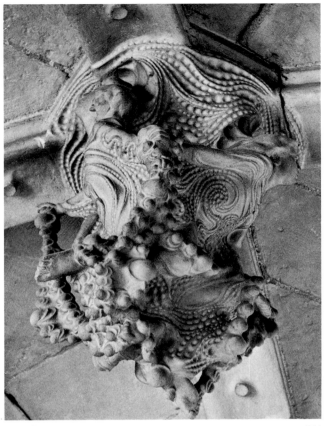

244

Le Cygne noir in 1896. The swans of Eckmann, of Toorop, and of the Berlin *Sezession* painter, Leistikow, find their counterpart in the English peacocks—also very decorative birds which, in addition, display Art Nouveau colors, blue and green, in the metallic, scintillating, brocade-like splendor of their feathers. The silhouette of the peacock, determined either by its trailing tail or unfolded tail feathers, corresponds to Art Nouveau's ideas, as do the details of the tail's scale and eye patterns; moreover, peacocks always strike an exotic note. We have mentioned Whistler's *Peacock Room*; Beardsley's Salome wears a peacock train; and Herod, in Wilde's *Salome*, speaks at great length of his white peacocks. Art Nouveau would not be what it is without its love of the glorious exception and the perverse inversion: it produced white peacocks and black swans, and Oscar Wilde invented the "green carnation." In England, a book of poems was entitled *Grey Roses*. Ricketts designed a peacock on his cover for Wilde's *House of Pomegranates*. Heinrich Vogeler, on the title page for Hofmannsthal's *The Emperor and the Witch* and on the title page of the German periodical *Die Insel*, drew the peacock as a fabulous bird, and Thomas Theodor Heine then seized the opportunity of making charming parodies of these designs. The peacock is not only the symbol of beauty and vanity, but also the bird of legends. Up until the early Middle Ages, traditional iconography showed the bird of paradise in the shape of a peacock. The circle is then closed with Stravinsky's *Firebird* and Maeterlinck's *Blue Bird* (though not peacocks *per se*, both were fabulous birds), both of which played a part in the neo-Romanticism of 1900 not unlike that played by the "blue flower" during the German Romantic movement of 1800.

Art Nouveau's lily is derived from those one sees in Rossetti's early paintings, where it represents the flower of the Annunciation, of the Holy Virgin, of purity, retaining an element of consecration. From Rossetti's day, the lily became the heraldic flower of the London aesthetes. Lady aesthetes appeared in society with long-stemmed lilies in their hands; Oscar Wilde carried one in the street; Proust's little actress, who endeavored without success to recite fragments from Maeterlinck, made her appearances holding a lily and wearing a gown copied from Rossetti's *Ecce Ancilla Domini*; Otto Eckmann is famous for his fine lilies in *Pan*. Art Nouveau's conception of form was, of course, also satisfied by the lily design; a long, linear stem with sharply outlined and narrow leaves that bears aloft a flower of striking shape, the beauty of which is revealed especially in profile. Art Nouveau fancied flowers with long stems and blooms with petals that could easily be transposed in two dimensions: above all, irises, then poppies, and tulips, too. Roses occur rarely in High Art Nouveau, being too substantial with their petals that cover one another and which cannot be arranged in

it with so much aesthetic feeling? Wherever high quality is concerned, Art Nouveau treats even what is repulsive in the lower organic forms with delicacy and often with playful grace. All serious Symbolist and Art Nouveau artists from Baudelaire to Beardsley possessed a magical ability to "transform the most loathsome things into objects of particularly enticing beauty."

How far back to the origins of life this substance is made to regress is revealed in the irregular small cells which entirely cover the walls of Gaudí's *Casa Batlló*. Enlarged by the magnifying eye of Art Nouveau, we find here the core of protoplasm, the original units of living substance. Above a frieze with sea monsters and between coral-shaped lamps, cells are also depicted on the ceiling of Endell's *Buntes Theater* in Berlin, and Blake's watercolors for Milton's *Paradise Lost* begin to intimate these themes.

A few typical themes stand out in the iconography of Art Nouveau. The theme of the swan and that of the lily (which have in common a pure white and a clear outline) were of course chosen on account of their beauty. But the swan was also elected because it is a rare, proud, and solitary bird and because its quiet gliding on glittering waters arouses a vague nostalgia. The swan had Romantic predecessors: not so much the decorative swans of the Empire period as those of Tchaikovsky's ballet, *Swan Lake*, and the swan in Wagner's *Lohengrin*. Francis Vielé-Griffin entitled a book of his poems *Les Cygnes* (1885–86) and W. Degouve de Nunques painted

244 ANTONI GAUDÍ *Pendant in the cloister of the Church of the Sagrada Familia, Barcelona* (1887–91)
245 ÉMILE GALLÉ *Bowl* (1899)

juxtaposition as a surface-design. But roses were then rediscovered by late Art Nouveau on account of their geometrically circular outline. Water lilies were, naturally, popular; firstly because they evoke water, and secondly because their stems sway under the surface of the water like long and pliant tubes. Orchids are also important; the first cattleya-like blossoms appear in Blake's watercolor for Dante's *Purgatory*; later, they reappear especially in three-dimensional objects such as glass vases. In the first volume of Proust's *A la recherche du temps perdu*, the lovely cattleya has acquired a special meaning which, in another sense, is not far removed from the biological domain.

Art Nouveau and Symbolism were particularly attracted to nymphs, mermaids, and other hybrid creatures. Related to them are Heywood Sumner's *Undine*, the first representational figure in pure High Art Nouveau (plate 56), Jean Dampt's *Mélusine*, with her thick, jointless, snake-like arms, and the mermaid in Wilde's *The Fisherman and His Soul*. The French poet Henri de Régnier entitled a volume of his poems *Aréthuse*, after the Greek fountain-nymph. Odilon Redon and Gustave Moreau painted and repainted numerous versions of the birth of Venus, and in one painting, Redon shows her under water, emerging from a shell. A Symbolist periodical was named after the sea shell, *La Conque*; another was called *Le Centaure*. Verlaine wrote *Poèmes saturniens*; Symbolist and Art Nouveau representations of sphinxes are innumerable (plate 137); Khnopff painted the *Blood of Medusa*, Moreau often depicted chimeras or aristocratic and marvelously adorned sirens. This nostalgia for creatures that are half human and half animal is characteristic of the whole style. In popular publications like *Die Jugend*, we find laughing mermaids, satyrs, and nymphs as the ideal images of unbridled eroticism; but in works of a higher quality we also feel the dangerous attraction and the demonic and magic elements of this intermediate world. Beside personifications of voluptuousness, those of the enigma, of mystery, and of corruption also appear.

Another symptom likewise reveals dissatisfaction or weariness of the merely human condition: the closer relationship of the other arts to music. This approach can already be felt in the great importance ascribed to rhythm in Art Nouveau forms. "The human figure provides the basis for all thought and art except music . . . where pure *humanitas* is not necessarily contained; there even exists a kind of music which sets out to deprive man of this higher form of his condition by bringing him back, with all the power of its sweet seductions, to prehuman conditions."[43] Actually, this kind of music developed mainly as a parallel to Art Nouveau, or even preceded it in Wagner's *Tristan und Isolde*, with its fusion of love in death and death in love. Later, from Debussy's *Pelléas et Mélisande* to Stravinsky's *Sacre du Printemps*, such music offers infinite temptations to abandon oneself to the primitive moods of the dawn of humanity (although Debussy's filaments of sound and Stravinsky's brutal

avalanche of rhythms are poles apart, they both are descriptions of that curious admixture of sex and death). In Stravinsky, we thus reach the borderline of brutality and barbarism which is often suggested in modern art, but a decade earlier, Scriabin had already expressed the voluptuousness of self-annihilation in its most perfect form in his *Poème d'extase*.

The subconscious remembrance or nostalgia for man's interuterine avatars asserts itself in Art Nouveau's forms and substances as well as in the choice of thematic materials; we repeatedly encounter the themes of water, marine life, or the lower organic life forms in general. Wallpapers, textiles, ceramics, and silverware are the chief mediums for this type of decoration. At the boundary between English early and High Art Nouveau, Walter Crane represented mermaids in his ceramics, and designed a wallpaper depicting water with a swimming fish here and there. In William Burgess' house in Melbury Road, Art Nouveau expresses itself in the frieze above the fireplace: incongruously enough, for a fireplace decoration, it shows the waves of the sea with fishes frolicking among the surging billows.

William Blake's predilection for fire motifs did not exclude his interest in aquatic themes, as can be seen in an illuminated page from his *Jerusalem*, which in addition also carries marginal decorations showing many varieties of submarine or worm-like creatures. In High Art Nouveau, such themes are so frequent that we need only cite two examples: Gilbert's fountain in Piccadilly Circus (plate 247), and the choir in Gaudí's *Sagrada Familia* (plate 246). In the latter, the gargoyles in the buttresses appear in the form of huge lizards, snakes, seashells, salamanders, and snails—all successors to the demons of Gothic cathedrals. These creatures are connected to the building with tube-like drainpipes that look like umbilical cords.

The aims of Art Nouveau were not so much directed at nature in the popular sense, as at the basic forces of life itself. The sources of life, and the power of life to transform itself eternally, could also be made apparent without employing themes borrowed from nature: they

245

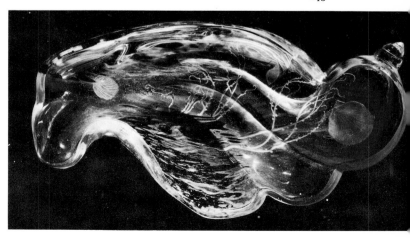

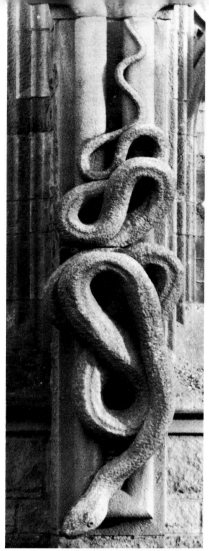

246

could be expressed in terms of eroticism. Munch painted *Puberty*, and revealed the merging of bodies in *The Kiss* (colorplate XXI). In one of Ricketts' illustrations for Oscar Wilde's *The Sphinx*, the diver seeking the ring is shown in a kind of water tank outlined with flames. Beardsley, we are told, studied works on embryology, and his fascination with this subject may be seen in some of his drawings although most of these were published privately. In these latter works he not only gave expression to images that reveal unashamed desires, but he also made use of gynecological themes which he developed with great precision, delighting in details suggestive of both horror and disgust. At the same time, however, these black-and-white drawings were treated with a certain fanciful playfulness. Far from being frivolous, Munch, in turn, represented a human embryo in his lithograph, the so-called *Madonna* (plate 175). Here, the figure of the woman is blasphemously surrounded by a border—a flow of spermatozoa, the "springs of life." Some years later, in 1902, the French author, Alfred Jarry, wrote a "modern novel," *Le Surmâle*: to Nietzsche's superman he opposed the supermale, a monster of sexual potency. In some of its brutally clinical details, Jarry's novel anticipates *The Kinsey Report* by fifty years.

Art Nouveau's characteristic and fundamental concern with life is confirmed by its literary production; the eloquent titles of many of these works, the verbal images, and, of course, by the various manifestos, periodicals, and other literary mediums expressing its doctrines. The principal *Jugendstil* periodicals in Germany were *Die Jugend* and *Pan*. The first, meaning "youth," speaks for itself; *Pan*, the title of the second, recalls the Greek god of nature, the master of the nymphs and satyrs who personified erotic and orgiastic existence. Nietzsche distinguished Apollonian and Dionysiac art by assigning to the former category all that is luminous, clear, and meditative, and to the latter all that is passionate and unbounded. To the latter, he seems almost ready to categorize all the works of Richard Wagner, who certainly influenced Art Nouveau through his later music and his Symbolist writings. *L'Après-midi d'un faune* is similarly the title of one of Mallarmé's poems, and Rodin created fauns and nymphs many times; ageless creatures, ideal images of eternal youth and exuberant life.

Ver Sacrum, "the sacred spring," was the name of the leading Art Nouveau periodical in Vienna. The meaning of this title was made quite clear in the cover design of the first issue: an ornamental shrub in a wooden tub which the tremendous vital forces of the plant's roots had burst asunder. A later cover design showed a volcano erupting flowers instead of lava—the springtime of life and blossoms breaking forth with volcanic power. A French Symbolist periodical was named *Floréal*, the "official" name for May after the French Revolution. *Frühlingserwachen (Spring's Awakening)* is the title of a drama on puberty by the German playwright, Frank Wedekind (who also wrote a play called *Erdgeist—Earth Spirit*). The name of the Scottish periodical, *Evergreen*, suggests eternally youthful life, and its individual issues were given the names of the seasons rather than the usual numbers assigned to magazines. Though there was a great deal in *Evergreen* relating to the Celtic renaissance in Scotland, its pages also contain articles on biological themes, treated with surprising frankness for the times. Nor was it an accident or coincidence that an expert in sexology, Havelock Ellis, contributed to Beardsley's sophisticated and worldly magazine, *The Savoy*. In the Spanish Art Nouveau periodical, *L'Avenç*, the Catalan poet, Alejandro Sawa wrote about vitalism. Even the Pre-Raphaelites, who otherwise revealed no great interest in this general subject, were concerned with the germ of life: a publication on art, founded in his youth by Rossetti, was thus called *The Germ*. Seed or germ are, of course, used here merely as metaphors for the origin of a new art, but just as certain titles are instructive, so are verbal images which may reveal an unconscious attitude toward

246 ANTONI GAUDÍ *Rain pipe on the exterior of the Church of the Sagrada Familia, Barcelona* (1887–91)
247 ALFRED GILBERT *Detail of the Shaftesbury Memorial Fountain (known as the "Eros Fountain") in Piccadilly Circus, London* (1887–93)

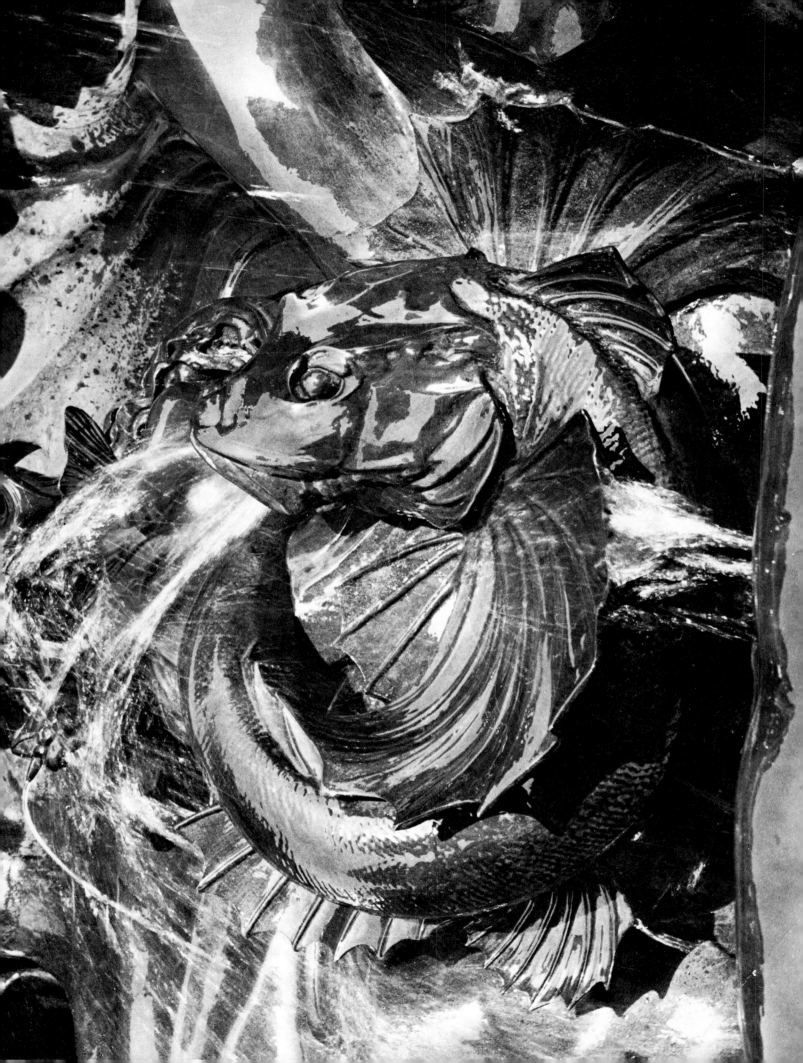

the actual meaning they express. Van de Velde—to quote only one example among many—certainly displayed great control in his art, but, just as certainly, his verbal association was completely spontaneous of any double meaning when he wrote: "Beauty is once again filled with lifegiving sap and inner strength; we have suddenly discovered that it has not withered, since its vital force is eternal and indestructible and can always produce new blossoms."

Under the influence of Darwin's theories, Romantic historicism was transformed into biological historicism. When a new Romanticism began to emerge at the end of the nineteenth century, it was related to the nature Romanticism of the early 1800s, and became a "biological Romanticism." How much Darwin (who considered all life, from the amoeba upward, in terms of "historical" development) had indeed influenced even the art theory of his time, becomes evident in a text by Eberhard Baron von Bodenhausen. Bodenhausen, a German industrial magnate who later became a friend of Hugo von Hofmannsthal, wrote in an 1899 issue of *Pan*: "Since Darwin's achievement, we view the world in the light of his doctrines . . . modern ethics will respond to the trend of our time according to its ability to develop according to the basis of his doctrines." Art Nouveau did not choose to favor forms that are similar to sea anemones and other such lower organisms, half plant, half animal, for their flowery elegance and ornamental form alone, but also because they are close to those forms which first appeared when life was beginning. The biologists Darwin and Haeckel both began their careers with research on jellyfish and medusae. Obrist asks: "What can stir our vital emotions more strongly than the graceful, long, sinuous, linear tentacles of a jellyfish swaying in the water?" As if the Art Nouveau lines and rhythms were to be scientifically illustrated and confirmed, Haeckel had written about "the curvilinear progression of the procreation of life."

Abstract Dynamism

"Energy is eternal delight."
William Blake: *The Marriage of Heaven and Hell*

Even in concrete expressions of fanciful ornament, abstract forms already existed in High Art Nouveau, suggesting movement and life without direct reference to any particular themes derived from fauna or flora, or from the natural elements. Though Horta's use of metal scaffoldings generally suggests elements of plant life, many of his structures also become abstract by being conceived in terms of general and nonspecific dynamics. This abstract dynamism, however, is also alive and organic, just as are the forms of Van de Velde, who, most consistently of all, aimed at abstract form. Somehow, even in the work of Van de Velde, there is always a suggestion of rippling muscles and taut sinews, though he uses neither plants nor animals as his models. Representational Art Nouveau had been attracted to the lower or primal organisms, but Van de Velde and abstract High Art Nouveau embody the dynamics of the elements of life itself, suggesting Henri Bergson's *élan vital*, that eternal energy which continues its uninterrupted pulsation, regardless of the stage of metamorphosis in which it happens to find itself, and of the particular form assumed by any species at any given time. Van de Velde—at least in theory—strove to distinguish the dynamism of his forms from personal and individual form: "A line is a force, filled with the energy of him who drew it." The "power lines" of Art Nouveau were thus conceived as bearers of energy, and the artist almost as an abstract source of energy. Such an abstract dynamism also has a lengthy previous history, particularly in England. Joseph Paxton, who was an outsider to early Art Nouveau, but, as one of the inventors of glass and iron buildings, had created the conditions possible for Horta's buildings, was inspired to undertake his skeleton buildings on seeing the great leaves of the *Victoria Regia* which are upheld on the water by their own veins, so that his architecture also owes its style to plant life. Christopher Dresser, the English designer, likewise started from botany; having studied the development of plant life, he was one of the first to achieve, in his glass and silverware, an entirely abstract High Art Nouveau, and one of his designs is even entitled *Force and Energy* (plate 36). Here, we find hints of the vegetal element, as with Horta, such as unrolling spiral tips of ferns or abstract forms of plants in the Gothic manner. But, on the whole, these associations were only intended to create an impression of energy and dynamism.

This abstract, functional, and dynamic aspect of Art Nouveau, now divested of Romanticism and of the orgiastic elements of nymphs and satyrs, leads on to late Art Nouveau as well as to modern art or modern functionalism. In late Art Nouveau, biological life and dynamism give way to rigid calm. The proportions are still directly related to those of High Art Nouveau and the rudimentary forms of the older curve are equally present everywhere. But we might well wonder whether, between geometrical rigid late Art Nouveau and organically animated High Art Nouveau, a profounder relationship had not been expressed in a common nostalgia for the primitive state. The feeling of discomfort that culture produced in Freud, the lure of music and of decoration developed into music, the attraction of a chaos created by a general fusion of the forces of life—might not the rigor of late Art Nouveau be understood as a necessary final phase of all this secret nostalgia, in fact as an "urge in all animated organic life to return to a more primitive condition," even to that of inanimate matter, of the crystalline stone? In his *Jenseits des Lustprinzips*, Freud, beyond the *libido* or sexual drive, detects another instinct, the *para-libido* or urge for repose and permanent liberation, in Nirvana, from the tensions and conflicts of which life is made. Because of its inner conflicts, Art Nouveau could not live long. Its turgid uni-

verse of the hothouse and the aquarium was destined to bring about a desire for immobility, for rectangular forms, when a reaction against High Art Nouveau assured, on the other hand, the continuity of its metamorphosis.

Art Nouveau and Its Time

However great the number of precious objects, admirable in their fragile beauty, Art Nouveau may have produced, the universal regeneration of art and life that it attempted was condemned to failure from the outset. The kind of return to the original source it tried to achieve over and over again cannot be successful if undertaken too deliberately. Nor could the inner constitution of this style or the sociological background of its artists and patrons make Art Nouveau an important movement of renewal. It was the ideal world of a select group, and when at last it reached the public at large it had already been corrupted by derivative and commercial artists: "When the leaders lose themselves in their dreams, the crowd is left empty-handed."[44]

A social phenomenon parallel to Art Nouveau shared the same fate, that of the *Wandervogel*, a youth movement, resembling the Boy Scouts, that remained peculiar to German-speaking countries. Here too a longing for a new beginning (like the one that characterized Art Nouveau) strove to take shape. Werner Helwig, who belonged to the movement, wrote in "melancholy memory" of the *Wandervogel*: "The urge for 'realization,' the longing to make a fresh start, the refusal of what was felt to be artificial, untrue, or a diversion from the essential, the restoring of relations between man and man, between man and nature, self-preservation and devotion to the universal whole: . . . all this pressed forward, thrust upward and sprouted side by side . . . and it will always be as difficult to say at which point, in this general psychological shift of emphasis, youth's awakening awareness of itself and of its struggle and its rights occurred, whether it was a genuine impetus coming from the depths or whether the whirlwind of time had but loosened a kind of ice pack that was already disintegrating . . . The harmful effects of industrialization were to be limited, . . . life itself was to be sanctified and declared the most precious of all possessions in an appropriately renovated devotion to religious service." This renewal is also mixed with melancholy and a feeling of uselessness: "The premonition of the instability of everything (which was beginning to assume the appearance of an indisputable certainty) filled us with sadness. In the whole movement there was, from the very start, a feeling of finality, of fading away, of renunciation, even of weariness."

How true this also was of German *Jugendstil* too, and even of the entire Art Nouveau movement, in its attempt to establish a contact with original traditions, its adoration of life and youth as "the most precious of all possessions," as well as its swiftly ensuing disappointment and disillusion. Art Nouveau thus contained a kind of self-frustration within itself, not so much because of its strong element of decadence, of *fin de siècle* and *morbidezza*, as because its romantic nature made it shrink from the harsh reality of modern industrialization, whether in order to seek the "uncorrupted" landscapes of the *Wandervogel*, or to shut out the unwelcome view with screens covered with peacocks and lilies, after the manner of the Aesthetes.

The Aesthete and his brother, the Dandy, are the true key figures of Art Nouveau. Max Beerbohm said in 1895 that Dandyism is a symptom of one's feeling of loneliness and, at the same time, in a sense the least egoistic of all the arts, since the Dandy reveals himself to the whole nation as soon as he emerges from the privacy of his home, when all people, whether princes or peasants, are free to admire his masterpiece. Dandyism, according to Sir Max, is one of the decorative arts; the Dandy, as long as he is nothing but a Dandy, never produces any work of art but turns himself and his life into a "work of art." All "your days are your sonnets," Oscar Wilde states in *The Portrait of Dorian Gray*, so that the Dandy is even obliged to raise the accessories of his life to the level of art. (Van de Velde designed silver knobs for walking sticks.) "Mr. Whistler's top hat is a true nocturne and his linen a symphony in white major," Beerbohm waggishly declared, adapting Whistler's "musical" titles to the painter's own appearance. A number of ladies who had no intention of appearing on the stage studied "eurhythmic" movements with Isadora Duncan or with Dalcroze at Hellerau, in order that the synthesis of rhythm and ornamentation, the "homogeneous system" of their Art Nouveau homes, should not be disturbed by the all-too-human behavior of not yet fully stylized inhabitants. Oscar Wilde discovered that life imitates art far more than art imitates life, not only because life is driven to imitate in any case, but above all because it consciously sets out to express itself and because art offers it beautiful forms in which it can satisfy this urge. Together with the critical Aesthete and the productive artisan who are sometimes united in him, the Dandy was thus the type of human being, or the representative of the state of culture, who best determined Art Nouveau. Through his demands, he closed the magic circle that made it possible to change the human figure into an ornament—the *Jugendstilman* of whom the Viennese writer Karl Kraus said that "the very convolutions of his brain became ornaments."

All this leads us inevitably to determine more exactly the sociological background of Art Nouveau. Art Nouveau is indeed a style of the upper bourgeoisie, that of the cultured and urbane middle class in the heyday of classical capitalism. It is essentially the first genuinely universal style of a period which was no longer under the domination of the clergy or aristocracy. Like Impressionist paintings, its creations were not commissioned by patrons but were offered directly to the purchaser by the artist. For whom did the leading Art Nouveau artists

work, and what was their socio-economic milieu? The *Palau Güell*, said to be the costliest private dwelling of that time, was built by Gaudí for the cosmopolitan industrialist and shipping magnate, Don Eusebio Güell, who was the architect's friend and patron, and was later raised to the nobility. Gaudí's apartment houses—the *Casas Milá, Batlló,* and *Calvet*—were, like Perret's houses in the Rue Franklin, not intended for occupancy by socially undistinguished tenants. When Güell donated to Barcelona the park named after him, he did this in the manner of a private patron, in the manner of the Continental bankers who continually underwrote the losses of Diaghilev's *Ballets Russes*.

Louis Comfort Tiffany, the extremely wealthy son of a New York jeweler, before he decorated the homes of men like Hamilton Fish and Havemeyer, designed a suite of studios for himself (plate 216) so lavish that they were fit to receive the court of Byzantium. James McNeill Whistler, the son of an American engineer who built Russia's first railroads, received a West Point education and thereafter led a provokingly elegant existence. His famous *Peacock Room* was commissioned by the Liverpool shipowner, Frederick Leyland, who was also a personal friend. Whistler painted the room in Leyland's absence, overstepping the limits of their agreement both in his exorbitant fee and in the overdecoration of the room (he had painted over the walls which had been covered with priceless Spanish leather hangings), thereby terminating their friendship and resulting in a lawsuit.

In Paris and Nancy, Art Nouveau developed a decidedly worldly character and, not infrequently, had a luxurious quality that even suggests the demimonde. Guimard's Métro entrances arouse in us expectations of the abode of Venus deep down in a mountain rather than a democratic subway; they seem to lead straight to Maxim's, the interior decoration of which is still unrivaled as a restaurant interior.

Victor Horta of Brussels, later raised to the nobility, built the *Maison du Peuple* for the Belgian Socialist party, but worked mainly for upper-middle-class and capitalist patrons. The mansion he constructed for the industrial magnate, Solvay, was of princely proportions. To be sure, there are exceptions to these examples of success: the sculptor Georges Minne almost died of starvation and

was, in an artistic sense, in love with a life of poverty, the sort that Maeterlinck praised but had never experienced. Minne's early drawings do not suggest destitution so much as what Meier-Graefe has called "the splendor of destitution." On the other hand, the Symbolist painter, Fernand Khnopff, came from a patrician family with international connections; he lived in a labyrinthine house in Brussels in which the Minotaur would have felt very much at home. In its almost surrealistically disposed mazes, with its unusual proportions, its surprising vistas like those in the backgrounds of his pictures, overdecoration alternated superbly with bare walls and empty rooms.

"Imprisoned in the palace of art"[45]—the phrase is true for the whole of Art Nouveau—imprisoned like the oyster in its mother-of-pearl shell, or entangled like the insect caught in the spider's web of the nymph Arachne, about whom Marcel Schwob wrote one of his most astonishing and fanciful prose passages: "Now I distinctly feel both of Arachne's knees gliding onto my body and the gurgling of my blood as it rises to her mouth. Soon my heart will be sucked empty; then it will remain smothered in its prison of white threads. And I? I will flee through the kingdom of the spiders to the dazzling network of the stars. Using the silk skein which Arachne will throw to me, I shall flee with her and leave to you —poor fools—a pale corpse, with a shock of fair hair shivering in the morning wind."

Starting from this psychological *fin-de-siècle* mood, and founding his theories on his studies of hysteria, Sigmund Freud later wrote a book on *Uneasiness in Culture*. Gauguin actually escaped from the confinements and discomfort of civilization to the island of Tahiti. But this escape was opposed to the more general trend of Art Nouveau, which shut its eyes to the reality of everyday life, enclosed itself in the artificial paradise of the imagination, frequented the chimera, and regressed from the world of human beings to the regions of biological prehistory. But despite all this, Art Nouveau never succeeded in shattering the glass walls of civilization. When aesthetic comfort and the self-indulgence of the *mal du siècle* were destroyed as if by a rough hand by the sudden appearance of Gauguin and Rimbaud, we have found that point in cultural history where we must place the first real origins of modern art.

NOTES

1 Friedrich Ahlers-Hestermann, *Stilwende. Aufbruch der Jugend um 1900*, 1st ed., Berlin, 1941, p. 73.

2 Julius Meier-Graefe, "Das plastische Ornament," *Pan*, Berlin, 1898, Vol. IV, No. 4, pp. 257–64. A study of the sculpture of Georges Minne.

3 Ernst Michalski, "Die entwicklungsgeschichtliche Bedeutung des Jugendstils," *Repertorium für Kunstwissenschaft*, Berlin, 1925, Vol. XLVI, p. 135.

4 T. R. Way and G. R. Dennis, *The Art of James McNeill Whistler*, London, 1903, p. 64.

5 Novalis speaks of an "art with a pleasant estrangement, an object of an alien cast, yet familiar and inviting." *Life and Works*, Berlin, 1943, Vol. III, p. 623.

6 Otto Eckmann, *Neue Formen. Dekorative Entwürfe für die Praxis*, preface by Aem. Fendler, Berlin, 1897.

7 Werner Blaser, *Wohnen und Bauen in Japan*, Teufen (Switzerland), 1958, p. 9.

8 Justus Brinckmann, *Hamburgisches Museum für Kunst und Gewerbe: Die Ankäufe auf der Weltausstellung Paris 1900*, Hamburg, 1901, pp. 40–41,54.

9 Ibid., p. 3.

10 Eduard von Bodenhausen, "Englische Kunst im Hause," *Pan*, Berlin, 1896, Vol. II, p. 332.

11 Richard Redgrave. Quoted in Sigfried Giedeon's *Mechanization Takes Command*, New York, 1948, p. 251.

12 Owen Jones, *The Grammar of Ornament*, London, 1856, introduction, p. 4.

13 Ibid., chapter xx, p. 154.

14 Ibid., introduction, p. 4.

15 Christopher Dresser, *Principles in Design*, London, 1870, Vol. 1, p. 121.

16 *Letters of Rossetti to Allingham*, ed. George Birbeck Hill, London, 1897, p. 241.

17 Jakob Walter, *William Blakes Nachleben in der englischen Literatur des 19. und 20. Jahrhunderts*, Schaffhausen (Switzerland), 1927, p. 7.

18 Ibid., p. 7.

19 Henry-Russell Hitchcock, *Architecture: Nineteenth and Twentieth Centuries*, Harmondsworth, 1958, pp. 287, 450.

20 Edgar Kaufmann, Jr., "224 Avenue Louise," *Interiors*, New York, Vol. CXVI (February 1957), No. 7, p. 88.

21 Jürgen Joedicke, *Geschichte der modernen Architektur*, 2nd ed., Stuttgart, 1960, p. 44.

22 Hermann Bahr, "Fernand Khnopff," *Ver Sacrum*, Vienna, 1898, Vol. I, No. 12, p. 3 ff.

23 Dolf Sternberger, "Jugendstil, Begriff und Physiognomie," *Die Neue Rundschau*, Berlin, Vol. XLV (September 1934), No. 9, p. 258.

24 Nikolaus Pevsner, *Pioneers of Modern Design from William Morris to Walter Gropius*, New York, 1949, p. 52.

25 Sigfried Giedion, *Space, Time and Architecture. The Growth of a New Tradition*, 5th ed., Cambridge, Mass., 1967, p. 245.

26 Marcel Proust, *Within a Budding Grove*, trans. C. K. Scott Moncrieff (copyright 1924, renewed 1951 by Random House, Inc. Reprinted by permission), *Remembrance of Things Past*, two-volume edition, New York, 1951, p. 592.

27 Marcel Proust, *Swann's Way*, trans. C. K. Scott Moncrieff (copyright 1928 by The Modern Library, Inc., reprinted by permission of Random House, Inc.), *Remembrance of Things Past*, two-volume edition, New York, 1951, p. 151.

28 Martin Birnbaum, *Jacovleff and Other Artists*, New York, 1946, p. 131.

29 Ibid., p. 131.

30 *Aubrey Beardsley. Letzte Briefe*, ed. Max Meyerfeld, Leipzig, 1910.

31 Friedrich Ahlers-Hestermann, *Stilwende. Aufbruch der Jugend um 1900*, 1st ed., Berlin, 1941, p. 101.

32 Georg Fuchs, "Hermann Obrist," *Pan*, Berlin, 1896, Vol. I, No. 5, p. 321.

33 Quoted from Carola Giedion-Welcker's *Plastik des XX. Jahrhunderts*, Stuttgart, 1955, p. 281.

34 Georg Fuchs, "Hermann Obrist," *Pan*, Berlin, 1896, Vol. I, No. 5, p. 320.

35 Ibid., p. 324.

36 Quoted from the exhibition catalog of the Zurich Kunstgewerbemuseum: *Um 1900. Art Nouveau und Jugendstil*, Zurich, 1952, pp. 33–34.

37 Carola Giedion-Welcker, *Plastik des XX. Jahrhunderts*, Stuttgart, 1955, p. 281.

38 Friedrich Ahlers-Hestermann, *Stilwende. Aufbruch der Jugend um 1900*, 1st ed., Berlin, 1941, p. 73.

39 Ibid., pp. 27–28.

40 Theodor Däubler, *Der neue Standpunkt*, Leipzig, 1919, p. 100.

41 Dolf Sternberger, "Jugendstil, Begriff und Physiognomie." *Die Neue Rundschau*, Berlin, Vol. XLV (September 1934), No. 9, pp. 258.

42 Martin Birnbaum, *Jacovleff and Other Artists*, New York, 1946, p. 131.

43 Friedrich Sieburg, *Die Lust am Untergang*, Hamburg, 1954, p. 286.

44 Hugo von Hofmannsthal, "Aufzeichnung 1890 bis 1895," *Corona*, Munich, Berlin, and Zurich, 1941, Vol. X, No. 4, pp. 443–44.

45 Arthur Symons, "Walter Pater," *Insel-Almanach auf das Jahr 1906*, Leipzig, 1906, p. 66.

SELECTED BIBLIOGRAPHY

Ahlers-Hestermann, Friedrich. *Stilwende. Aufbruch der Jugend um 1900.* Berlin, 1941.

Amaya, Mario. *Art Nouveau.* London and New York, 1966.

Aslin, Elisabeth. *The Aesthetic Movement. Prelude to Art Nouveau.* New York, 1969.

Battersby, Martin. *The World of Art Nouveau.* New York, 1968.

Bauer, Roger (Ed.). *Fin de Siècle.* Frankfurt am Main, 1977.

Cassou, Jean, Langin, Emil, and Pevsner, Nikolaus. *Gateway to the Twentieth Century. Art and Culture in a Changing World.* New York, 1962.

Champigneulle, Bernard. *Art Nouveau.* Woodbury, N. Y., 1976.

Cirici-Pellicer, Alexandre. *1900 in Barcelona. Modern Style, Art Nouveau, Modernismo, Jugendstil.* New York, 1967.

Collins, George R. "Some Reflections on the Art Nouveau," *Art International,* V. 4, No. 7, September 1960, pp. 63–70.

Cremona, Italo. *Il tempo dell'Art Nouveau.* Florence, 1964.

Darmstadt. Hessisches Landesmuseum und Kunsthalle. *Darmstadt. Ein Dokument deutscher Kunst. 1901–1976.* Exhibition catalogue, 1976–77.

Guerrand, Roger-Henri. *L'Art Nouveau en Europe.* Paris, 1967.

Hamann, Richard, and Hermand, Jost. *Stilkunst um 1900.* Berlin, 1967.

Hermand, Jost. *Jugendstil. Ein Forschungsbericht 1918–1964.* Stuttgart, 1965.

———(Ed.). *Jugendstil.* Darmstadt, 1971.

Hofmann, Werner. *Turning Points in Twentieth-Century Art: 1890–1917.* New York, 1969.

Hofstätter, Hans H. *Geschichte der europäischen Jugendstilmalerei.* Cologne, 1963.

Hope, Henry R. *The Sources of Art Nouveau.* Ph.D. dissertation. Harvard University, Cambridge, Mass., 1943, ms.

Houston. Rice University, Institute for the Arts. *Art Nouveau: Belgium/Holland.* Exhibition catalogue, 1976.

Hutter, Heribert. *Art Nouveau.* New York, 1967.

Jullian, Philippe. *Dreamers of Decadence. Symbolist Painters of the 1890's.* New York, 1971.

Koreska-Hartmann, Linda. *Jugendstil-Stil der 'Jugend.' Auf den Spuren eines alten, neuen Stil-und Lebensgefühls.* Munich, 1969.

Lenning, Henry F. *The Art Nouveau.* The Hague, 1951.

Mackay, James. *Dictionary of Turn of the Century Antiques.* London, 1974.

Madsen, Stephan Tschudi. *Sources of Art Nouveau.* Oslo and New York, 1956.

———. *Art Nouveau.* Oslo, 1967.

Michalski, Ernst. "Die entwicklungsgeschichtliche Bedeutung des Jugendstils," *Repertorium für Kunstwissenschaft.* Berlin and Leipzig, Vol. XLVI (1925), pp. 133–49.

Paris. Musée National d'Art Moderne. *Les Sources du XX^e Siècle. Les Arts en Europe de 1884 à 1914.* Exhibition catalogue, 1960–61.

Pevsner, Nikolaus. *Pioneers of the Modern Movement from William Morris to Walter Gropius.* London, 1936. 2nd ed.: *Pioneers of Modern Design. From William Morris to Walter Gropius.* New York, 1949.

———. *The Sources of Modern Architecture and Design.* New York, 1968.

Rathke, Ewald. *Jugendstil.* Mannheim, 1958.

Rheims, Maurice. *The Flowering of Art Nouveau.* New York, 1966.

Richards, J. M., and Pevsner, N. (Eds.). *The Anti-Rationalists.* Toronto, 1973.

Schmalenbach, Fritz. *Jugendstil. Ein Beitrag zu Theorie und Geschichte der Flächenkunst.* Würzburg, 1934.

Seling, Helmut (Ed.). *Jugendstil. Der Weg ins 20. Jahrhundert.* Munich, 1959.

Selle, Gert. *Jugendstil und Kunst-Industrie. Zur Ökonomie und Ästhetik des Kunstgewerbes um 1900.* Ravensburg, 1974.

Selz, Peter, and Constantine, Mildred. *Art Nouveau. Art and Design at the Turn of the Century.* New York, 1959.

Simon, Hans Ulrich. *Sezessionismus. Kunstgewerbe in literarischer und bildender Kunst.* Stuttgart, 1976.

Sternberger, Dolf. *Jugendstil.* Frankfurt, 1977.

Sterner, Gabriele. *Jugendstil. Kunstformen zwischen Individualismus und Massengesellschaft.* Cologne, 1975.

Wallis, Mieczyslaw. *Secesja.* Warsaw, 1974. German: *Jugendstil.* Dresden, 1974.

Zurich. Kunstgewerbemuseum. *Um 1900. Art Nouveau und Jugendstil. Kunst und Kunstgewerbe aus Europa und Amerika zur Zeit der Stilwende.* Exhibition catalogue, 1952.

LIST OF ILLUSTRATIONS

33 Arthur Heygate Mackmurdo. *Decorative fabric.* Printed cotton fabric, 1883. Woven for the Century Guild by Simpson and Godlee, Manchester (?). The Victoria and Albert Museum, London

34 Christopher Dresser. *Plans and Elevations of Flowers* from Owen Jones' *The Grammar of Ornament,* London, 1856

35 Philipp Otto Runge. *Geometric drawing of the cornflower,* 1808. Pen and pencil, 15 3/4 × 7 7/8", Kunsthalle, Hamburg

36 Christopher Dresser. *Force and Energy* from Christopher Dresser's *Principles in Design,* London, 1870

37 Christopher Dresser. *Design for a stained-glass window* from Christopher Dresser's *Principles of Decorative Design,* London, 1873

38 Christopher Dresser. *Vase.* Ceramic, 1892–96. Made by William Ault's Pottery, Swadlincote. Height 8 1/2". Collection Miss C. J. Ault

39 Christopher Dresser. *Pitcher.* Ceramic, 1879. Made by William Ault's Pottery, Swadlincote. Height 8 1/2". Collection Miss C. J. Ault

40 Arthur Heygate Mackmurdo. *Writing desk.* Oak, 1886. Height 39". The William Morris Gallery, Walthamstow, England

41 Arthur Heygate Mackmurdo. *Chair.* 1881. From *The Studio,* Vol. XVI, London, 1899

42 Arthur Heygate Mackmurdo. *Title page* from *Wren's City Churches,* Orpington, Kent, 1883

43 Richard Norman Shaw. *Old Swan House.* 1876. London

44 Dante Gabriel Rossetti. *How Sir Galahad, Sir Bors and Sir Percival were Fed with the Sancgreal; But Sir Percival's Sister Died by the Way.* Watercolor, 1864

45 William Blake. *The Chorus of the Skies* from the series of illustrations for Edward Young's *Night Thoughts.* Watercolor with printed text, 1796. 20 7/8 × 15 3/4". The British Museum, London

46 Dante Gabriel Rossetti. *Ecce Ancilla Domini (The Annunciation).* Oil on canvas stretched over wood, 1850. 28 3/8 × 15 3/4". The Tate Gallery, London. Reproduced by courtesy of the Trustees of the Tate Gallery

47 John Everett Millais. *Design for a Gothic window.* Watercolor, 1853. From John Guille Millais' *The Life and Letters of Sir John Everett Millais,* Vol. I, London, 1899

48 William Blake. *Angels Hovering over the Body of Christ.* Watercolor, 1808. 16 3/8 × 11 3/4". Collection Sidney Morse

49 William Blake. *Then the Lord answered Job out of the Whirlwind* from the series of illustrations to *The Book of Job.* Copperplate engraving, 1825. 8 1/4 × 6 1/4". The British Museum, London

50 Edward Burne-Jones. *The Golden Stairs.* Oil on canvas, 1880. 109 × 46 1/8". The Tate Gallery, London. Reproduced by courtesy of the Trustees of the Tate Gallery

51 William Blake. *The Dream of Jacob.* Watercolor, 1808. 14 5/8 × 11 3/8"

52 Frederick Shields. *Binding* for Alexander Gilchrist's *Life and Works of William Blake,* second edition, London, 1880. Gold leaf on linen. The British Museum, London

53 Robert Blake. *The King and the Queen of the Fairies* from William Blake's *Notebook* (the so-called "Rossetti Manuscript"), begun by William Blake's brother, Robert. Watercolor, 1787. The British Museum, London

54 Arthur Heygate Mackmurdo. *Screen.* Satin, embroidered in silk and gold threads, 1884. 47 1/2 × 42 7/8". The William Morris Gallery, Walthamstow, England

55 Heywood Sumner. *Binding for Cinderella, A Fairy Opera in Four Acts,* music by John Farmer, text by Henry S. Leigh, London, 1882. Gold leaf on linen

56 Heywood Sumner. *Binding* for Friedrich de la Motte-Fouqué's *Undine,* London, 1888. Blindstamped on imitation leather

57 Félix Bracquemond. *Plate.* 1867. Musée des Arts Décoratifs, Paris

58 Jules Chéret. *Folies-Bergère, Les Girard.* Color-lithographed poster, 1877. 22 1/2 × 16 1/2". Bibliothèque Nationale, Paris

59 Pierre Puvis de Chavannes. *The Poor Fisherman.* 1881. Musée du Louvre, Paris

60 Maurice Denis. *Title page* for Maurice Denis' *Amour: Douze lithographies en couleurs,* Paris, 1898. Colored lithograph. 22 × 16 1/2". Stadelsches Kunstinstitut, Frankfurt am Main

61 Gustave Moreau. *Dusk.* Watercolor and gouache. 14 5/8 × 8 5/8". Formerly in a private collection, New York

62 Odilon Redon. *Lady in a Shell.* Collection Hahnloser, Winterthur, Switzerland

63 Paul Gauguin. *Soyez amoureuses, vous serez heureuses.* Painted wood bas-relief, 1890. 40 1/2 × 28 3/8". Museum of Fine Arts, Boston

64 Paul Gauguin. *Vase with Breton designs.* Ceramic, *circa* 1888. Height 11 3/8". Musées Royaux d'Art et d'Histoire, Brussels

65 Émile Bernard. *Breton Women.* Colored woodcut. 4 3/8 × 15 3/8". Kunsthalle, Bremen

66 Auguste Rodin. *Danaïde.* Marble, 1885. Height 12 3/4", length 28 3/4". Musée Rodin, Paris

67 Émile Gallé. *Vase, with a design of aquatic plants.* Glass, *circa* 1900. Height 15 3/4". Musée de l'École de Nancy, Nancy, France

68 Victor Horta. *Staircase in the Tassel residence.* 1892–93. Brussels

69 Victor Horta. *Staircase in the Tassel residence.* 1892–93. Brussels

70 Victor Horta. *Detail of the balcony of the Horta residence.* Cast iron, 1898–1900. Brussels

71 Victor Horta. *Dining room of the Horta residence.* 1898–1900. Brussels

72 Victor Horta. *Solvay residence* (presently the L. Wittamer-De Camps residence). 1895–1900. Brussels

73 Victor Horta. *Dining room in the Solvay residence.* 1895–1900. Brussels

73a Victor Horta. *Buffet in the dining room of the Solvay residence.* 1895–1900. Brussels

74 Victor Horta. *Detail of a door in the Solvay residence* (presently the L. Wittamer-De Camps residence). Wood, 1895–1900. Brussels

75 Victor Horta. *Inlaid floor in the Solvay residence* (presently the L. Wittamer-De Camps residence). Parquet, 1895–1900. Brussels

76 Victor Horta. *Auditorium of the Maison du Peuple.* 1896–99. Brussels

77 Victor Horta. *Façade of the Maison du Peuple.* 1896–99. Brussels

78 Gustave Serrurier-Bovy. *Interior display for an exhibition.* Between 1894 and 1898

79 Henry van de Velde. *Desk.* 1898

80 Henry van de Velde. *Music Room.* 1902. Folkwang Museum (now the Karl-Ernst-Osthaus Museum), Hagen, Germany

81 Henry van de Velde. *Bloemenwerf residence.* 1895–96. Uccle, near Brussels

82 Henry van de Velde. *Dining room furniture.* Wooden chairs with seats of woven straw. Table of wood with brass inlays. Height of chairs 37", 1895. Bloemenwerf residence, Uccle, near Brussels

83 Henry van de Velde. *Woman's dress.* Circa 1896

84 Henry van de Velde. *Haymaking.* Oil on canvas, *circa* 1893. 29 1/2 × 37 3/8". Estate of Henry van de Velde, Brussels

85 Georges Minne. *Fountain with five kneeling boys.* Marble, 1898–1906. Height (of figures) 30 3/4". Folkwang Museum (now the Karl-Ernst-Osthaus Museum), Hagen, Germany

86 Georges Minne. *Drawing* from *Van Nu en Straks,* 1890. Pencil

87 Georges Minne. *Illustration* for Maurice Maeterlinck's *Serres chaudes,* Paris, 1889. Bibliothèque Royal de Belgique, Brussels

88 Fernand Khnopff. *I Lock My Door Upon Myself.* Oil on canvas, 1891. 28 3/8 × 55 1/8". Bavarian State Collection of Pictures, Munich

89 Fernand Khnopff. *On n'a que soi* (bookplate), *ex libris* page from *Ver Sacrum* 1, Vienna, 1898, No. 12

90 Jan Toorop. *Sketch for "The Three Brides."* Black crayon, 1892. 24 3/4 × 29 1/8". Gemeentemuseum, The Hague

91 Jan Toorop. *Song of the Times.* Black chalk and pencil over colors on brown paper in a painted and carved wood frame, 1893. 12 5/8 × 23 1/4" (without frame). Kröller-Müller Museum, Otterlo, The Netherlands

92 Jan Toorop. *Vignette* from *Van Nu en Straks,* Brussels-Antwerp, 1893, No. 2.

93 Jan Toorop. *Preliminary study* for *"The Three Brides."* Colored crayons and pen, 1891 or 1892. 7 1/2 × 10 1/4". Kröller-Müller Museum, Otterlo, The Netherlands

94 J. Jurriaan Kok (designer of piece) and J. W. van Rossem (decorator). *Vase.* So-called "eggshell" porcelain, *circa* 1900. Height 12 1/4". Made by Manufaktur Rozenburg, The Hague. Gemeentemuseum, The Hague

95 Christophe Karel de Nerée tot Babberich. *Benediction.* Embroidery on silk, executed by the artist's mother, Mevrouw C. de Nerée tot Babberich-van Houton, before 1909. 21 1/8 × 11 3/8". Gemeentemuseum, The Hague

96 Jan Toorop. *Under the Willows.* Oil on canvas, n.d. 24 3/4 × 29 7/8". Stedelijk Museum, Amsterdam

97 Johan Thorn Prikker. *De Bruid.* Oil on canvas, 1892–93. 57 1/2 × 33 7/8". Kröller-Müller Museum, Otterlo, The Netherlands

98 Agatha Wegrif-Gravesteyn. *Wall hanging.* Batik-dyed chiffon velvet, *circa* 1900. 78 5/8 × 37 3/8". Gemeentemuseum, The Hague

99 Theodorus A. C. Colenbrander. *Bowl.* Ceramic, 1886. Height 3 1/2", diameter 7 7/8". Gemeentemuseum, The Hague

100 Gerrit Willem Dijsselhof. *Dijsselhof Room.* 1890–92. Created for Dr. Hoorn, Amsterdam. Wall decoration in batik-dyed linen. Gemeentemuseum, The Hague

101 Hendrik Petrus Berlage. *Desk.* Mahogany with brass hardware, desk top covered with felt, *circa* 1900. Height 29 1/2". Collection A. C. Strasser-Berlage, Bern

102 Hendrik Petrus Berlage. *Great Hall of the Amsterdam Stock Exchange.* 1898–1903. Amsterdam

103 Hendrik Petrus Berlage. *Stock Exchange.* 1898–1903. Amsterdam

104 René Lalique. *Brooch.* Gold, enamel, and pearls, *circa* 1900. Height 4 3/8", width 2 3/4". Austrian Museum for Applied Arts, Vienna

105 René Lalique. *Ornamental comb.* Horn, gold, and enamel, *circa* 1900. Austrian Museum for Applied Arts, Vienna

106 René Lalique. *Pendant.* Gold, enamel, brilliants, and pearls, *circa* 1900. Height 2 3/8". Collection His Royal Highness Prince Ludwig von Hessen und bei Rhein, Schloss Wolfsgarten near Langen, Germany

107 Émile Gallé. *Vase.* Multicolored glass, *circa* 1895. Height 7 1/8". Collection Dr. W. Rotzler, Zurich

108 Émile Gallé. *Vase.* Multicolored, carved, and etched glass, *circa* 1895–1900. Musée des Beaux-Arts, Nancy

109 Émile Gallé. *Woman's desk.* Circa 1900. Musée des Beaux-Arts, Nancy

110 Hector Guimard. *Detail of a Métro station.* Painted cast iron and colored glass, *circa* 1900. Paris

111 Hector Guimard. *Métro station, Place de l'Étoile* (demolished). 1900. Paris

112 Hector Guimard. *Detail of a Métro station.* Painted cast iron and glass, *circa* 1900. Paris

113 Hector Guimard. *Staircase in the artist's house.* 1911. Paris

114 Hector Guimard. *Desk.* From the artist's house. Ashwood, *circa* 1903. Height 28 3/4", width 101". The Museum of Modern Art, New York. Gift of Mme. Hector Guimard

115 Hector Guimard. *Auditorium in the Humbert de Romans Building.* 1902. Paris

116 Henri de Toulouse-Lautrec. *Troupe de Mlle. Églantine.* Colored lithograph poster, 1896. 24 3/8 × 31 1/4″. Victoria and Albert Museum, London

117 Henri de Toulouse-Lautrec. *Divan Japonais.* Color lithograph, 1892. 31 5/8 × 23 7/8″. The Museum of Modern Art, New York. Mrs. John D. Rockefeller, Jr., Purchase Fund

117a Pierre Bonnard. *Screen.* Four colored lithograph panels, 1899. Each panel 53 7/8 × 18 5/8″. The Museum of Modern Art, New York. Mrs. John D. Rockefeller, Jr., Purchase Fund

118 Aristide Maillol. *The Laundress.* Bronze, *circa* 1893. Height 7 7/8″. Collection Helmut Goedeckemeyer, Frankfurt am Main

119 Auguste Perret. *Apartment house (street façade).* 1903. Rue Franklin, Paris

120 Auguste Perret. *Garage rue Ponthieu.* 1905. Paris

121 Léon Bakst. *Stage-setting for "L'Après-midi d'un faune."* Design for the ballet produced by Sergei Diaghilev's *Ballets Russes.* Watercolor, 1912

122 Edward Steichen. *Rodin, Victor Hugo, and "The Thinker."* Photograph, 1902. 10 1/4 × 11 3/4″. The Art Institute of Chicago. Alfred Stieglitz Collection

123 Aubrey Beardsley. *Caricature of James McNeill Whistler* (referring to Mallarmé's *L'Après-midi d'un faune*), from George Egerton's *Keynotes,* London-Boston, 1893

124 Aubrey Beardsley. *Caprice.* Oil on canvas, 1894. 11 3/4 × 9 7/8″. The Tate Gallery, London. Reproduced by courtesy of the Trustees of the Tate Gallery

125 Aubrey Beardsley. *Poster for a book publisher* (detail). Color lithograph, *circa* 1895. Dimensions 29 7/8 × 11 3/8″. Victoria and Albert Museum, London

126 Aubrey Beardsley. *Binding* for Ernest Dowson's *Verses,* London, 1896. Parchment. 8 × 5 7/8″. Victoria and Albert Museum, London

127 Aubrey Beardsley. *Binding* for Oscar Wilde's *Salome,* London and Boston, 1894. Gold leaf on linen, 8 1/2 × 7″. Private collection, Leipzig

128 Aubrey Beardsley. *The Peacock Skirt,* illustration for Oscar Wilde's *Salome,* London-Boston, 1894

129 Aubrey Beardsley. *The Toilet of Salome,* illustration for Oscar Wilde's *Salome,* London-Boston, 1894

130 Aubrey Beardsley. *Initial* from Sir Thomas Malory's *Le Morte d'Arthur,* Vol. 1, London, 1893

131 Charles Ricketts. *Vignette* from *The Dial,* London, 1889, No. 1

132 Charles Ricketts. *Vignette* from Oscar Wilde's *A House of Pomegranates,* London, 1891

133 Charles Ricketts. *Vignette* from Oscar Wilde's *A House of Pomegranates,* London, 1891

134 Charles Ricketts. *Title page* for Michael Drayton's *Nimphidia and the Muses' Elizium,* London, 1896. Woodcut, Victoria and Albert Museum, London

135 Charles Ricketts. *Binding* for Oscar Wilde's *A House of Pomegranates,* London, 1891. Stamped linen. 8 1/4 × 7 1/8″. The British Museum, London

136 Charles Ricketts. *Bookplate* for Gleeson White, 1892

137 Charles Ricketts. *Illustration* for Oscar Wilde's *The Sphinx,* London, 1894. Victoria and Albert Museum, London

138 Laurence Housman. *Title page* for Jane Barlow's *The End of Elfintown,* London, 1894. Victoria and Albert Museum, London

139 Beggarstaff Brothers (William Nicholson and James Pryde). *Don Quixote.* Poster for a dramatization of *Don Quixote* at the Lyceum Theatre, London. *Papier collé,* 1895. 76 × 77 1/8″. Victoria and Albert Museum, London

140 Edward Gordon Craig. *Illustration* for Hugo von Hofmannsthal's *Der weisse Fächer,* Leipzig, 1907. Wood block

141 Charles Annesley Voysey. *Elevations for a house in Bedford Park near London,* 1888–91

142 Charles Annesley Voysey. *Broadleys residence, Lake Windemere.* 1898. Westmorland, England

143 Charles Annesley Voysey. *Living room in the artist's home, "The Orchard."* 1900. Chorley Wood, Buckinghamshire, England

144 Charles Annesley Voysey. *"Tokyo" wallpaper.* 1893. Printed by hand at Essex and Co. Victoria and Albert Museum, London

145 Charles Annesley Voysey. *"Cereus" wallpaper.* 1886. Made for Woolams and Co. Victoria and Albert Museum, London

146 Charles Robert Ashbee. *Pendant.* Silver, gold, and mother-of-pearl, *circa* 1900. Height 5 1/8″. Made by the Guild of Handicraft. Collection Miss Jean Stewart, Letchworth, England

147 Charles Robert Ashbee. *Mustard pot and spoon.* Silver, green glass, and semiprecious stones, *circa* 1900. Height of mustard pot 4 3/8″; length of spoon 3 7/8″. Made by The Guild of Handicraft. Museum of Applied Arts, Zurich

148 Charles Robert Ashbee. 38 *Cheyne Walk.* 1903. London

149 Charles Harrison Townsend. *St. Mary the Virgin.* 1904. Great Warley, Essex

150 Charles Harrison Townsend. *Whitechapel Art Gallery.* 1897. London

151 William Reynolds-Stephens. *Detail of the interior of St. Mary the Virgin.* Pulpit and lectern covered with sheets of metal. Screen leading into side chapel: walnut. Parapet of choir screen: marble. Relief over pulpit: hammered aluminum. 1904. Great Warley, Essex, England

152 Hans von Marées. *The Abduction of Ganymede.* Oil on canvas, 1887. 38 1/8 × 30 3/4″. Bavarian State Collection of Pictures, Munich

153 Max Klinger. *Page border* from Apuleius' *Amor und Psyche,* Munich, 1880

154 Hermann Obrist. *"Cyclamen" wall hanging | "The Whiplash."* Silk embroidery on wool, 1895. 46 7/8 × 72 1/4″. Münchner Stadtmuseum, Munich

155 Hermann Obrist. *Fountain* for the Krupp von Bohlen residence. 1913. Essen, Germany

156 Hermann Obrist. *Monument to the Pillar.* 1898

157 Hermann Obrist. *Design for a Monument.* Plaster, 1902. Height 35 7/8″. Museum of Applied Arts, Zurich

158 August Endell. *Façade of the Elvira Photographic Studio.* Colored stucco, 1897–98 (destroyed). Munich

159 August Endell. *Staircase in the Elvira Photographic Studio.* 1897–98. Munich

160 August Endell. *Buntes Theater.* 1901. Berlin

161 Otto Eckmann. *Fighting Swans.* Colored woodcut, *circa* 1900. 6 3/8 × 13 1/8″. Museum of Arts and Crafts, Hamburg

162 Otto Eckmann. *Sketch for a decorative design* from Otto Eckmann's *Neue Formen: Dekorative Entwürfe für die Praxis,* Berlin, 1897

163 Otto Eckmann. *Sketches for supports* from Otto Eckmann's *Neue Formen: Dekorative Entwürfe für die Praxis,* Berlin, 1897

164 Otto Eckmann. *Capital letter* designed for the Rudhard Type Foundry, Offenbach, Germany, *circa* 1900

165 Otto Eckmann. *Margin design* from *Pan* I, Berlin, 1896, No. 5

166 Aubrey Beardsley. *Margin design* from Sir Thomas Malory's *Le Morte d'Arthur,* Vol. I, London, 1893

167 Peter Behrens. *Butterflies on Water Lilies.* Colored woodcut, between 1896 and 1897. 19 7/8 × 25 1/4″. Städelsches Kunstinstitut, Frankfurt am Main

168 Peter Behrens. *The Brook.* Colored woodcut, before 1901. 14 1/8 × 18 1/2″. Art Library of the former Berlin State Museums, Berlin-Charlottenburg

169 Bernhard Pankok. *Living room.* Designed for the International Exhibition of 1900. Paris

170 Richard Riemerschmid. *Armchair.* Mahogany, with leather seat, 1899. Height 31 1/2″. The Museum of Modern Art, New York

171 Richard Riemerschmid. *Armchair.* Red-painted wood, before 1900. Height 33 1/2″. Museum of Applied Arts, Zurich

172 Johann Julius Scharvogel. *Vase.* Porcelain covered with flowed glaze, *circa* 1900. Height 4 3/8″. Museum of Arts and Crafts, Hamburg

173 Akseli Gallén-Kallela. *Armchair.* Birchwood, upholstered in handwoven wool material, *circa* 1900. Height 30″. Museum of Arts and Crafts, Hamburg

174 Ivar Arosenius. *Endpapers* for Ivar Arosenius' *Tjugonio Bilder i Färg,* Göteborg, 1909. Both pages together 11 3/4 × 22″. Collection Mr. and Mrs. Eric de Maré, London

175 Edvard Munch. *Madonna.* Color lithograph, 1895. 24 × 16 1/2″. Oslo Komunes Kunstsamlinger, Oslo, Norway

176 Joseph Maria Olbrich. *Room in the Playhouse of the Princesses.* 1902. Schloss Wolfsgarten, near Langen, Germany

177 Ferdinand Hodler. *Spring.* Oil on canvas, 1901. Folkwang Museum (now the Karl-Ernst-Osthaus Museum), Hagen, Germany

178 Ludwig von Hofmann. *Vignette* from *Pan* III, Berlin, 1897, No. 3

179 Peter Behrens. *Library in the Behrens home.* 1901. Mathildenhöhe, Darmstadt

180 Peter Behrens. *Door in the artist's house.* Wood, with wrought metal, 1901. Mathildenhöhe, Darmstadt

181 Henry van de Velde. *Dining room* (wall painting by Maurice Denis). 1902–03. House of Count Harry Kessler, Weimar

182 Henry van de Velde. *Knife, fork, and spoon.* Silver, *circa* 1912. First made by Theodor Müller, Weimar; later by the tableware firm of Franz Bahner, Düsseldorf. Collection Dr. Eich, Düsseldorf

183 Henry van de Velde. *Entrance to the Werkbundtheater* (destroyed). 1914. Cologne

184 Henry van de Velde. *Binding* for Paul Verlaine's *Vers,* Leipzig, 1910. Executed by Elsa von Guaita. Gold leaf on leather. 9 1/2 × 6 1/4″. Collection S. van Deventer, De Steeg, The Netherlands

185 Henry van de Velde. *Tea service.* Silver, with boxwood handles, 1905–06. Executed by Theodor Müller. Karl-Ernst-Osthaus Museum, Hagen, Germany

186 Henry van de Velde. *Candelabra.* Circa 1900. Musées Royaux d'Art et d'Histoire, Brussels

187 Peter Behrens. *AEG Turbine factory.* 1908–09. Berlin

188 Antoni Gaudí. *Banister and garden railing.* Wrought iron, 1878–80. Casa Vicena, Barcelona

189 Antoni Gaudí. *Drawing room of the Palau Güell.* 1885–89. Barcelona

190 Antoni Gaudí. *Domed ceiling of the music room in the Palau Güell.* 1885–89. Barcelona

191 Antoni Gaudí. *Ornamental detail in a bedroom of the Palau Güell.* Wrought iron, 1885–89. Barcelona

192 Antoni Gaudí. *Dressing table.* Designed for the Palau Güell. 1885–89. Collection Amigos de Gaudí, Barcelona

193 Antoni Gaudí. *Chaise longue.* Designed for the Palau Güell. Wrought iron, upholstered in calfskin, 1885–89

194 Antoni Gaudí. *Chair.* Designed for the Casa Calvet. 1898–1904. Barcelona

195 Antoni Gaudí. *Detail of the roof of the Casa Batlló.* Glazed tiles, pottery and marble fragments, 1905–07. Barcelona

196 Alexandre de Riquer. *Binding* for *"Crisantemes,"* Barcelona, 1899. Tooled leather. 7 7/8 × 4 3/8″. Museum of Arts and Crafts, Hamburg

197 Lluís Domènech y Montaner. *Chandelier in the auditorium of the Palau de la Musica Catalana.* 1906–08. Barcelona

198 Lluís Domènech y Montaner. *Palau de la Musica Catalana.* 1906–08. Barcelona

199 Raimondo D'Aronco. *Pavilion for the International Exhibition of Decorative Art.* 1902. Turin

200 Antoni Gaudí. *Rear façade of the Casa Batlló.* 1905–07. Barcelona

201 Antoni Gaudí. *Front façade of the Casa Batlló.* 1905–

INDEX OF NAMES

PHOTOGRAPH SOURCES

A. C. L., Brussels 3, 77
Jean Alliman, Nancy 67
Archivo Amigos de Gaudí (photo by Aleu) 2, 13, 192, 195
T. & R. Annan & Sons, Glasgow 229
L'Art Ancien, S.A., Zurich XVIII
The Art Institute of Chicago 122, 140
The Ashmolean Museum, Oxford 20

Bayerische Staatsgemäldesammlungen, Munich 88
Bibliothèque Nationale, Paris 58
Bibliothèque Royale de Belgique, Brussels 71, 86, 87
Bildarchiv Foto Marburg 29, 85, 103, 146, 155, 159, 168, 177, 181, 239, 240

F. Catalá Roca, Barcelona 244
Chevojon, Paris 120
Fred R. Cohen, New York XVII
Collins, New York XXIV

Dotreville, Brussels 9, 11, 73, 73a

Grete Eckert, Munich XXII

A. Frequin, The Hague 94

Gemeentemuseum, The Hague 90, 95, 98, 99, 100

Photo-Atelier Gerlach, Vienna 241
Joaquin Gomis and Joan Prats, Barcelona XXV, XXVI, 188, 189, 190, 204

Hedrich-Blessing, Chicago 213
Lucien Hervé, Paris 119
Karl Holste, Berlin-Zehlendorf XIV, XVI
Thomas Howarth, Toronto 197, 222, 232

Kunstbibliothek der Ehemals Staatlichen Museen, Berlin (photo by Karl H. Paulmann) XX, 168
Kunstgewerbemuseum, Zurich 5, 10, 40, 54, 59, 64, 69, 76, 78, 79, 82, 84, 93, 96, 101, 104, 107, 108, 109, 147, 157, 171, 175, 180, 182, 183, 184, 185, 220, 228, 234, 245
Kunsthalle, Hamburg 35

The Library of Congress, Washington, D.C. 215

Eric de Maré, London 148, 149, 151, 174, 247
André Martin, Paris 110, 112
MAS, Barcelona XXIII, XXVII, 191, 193, 194, 197, 198, 200, 201, 203, 205
Paul Mayen, New York 1, 70, 72, 210, 217
The Metropolitan Museum of Art, New York 8, 221
Bernhard Moosbrugger, Zurich 105
Museum of Fine Arts, Boston 63
Museum für Kunst und Gewerbe, Hamburg 27, 126, 172, 173, 196
The Museum of Modern Art, New York I, 113, 114, 115, 117a, 170

Nasjonalgalleriet, Oslo II
National Buildings Record, London 24, 43

Österreichische Galerie des XIX. und XX. Jahrhunderts, Vienna 242
Österreichische National-Bibliothek, Vienna 235

Frau Marietta Preleuthner, Vienna XIII

Rijksmuseum Kröller-Müller, Otterlo 91, 97
Ro-Foto, Barcelona 206

Jacques Seligmann & Company, New York 61
Smithsonian Institution, Freer Gallery of Art, Washington, D.C. IV
Städelsches Kunstinstitut, Frankfurt am Main 60, 167
Hermann Stickelmann, Bremen 65
Dr. Franz Stoedtner, Düsseldorf 12, 66, 80, 102, 111, 142, 152, 169
John Szarkowski, Ashland, Wisconsin 208, 209, 212, 214

The Tate Gallery, London 16, 21, 45, 46, 124, 226, 227

O. Vaering, Oslo XXI
Verlag Georg D.W. Callwey, Munich XXXI
Victoria and Albert Museum, London (Crown Copyright Reserved) 15, 25, 26, 30, 32, 33, 38, 39, 116, 123, 125, 126, 128, 129, 138, 139, 141, 144, 145, 223, 225, 233

Virginia Museum of Fine Arts, Richmond XXIX

Étienne Weill, Paris VIII

A. Zerkowitz, Barcelona 246
Zingher, Brussels 74, 75